www.wadsworth.com

www.wadsworth.com is the World Wide Web site for Wadsworth and is your direct source to dozens of online resources.

At *www.wadsworth.com* you can find out about supplements, demonstration software, and student resources. You can also send email to many of our authors and preview new publications and exciting new technologies.

www.wadsworth.com
Changing the way the world learns®

Modern Radio Production

Production, Programming, and Performance

SIXTH EDITION

Carl Hausman
Rowan University

Philip Benoit
Middlebury College

Fritz Messere
State University of New York–Oswego

Lewis B. O'Donnell
State University of New York–Oswego

THOMSON

WADSWORTH

Australia • Canada • Mexico • Singapore • Spain
United Kingdom • United States

THOMSON

WADSWORTH

Publisher: Holly J. Allen
Assistant Editor: Shona Burke
Editorial Assistant: Laryssa Polika
Technology Project Manager: Jeanette Wiseman
Media Assistant: Bryan Davis
Marketing Manager: Kimberly Russell
Marketing Assistant: Neena Chandra
Advertising Project Manager: Shemika Britt
Project Manager, Editorial Production: Mary Noel
Print/Media Buyer: Kris Waller

Permissions Editor: Elizabeth Zuber
Production Service: Robin Gold, Forbes Mill Press
Text Designer: Robin Gold
Photo Researcher: Myrna Engler
Copy Editor: Robin Gold
Cover Designer: John Odam
Cover Image: Craig McClain
Compositor: Thompson Type
Text and Cover Printer: Phoenix Color Corp

Printed in the United States of America
1 2 3 4 5 6 7 07 06 05 04 03

For more information about our products,
contact us at:
**Thomson Learning Academic Resource Center
1-800-423-0563**
For permission to use material from this text,
contact us by:
Phone: 1-800-730-2214 **Fax:** 1-800-730-2215
Web: http://www.thomsonrights.com

Library of Congress Control Number: 2003102729

ISBN 0-534-56396-1

Wadsworth/Thomson Learning
10 Davis Drive
Belmont, CA 94002-3098
USA

Asia
Thomson Learning
5 Shenton Way #01-01
UIC Building
Singapore 068808

Australia/New Zealand
Thomson Learning
102 Dodds Street
Southbank, Victoria 3006
Australia

Canada
Nelson
1120 Birchmount Road
Toronto, Ontario M1K 5G4
Canada

Europe/Middle East/Africa
Thomson Learning
High Holborn House
50/51 Bedford Row
London WC1R 4LR
United Kingdom

Latin America
Thomson Learning
Seneca, 53
Colonia Polanco
11560 Mexico D.F.
Mexico

Spain/Portugal
Paraninfo
Calle/Magallanes, 25
28015 Madrid, Spain

About the Authors

Carl Hausman (Ph.D., the Union Graduate School; postdoctoral fellowship, New York University) is Associate Professor of Communications at Rowan University in Glassboro, New Jersey. Hausman is the author of 20 books, including 9 on the mass media. He has worked in various news and news management positions in radio and television, has worked as a radio producer, staff announcer, and freelance voice-over announcer, and has testified before Congress on media ethics issues.

Philip Benoit (M.A., State University of New York at Oswego) is director of Public Affairs at Middlebury College in Middlebury, Vermont. Formerly the director of broadcasting at SUNY Oswego, Benoit has a broad background in radio, television, and public relations. He was executive officer of the American Forces Network in Europe and American Advisor to the Vietnamese Armed Forces Radio Network.

Fritz Messere (M.A., State University of New York at Oswego) is Professor of Broadcasting and Telecommunications and chairman of Communication Studies at SUNY Oswego. Messere has worked in radio and television and has an extensive background in production. He served as external assistant to FCC Commissioner Mimi Dawson and was the Faculty Fellow of the Annenberg Washington Program in Communication Policy Studies.

Lewis B. O'Donnell (Ph.D., Syracuse University) is Professor Emeritus of Communication Studies at SUNY Oswego. O'Donnell, former president of a radio station ownership group, has worked in a variety of management and performance positions in radio and television. He has been awarded the Frank Stanton Fellowship by the International Radio and Television Society and the New York State Chancellor's Award for Excellence in Teaching.

Contents

PART TWO ◆ THE TECHNIQUES 127

6 *Electronic Editing*

PART THREE ◆ THE APPLICATIONS 209

Preface

Modern Radio Production goes into its sixth edition as we firmly plant both feet in the new century. The technology of the twentieth century started out with scratchy wax disk recordings and ended with crystal clear digital technology. The twenty-first century will undoubtedly bring even more advances. Perhaps historians will look back at the twenty-first century and think that our current technology was crude in comparison to what is to come.

But radio is an unusual medium because it clings to tradition—even when it comes to equipment. The modern radio station is often a mix of old and new. Our goal in this newest edition is to provide updates on the very latest technology—while integrating the traditional equipment and practices that will surely stay in place for decades. You'll find a greatly expanded discussion about digital recording of all kinds, but radio is a seamless mix of tradition and technology, and we hope this text can be described the same way.

Note that we continue to cling tenaciously to the central theme of each and every edition: Radio production is about communicating a message, not about gizmos.

We also stand by our pledge to make every explanation of technology—no matter how cutting-edge the technology—completely accessible. Things are supposed to make sense, and we will continue to do our best to de-mystify technical explanations.

Features

This edition contains updated and expanded versions of some of the features found in prior editions of the text. These include the following:

- "You're On!" features that deal with fine points of announcing, ad-libbing, and other performance aspects of radio.
- "Tuning into Technology" features in which new trends, equipment, and practices are described and explained. These include updates on computer editing with step-by-step instruction that can be applied to any editing software and hardware.
- "Industry Update" features that include a realistic look at the radio industry in transition and the implications for people seeking employment in radio. These include explanations of everything digital, with no-nonsense recommendations and evaluations regarding when digital is better and when it is not.

New to This Edition

This new edition of *Modern Radio Production* includes some exciting new additions based on comments from students and professors who use the book:

- New updated focus on digital technologies and processes throughout text.
- Chapter 2 (The Console) includes new comparisons illustrating differences in recording analog versus digital.
- Chapter 4 (Recording and Playback Devices) includes new coverage of digital recording processes and equipment and new discussions outlining recording formats, including MP3s.
- Chapter 9 (More About the Computer in Radio Production) covers new and updated computer technologies and the latest trends in using standard PCs to automate radio production functions and on-air work.
- Chapter 12 (Commercial Production) includes a new checklist for a good commercial to help students cover all necessary concepts.
- Expanded discussion of the art and science of fitting into today's super-segmented marketplace.
- Explanations about new satellite radio technology and programming.
- Suggested Web links added at the end of each chapter to help illustrate examples of concepts and processes.
- Scores of new photos and illustrations highlighting new equipment and practices.

Online Resources

We are also pleased to offer an online Instructor's Manual for this text. This edition of the manual will include invaluable assistance in teaching the course by providing sample syllabi, test questions, and chapter overviews.

This will be available on the Wadsworth Communication Web site at http://communication.wadsworth.com/hausman/MRP. On the Web site, you will also find student resources for the book, including a glossary, Web links, exercises, and summaries.

Finally, we've added a new author to the sixth edition. Fritz Messere, who was the technical consultant on the first four editions of *Modern Radio Production*, now joins us on this and future editions. His knowledge of technology issues is evident throughout this edition.

Acknowledgments

We wish to thank many colleagues around the country who have made suggestions that have improved the text: Tony DeMars, Sam Houston State University; Karen Kearns, California State University, Northridge; Warren Kozireski, State University of New York–Brockport; Nancy Reist, San Francisco State University; Dave Sabaini, Indiana State University; and David Spiceland, Appalachian State University.

Foreword

I got my start in radio, and learned so much about the magic medium from one of the co-authors of this fine tome, Dr. Lew O'Donnell, when I was a broadcasting major at the State University of New York at Oswego. In fact, "Doc," as we called him, told me in my freshman year that "I had the perfect face for radio!" I actually consider that a compliment.

My colleagues at the time, Carl Hausman and Phil Benoit, shared, if not my facial deficiencies, then certainly my enthusiasm for radio—and I think the authors' view of radio shines through in this latest edition of their text.

This edition has been expanded to include more guidance about programming and on-air performance. Those are vital areas for anyone who wants to go into broadcasting, because in today's competitive marketplace, you need a complete arsenal of skills.

And of course *Modern Radio Production* still does what it did from the start: It provides a jargon-free, user-friendly introduction to the process of communicating with radio. While there's plenty of high-tech here, there's also a lot of down-to-earth information. I hope you enjoy this book. I know I have. And I'm not saying that just because Phil Benoit still has in his possession certain negatives from my college years that might prove embarrassing.

Al Roker
NBC's *Today Show*

Photo by Eddie Adams/Outline Press Syndicate, Inc.

PART ONE

The Tools

Production in Modern Radio

In a world bombarded with media, it seems inconceivable that one medium could continue to score in the cutthroat battle to reach consumers for several hours on a daily basis. Intuitively, a reasonable person would conclude that a single medium could not continue to increase revenues in a time when broadcast, cable, and Internet outlets are fragmenting the audience. That same reasonable person would surmise that attempting to lure the average consumer into staying with one medium for several hours a day is impossible.

And that reasonable person would be dead wrong!

Radio advertising revenues continue to climb—reaching $18.3 billion dollars in 2001, up more than $10 billion dollars from a decade earlier.

Radio listenership continues to be strong. The most recent figures available show that the average American spends about 1200 hours per year listening to radio—38.6 percent of his or her average time spent with all media. That's about three hours a day, more time than the average media consumer devotes to watching network-affiliated television stations. And *10 times* more than time spent reading magazines.

And even though new media are exciting, we need offer only one telling remark about the continuing strength of radio:

Try surfing the Internet in your car. The wireless Internet is still a ways off.

This chapter will put the ever-exciting world of radio in perspective, leading you through a bit of history and sketching the way radio came to do what it does so well today: Target a specific audience that loves what a particular station has to offer.

Radio's beginnings in the early part of this century gave no hint of the role it would play in today's world. Early radio experimenters such as Guglielmo Marconi and Reginald Fessenden never envisioned an era when their elec-

tronic toy would become a means of providing entertainment and information to audiences in their cars, in their boats, and in their homes—much less to joggers in their stride.

Early radio programming evolved from a novel attempt to bring the cultural offerings of major cities into the living rooms of all America; gradually, radio assumed its status as a personal "companion." Early radio programming consisted of live symphony broadcasts, poetry readings, and live coverage of major news events, along with the same kinds of drama, situation comedy, and other programming that form so much of today's television schedules.

Some historians maintain that radio emerged into its present form in 1935, when Martin Block first aired his *Make-Believe Ballroom* show on New York City's WNEW. The idea for the program came from a West Coast station when a planned remote broadcast of a band performance at a local ballroom was canceled. To fill the time, the enterprising broadcaster obtained some of the band's recordings and played them over the air. He identified the program as coming from a "make-believe" ballroom, and the time was filled. When Block brought the idea to New York, it was the birth of the **disc jockey**[1] (or DJ) era in radio.

Production in radio reached its zenith during the golden age of radio (the 1930s and 1940s). Radio programs of that era often originated in large studios, where production people and performers created elaborate programs that depended for their effectiveness on sophisticated production techniques. Dramas were done live because audio tape recorders hadn't been invented yet.

Music was provided by studio orchestras that performed live as the program aired. Sound effects were imaginatively created by production people present in the studio with actors and musicians. Coconut shells, for example, were used to recreate the sound of horses' hoofbeats, and the crackling of cellophane near the microphone recreated the sound of fire.

The arrangement and orchestration of various sound sources combined to create the desired effect in the minds of the listening audience. Budgets were elaborate, scores of people were involved, and scripts were often complex. In fact, production is what made the golden age golden.

Today, the mainstay of radio is recorded music, interspersed with news, talk, and information—and, of course, commercial messages, which pay for the operation of commercial stations. When television took over the living rooms of American homes and supplied, in a far more explicit way, the drama, variety, and other traditional program fare that had marked radio in its heyday, the DJ format became dominant on radio. Music and news and personality in a careful blend known as a **format** became the measure of radio's ability to attract listeners.

The development of **solid-state** technology, and later **microchip** electronics, freed radio from bulky, stationary hardware. At the beach, in the car,

[1] Terms set in boldface are defined in the glossary.

and on city streets, radio can be the constant companion of even the most active of listeners. And freedom from the long (half-hour and hour) programs that once characterized radio and still typify television programming means that information cycles quickly in radio. For example, when people want to find out about a breaking news event, they turn first to the radio.

All this has great significance for anyone who wants to understand the techniques of radio production. **Production** in radio is the assembly of various sources of sound to achieve a purpose related to radio programming. You, as a production person in radio, are responsible for the "sound" of the station.

Sound of the Station

The station's sound is created by using various sources of sound to create a specific result, a specific product that appeals to specific listeners. It's how these sources blend that makes one station different from the others that compete for the audience's attention.

The unique sound of a station emerges from a combination of the type of music programmed, the style and pace of vocal delivery used by the station's announcers, the techniques used in the production of commercials and public service announcements, the sound effects used in the presentation of newscasts, and other special recording techniques and sound production methods.

Formats

Commercial radio stations make their money by targeting audiences for advertisers who buy time on the stations' airwaves (see Chapter 16). The audiences are "delivered" to the advertisers. They are measured by rating services, which use sampling techniques to provide a head count of the audience, including data on such characteristics as age, sex, and level of income.

A commercial radio station's programming goal is to provide on the air something that will attract audiences, which then can be "sold" to advertisers. If the programming doesn't achieve this goal, there will be few advertisers and, of course, little money coming into the station's coffers. Without money, the station cannot operate. So, the name of the game is to attract and hold an audience that will appeal to advertisers. This crucial aspect of radio programming—that is, developing a format—becomes a highly specialized field of its own.

Just as commercial radio strives to attract and hold a specific audience to be successful in the marketplace, public radio stations must use the same fundamental techniques to design programming that will meet the needs of their audiences. Though public radio stations do not sell time to advertisers, they must successfully package their programming to obtain program underwriters and individual subscribers.

Reaching a Specific Audience

Unlike television, which tries to appeal to broader, more general segments of the public with its programs, radio has developed into a medium that focuses on smaller groups, the so-called *target audiences.* For example, a station may choose to program rock music to attract a young **demographic.** (Demographics are the statistical characteristics of human populations; the word is commonly used in the singular in the broadcasting industry to designate any given segment of the audience.) By appealing to one segment of the public (such as people of a certain age, sex, or income) that shares a preference for a certain type of music, a station can hope to attract advertisers wanting to sell products to people of that group.

How Target Audiences Affect Format

Much research and effort has gone into determining the types of programming that attract different types of audiences. The results of these efforts are identification of formats that appeal to specific audiences.

A format is essentially the arrangement of program elements, often musical recordings, into a sequence that will attract and hold the segment of the audience a station is seeking. For example, a format labeled "top 40" or "CHR" (contemporary hit radio) is constructed around records that are the most popular recordings sold to an audience mostly in its teens and early twenties. By programming these recordings successfully, a station will attract a number of these listeners in these age groups. The more teenagers and young adults who listen to the station, the more the station can charge the advertisers who want to use radio to reach this valuable target audience.

There are a great many formats, including CHR (a newer and more inclusive version of the top-40 format), adult contemporary (which reaches adults with modern music), urban, country, classic rock (now a fixture on FM), Spanish, modern rock, dance, and classical. There are other specialized formats, too, such as urban contemporary, ethnic, smooth jazz, and news, which has developed several forms, including all-news, news-talk, and other hybrids. Table 1.1 shows the latest station-by-station tally.

Format, remember, is more than music. The formula for constructing a format might be expressed as production, personality, and programming. How the production, personality, and programming are integrated into a format depends on a marketing decision by the station's management. This decision is usually based on a careful analysis of the competition in a given market and an ascertainment of which audience segments can realistically be expected to become listeners to a particular station. A format is then sought that will position the station to attract a large share of listeners in that market.

Stations switch formats frequently. Switching usually occurs because of a decision to go after a more profitable demographic segment; in other instances, the tastes of audiences may shift. Perhaps there is too much compe-

Table 1.1	**Radio offers a variety of different formats. In 2002, there were more than 13,000 radio stations in the United States. Nearly 11,000 are commercial radio stations. Here are the most popular radio formats.**		

Top formats	AM	FM	Total
Country	643	1491	2134
News/Talk	1141	621	1762
Oldies	308	508	816
Religious (Teaching/Variety)	347	387	734
Adult Contemporary	116	592	708
Spanish	386	309	695
Contemporary Christian	116	564	680
Top 40	8	496	504
Variety	47	416	463
Hot Adult Contemporary	8	396	404
Sports	369	22	391
Classic Rock	7	375	382
Soft Adult Contemporary	74	269	343
Classic Hits	12	250	262
R&B	22	187	209
Modern Rock	3	163	166

SOURCE: *M Street Radio Directory,* June 2002. Used by permission.

tition in a particular format, and a station elects to go after a segment of the audience for which there is less competition.

How Formats Are Constructed

Stations assemble their formats in several different ways. Some simply obtain recordings and program them in some sort of sequence throughout the schedule. Other stations carry different formats for different parts of the day. A station that plays mostly music throughout the day may feature a talk show such as Howard Sterns during the morning drivetime.

The different times of the broadcast day are called *dayparts.* Research has shown that different populations or demographics listen to different dayparts. We tune into one station because we want to hear traffic reports in the morning, but we may prefer another station in the afternoon because of the music that particular station plays. We tune into a third station at night because it carries a sports broadcast we're interested in hearing. (We present an extensive discussion of formats in Chapter 16.)

A very big industry that has grown up in recent years provides stations with "ready-to-use" formats. Firms known as **syndicators** will, for a fee, pro-

vide satellite feeds, music tapes, or program features ready for broadcast. The music has been carefully planned and produced in a pattern designed to attract the maximum numbers of the desired audience segments. Some formats are delivered to stations via satellite. Some of these services have all the music and announcer segments included, with spaces for local commercials and newscasts. Others simply supply music on compact discs.

Computer automation in radio has made it possible to use programming from syndicators with only a minimum number of people needed at the station level to get the program on the air. Many stations whose programming appears to involve many people performing various functions over the air are actually staffed by a sole operator, babysitting a computer that stores the station's music, voice-tracks, commercials and promotional announcements on a large hard disk drive.

Networks

In the 1930s and 1940s, radio networks were major sources of programming for affiliated radio stations around the country. They supplied news, comedy, variety, and dramatic shows, along with music programs of all types. At one point, local origination on many stations merely filled the hole in the **network** schedules. In fact, rules were developed by the Federal Communications Commission (FCC) to prevent the domination of radio station schedules by network programming.

Today's radio networks serve a function quite different from those of the earlier era. Stations today depend on their networks as ancillary sources of programming and use them to supplement locally originated programming. Many stations take news from networks, and this provides a national and international news service that usually is not available from a strictly local operation. In addition, radio networks often offer short feature programs to their affiliated stations; these programs may be carried directly from the network or used later.

Many radio networks have begun to offer blocks of radio programming to local stations. Networks, for example, offer stations programming blocks featuring political-entertainment formats like Rush Limbaugh, primarily entertainment programs like "Imus in the Morning," and programs that help listeners deal with problems, such as "Dr. Laura Schlesinger." Increasingly, networks are providing other forms of programming, such as music or holiday specials; this programming is used by affiliates to supplement their local schedules. In return, networks expect their affiliates to carry the networks' advertising. Such advertising is the networks' basic source of revenue.

Networks also take advantage of modern technology to offer programs to their affiliates via satellite (see Figure 1.1), which provides excellent-quality sound reproduction. And though radio networks are certainly less a programming centerpiece than in pre-television days, growth in services is occurring

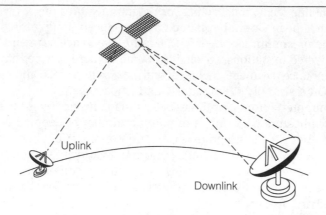

Figure 1.1

Signals from the earth are transmitted from a satellite 22,000 miles above the earth. The signal is received on the satellite's transponder and retransmitted to a satellite dish on the earth's surface.

Uplink

Downlink

rapidly. Many foresee the day when network services will not differ greatly from those of format syndicators.

Other Programming Developments in Radio

Format syndication, network programming, and locally produced elements form the bulk of programming sources in modern radio. Variations, such as syndicators specializing in short health features, food shows, business reports, and so on, emerge almost daily. Nonmusical formats, such as all-news, sports, and all-talk, also thrive.

Radio production is a medium of great vitality, a medium that is still developing rapidly. Today satellite radio, with more than 100 channels of programming, is redefining radio by introducing new niche formats. It is exciting and full of career opportunities. Production—using sound elements to create an effect or deliver a message—has always been and will always be a key element in radio.

Noncommercial Radio

Much of what we have said so far about the radio industry pertains to that segment of the industry geared toward making a profit for its owners. Noncommercial radio exists for other reasons.

Noncommercial radio includes a relatively small number of stations that gain their financial support strictly through the generosity of donors. Some of these outlets are affiliated with nonprofit organizations, such as religious organizations. These radio stations receive most of their funds from their parent organizations or listeners, with occasional grants from foundations or businesses.

Tuning into Technology

WEB RADIO

The World Wide Web offers an exciting new venue for broadcasters. Audio and (fairly primitive) full-motion video can be transmitted over the Web, and many broadcast outlets find this new medium to be a promising new way to reach audiences or provide services for their current listeners. Anyone beginning a career in broadcast announcing is well advised to become Web literate in a hurry, because that is where many future jobs may be created.

At the time this text was written (2002), many radio stations had stopped webcasting because of a dispute over copyright and royalties paid for music played. Currently stations are placing information relevant to their listeners, such as restaurant reviews, latest news, and texts of feature reports, on the Web.

Radio station Web sites can be a carnival of features and information. For example, New York City pop station Z100 integrates pictures, weather, a shopping area, and a contest page into its Web site (see Figure 1.2).

By contrast, television on the Web generally consists of sites where video clips can be downloaded, such as CNN's large site (www.CNN.com) or "streamed." Although most streaming video produces a small picture of fairly low resolution, newer media players such as the QuickTime 6 player is capable of producing higher quality audio and video playback. C-SPAN, which features many interview programs with "talking head" shots, uses streaming video to replicate portions of its entire broadcast day on its Web site, www.C-SPAN.org.

Getting Started in Web Broadcasting

First, you need to get on the Web. Most colleges have excellent Web access, and all Internet service providers can set you up with the correct browser software. (A browser is a program that allows you to view Web pages. The most popular are Microsoft Explorer and Netscape Navigator.) If you are a novice to the Web, don't worry. There are plenty of starting points to familiarize you with its workings and structure. Try logging onto *Wired Magazine's* Web site at www.wired.com, or look at Yahoo's portal (a gateway to the Web) at www.yahoo.com. These are two good starting places for Web-based adventures.

Finding Broadcast Outlet Stations on the Web

Up to speed on the Web? Then the next step is to tune into Web radio and TV. You may need some special additions to your browser (you can

Continues

Tuning into Technology Continued

Figure 1.2 *The Z100 Web page is as carefully designed to meet audience*
expectations, as is the music on the station.

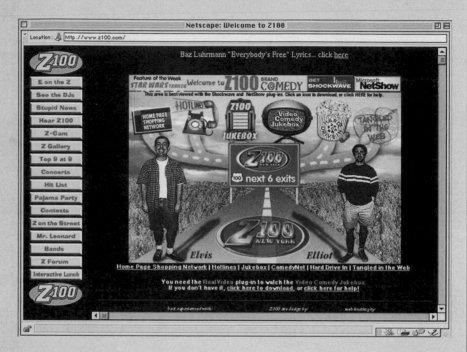

Courtesy of Z100 Radio, New York

download media players at www.webcasting.com), but the easiest way
to find out is attempting to tune in. If you don't have the right software,
the radio station Web site will usually instruct you about how to down-
load it.

One of the most convenient stops for finding Web radio is the BRS
Web Radio home page at www.web-radio.fm/. There you can search for
a station by call letters or formats. Another good site is Radio-locator (www.
radio-locator.com). You can browse this site based on formats or choose
from featured music selections. Happy Web-surfing!

Software for the Web

Several programs take care of the complex task of transmitting audio,
and in some cases video, over the Web. They are called streaming media

Continues

Tuning into Technology Continued

programs. Among the most common are Microsoft Media Player, Apple QuickTime, RealPlayer, and VivoActive. But be sure to tune into a Web site before you download. The necessary components might already be loaded into your browser.

Putting your radio or TV station on air is a little more complicated than receiving, but modern technology is simplifying the task. The same companies that produce the free listening or viewing software also sell (usually for a quite reasonable price) the necessary software to transmit the signal. Their respective Web sites contain detailed information on the process.

If you are affiliated with a college, you probably have access to a very good internal Web infrastructure, meaning it's likely that you would be able to put your station on the Web with minimal hassle.

One of the largest of these outlets is the Christian Science Church. In a large, well-equipped facility in Boston, the church operates studios and offices that produce and distribute radio programming worldwide through shortwave transmission and domestically through such outlets as public radio stations, which broadcast some of the organization's news programming.

The segment of the industry most people think of when they think of non-commercial radio, however, is public radio. Public radio is characterized by its participation in a funding structure that includes two major sources of revenue: government funds and private funds. Government funds are distributed to public radio for use in station operations and programming costs. The formulas and procedures that govern how this funding is distributed are complex, and it serves no purpose to go into the details here. The other major source of funds for public radio is through solicitation of donations from listeners and other private sources.

Economics of Noncommercial Radio

Radio is a business. Though that sounds obvious, it is important to note that increased consolidation has made the radio market more profit-centered. Large corporations purchase radio stations to make money and to make it more efficiently:

When a corporation owns many radio stations, certain costs can be amortized (reduced by economy of scale), including management, computerization, and cost of programming.

Today, such consolidations have resulted in the loss of certain types of jobs in the radio market. At the same time, economic trends can also produce increased demand for multitalented production personnel who are skilled at in-demand tasks, such as computer-assisted editing.

Unlike commercial radio, noncommercial radio stations are not tightly wedded to specific formats designed to increase the listenership. Two types of noncommercial radio stations exist. Public radio stations provide programming that is not generally available through commercial outlets. This philosophy is reflected in the broader scope of programming that is heard on National Public Radio (NPR) or Public Radio International (PRI). Extensive daily news programs like "All Things Considered," live broadcasts of classical and semiclassical music and often jazz, and coverage of such activities as National Press Club luncheons are some examples of the kinds of programming that most commercial stations would shun, fearing lack of substantial audience interest. The second type of noncommercial station may feature student radio programs or may be sponsored by colleges, churches, and local community groups. These stations may feature an eclectic assortment of offerings that do not fit into specific format categories.

Of course, a major programming difference between these stations and commercial radio is the absence of commercials. At one time, it was a sacrosanct principle in public radio that promoting commercial products and services was inappropriate. In recent years, however, this prohibition has relaxed with recognition that more underwriters could be persuaded to give more money for programming if they were allowed to use some of the time allocated for announcing their donations to get in a short pitch for their products and services.

The absence of commercials hasn't prevented some listeners from criticizing public radio stations for their on-air fund-raising efforts. At increasingly frequent intervals, it seems, most public radio stations take breaks from their scheduled programming to air lengthy appeals for donations from listeners. Some listeners say they would prefer product commercials to what they sometimes label as harangues that appeal to guilt and threats to drop programming unless listeners contribute.

Some stations have experimented with alternative methods of soliciting donations, such as promising to shorten scheduled on-air fund-raising drives if response is sufficient before the time that the drives are scheduled. Efforts like these have had limited success in some areas, but the bottom line is that there will always have to be some way of appealing for funds if public broadcasting is to continue to survive.

Noncommercial broadcasting offers many opportunities for radio production people. Depending on whether you work at a small or large station or at the network level in public broadcasting, you are quite likely to find a wider variety of radio production taking place in noncommercial radio than in commercial radio.

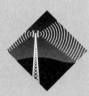

Industry Update
SATELLITE RADIO GOES COAST-TO-COAST

Satellite radio provides continuous programming from geostationary satellites in space directly to your car or home receiver. Two different systems each provide numerous channels of service. XM Radio, based in Washington, D.C., beams continuous music and talk to listeners willing to pay about $10 a month for the service. Sirius offers commercial free broadcasts for about $13 a month.

Being able to drive long distances without changing the channel could change the way people listen to radio. For example, if your taste is strictly swing music, you could drive from Bridgeport, Connecticut, to Eugene, Oregon, and never have to change the channel.

Because each satellite system offers more than 100 channels of its own programming, listeners have quite a variety to choose from. XM Radio has more than five country channels and provides several different choices for jazz, depending on the type of jazz you like. In fact, formats that are quickly becoming extinct on AM or FM are available once again via satellite radio.

Other innovations separate satellite radio from AM or FM. First, satellite radio sounds better than terrestrial radio because the signals are digital. These studios are among the most modern (see Figure 1.3). In addition to offering crystal-clear sound quality, the radio receiver is capable of displaying the title of the song and the name of the artist. You'll never have to wonder who played that last selection.

But, there is a catch. At the moment, you'll need a special receiver to hear the service and the current batch of satellite receivers are not compatible with each other. Radios made for XM cannot tune in Sirius programming and vice-versa, although newer models are expected to be able to receive both services in the future. And, satellite radio is not local, so if you need to listen for special weather or traffic information, you'll still need to tune into good old AM or FM radio.

But, if you're looking for diversity, satellite radio provides the ultimate in choice for the listener. For example, both services program over a dozen channels of news. And, XM radio programs a series of six radio channels called *Decades*. Each of the six channels specializes in music from one decade. Your taste runs to big bands and ballads? Chances are you'd like *The Forties* channel whereas *The Fifties* channel will give you "Doo Wop" and *How Much Is That Doggie in the Window?* Want U2 and REM? Which decade should you choose? And, you'll find special channels

Continues

Industry Update continued

Figure 1.3 *XM Radio's broadcast operations center controls two satellites and one hundred channels of radio.*

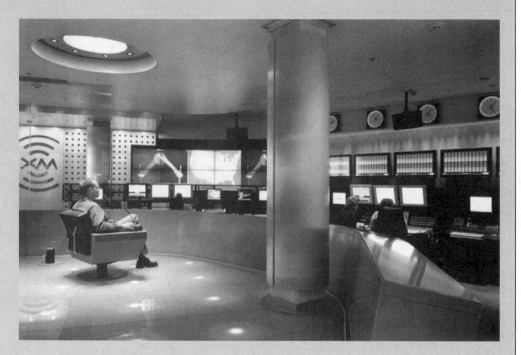

Photo courtesy of XM Radio

for blues, hip-hop, contemporary jazz, opera, Euro hits, acoustic rock, underground dance, and dozens of other choices. Not the stuff you'd hear on your run-of-the-mill rock station.

Format veteran Lee Abrams, XM's Chief Programmer, thinks that satellite radio will be the next big thing. "Listeners will appreciate the lower number of commercials, richer music choice, and the fact that you can receive great sound quality anywhere in the U.S.," he says. Is Abrams right? Will XM and Sirius radio take listeners away from AM and FM in the next few years? As satellite radios become more prevalent in new cars, starting with the 2003 models, it will be interesting to see how these services affect current broadcast programming and formats.

Radio drama is still aired on public radio, for example, and many stations record musical performances on location. Such projects challenge radio producers in ways that commercial radio never will. Some noncommercial situations may also have more news production. And, of course, *airshifts* require the ability to operate the equipment in an on-air studio.

The Role of the Producer in Modern Radio

With all the excitement over automated radio and prerecorded formats, it may appear that little remains to be done in radio production at the local level. In fact, the opposite is true.

Production skills form the basis of producing a station's sound. Without those skills, the unique sound can't be created. But skills alone won't suffice, and that's why we've begun this production book with a discussion of programming. Good production is an extension of the station's programming, and a **producer**—anyone who manipulates sound to create an effect or deliver a message—must tailor that production to reinforce the station's sound.

An increasingly important area of radio station operations is promotion. Today's climate of intense competition among all forms of media for audience attention means that stations must work harder than ever to make themselves stand out. Production plays a key role in this process. Audience promotion takes many forms—on-air contests, bumper stickers, and other premiums bearing the station's identifying graphics; billboards; television advertising; and the like. But a key resource for audience building is the station's airtime. Production people can play a major role in helping the station promote itself by creating imaginative uses of sound to create a clear identity for the station in listeners' minds.

In this text, we explore the nuts and bolts of radio broadcasting. By learning the elements of radio production, you will be exploring the essence of radio programming. Production, from a mechanical standpoint, can be seen as the method of combining various sources of sound into a product that accomplishes something specific. Anyone in a radio station can perform this function. The sales manager who records and assembles a commercial is a producer, as is the person who constructs a newscast. The staff announcer who runs the console (known as a **combo** operation) is also a producer. In larger stations, the bulk of the production may be the responsibility of a production manager, who specializes in producing such items as commercials, public-service announcements (PSAs), or talk shows. Some very large stations and networks have full-time producers who exclusively handle specialized programming, such as concerts and sporting events.

The particular responsibilities of a producer depend on the station where he or she is employed. Radio stations run a wide gamut in sophistication, from small daytime-only stations with minimal and aging equipment to high-tech

Figure 1.4 Production studio of a major-market radio station.

KEYT News Radio 1250, Santa Barbara, CA/Photo by Austin MacRae Photography

powerhouses in major cities (see Figures 1.4 and 1.5). But regardless of the size of the station (see Figure 1.6), the role and importance of production and the producer is the same.

The producer at any level may be called on to create and execute a commercial that sells a product for an advertiser, to put together a newscast introduction that arrests the attention of the listener, or to combine a number of previously recorded elements with live vocal delivery in a distinctive package known as an **airshift.** All these functions, and more, create the radio product in small, medium-sized, and large markets.

By becoming proficient in these skills, you will be opening the door to a variety of opportunities in the radio field. And although our focus is radio broadcasting, the skills and knowledge in this text can be applied in various other professional situations. Studio recording; sound productions for multimedia presentations; audio for television; and specialized sound production for advertising agencies, production houses, and other commercial clients are but a few of the professional areas that require many of the skills covered in this text.

Overall, you will be exploring a field that requires a variety of skills, and you'll need to invest some time in learning them. But understanding the basics

Figure 1.5 This production studio features sound proofing and a double glass window that looks into an adjoining studio.

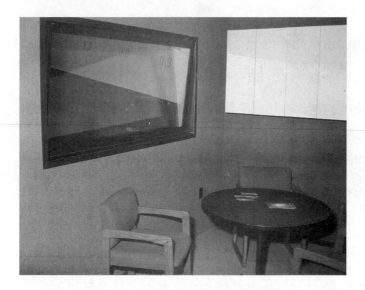

KEYT News Radio 1250, Santa Barbara, CA/Photo by Austin MacRae Photography

is just the beginning. Real proficiency in radio production requires professional commitment, experience, creativity, and a certain sense of adventure. A truly effective production bears the identifying mark of its producer. It is unique.

The skills involved are tools. The way you use the tools makes the difference. Even though some frustration may be involved in trying to come up with a production that sounds the way you've heard it in your mind, much satisfaction results when the magic happens and you can hear the finished result of your efforts—and you say, "Yes! That's it!"

Many radio veterans feel that production is one of the most satisfying parts of their jobs. It's a chance to be, at once, an artist, a technician, and a performer. Production is one of the key jobs in any radio station. The people who do production well are those who form the foundation of radio broadcasting. In addition, audio production opens up career opportunities in areas other than radio broadcasting. Film and television also require competent audio producers, and business and industry require the services of skilled in-house producers.

So enjoy yourself while you learn how to produce the magic. You'll work hard, but the rewards will be long lasting. You will acquire skills that will last a lifetime as well as an enduring passion for an exciting and rewarding activity in a profession that is a vital part of our world today.

Figure 1.6　This small market news production studio uses equipment that some stations would consider too dated for continued use. It serves the purpose of this station very well.

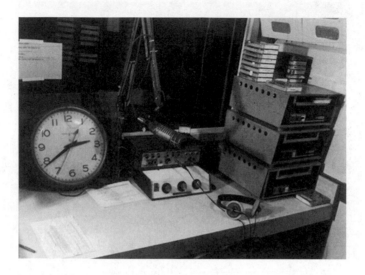

Photo by Philip Benoit

Summary

Radio has moved from a mass-audience medium to a more specific medium; that is, it reaches a specific target audience that is more narrowly defined than is the audience targeted by the modern mass medium of television.

Formats during the golden age featured imaginative and often lush production effects, including full symphony orchestras. The golden age also was the heyday of the theater of the mind—producers came to appreciate the full value of the medium's impact.

The sound of the station is the overall blending of music, vocal delivery, timing, pacing, and other production elements that combine to create a cohesive, identifiable signature.

The modern radio station carefully develops and fine-tunes its format to reach a quantifiable target audience—an audience that is, in turn, "sold" to buyers of radio-station advertising time.

The impact of networks declined considerably after the golden age, but satellite transmission capabilities and other technical advances have given new life to the network concept. Many stations now integrate network programming in a blend that complements their formats, allowing stations to localize the network feed.

You're On!

TECHNIQUES FOR EFFECTIVE ON-AIR PERFORMANCE: THE ROLE OF THE ANNOUNCER IN MODERN RADIO

Though not every radio producer will go on-air, many will. Even if you don't run a live airshift, you may find yourself recording commercials, promotions, or other announcements. Perhaps you might do an occasional newscast.

Even if you do not go on-mic yourself, you, the producer, will certainly be working with on-air talent and will need to understand the techniques, skills, and requirements.

The "You're On!" features in this edition of *Modern Radio Production* will help you understand the workings of on-air communication as they apply to the content of specific chapters.

To begin this exploration of the role of the announcer in modern radio, we need to travel briefly to the past.

Early Announcers

The first announcers on radio were part salespeople, part masters of ceremonies (MC), and part sophisticated guides to the world's events.[1] Announcers would perform varied duties, such as acting as MC of a variety program, announcing the cast of a radio drama, or serving as the introducer of a radio play (see Figure 1.7).

The announcer was seen as performing, rather than talking, when on the air. This perception resulted in the development of a stylized form of speech that was emphatic and dramatic. Announcers used a distinctive style that was heard nowhere else but in radio.

But when television arrived in the 1950s, radio found it could no longer fulfill the mission of being the medium of choice for everyone. Gone were the days of grand radio variety programs or weekly comedies.

The Modern Medium

Almost by accident, radio began serving as a lifestyle companion for people who enjoyed a certain type of music. Up until the 1950s, the idea of

[1]For a more complete history of the announcer, see Hausman, Benoit, Messere, and O'Donnell, *Announcing: Broadcast Communicating Today*, 5th ed., Wadsworth. This "You're On!" feature and others are adapted from the principles and techniques discussed in that book.

Continues

You're On! Continued

Figure 1.7

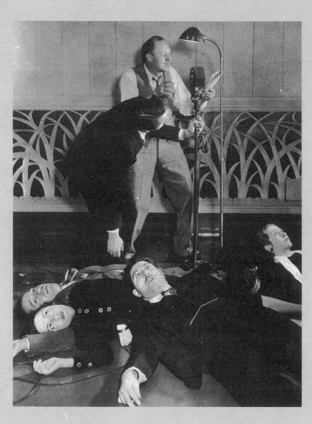

Radio drama enacted in NBC radio studio with the aid of a sound effects man and groaning victims (on floor) on "Lights Out."

SOURCE: © Bettmann/ CORBIS

playing recorded music on radio did not occur to many industry executives, but the desperation wrought by the arrival of television—media's 800-pound gorilla—impelled them to try.

And radio for the individual turned out to be a smashing success. The medium, now portable because of the introduction of the transistor radio, surrounded the listener with nonstop music that reinforced a particular lifestyle.

Today, we see an increasing specialization of radio and, as will be discussed elsewhere, formats are tailored toward highly specific audiences.

What This Means to the Announcer

For the on-air performer, the evolution of radio has several very clear implications:

Continues

You're On! Continued

1. Reaching the individual is the key. One-to-one contact is the name of the game in radio. Two people—the announcer and the listener—are sharing music and a lifestyle. As a result, the announcer's style must be intimate, communicative, and personal. There is very little room in radio today for the old-style, affected, booming announcer-voice.

2. Understanding the material is critical. The old-style announcer had to be glib and facile in handling an incredibly wide variety of tasks, from introducing classical music to announcing polka selections to moderating a local quiz program. But today, an announcer will be handling only one style of music, and further, usually only a specific niche within that style. (For example, "hot" rock-style country as opposed to generic country music.) It is difficult or impossible to fake knowledge of music for such a concentrated audience, and audiences will not tolerate announcers who don't know the material.

3. Technical competence is important. At one time, announcers would simply read copy. They did not touch equipment, and, in fact, were often prohibited from doing so by union rules. There was sometimes good reason for this—early radio equipment was complex, jury-rigged, and often dangerous if mishandled.

But as equipment became simplified and standardized, it became part of the announcer's duty to run his or her own "board," or console. Today, you'll need to know your way around a computer because it is likely that you'll be executing some commands via computer-run editing programs or even having the computer "fire" your next music cut.

In summary, the days of the booming, golden-throated announcer are gone, and it is important that you avoid sounding like the stereotypical "hello-out-there-in-radio-land" announcer. That style is extinct and exists only at camp when someone is making fun of it.

Noncommercial radio consists of stations and networks operated by various nonprofit entities. The largest system is known generally as public broadcasting. The major difference between noncommercial outlets and their commercial counterparts is that their funding comes from sources other than advertising revenues.

Producers in modern radio still do their work in the theater of the mind. Today, they use a wide variety of elements from traditional radio sources (as well as new digital computer-based equipment) to create effects. Despite technical advances, the skill of the producer is still paramount.

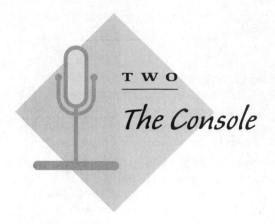

T W O

The Console

*P*robably nothing in radio production is more intimidating than one's first
exposure to the **console**—a complex network of switches, knobs, and
meters—or sometimes, a dauntingly complex computer screen. However, op-
erating the console, or **board,** soon becomes second nature. In fact, most
radio professionals will tell you something like, "When I first started in radio,
all I thought about was running the board, and what would happen when I
changed jobs and had to learn a new board. But after a few months, I found
out that running the board was really one of the simplest aspects of the job.
And when I changed stations, I picked up the new board in an afternoon."

We think it's important to emphasize that one does acquire familiarity
with the console because many newcomers to radio production become dis-
couraged with their first few experiences at the controls and never gain the
confidence they need to experiment, to use the board as a versatile tool, and to
"play it" like a musical instrument.

Remember, anyone can learn to run a console. You don't have to be an
engineer or a technician; all you need is an understanding of what the con-
sole does and some practice in the necessary mechanical operating skills.

Function of the Console

Whether digital or analog, the audio console is simply a device for amplify-
ing, routing, and mixing audio signals. *Audio* is the term used to refer to the
electrical signals that are involved in the reproduction or transmission of
sound. It's important to keep the distinction between audio and sound firmly
in mind. **Sound** is a vibration through air or another medium; **audio** is the
electrical signal used in reproducing or transmitting the original sound.

Amplification

Amplification is the boosting of a signal to a usable level. The tiny voltage produced by a phonograph, a CD player, or a computer is not strong enough to send to a loudspeaker or over the air. (This is precisely why the CD player on your home stereo is connected to an amplifier, whether a built-in amplifier or a separate component.) The console gives the operator convenient control over the **volume** of various signal sources such as microphones, turntables (professional-quality record players), CDs, and various playback units.

Routing

The console allows the producer to determine the path of the signal or, in other words, to **route** it. As we will see, the console can send a signal either over the air or into a cue channel, which lets the operator hear an audio source without having the signal go over the air. In addition to routing signals through the console, the operator can turn signals on and off.

Mixing

The console can put two signals out at once—the announcer's voice and music, for example. The console also allows the volume of both to be controlled separately, or **mixed**, so that the music doesn't drown out the announcer.

Through amplification, routing, and mixing, the console operator can produce a final product that will be sent out over the air (as in the case of a radio announcer doing an airshift) or routed to a computer or minidisc (as someone would do when producing a commercial to be played back over the air later).

Understanding Console Function: Some Hypothetical Examples

The preceding discussion of amplification, routing, and mixing is fine as a theoretical explanation of how a console works, but how do they function in practice?

To explain, we take an approach that is a bit unusual: We present a series of hypothetical consoles used at equally hypothetical radio stations. We briefly touch on the use of CD players, microphones, and playback units, but detailed instruction about these devices comes in later chapters. So don't worry about anything except understanding what the console does and why it does it. The purpose of these examples is to demonstrate how a console carries out certain operations.

We will show standard "physical" consoles that resemble what are commonly used in most stations today. We should note here that digital consoles can convert analog audio into data or use data straight from an input source,

such as a minidisc player; however, for the purposes of our discussion, we'll assume that analog and digital consoles function the same way. Later in the chapter we'll illustrate a computer-based, "virtual" console. Note that although virtual consoles are gaining popularity, the physical console remains more popular and probably will be the workhorse of the industry for some time to come.

Hypothetical Console A

The radio station using console A plays only one sound, the same disc, over and over. The only equipment owned by this station consists of a **CD player** and console A (see Figure 2.1). Here are the features on console A.

PREAMPLIFIER The signal from some input devices is very weak, so a device called a **preamplifier** (usually shortened to *preamp*) boosts it to a more usable level. Here console A has a CD player connected to it.

POTENTIOMETER In engineering terms, a **potentiometer** is a variable resistor; in nonspecialist's terms, it's nothing more than a volume control. The potentiometer is almost always referred to as the **fader** or a **pot.** Usually, a slider or a knob raises volume, just as a rheostat switch turns up the level of lights in a dining room. The pot raises the volume of the console's output; it is therefore an adjustment for the VU meter (discussed shortly) and not a control for the monitor.

KEY OR ROUTING SWITCH The **key** is an on-off switch that puts the signal out over the air when the key is pushed to **program.** The key is thrown

Figure 2.1 Console A at a station that uses only one CD player (CD1).

into program when it is moved to the right or, if it is a button, when it is depressed. We show other functions of this key in later examples.

VOLUME-UNIT METER You know that the pot allows adjustment of the level of volume, but how do you know what level is correct? Volume is a pretty subjective judgment.

The **volume-unit meter** (usually called a **VU meter**) gives an objective visual representation of loudness. It's a very important component of the console, and the ability to read it properly is critical in every phase of radio production.

Essentially, the most important aspect of reading a VU meter is to know that zero on the top scale is the reference for proper volume. A close-up of the meter on console *A* (see Figure 2.2a) shows that the record is playing at proper volume or level of sound.

A reading of +1 volume unit (see Figure 2.2b) means that the signal is playing too loudly; if it goes much higher, the signal will sound distorted. (A volume unit is a relative measurement of audio loudness and is similar to a **decibel,** a measurement we discuss in Chapter 5.) A reading above zero is known as being "in the red" because the part of the scale above 0 is colored red. A reading of +2 indicates that matters are worse, and +3 will put the needle all the way to the right, known as "pinning the meter," and can cause severe distortion.

On the other hand, too low a reading will result in too little music level and too much noise. Noise is always present in these electrical components, and when there's not enough signal volume, the noise becomes much more apparent; this is known as an unacceptable **signal-to-noise ratio.** This is the ratio of signal in a **channel** to noise in a channel; the greater the signal-to-noise ratio, the better. A reading consistently lower than –3 or so (Figure 2.2c) is known as running "in the mud." The operator of console *A* is responsible for keeping the peaks as close to zero as possible. This isn't particularly difficult because the VU meter is built to respond to averages. The needle tends to float

Figure 2.2 VU meter readings.

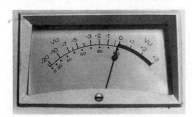 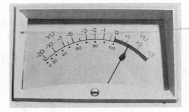 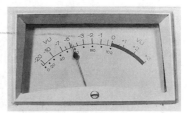

a. Proper-level reading. b. Reading "in the red." c. Reading "in the mud."

Photos by Philip Benoit

around, seeking an average volume level. The operator should *not* crank up the pot each time the level drops below zero or crank the pot down each time the needle goes into the red. Riding the pot too closely will result in an elimination of loud and soft passages in music, especially classical music.

Some VU meters use LED lights instead of a pointer. These meters react more quickly to overall levels than the mechanical VU meters pictured in Figure 2.2 do, but the scale is exactly the same.

By the way, you can also read the VU meter according to the bottom scale, which indicates the percentage of **modulation.** Modulation is the imprint of sound on a radio signal, and 100 percent is the ideal. Modulation is a measure in percentage of voltage passing through the console to a transmitter or to a recording device. If 100 percent represents the maximum voltage permissible, the fluctuating VU meter can compare the sound imprint of our source to that of the maximum desired level.

Note that 100 percent corresponds to 0 volume units, also the ideal reading. Too much modulation results in an overmodulated, distorted signal; too little causes problems with signal-to-noise ratio and makes the signal sound muddy. Whichever scale is used, the major task facing a console operator is to keep the needle on the VU meter hovering around the points marked 0 (top scale) and 100 (bottom scale). Occasional peaks into the red are acceptable—indeed, unavoidable—as are infrequent dips into the mud.

MONITOR This is a loudspeaker that lets the operator hear what's going over the air. The **monitor** (or **air monitor**) is not really a part of the console, although it is connected to the console and operated by console controls. These selection controls allow the operator to use the monitor to listen to a number of sources other than what's going over the air. This is the operator's personal speaker; it does not affect the sound going out over the air.

AMPLIFIER Before the signal leaves the board, it must be amplified—boosted—again. The final step involves putting the signal through the **amplifier** for this purpose.

REVIEW OF CONSOLE *A* The signal from the CD player first passes through the preamp, an internal electrical function of the console. The volume of the preamplified signal is controlled by a pot. After the signal has run through the pot, a key functions as an on-off switch; in this case, the on position is referred to as program. (You'll learn more about the need for this switch with the next console.) Finally, the signal is amplified again. In the case of a radio station that plays only one disc, the **output** of the console is then sent to the hypothetical transmitter. In Figure 2.3, we have diagrammed console *A* the way a broadcast engineer would do it.

Console *A* is certainly simple to operate, and it ideally suits the needs of a station that plays just one disc. But it has no flexibility. It allows only the constant repetition of a disc played on the station's only CD player. You could,

Figure 2.3

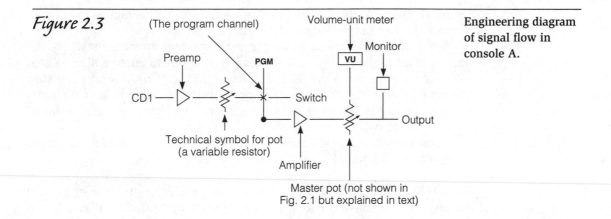

(The program channel)

Preamp PGM

CD1 — ▷ —

Switch

Technical symbol for pot
(a variable resistor)

Amplifier

Volume-unit meter

Monitor

VU

Output

Master pot (not shown in
Fig. 2.1 but explained in text)

Engineering diagram
of signal flow in
console A.

Figure 2.4

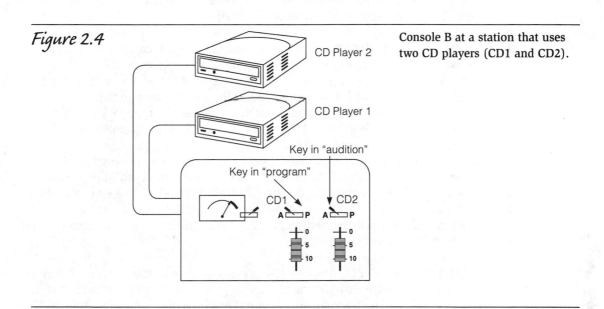

CD Player 2

CD Player 1

Key in "audition"

Key in "program"

CD1 CD2
A ▭ P A ▭ P

0 0
5 5
10 10

Console B at a station that uses
two CD players (CD1 and CD2).

of course, change discs, but doing so on-air would leave even larger gaps in
the program than just starting all over when you get to the end of the disc
and quickly going back to the beginning. So let's see how a more advanced
console solves the problem.

Hypothetical Console *B*

The station using hypothetical console *B* has two CD players (see Figure 2.4).
This allows the operator to make smooth transitions between selections by

having another CD all set to go when one ends. This will eliminate gaps in the program, known in the trade as **dead air.**

But if the goal is to eliminate gaps, the operator must know where the starting point of the CD cut is. There has to be a way to **cue** the disc, to hear where the first sound in the piece of music starts so that the sound can start immediately after the CD player is started. And as is common in many radio formats, the end of one song and the beginning of another can be overlapped for a second or two.

Console *B* is similar to console *A,* but it has several additions that allow the operator to eliminate gaps and overlap music.

MULTIPLE INPUT CHANNELS Having two pots allows the use of two CD players. This console has two input channels: channel 1 for CD player 1, and channel 2 for CD player 2. CD player 1 and CD player 2 are both sources; that is, each provides an incoming signal. So, aside from the two pots, there will also be two preamps and two program keys.

THE AUDITION CHANNEL Don't confuse the audition channel with the input channels on console *B.* The audition channel is a completely different animal.

Audition allows you to hear a disc, tape, or other source without putting it over the air. The audition channel routes the signal from a source to a speaker in the control room. (And there's another specialized application, which we discuss in a moment.) Anything that can be put on program can be played over audition.

Do you notice, in Figure 2.4, the provision made for selecting the audition channel? The on-off key in console *B* is really made up of two separate switches. One switch turns on the audition channel and one activates the program channel. This is a change from console *A* that only had a program switch that could be turned on and off. Both Audition and Program can be used independently.

THE CUE CHANNEL The cue channel serves one of the same purposes as the audition channel: It allows the operator to hear a source without putting it over the air. The operator of console *B* is able, using cue, to find a specific point on the disc before it is played over the station and can therefore cue the disc to start immediately. Cueing often involves some strange-sounding noise (we demonstrate the cueing technique in Chapter 3), so the operator certainly doesn't want to do it over the air. The cue channel plays over a small speaker located within the console. To put the pot in cue, the operator generally selects it by depressing the cue button. (Frequently, this will temporarily disengage the program channel while the channel is in cue.) On older consoles that use knobs instead of faders, you turn the pot fully counterclockwise to activate the cue channel.

Why, you might wonder, are there two provisions for hearing sources that are not on the air? Cue and audition have their separate advantages and

disadvantages. Cue is very simple to use as it takes only a push of a button to put the pot in the cue channel. After cueing up a disc, the operator of console *B* doesn't have to do anything until putting the CD player on air—"potting it up" in radio lingo. But the cue speaker is often tinny and cheap, so if the operator wants to listen to a new piece of music to gauge its suitability for airplay, the cue system is a poor choice.

Audition, on the other hand, routes the signal through a high-quality loudspeaker. Sometimes it is a separate speaker in the control room, though often the audition channel is fed through the same speaker as the program. The operator uses a monitor selector switch to determine which channel—program or audition—goes to the speaker. Audition has another very useful capability: At will, the operator can play a disc over the air on the program channel while producing a commercial on the audition channel. We explain how this is done later.

Adding the multiple-source channels, the audition channel, and the cue channel to the broadcast engineer's diagram, we have the signal flow of console *B* shown in Figure 2.5.

REVIEW OF CONSOLE *B* The outputs of two CD players are fed into console *B;* each CD player has its own source channel. Because of the two CD players, two source channels, and of course, two pots, the operator of console *B* is able to make smooth transitions between compact discs, even overlapping the beginning of one with the end of another. More important, the operator of console *B* can use the audition or cue channel to listen to a source channel without putting it over the air.

As shown in Figure 2.5, the signal flow path for console *B* starts at the CD players, proceeds through the appropriate source channels, through the pots, and to the key. On this console, the key has the capability of putting the signal through the program channel or through the audition channel. Note, too, that the cue channel is activated by the pots, not by the key. The VU meter gauges the loudness of the signal, the output of the board is amplified, and the signal goes to the transmitter.

Figure 2.5

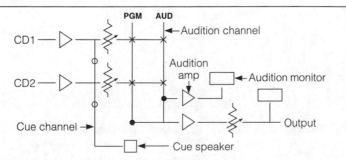

Engineering diagram of a two-channel console.

Industry Update

SIMPLIFY, SIMPLIFY!

Consoles have grown increasingly complex over the years primarily because new technology has enabled engineers to build in many additional features at a comparatively small cost. But because many people simply couldn't *use* consoles that looked like the cockpit of a jet plane, there's been something of a backlash in the industry. Today, the emphasis is increasingly on simplified function.

Figure 2.6 shows a modern console that exemplifies this trend. This is a console designed mainly for on-air, control-room work and simple production. Another type of console, a multichannel console, is specially made for recording with many sources onto multiple-track tape; we will show one of them in Chapter 15. Both types of consoles—control-room and multichannel—route and amplify the signal. But the on-air console is meant to control a variety of sources, such as CDs, mics, and tape machines, and put them over the air (or to the production room tape recorder or computer) quickly and easily. The assignment of various sound sources

Figure 2.6 *The Wheatstone A-50.*

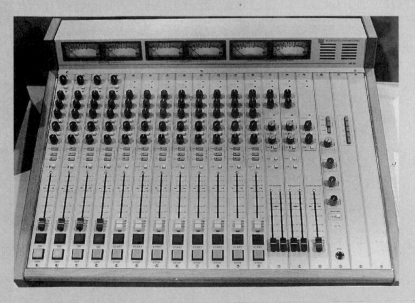

Photo by Philip Benoit

Continues

Industry Update Continued

to the faders is more or less permanent. *You want CD 1 to always be on the same fader.*

The multichannel console is meant to perform delicate balances with, let's say, three singers, two trumpets, drums, a violin section, and so forth. As such, it needs many faders *and* a mechanism to take all those different inputs and assign them to various faders and eventually various tracks on the tape. Furthermore, the multichannel console allows a great deal of electronic filtering for each source. In a multichannel console, you might want the ability to assign violins and one guitar to different faders, and two microphones picking up drums to another. In other words, *you want whatever sources are convenient to appear on whatever fader you want at the moment, and you want a lot of inputs for sources.*

In any event, at this point, we are considering the control-room console. Figure 2.7 shows a simple diagram that explains some (but not

Figure 2.7 *Functions of a control-room console.*

a. Overview of control-room console.

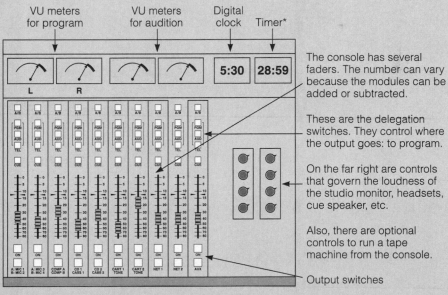

*The timer can keep track of a segment, or how long a particular source plays, or whatever else you program it to do.

Continues

Industry Update Continued

Figure 2.7 (Continued)

b. Close-up of one fader module.

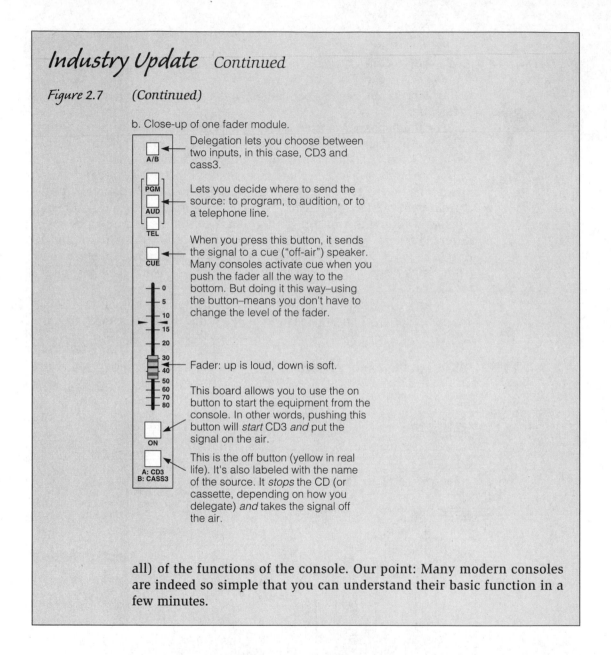

Delegation lets you choose between two inputs, in this case, CD3 and cass3.

Lets you decide where to send the source: to program, to audition, or to a telephone line.

When you press this button, it sends the signal to a cue ("off-air") speaker. Many consoles activate cue when you push the fader all the way to the bottom. But doing it this way–using the button–means you don't have to change the level of the fader.

Fader: up is loud, down is soft.

This board allows you to use the on button to start the equipment from the console. In other words, pushing this button will *start* CD3 *and* put the signal on the air.

This is the off button (yellow in real life). It's also labeled with the name of the source. It *stops* the CD (or cassette, depending on how you delegate) *and* takes the signal off the air.

all) of the functions of the console. Our point: Many modern consoles are indeed so simple that you can understand their basic function in a few minutes.

Hypothetical Console *C*

The operator of hypothetical console *C* has a microphone (see Figure 2.8) in the control room and, because of the expanded capabilities of console *B*, can put the microphone over the air and mix it with other sources. The **microphone** is on source channel 3. The abbreviation *mic*, which is pronounced "mike," is now used widely in the profession (in vendors' literature, in-station

Figure 2.8 Console that could be used with two CD players and a microphone.

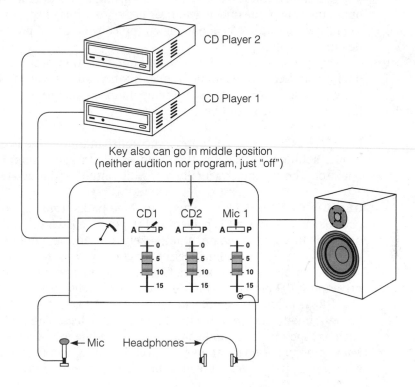

printed material, and audio and broadcasting publications). You will see newer consoles with labels "Mic 1," "Mic 2," and so on, and we have used *mic* both as a noun and as an adjective. However, the past and present participles, which are essential in many discussions of radio production, are spelled *miked* and *miking,* respectively. This small inconsistency represents an accommodation to ingrained habits of reading and pronunciation.

Besides the microphone, this console also has other additions.

MUTING SYSTEM The **muting system** cuts the monitor (the loudspeaker that lets the operator know what's going over the air). The muting system is essential when a mic and a speaker are in the same room because, without muting, the mic picks up the output of the speaker, feeds it through the amplification system, picks it up again as it exits the speaker, and so on. The result is known as **feedback,** the same unpleasant phenomenon that occurs when a rock singer gets careless with a microphone too near a speaker. So, every time the key switch on the mic channel is opened, the muting system built into the console will cut the speaker off. This, of course, makes necessary the use of the next item: headphones.

HEADPHONES These form a close seal over the operator's ears, preventing any possibility of feedback. Because the headphones operate when the mic is open, they allow the operator to hear herself or himself speaking into the mic. There's an output for headphones on the console and a pot that controls the headphone volume.

Console *C* also contains a headphone selection button. This allows the operator to hear, for example, the audition channel over the headphones or the cue channel (very useful if the operator is talking over the air and finds that the next disc hasn't been cued up yet).

MASTER POT This pot controls the entire output of the board. Usually, its proper setting is marked by the engineering staff and is not changed by the operator. The VU meter actually reads the output of the **master pot.**

REVIEW OF CONSOLE C There are three paths from the equipment in the control room: the two CD players and the mic. In each path, the source channel feeds through a preamp, a pot, a key, the console amplifier, and the master pot. Figure 2.9 is an engineering diagram of console *C*.

One bit of new information: The preamp for the mic is different from the preamp for CD players. CD players commonly have preamps outside the console (those preamps are not shown in Figure 2.9), and the CD player signal is brought into the board at what is known as *line level*. Other playback devices, such as tape machines and computers, also come into the board at line level. Mics come to the board at a lower level than line-level sources, and the signal goes through a *mic-level* preamp. Because mic level is lower than line level,

Figure 2.9

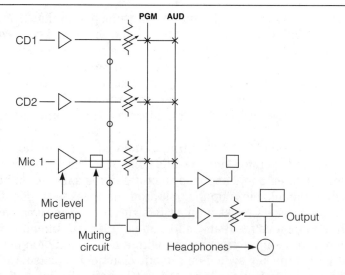

Signal flow in console C.

preamps on mic-level channels must raise the level of the signal higher than must preamps for line-level inputs. The goal of preamps is to bring both mic-level and line-level sources to the same level within the console. CD and tape player preamps may also change the **equalization** of the audio signal; we explain equalization in connection with advanced radio production (see Chapter 15).

Hypothetical Console *D*

The radio station using console *D* is linked up with a radio network that supplies a 5-minute newscast every hour on the hour. The network feed is brought into the studio via a special telephone line or a satellite downlink, which the engineer has wired into the board. Another program offered on the station using console *D* is a 10-minute telephone talk show, which starts at 30 minutes after the hour.

Now, it certainly doesn't make sense to have two separate pots for signals that are never used at the same time. Console *D* (see Figure 2.10) has an option that allows the operator to choose the network (Net) or the telephone (Tel). Many boards label these signals "remote lines" because the sources are located outside the studio.

DELEGATION SWITCH The operator has to be able to decide which signal will be chosen, or delegated, to go onto the source channel. Figure 2.11 shows how the delegation switch, which permits this, is drawn into the engineer's diagram of console *D*. The **delegation switch** is often, but not always, immediately above the pot.

REVIEW OF CONSOLE *D* The only new addition to this console is the delegation switch, which brings a fourth input into the board. The delegation switch allows the operator to select the signal that will go onto the source channel and be governed by the pot.

Figure 2.10 Console with a delegation switch.

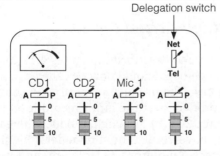

Delegation switch

Figure 2.11

Signal flow in console D.

Summary of the Hypothetical Consoles

The consoles we've illustrated wouldn't be of much use in a modern radio station. Even the relatively sophisticated console *D* doesn't have the flexibility typically needed in a broadcast station, which may use two or more CD players, a turntable, three mics, two or more tape units, a computer, and perhaps several **cartridge machines.** But the principles illustrated are common to every console. If you understand these principles, you will be able to figure out the operation of any actual radio console.

Understanding Console Function: Actual Consoles

The radio consoles shown and described in Figures 2.12(a), (b), (c), and (d) allow the operator—who perhaps should now be called a producer—to choose from numerous of sources. The producer can mix the sources, route them, and put the combined product over the air or record it on tape for use later.

The console in Figures 2.12(b) has circular pots, whereas the consoles in Figures 2.12(a) and (c) have vertical or slide faders; Figure 2.12(d) shows a digital console that uses a monitor to display many functions. All types

Figure 2.12 Audio consoles.

a. Broadcast audio console that uses slide faders.

Photo courtesy of Harris Corporation, Quincy, Ill.

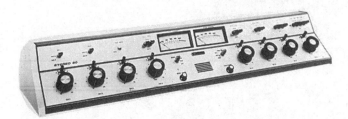

b. Console that uses knob-style potentiometers.

Photo courtesy of Harris Corporation, Quincy, Ill.

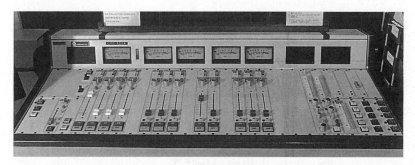

c. Stereo console used at public radio station WRVO, FM 90, at State University of New York, at Oswego.

Photo by Philip Benoit

Continues

Figure 2.12 (Continued)

d. Integrity Digital Console that handles analog and digital inputs.

Photo courtesy of Pacific Research & Engineering, Carlsbad, CA

accomplish the same purpose, using the same principles demonstrated in the hypothetical consoles. All units have the following elements:

- Preamps, which are built into the console and aren't visible.
- Input channels, which allow a number of signal sources to be used and, possibly, mixed together.
- A delegation switch, to determine which of several signals will go onto the source channel.
- Pots (either the traditional circular pot or the more modern vertical fader).
- A cue channel.
- A key or selector button to route the signal over either the audition channel or the program channel.
- A VU meter to give an objective reading on the loudness of the signal.

- An amplifier, which boosts the output of the console (and is not visible because it is built into the console).
- Some miscellaneous controls, which allow the producer to adjust headset volume, choose the source feeding into the headset, or select other convenient functions. An important control is the monitor volume control, which should always be used (rather than the VU meter) when you are adjusting the level at which you choose to listen.

All consoles do essentially the same thing, using the principles shown with the hypothetical consoles. Think in terms of those principles, rather than using a learned-by-rote knowledge of console switches and knobs, and you'll be able to operate any board after a bit of mechanical practice.

Figure 2.13 shows a board in use at a radio station. An adept operator can choose sources and adjust levels while talking into the microphone.

There are many console types other than those pictured in Figures 2.10, 2.12, and 2.13, but it is not practical to present a catalog of radio consoles here. Don't get hung up on hardware. Rely on a thorough understanding of the principles of console function, and you will be able to operate almost any console.

Figure 2.13 WRVO-FM Public Radio, Oswego, New York, board in use.

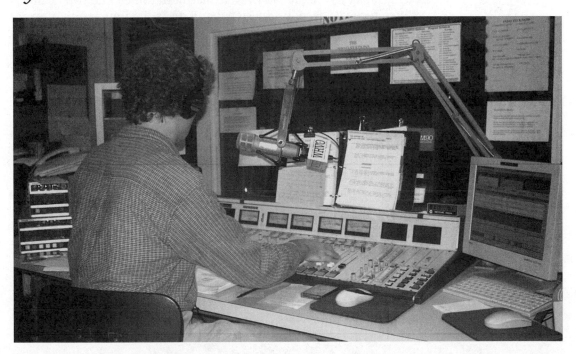

Photo by Fritz Messere

Operation of the Console

An instructor or an experienced operator at your radio station can explain the workings of your particular console to you. Exercises at the end of this chapter will help you build your mechanical skills. Regardless of what equipment is hooked up to the console, and regardless of what kind of production is being done, you'll still be doing three basic operations through the board:

- Amplification
- Routing
- Mixing

All these operations are used in the production techniques introduced in later chapters.

At this point, you should primarily be concerned with finding the signals from input sources on the console, riding the **levels** properly (with the VU meter) to avoid distortion or muddiness, and understanding the signal path. The fine points of production will come later, and your performance will be enhanced with practice.

One other aspect of console operation involves the use of stereo consoles. A stereo signal, as you're probably aware, has been routed into two channels, and a stereo receiver decodes the signal and gives the impression of sound sources being located in certain positions. A station broadcasting a stereo signal uses a stereo console, which we examine in Chapter 15. For now, all you need to know is that operating a stereo console is essentially the same as operating the consoles described previously.

The Virtual Console

Digital "virtual" consoles re-create the look of a standard console while offering some additional features. For example, a program called Deck from Bias Software creates a virtual console on your monitor (see Figure 2.14).

You can use a mouse to raise or lower the levels of the "faders"; you can also assign sound sources to different faders or "busses," meaning a collection of circuits assigned to one fader. (Pictured is a more complex editing job that we have not yet covered. Don't worry if you do not understand the purpose of all the different virtual controls. We will explain them in later chapters.)

ADVANTAGES OF THE VIRTUAL CONSOLE
1. It's easy to assign sources to various faders. In some cases, you can accomplish with the computer what you would actually have to rewire the console to do.
2. The computer "remembers" all this. Settings can be stored for later recall.
3. You can try different arrangements to your heart's content. Suppose you have 30 different takes of an announcer's voice-over. You want to hear

Figure 2.14 Deck from Bias Software offers a visual representation of an audio console with tracks highlighted.

Screen shot used courtesy of Bias Software

how they all sound in conjunction with the music you also have previously recorded.

With a real console, you have to run the tapes through one fader, recueing each time. With the virtual console, you can simply click on each take in sequence and try, try again. (The takes are stored in a digital file, just like documents in a word processor; see Figure 2.15.)

ADVANTAGES OF THE REAL CONSOLE

1. It's still difficult to use your virtual console for actual recording when you need to fade several sources. If you have several announcers in the studio, for example, it's really much simpler just to open the announcers' mics on the real console and record, riding their levels as you work.

Figure 2.15 Time Using a digital "virtual" console.

This is a simplified diagram showing the advantage of using a digital virtual console. All this appears on the computer screen. You select any "take" with a click of the mouse. They're all stored in computer memory.

Don't worry if you do not yet understand the waveforms. All you need to know now is that they get taller when the sound is louder.

2. It is easier to run an airshift with a real console because the real console stays static—that is, it is always there and in the same position and perspective. Remember, too, that if you turn on a sound source and it's too loud— say, a CD comes booming through—it is much quicker to simply turn down a pot or yank down a slider than to use a mouse to find the virtual slider.

A broad conclusion: The virtual console is much better for doing complicated production of previously recorded segments or for multitrack work. The real console is better for fast, simple jobs or putting material out live on air.

The next steps help you become familiar with the units that feed signals into the console (Chapter 3): recording and playback units (Chapter 4) and microphones (Chapter 5). First, however, let's wrap up our discussion of console operation by briefly introducing two options that extend the flexibility of the radio console: submixing and patching.

Submixing

A **submixer** is nothing more than a miniature console that combines or "gangs" a group of inputs; the output of the submixer is fed into the radio

Figure 2.16 The Electro-Voice ELX-1, a four-channel mixer that can be used to expand the capability of an audio console.

Photo courtesy of Electro-Voice, Inc., Buchanan, Mich.

console. An example will help clarify. Suppose you have in your studio four talkshow guests and one moderator, each with a separate mic. It might not be possible to use five separate pots because your particular console might not have five mic-level inputs, or you might not be able to rearrange existing assignments. The solution? Plug the mics into a submixer (which has several pots and a VU meter so that each mic level can be adjusted), and run the output of the submixer (which is at line level) into your console, where it ties up only one pot.

Figure 2.16 shows a popular submixer. Submixers come in handy during remote recordings or broadcasts, as we explain in later chapters.

Patching

Patching allows you to route a signal in a way different from that envisaged when the board was wired together by the station's engineer. There are two ways to change the routing of audio signals. One way is to automate the process using a routing switcher, a device that makes connections between the console and its input and output sources at the touch of a button. The second way is to use a patchbay (sometimes called a patch panel). Basically, the patchbay (which we explain in a moment) performs the same function as an old-time telephone switchboard, using connectors (plugs) to send a signal to a specific source. You, as a radio producer and console operator, will use the patchbay from time to time to make an operation easier or as a short-term emergency measure if something breaks down. For example, let's assume that the output of a computer is normally connected to source channel 3 of a console. Suppose, though, that the computer is broken. Suppose, too, that the only other computer hooked up to the console can't be used because it's on the same pot with a CD player that is in constant use. (How? By using a delegation switch.)

Figure 2.17 Patchbay with patchcords connected.

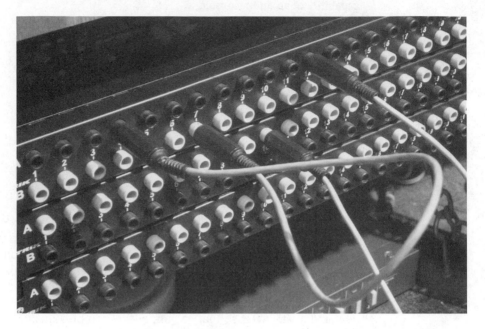

Photo by Fritz Messere

The solution would be to patch the output of the working computer into channel 3. This is done with a **patchcord** (see Figure 2.17), which plugs into jacks on the **patchbay.** Patchcords may be single- or double-pronged, depending on their intended use or the configuration of the bay.

Generally, the outputs, or sources, are on the top row of the patch locations, with the inputs on the bottom. In other words, you will usually find what comes out of a unit (such as the working computer on the top row, labeled "Comp 2 Out" or something similar. The place where the signal can go in usually is on the bottom row, labeled something like "Channel 3 In." Close examination of a patchbay will reveal that the outputs and inputs that normally match up are in line vertically. Let's say that compact disc 1 (CD1) normally goes into channel 2. The holes for CD1 will be directly above the holes for channel 2 on the patchbay. This, not surprisingly, is called a **normal connection.** The term is also used as a verb: CD1 *normals through* to channel 2. And when you change the arrangement with a patch cord, you are *breaking normal.*

A special jack in the patch panel is called a **multiple.** This allows you to patch one source into the multiple and plug in several patchcords that all carry the same output. That way, you can route one signal to several sources,

a practice that is useful on rare occasions, such as when recording a network signal and sending it over the air simultaneously. Notice that in Figure 2.17, Programs 1, 2, and 3 (located on the left side of the patchbay) feed different recording devices.

It is a good idea always to normal a patchbay when you're finished with the studio so that the next person doesn't inherit your special connections.

A Final Look at Two Broadcast Consoles

After this chapter's discussion, you can probably map out in your head what a typical console does and why it is set up the way it is.

Figure 2.18 shows diagrams of two consoles—the on-air console (Figure 2.18a) and the production console (Figure 2.18b)—in use at WLGS-FM in Glassboro, New Jersey, a station chosen as the National Association of College Broadcasters' Station of the Year. You'll note that there is now nothing unfamiliar to you on the board, with the exception of the trade names of a few pieces of equipment. ("Marti" is the manufacturer of a piece of equipment that sends back a signal from a remote event, and "Dalet" is the manufacturer of a digital audio workstation.) Note that even at this very modern station, old-style turntables are still wired into the board.

Summary

All consoles perform essentially the same functions: amplification, routing, and mixing. Digital consoles frequently can accept both analog and digital inputs.

Among the most significant instruments and controls on the console are the potentiometers (pots), which are simply volume controls; the volume-unit (VU) meters, which give a visual representation of the strength of the signal; and the keys, which turn the pots on and off.

There are three main channels in the typical console: program, audition, and cue. Program goes over the air or to a recording device. Audition is used for private listening through a studio monitor. Cue feeds a signal through a small speaker and is used to find the beginning sounds on records and tapes.

A submixer is a miniature console that allows inputs to be ganged together before being fed into the console.

Patching allows you to reroute the normal signal flow in the console. It is useful for special operations or for emergency use of equipment not wired into the console.

All consoles, regardless of their configuration, operate in much the same way. There is no need to be intimidated by a new console; if you learn the basics, you will be able to run any board, however complex it may appear to be.

Figure 2.18 The primary purpose of the console output is to amplify the audio signal and send it to the correct location. The program output, or channel, is used primarily for recording or placing the signal on the air. The audition and cue channels are used to help the operator get something ready to record or play on the air. Here is a list of the various console output controls on these diagrams:

Monitor volume—controls the loudness of the speaker in the control room
Monitor select—determines whether you listen to program, audition, cue, or an external source in the studio speakers
Phone volume—controls the loudness of the headphones the console operator is wearing
Phone select—determines whether you listen to program, audition, cue, or an external source (WGLS) in the headphones
Cue volume—controls the loudness of the cue speaker
Program (P)—places the audio source on the program channel
Audition (A)—allows you to preview an audio source on the monitor speakers before putting it on the air
Cue—allows the source for a particular fader to be fed into a separate speaker. This gives the operator on duty the ability to monitor or cue up a particular source before putting it on the air
External (EXT)—lets you hear what is going out over the air in the monitor speakers or headphones

a. WGLS on-air console

Fader Assignments

1A: Control Room Microphone
1B: Tone

2A: Guest Microphone #1
2B: EAS Generator

3A: Guest Microphone #2
3B: Patch Field

4A: CD #1
4B: Left Turntable

5A: CD #2
5B: Right Turntable

6A: Cart #1
6B: Cassette #1

7A: Cart #2
7B: Tape #1

8A: Cart #3
8B: Cassette #2

9A: Sports Remote Phone
9B: Marti Remote

10A: ABC Network
10B: News Booth

11A: Dalet
11B: Conference Studio

12A: Telephone
12B: Production Studio

Continues

Figure 2.18 (Continued)

b. WGLS production console

Fader Assignments

1A: Control Room Microphone
1B: Tone

2A: Guest Microphone #1
2B: Open

3A: Guest Microphone #2
3B: Equalizer Output

4A: CD #1
4B: Left Turntable

5A: CD #2
5B: Right Turntable

6A: Cart #1
6B: Cassette #1

7A: Cart #2
7B: Tape #1

8A: DAT
8B: Tape #2

9A: News Booth
9B: Marti Remote

10A: ABC Network
10B: Cassette #2

11A: Dalet
11B: Conference Studio

12A: Telephone
12B: Main Studio

Illustrations courtesy of WGLS-FM

Applications **SITUATION 1 / THE PROBLEM** A baseball game, fed from a network, was being aired and would last until 11:30 P.M. At 10:00 P.M., a call came in from the station's general manager: A new commercial had to be made for a client, and it had to go on the air first thing in the morning. Would the operator on duty produce the commercial?

ONE POSSIBLE SOLUTION The operator on duty decided to produce the commercial, which consisted of an announcement read over a record, on the audition channel. To do so, she keyed the control room mic and a turntable to the audition channel. She then found the audition output on the patchbay and patched Audition Out into Tape 1 In.

By producing the commercial on audition, she was able to use the same console that was sending the baseball game out on program. As an additional

benefit, she was in the control room, not in a separate studio, and therefore was able to check on the game from time to time—not necessarily because she wanted to know the score but because network feeds can and do run into technical problems, and an inattentive operator can put a half-hour of static over the air. Most boards have separate VU meters for audition and program.

SITUATION 2 / THE PROBLEM The pot on channel 3 caused a crackling static noise every time it was adjusted. (This happens from time to time, often because the internal workings of the pot are shorted or badly in need of cleaning.) The pot on channel 3 controlled the CD player, and because the operator was in the midst of a show, the problem was becoming critical.

ONE POSSIBLE SOLUTION Before using the CD player, the operator simply patched its output into a different channel, breaking the normal. Now, the CD player would be governed by a different pot and key until repairs could be made to the console. The operator also left a note for the next board operator, explaining the patch.

Exercises

1. Perform a combo operation (operate the console and announce) with two records and a mic. The goal is not clean production, just board operation.
 Start one record, and place the tone arm on the other record. (Don't worry about hitting a specific point in the music; that's cueing, which we discuss in the next chapter.) Start the second record after the first one ends, potting it up on the console. Try talking over the music, making what you think is a proper balance between voice and music. Do the typical disc jockey routine: Announce the name of the song just played, introduce the next song, start the turntable, and bring it up on the board.

2. Make out a slip of paper with the name of each piece of equipment hooked to the console in your radio production studio or lab—for example, CD Player 1, Mic 2, Cart 1, CD Player 2. Toss the slips of paper into a hat.
 Put CDs into the CD players, and put tapes on the reel-to-reel or a minidisc and cartridge (cart) machines. Have someone standing by the mic(s). Your instructor or lab assistant will draw slips of paper out of the hat and announce the name of the piece of equipment.
 Your assignment is to quickly start the piece of equipment and pot it up on the board. More than one source may be called up at the same time. When a mic is called out, you—the operator—are responsible for *throwing a cue* to the person stationed at the mic; that is, you point to him or her sharply. This is the standard instruction to begin speaking.
 When your instructor calls out "Lose it," you must pot down what's up on the board and then turn that piece of equipment off. Give the person at the mic a *cut signal* by drawing a finger across your throat.

You're On!

TECHNIQUES FOR EFFECTIVE ON-AIR PERFORMANCE

Working Combo

Working combo means running your own console while performing announcing duties. It is one of the more challenging parts of the job, and takes some practice, both in terms of running the equipment and in announcing gracefully while on-air. Today the announcer who runs combo must also be prepared to use computer equipment (Figure 2.19).

Although combo duties vary, an announcer might have to play all of his or her own music cuts and commercials, as well as hit newscasts at the top of the hour, record programs off-air, play recorded cuts for the news anchor during a newscast, or monitor the Internet or CNN.

Figure 2.19 *Announcer working combo, using traditional and digital tools.*

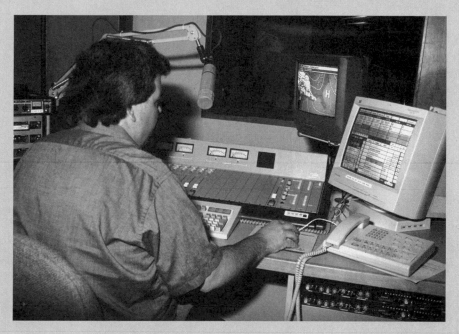

KEYT News Radio 1250, Santa Barbara, CA/Austin MacRae Photography

Continues

You're On! Continued

Here are some tips for graceful combo announcing:

- Don't make mention of or call attention to the fact that you are running equipment. The audience doesn't care, won't be impressed, and doesn't appreciate having its mood spoiled by your reminder that this is, after all, a highly technical business.

- Watch out for control room noise. Don't let the audience hear you moving things around and clicking switches.

- Think ahead. Worry about the next three steps (read the weather open, punch up the meteorologist on line three, and then introduce the next cut). Make a short list and stick to it.

- Keep an emergency "life preserver" at hand—something you can read or play if you're stuck and can't figure out which button to push. The weather forecast is always good, or a recorded public service announcement.

- Communicate over the air first and foremost, run equipment second! When you speak on-air take your time, don't rush while thinking about equipment issues, and focus on the message.

(We discuss some of the more common visual signals used in radio in Chapter 7.)

This drill may seem a little like boot camp; in fact, it is pretty much the same approach used to teach soldiers operation of equipment or assembly of weapons. You'll find, though, that trying to locate pots and equipment under this kind of pressure is a very effective way to learn the operation.

3. Draw a diagram, in the same form as the engineer's diagrams shown in this chapter, of the console in your studio or radio production lab. Don't worry about the details; just try to include the channels and label the sources and delegation switches.

CD Players, Recordable CDs, and Turntables

*I*n the preceding chapter, we spoke about the way an audio signal is routed through a console; we touched only briefly on the sources that produce that signal.

In Chapters 3 and 4, we describe all the sources you're likely to encounter in a modern radio station (except for microphones, which we deal with in Chapter 5). Compact disc players and turntables are the subject of this chapter. Chapter 4 deals with recording and playback devices and discusses the concept of digital audio, which has revolutionized the field of radio production. Learning the specifics of the function and operation of record and playback units will prove valuable during actual production.

In the first edition of this book, it was extremely important for would-be radio production people to understand turntable operation. At that time (1986), the turntable was a workhorse of radio production in nearly any broadcast facility you could name.

Things have changed dramatically. Today, the turntable and vinyl discs that supplied the production music and other sound elements for most of the history of broadcasting are rare, although they have not completely disappeared.

Compact discs (CDs), minidiscs, computers, and, to a lesser extent, digital audiotape (DAT) have developed into broadcast tools with remarkable speed. Today's broadcaster can select from a wide range of modern, increasingly affordable equipment that makes the turntable, cartridge machine, and reel-to-reel machine seem virtually obsolete.

We will include an abbreviated discussion about turntables and traditional tape recording equipment in this edition of *Modern Radio Production*. Nevertheless, you will need to know what kinds of capabilities exist in today's exciting world of digital production technology. Thus, we have added

51

material so you will know how the equipment of today works, and what its role is and will be in radio production of the future.

The field of radio production is changing rapidly, and the ongoing development of sophisticated audio production systems continues at a frightening pace. Today, digital technology systems have all but supplanted analog systems. In our exploration of the old and the new together, however, remember that the *result* of creating an effect through the use of production techniques is of greatest importance.

Compact Discs

The compact disc has replaced the vinyl record for music distribution today. Radio stations use compact discs for music and audio production. The advent of recordable CDs—compact discs that can be recorded at the station—offers exciting possibilities because they allow for storage and quick retrieval of sounds specific to the station, such as IDs or jingles.

The compact disc (Figure 3.1a) comes in two sizes (both less than 5 inches in diameter) and is made of plastic; the CD resembles a traditional vinyl disc. The information on the CD is read by a laser beam contained in a CD player (see Figure 3.1b).

A compact disc does not have grooves. In fact, CDs contain one long, continuous stream of data that spiral from the inside toward the outer edge. And because the disc itself is not touched physically by a stylus or a pickup device such as a tape head, it is less subject to wear than a standard phonograph record or audiocassettes are.

But there is another, more profound difference between the conventional phonograph record or an audiocassette and the CD. The record and cassette are both **analog** recordings, whereas the CD is a **digital** recording.

The word *analog* means something that shows a resemblance or similarity to something else; it is the root of the words *analogy* and *analogous*. In the case of analog recording, *analog* means to produce a series of sound waves that closely resemble the sound waves of the original signal. We use the term *analog recording* to refer to any of the conventional transduction techniques involving audiotape or vinyl records.

Digital recording means using samples of sound to produce a recording that is stored in computer language—the on-or-off binary code of digital technology. The exact method by which sounds are transduced (converted from one form into another) into digital information is not particularly relevant to radio production work (nor is it readily understandable), but the following basic points are important:

1. Digital recordings actually comprise numerically transcribed samples of the original sounds, so in engineering terms, the digital recording is a collection of samples of sound and not an analog of sound—hence the

Figure 3.1 Elements of a compact disc system.

a. Compact disc.

b. Compact disc player.

Photos by Philip Benoit

difference in word usage (although a case could be made that the digital version is obviously a representation of a sound, too).

These samples are taken with great rapidity. In most cases, digitally processed information is sampled at rates that are two times higher than humans can hear; this is the **sampling frequency** and is expressed in units called *hertz* (cycles per second, abbreviated *Hz*). One of the sampling frequencies typically used for digital recording, then, would be expressed as 44.1 kHz. (*kHz* stands for *kilohertz,* which is a unit of

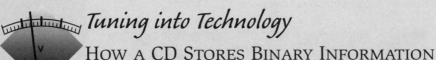

Tuning into Technology

HOW A CD STORES BINARY INFORMATION

This chapter explains sampling and digitizing, meaning the process whereby sound is encoded into digital form. The computer reads "binary" code, meaning a series of on-and-off pulses—in actuality, the numbers 1 and 0.

You might be interested, then, in a close-up view of a CD. Figure 3.2 shows the basics of storing binary code on a CD disc.

Figure 3.2 *Storing binary code on a CD.*

If you look closely, you can see that a CD has hundreds of concentric grooves (really *one* groove in a spiral, of course).

Now, if you were able to magnify one groove, you'd see a "visual definition" of binary. Remember, binary means *two numbers:* 1 and 0. That's what a computer is able to manipulate – binary code.

The groove looks like this

and in extreme close-up, like this. The holes are microscopic pits in the metal.

Laser

Laser

Laser

A laser beam "reads" the binary code. When it strikes a pit, the laser light is absorbed, and it produces a 1. When it strikes metal with no pit, the light is reflected, and it produces a 0.

1,000 cycles per second.) Samples are then coded into the binary digits that give digital recording its name. (See Chapter 4 for additional information on the digital recording process.)

2. Digital recording produces a cleaner-sounding signal. Very little (if any) extraneous noise is introduced into the system during digital recording and playback—no hiss and no scratchy sounds.

3. The cleaner technology produces a different sound than does analog; many listeners characterize it as "clearer," and unquestionably noise is reduced. Some listeners, however, claim not to like the digital sound as much as (or better than) analog. When the CD was first introduced, many maintained that it sounds too harsh, too mechanical, or too unnatural.

In any event, the entire concept of a natural sound is difficult to define. The natural sound of a concert hall, for example, almost always involves some peculiarities of room acoustics, unintended echoes, and various background noises of seat shuffling and coughing. A recording that omits these sounds can hardly be faulted for being unnatural, so we can assume that the goal of audio is not always to reproduce with total realism whatever sounds were originally made.

The preceding points have contributed to an explosion of compact disc use in radio. Even though the CD is only one link in the audio chain (because all the signals still must pass through many analog devices), listeners feel that the CD sound is superior, and most all radio stations have converted entirely to playing CDs or some other digital form. (Not all recorded material is available on CD and some specialized formats may still be playing vinyl or tape.)

At their present stage of development, CDs seem well suited, but perhaps not perfectly suited, to broadcast operations. On the plus side, they do not wear out or suffer damage as easily as other recordable media do. CDs are also convenient to use and to automate. Professional-quality compact disc players, such as the model pictured in Figure 3.3, can store many discs with virtually instant access to any cut on any disc. This makes CDs one

Figure 3.3

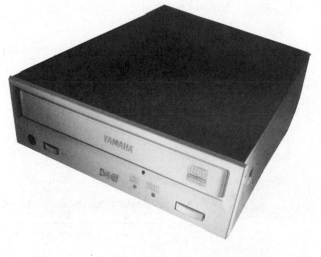

This CD recorder is commonly found on modern PCs.

Photo courtesy of Yamaha Electronics Corporation, Buena Park, CA

possible choice for automation applications or in situations where partial automation is used to assist the on-air operator.

Recordable CDs

In the last few years, manufacturers have made progress in developing CDs that will record as well as play back. These systems use recordable discs called CD-Rs (CD-write once) or CD-RWs (CD-rewriteable) that have a special photosensitive coating. Digital audio information is recorded on the disc by using a "write" laser to heat up or burn the CD-R coating. When the laser beam touches the CD-R, it causes the coating to turn opaque (see Figure 3.4). As the data is burned, it sets up microscopic light and dark patterns that either pass or reflect light back into the CD player's "read-laser." This technology was relatively expensive just a few years ago, but today CD recorders are available on most computers and as stand-alone units.

We should note that two different types of CD burners exist (see Figure 3.5). CD-R devices record onto a compact disc permanently whereas CD-RW

Figure 3.4 The write laser is a more powerful laser that alters the CD-R light sensitive layer and burns a pattern of reflective and nonreflective areas that are read by the playback laser.

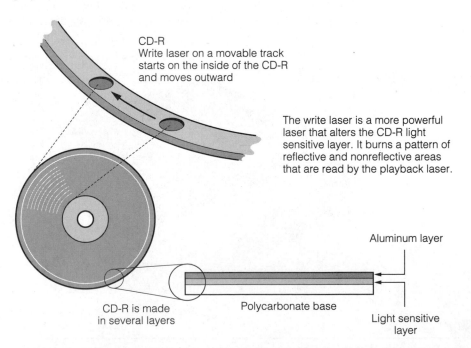

CD-R
Write laser on a movable track starts on the inside of the CD-R and moves outward

The write laser is a more powerful laser that alters the CD-R light sensitive layer. It burns a pattern of reflective and nonreflective areas that are read by the playback laser.

Aluminum layer

CD-R is made in several layers

Polycarbonate base

Light sensitive layer

Figure 3.5 a. Recordable CD-ROM.

Photo courtesy of TDK Electronics Corporation.

b. Modern AV computers such as this iMac have simplified the process of burning CD-Rs.

Photo by Fritz Messere

burners can record on a CD that can be rewritten repeatedly. CD-R discs can be played on a standard compact disc player, however, not all CD players will play back CD-RW discs. Thus, CD-RWs are not a good choice for audio duplication. In the last few years, CD recording technology has proliferated in home and broadcast audio. Today CD burners are standard equipment on most personal computers.

Audio CDs and MP3s

Today, several different data formats are used to play back audio burned on CD-Rs. The standard audio format for a compact disc is called *CD-DA* (compact disc–digital audio), and this format samples music at a rate of more than 44,000 times each second. The data stored in the CD-DA format uses *uncompressed audio* files that allow you to store between 70 and 80 minutes on the compact disc.

Many computers and CD-R burners use a different format called *MP3* (short for MPEG audio layer 3) that can store as many as 14 hours of audio on a single disc. How can MP3 record so much more audio on a CD? The answer is simple, although the process is amazingly complex. An MP3 format file compresses a music soundfile by a factor of 10 or more by using an advanced mathematical modeling technique known as *perceptual noise shaping.* This compression scheme eliminates certain parts of a sound that the human ear cannot hear when it is being masked by louder sounds. For example, when an ambulance siren is going nearby, that loud sound often masks softer sounds around it. Perceptual noise shaping can reduce a 30- or 40-megabyte file CD-DA file into a 3-megabyte MP3 file, allowing the CD to contain many more music files.

Although the standard audio CD-DA compact disc produces a higher quality sound output than its MP3 disc counterpart, you might have a difficult time actually hearing the difference. However, the problem is that most CD players will not play back MP3 files, even though many computers can play back these files. Although CD-R technology is still not universal in radio stations, many producers do want to "burn their own" so they can put frequently used sound elements on a durable and easily accessible medium (see Figure 3.5b).

Compact discs are fairly sturdy media but you should still exercise some caution in handling them. Most experts maintain that most CD "crashes" have been because of poor handling by production personnel. Despite initial claims to the contrary, CDs are not immune to damage; surface scratches can badly impair playback, and damage to the disc can result in poor audio quality, skipping, or shutdown of the playback.

CD playback is generally quite simple. You insert the disc into a mechanized drawer, which closes automatically and brings the disc into position for playback. The player displays the number of tracks on the CD. When you press *play,* the laser is guided to the correct portion of the CD. The laser reads the disc from the inside out toward the edge. Because CDs have several cuts, a selector knob or button on the machine allows you to pick the cut you want to play (selection number 3, for example). Most CD players will display the playing time and total time of the disc in the player. CDs have information only on one side, but that one side can hold more than an hour of program material.

When CDs are automated, the cut numbers are programmed into the computer. Methods of programming range from a simple computer instruc-

tion, to play at random without repeating any cuts for a certain time, to complete program control cut-by-cut and hour-by-hour.

Today, computer hard drives have emerged as an alternative to using a control-room CD player; however, several other options such as minidiscs and digital audiotape, which we discuss in the next chapter, are found in many radio stations.

Structure of a Turntable

A turntable operates in the same way as a record player does, except that it's a heavier-duty device. Before we explain its operation, let's clear up some questions of terminology. In radio parlance, the turntable is never referred to as a record player. And a phonograph record, more often than not, is called a **disc.** From here on, we use the terms *turntable* and *disc.*

The broadcast turntable pictured in Figure 3.6(a) has several components. And although some minor operational and cosmetic differences exist among various turntable models, all work in much the same fashion.

Parts of the Turntable

The disc is placed on the **plate;** this is the part of the turntable that actually turns around. The switch, also known as the start switch, is a smooth-action, noiseless switch that turns the turntable on and off. It's noiseless because you don't want a click while the mic is open. The speed control allows the operator to select from among speeds of 33⅓, and 45 rpm (revolutions per minute) by merely pressing a button. The 12-inch discs play at 33⅓ (sometimes shortened to read "33" on turntable settings), whereas the smaller 7-inch discs with the large holes play at 45 rpm. (Although 78-rpm records aren't made any more, many turntable units retain the option of playing that speed. On some older models, there is a neutral position, too, which allows the motor to idle out of gear).

The Drive Mechanism

Most broadcast turntables are known as direct-drive turntables; that is, the motor drives the plate directly. With these turntables, there is no neutral position, and speed change is accomplished electronically.

The Tonearm

The **tonearm** (see Figure 3.6b) is the movable device that is put onto the disc. At the end of the tonearm are the **stylus** and the **cartridge.** The stylus is usually a pointed piece of diamond; some people call it a needle, but it really isn't one. The stylus is attached to a strip of metal called a cantilever,

Figure 3.6 a. This direct-drive turntable is typical of modern turntables.

Photo by Fritz Messere

b. The tonearm and stylus are placed in the record grooves.

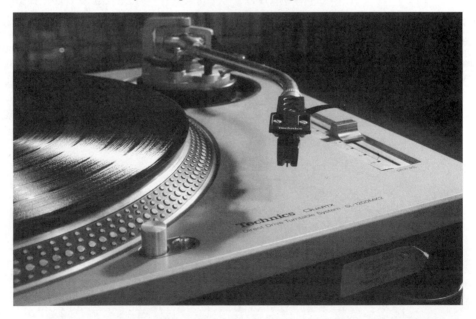

Photo by Fritz Messere

which in turn is attached to the cartridge. The cartridge translates the physical vibration of the stylus into an electrical signal. The process of changing one form of energy into another is called **transduction;** this is a very important concept, and we refer to it many times in this text.

The Disc

Where do the vibrations picked up by the stylus come from? They're impressed into the grooves on the disc. The vibrations cut into the grooves correspond to variations in the sound that was recorded.

Actually, the vibration patterns are pressed into the **grooves** of the disc. At the beginning of the manufacturing process, the master disc is cut with a stylus, which is connected to the output of a tape machine. When the master disc is cut, an electrical signal is transduced into a physical vibration.

You'll notice that there are gaps between the cuts, or individual pieces of music, on the disc; these separating grooves (and the groove at the beginning of the disc) carry no sound. They are called lead grooves.

During operation of the turntable, you will want to place a disc on the plate, place the stylus at the beginning of the cut you select, and position the disc so that the beginning of the music will start immediately, or at least within a second or so of your starting the turntable. Positioning the disc, as we noted earlier, is called *cueing.* Handling discs and cueing them up are very common tasks in radio production, and there's a proper way to do both.

Handling and Cueing a Disc

Putting your fingers on the grooves of the disc will coat the grooves with oil; worse, the stylus may pick up that oil, causing the sound quality of the playback to deteriorate. You can avoid this problem by handling the disc as shown in Figure 3.7.

The first step in cueing a disc is to select the cut you want to play and place the stylus in the lead groove (the gap preceding the cut). If the cut you want to play is the first on the disc, place the stylus at the beginning groove.

All cueing operations involve a **backtracking** of the disc. You will spin the disc (or the plate, as we explain in a moment) backward and forward until you've pinpointed the spot where the sound starts. Don't be squeamish about backtracking a disc; the stylus of a broadcast turntable won't damage the grooves.

There are two common methods of cueing a disc: spinning the plate, and slipcueing.

SPINNING THE PLATE Start the plate spinning with your hand (see Figure 3.8a); you should try to spin it at approximately the same speed at which

Figure 3.7 Handling discs.

a. Holding the disc in this manner prevents the oil on your hands from contaminating the grooves.

b. You can observe both sides of the disc by holding the edges with your palms . . .

c. . . . and turning it in the manner shown. This way you won't touch the grooves.

Photos by Philip Benoit

Figure 3.8 Cueing by spinning the plate.

a. Set the plate spinning with your hand.

b. Rock back and forth until you locate the first sound (indicated by the white arrow).

c. Then backtrack the plate a quarter-turn, and put the speed selector into gear.

Photos by Philip Benoit

it normally runs. The plate is heavy and will keep up to speed for a surprising amount of time.

Drop the stylus in the beginning or separating grooves, and let the disc turn until the sound begins. (Remember to use the cue or audition channel of the console; you don't want the cueing noises to go out over the air.) Then stop the motion of the disc with your hand, and move the plate in the opposite direction, backtracking the disc. By rocking the plate clockwise and counterclockwise, you'll be able to pinpoint·the exact spot where the sound begins. Be careful not to nudge the tonearm.

With the stylus over the exact point where the sound begins, move the plate counterclockwise one-eighth to one-fourth of a turn. Backtracking the plate and the disc will give the turntable time to get up to speed before the cut begins. If the turntable can't get up to speed before the sound starts, there will be an objectionable noise known as a **wow.**

Figures 3.8(b) and (c) review the sequence of cueing a record. For the sake of illustration, we've placed an arrow (the large white one) on a disc to show the point at which the sound begins. (Be careful to keep your hand away from the tonearm while backtracking, or you may accidentally bump the arm and knock the stylus out of the groove.)

After you've pinpointed the sound and backtracked the disc by spinning the plate, make sure the speed selector is set for the proper speed. Now you're all set to start the disc by turning on the switch and potting the proper channel up on the board.

SLIPCUEING To perform **slipcueing,** first find the point where the sound begins, either by spinning the plate or by spinning the disc. With the turntable motor started, hold the disc by the very edge, as shown in Figure 3.9a.

The disc won't spin even though the plate is spinning. Then, at the instant you want the music to start, release the disc (see Figure 3.9b). With slipcueing, of course, you do the actual cueing in the cue or audition channel. You pot up the turntable before releasing the disc.

Once you become proficient at the slipcueing method, you can drop the stylus in the groove while the disc is turning and stop the movement of the disc (but not the plate) as soon as you hear the first sound. If you do this fast enough, you'll have to back up only a fraction of a turn; now, you're ready to let the disc go when you want the cut to start.

A combination of spinning the disc and slipcueing is a very popular way of cueing a disc: With the turntable motor off, place the stylus in the lead groove of the cut; start the motor, and when the first sound is heard, stop the disc by placing your finger on the edge. Then stop the motor and backtrack the disc.

We've identified the basic methods of cueing a disc; the choice is pretty much a personal decision. In some cases, slipcueing is handy when you need to make a very tight entrance with music; slipcueing starts the cut immediately

Figure 3.9 Slipcueing.

a. The plate is spinning, but the disc is being held in place.

b. The disc is released.

Photos by Philip Benoit

without the momentary wait for the turntable to get up to speed. This is very useful for cueing up live concert album cuts because the sound of the audience would create a wow if the record were started by other methods. A disadvantage of slipcueing is that it ties up one of your hands during production.

When slipcueing, it's advisable not to pot up the turntable until immediately before you plan to start the cut; this is called **dead-potting.** Otherwise, you may pick up the rumble of the turntable motor and the spinning disc. Starting the turntable with the pot up is known as **hot-potting.** Potting up, or dead-potting, the turntable is generally considered better practice, but with modern, rumblefree turntables, hot-potting seems to be gaining acceptance.

Review of Turntable Operation

The turntable is a heavy-duty version of a record player. It's almost always called a turntable rather than a record player, and records are more commonly called discs. The parts of the turntable are the plate, the switch, the speed control, the drive mechanism, the tonearm, the stylus, and the cartridge. All turntables have the same basic components, and although various models are manufactured, they all have the same principles of operation.

Turntable cartridges operate on the principle of transduction, whereby one form of energy is changed into another. In this case, vibrational energy picked up by the stylus vibrating in the grooves is changed—in the cartridge—to electrical energy. The principle of transduction comes up again and again in radio production, so it's a good idea to be familiar with it. The discs themselves require some care in handling to avoid getting skin oil on the grooves. There are two methods of cueing: spinning the plate and slipcueing.

Summary

A broadcast turntable consists of the plate, switch, speed control, drive mechanism, and tonearm. The tonearm has a stylus and a cartridge on the end. The stylus picks up vibrations from the grooves in the disc, and the vibrations are transduced into audio.

A compact disc employs a laser beam in place of a mechanical stylus. The laser reads sound information encoded digitally on the compact disc.

Cueing is the procedure by which a standard vinyl disc is positioned so that the recording starts precisely on time. There are two basic methods of cueing: spinning the plate and slipcueing.

Compact discs are cued electronically, often by computer. Computerized control units can be programmed to play a long sequence of CD cuts; the CD player is capable of locating a particular selection almost instantly. Compact discs offer more nearly distortion-free sound reproduction than do standard discs, and they are less subject to wear. CDs, though, are not indestructible; they do wear eventually. Today recordable compact discs CD-Rs are found in many audio applications.

Applications **SITUATION 1 / THE PROBLEM** A producer at an oldies station was putting together a commercial that called for very tight meshing of 1960s musical elements not available on CD. The station format involved fast-paced, extremely closely packed sound elements. Backtracking the disc and potting it up on the board resulted in a tiny, but noticeable gap in the sound.

ONE POSSIBLE SOLUTION The producer decided to slipcue the musical elements. By identifying the first sound of the music selection desired, backtracking ever so slightly, and hot-potting the cut, she was able to make a very tight production.

SITUATION 2 / THE PROBLEM The producer of a spot wanted to use a lyric from a popular song. Unfortunately, there was an instrumental introduction leading directly into the beginning of the lyric. The spot really needed that lyric, but the 10-second instrumental before the lyric wasn't appropriate.

ONE POSSIBLE SOLUTION The producer elected to use the pause function on the CD player. He listened to the instrumental introduction and was able to pause the CD player right before the lyrics began. By pressing play, the CD started instantaneously with the singer's voice. By using this method, he avoided hearing any of the instrumental portion of the music.

Exercises

1. This exercise is strictly a matter of practicing some mechanical movements. It may seem a bit tedious, but practicing some of the basic movements will make the more complex operations much easier. The movements to practice are
 - Dropping the stylus into the lead grooves on a disc. Keep trying until you can hit all the grooves on an entire side without picking up any of the music.
 - Handling discs as shown in Figure 3.7.

2. Using three discs or CDs, go from one piece of music to another and then to another. (With two turntables or CDs, obviously, you'll have to change one disc.) Play each disc for 10 or 20 seconds; then fade it down and bring up another.

 The trick to the exercise is this: Cue each disc by a different means (if, of course, your equipment so allows). Cue up the first CD on a CD player. After you start the first disc (and put the output of that turntable in program), cue up the second disc by spinning the plate. While that's playing, cue up the third disc and slipcue it.

3. Cross-fade from a vocal to an instrumental; choose an instrumental cut that has a definite ending (rather than just a fade-out). Make the resulting segment exactly 5 minutes long. To do this, you will have to back-time and dead-pot the instrumental.

Recording and Playback Devices

*M*ost material in radio today is prerecorded. Compact discs provide most of the music, although more and more frequently music is being transferred to a computer hard disk for actual airplay. And today, it's quite common to use a CD-R disc burner to record materials during production. As late as the 1950s, many radio stations had vinyl disc-cutting machines just for the same purpose.

Ultimately cutting vinyl discs was impractical because they are useful primarily for permanent storage of sound, so they couldn't be edited. The need for a convenient way to record material that might be used only once or a few times, with further changes possible after recording, led to the development of magnetic recording technology and the use of *audiotape*.

Today, CD burners and minidiscs have largely replaced analog audiotape; however, magnetic recording media are alive and well in broadcast studios in digital applications. Computer hard drives use magnetic recording technology, and digital audiotape (DAT) is frequently used in broadcasting. Many digital multitracks use recording tape and standard cassettes are still widely used for news gathering and archiving purposes.

Audiotape is often called **magnetic tape** because its magnetic properties allow the storage of sound. Actually, sound isn't stored on the tape. Sound energy is first transduced into electrical energy, and those electrical pulses are then transduced into magnetic energy.

This chapter deals with the recording and playback technology commonly found in radio, which can be divided into two basic types: magnetic and optical. Magnetic tape can store both analog signals and digital information whereas optical recording media are used to store digital data. To understand this process, let's start by examining how digital recording works. Then, we'll look at how signals are stored on magnetic and optical media.

The digital process starts with converting sound into data; although the technology is fairly complex, we'll keep the explanations as simple as possible. Digital recording technology takes the two components of all audio signals, *frequency* and *loudness,* and converts these components into mathematical representations called samples and quantization.

Sampling

Sampling is the process of converting analog audio signals into numerical representations. Basically, sampling involves taking a snapshot of the audio wave and breaking it down into very small segments of the signal that can be expressed in a form computers can use. Thus, the sampled sound is going to be converted into a computer word, called a *bit.* Computer language uses these binary numbers, long sequences of 0s and 1s to represent the soundwaves we've sampled. The sampling process is incredibly fast. In fact, one second of audio will be sampled 44,100 times. But let's start with a rudimentary sample that measures an audio signal only twice per second. In broadcasting, these binary numbers will end up representing our audio signals.

This waveform (Figure 4.1a) is frequently used to represent an audio wave; we call it a sine wave. You'll notice that it has a positive side and a negative side. Suppose we wanted to sample this wave at the rate of two samples per second. The positive and negative parts of the wave would represent the two samples for this sine wave, and we could provide some rough digital information as seen in Figure 4.1b. Unfortunately this digital sample doesn't provide very much information. It simply tells us the signal was on twice: once as a positive signal and once as a negative, so it wouldn't really be very useful to us.

Let's try to sample the same sine wave again using eight samples per second instead of two (Figure 4.2). This time you can begin to see the representation of the original sine wave because we've increased the number of samples to make the representation more detailed. Now, imagine using 24 samples per second (Figure 4.3) to represent this sine wave. This digital representation starts to look very similar to the original sine wave. Even though 24 samples are not fine enough for practical use, we can see what is occurring; that is, as the number of samples increases, so too does the accuracy of the representation of our original sine wave.

As the samples of the audio signal's waveform are taken, they are converted into binary numbers in a process called *quantization.* The greater the amount of quantization, the better the sonic resolution is. Binary numbers are expressed in 0s and 1s and a quantity expressed as a binary number is referred to as a digital word. The value of each *bi*nary digi*t* is called a *bit.* In practical terms, the binary numbers used for high quality digital audio are fairly large, which ensures that the digital signal is a very accurate representation of the original audio signal.

Figure 4.1 a. This representation of an audio signal is called a sine wave.

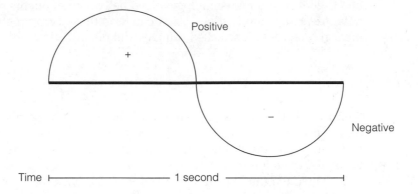

b. The digital representation of our audio signal shows two samples: one positive and one negative.

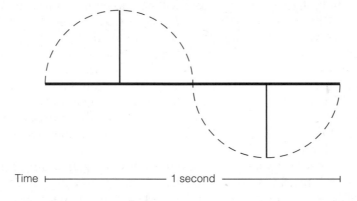

Let's see how the recording process works. First, a *sample and hold* circuit, used to execute the quantization process, holds the waveform in the computer's memory for a fraction of a second. During this sampling of data, information about both the signal's frequency and its loudness is converted into digital words. Once the signals are sampled and converted into digital words, they need to be coded. A steady stream of data generated by the coding process now represents the audio.

Next *error correction* is applied to minimize the potential for problems while storing and retrieving the data. A look at the block diagram in Figure 4.4 shows the path the audio signal went through to become bits of information that are ready to be stored in digital form.

Figure 4.2

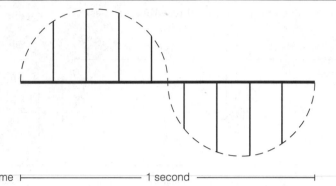

Time ⊢————————— 1 second —————————⊣

This digital representation of our sine wave uses eight samples: four positive and four negative.

Figure 4.3

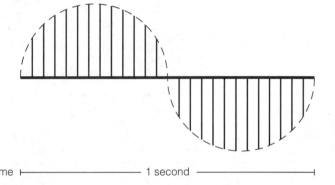

Time ⊢————————— 1 second —————————⊣

Digital representation of a sine wave using 24 samples.

Now that the original audio wave has been converted into usable form, coded, and error correction has been applied, we can store this information on a computer hard drive or record it on a DAT recorder for playback at a later time. Let's choose to store the data on a DAT machine that uses magnetic tape as the storage medium. To store the digital data on tape we need to *modulate* the digital words, comprised of 1s and 0s, as a series of magnetic pulses. At this point, we are going to look at one of the foundation technologies for modern broadcasting, magnetic tape.

Magnetic Tape

Audiotape is a strip of material with a thin coating of **iron oxide** (a fancy name for rust) on one surface. The iron oxide particles are in powdery form,

Figure 4.4 **Block diagram of the digital recording process.**

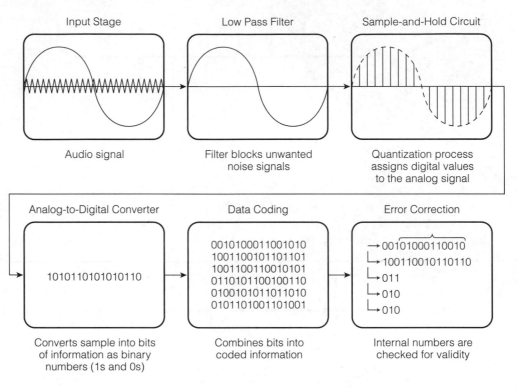

they line up when they are exposed to an **electromagnetic field** (more on that in a moment), and they are the elements that hold the magnetic information.

The backing of the tape—the material over which the coating is applied—is made of **Mylar**, which is a resilient, extremely tough substance that will stretch before it breaks. This isn't necessarily an advantage because a snapped tape can be repaired, whereas a stretched tape can't. With some care, however, magnetic tape is generally a reliable storage system.

Many different sizes of magnetic tape are used by the broadcasting and music industries, ranging from 2 inches wide to as small as $\frac{1}{8}$ inch wide. Some tapes are spooled onto open reels or cassettes. Different sized tapes serve different purposes. For example 2- and 1-inch wide tapes are usually found in large recording studios where multiple tracks are a necessity. Broadcasters tend to use stereo (two-track) tape machines, and these tapes can be found in either analog or digital formats. (See Figure 4.5.)

Figure 4.5 Reel-to-reel tape shown in 1-inch and ¹/₄-inch sizes. DAT and digital 8-track cassettes are some of the formats available.

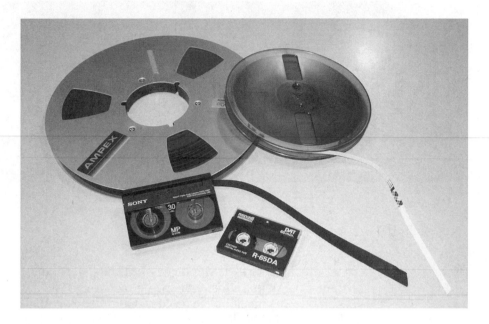

Photo by Fritz Messere

Digital Audiotape

Digital audiotape (DAT) is the tape corollary of the compact disc: It is recorded using the same kinds of sampling and coding methods described earlier. However, DAT has an advantage over CDs by being readily available for recording as well as for playback and the tape can be used over and over again.

R-DAT uses two tracks of digital audiotape on a cassette that is approximately the size of a pack of cards. The tape cassette is loaded into a machine that resembles a videotape deck. (For an example, see the R-DAT machine pictured in Figure 4.6.)

Most machines have a variety of sampling rates (the number of times per second that a sound is digitally sampled. R-DAT units typically offer sampling rates of 44.1 kHz, 48 kHz, and (for digital inputs only) 32 kHz.

A rotating head spins at a slant, crosswise over the tape, as the tape is moved past the head; thus, this action resembles the mechanism in a videotape recorder. The process is called helical scanning. A digital audio recorder can produce audio of roughly the same quality as audio from a compact disc. This allows the user to make copies that are virtually as good as the original master.

Figure 4.6 DAT recorder displays cut number and elapsed time on the alphanumeric display.

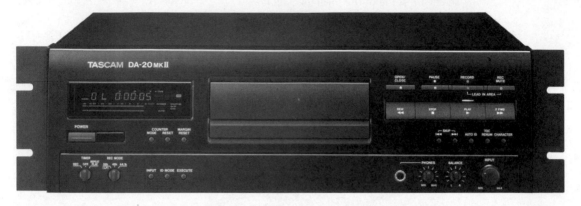

Photo courtesy of TEAC Corp. of America

Also remember that with digital recording, generation loss is not so significant a problem as it is with analog recording. The best example for understanding this might be to consider that producing multiple generations of analog tape is like making a copy of a photocopy and then making a copy of the second copy, and so on. Eventually each copy is a little less crisp than the previous copy. But digital recording essentially retransmits a series of on-and-off pulses, and the pulses are either on or off, so there are no shades of gray; consequently, digital recordings reproduce with great accuracy.

This is not to say that digital audiotapes (or compact discs, for that matter) are immune from wear; the thin tape can wear and break. But the point is that, as long as the tape itself retains its integrity, copies of copies of copies, ad infinitum, will not suffer appreciable loss of audio quality.

Because computers have made such inroads into broadcasting, many industry observers feel that a primary use of digital audiotape in the future will be in recording field events live, such as concerts or even news audio, and then dumping the results into a digital editing station. Once a DAT recording has been transferred to an audio workstation, the material can be edited or sweetened (equalized) easily. Digital audiotape has met with fairly widespread acceptance in broadcasting and recording studio operations in a variety of production applications.

Workings of the Digital Tape Machine

The process of magnetic tape recording happens when a tape passes by an electromagnet that arranges the pattern of magnetism in the particles to correspond to that of the sound message being fed into the recorder.

A device called a **record head** is the electromagnet in the tape machine. The heads in a typical tape recorder perform three functions, but before describing them, let's see where the heads are and how the tape is brought into contact with them.

Figure 4.7a is a simplified diagram of an R-DAT machine. All tape machines, regardless of their design differences, operate in pretty much the same way. Notice how the unit pictured in this drawing has the same basic controls as your cassette tape player at home. It has some advanced features that we'll explain, too.

Figure 4.7

a. Tape is drawn out of the cassette along precision guides, across an erase head, and across the record head. The capstan and roller pull the tape at a constant rate of speed. The tape is wound back into the cassette onto the takeup spool.

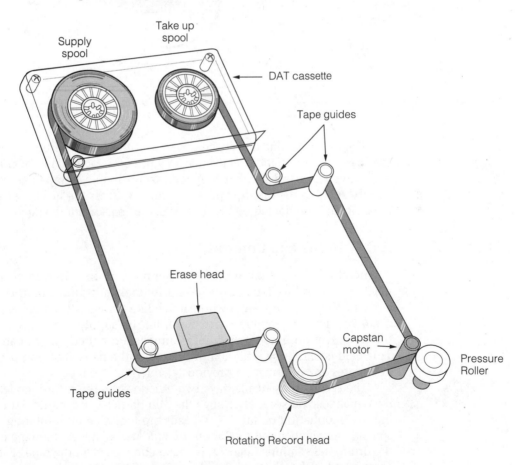

Figure 4.7 b. DAT recorders use a rotating head drum to increase the ability to record large amounts of data on tape. Tracks are recorded as a series of magnetic pulses.

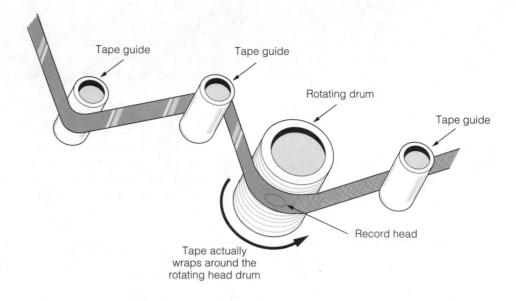

The tape machine draws the tape out of the cassette from the left side of the cassette to the right. The technical names of the left and right components, respectively, are the supply spool and takeup spool. As tape passes from the **supply spool** to the **takeup spool,** it is drawn across the heads, where a magnetic signal is implanted on the tape or played back from the tape.

R-DAT Heads and Controls

To encode all the digital information supplied by the electronics, the R-DAT machine uses rotary tape heads to imprint magnetic pulses on the tape along a diagonal path. The system works much like a home VHS tape recorder (Figure 4.7b). First, as the tape is pulled from the supply spool, guides position the tape over an **erase head** that produces a magnetic field, called a flux. This field is fairly powerful, and it scrambles the pattern of iron particles and obliterates any information previously stored on the tape.

The **record/play heads** have two functions. In the record mode, they produce magnetic pulses that arrange the iron particles in a particular order, storing the information on tape. The heads are mounted on a rotating drum that spins at very high speed (2000 rpm for standard play). As the tape encounters the drum, the spinning heads write magnetic pulses on the tape. These pulses correspond to the encoded data from Figure 4.7b. In the playback mode, the same heads read the magnetic pulses that were stored on the tape.

Despite the differences among models, the goal of all tape machines is the same: to pass a tape across the heads at a constant rate of speed. For the layout of the tape transport mechanism, refer to Figure 4.7a. Here's what the components of the drive mechanism do:

- The supply spool contains the tape that will be drawn across the heads.
- The takeup spool draws the tape up after it passes across the heads.
- The **tape guides** are precision designed to keep the tape correctly in position.
- The **capstan** is a revolving metal post that determines the speed and direction of the transport's movement. It turns the next piece of equipment—the pinch roller.
- The tape passes between the **pinch roller,** which is made of rubber, and the capstan and is pulled along. The capstan and the pinch roller keep the tape moving at a constant speed; then the tape is pulled back into the cassette by the takeup spool.
- The tape guides and idlers provide constant tension and keep the tape moving along its path without jitter.

Tape Machine Controls and Indicators

Although the style of levers and buttons differs from machine to machine, the controls and indicators perform typical functions (see Figure 4.8).

PLAY Depressing the Play button will cause the machine to play back the recording on the tape. The tape moves from the supply spool, across the heads, to the pickup spool. The erase head does not operate when the machine is in play mode. In play mode, the magnetic pulses on the tape set up electromagnetic changes in the head that correspond to the recorded signals.

RECORD (REC) Usually, the Record button is pushed at the same time as the Play control. When Record is activated, the record head impresses a signal on the iron oxide particles on the tape; this is the signal that can be read back by the play head. When the machine is in Record mode, the erase head is also activated; there would be no point in recording if the previous information (if any) on the tape were not removed.

VOLUME-UNIT (VU) METER Like the meter on the console, the tape machine's VU meter (not shown) monitors the signal coming into the tape machine so that proper levels can be maintained when recording. There are also separate controls on the tape machine to govern the level of the incoming signal. It is very important to maintain a proper level on this meter. Today most machines have VU meters that resemble a line of bars that illuminate from left to right to indicate relative volume level. Levels on DAT machines should never exceed 100 percent modulation.

Figure 4.8 Transport controls include rewind, fast-forward, stop, play, pause, and record. Pressing Skip will make the machine search for the next cut recorded on the tape.

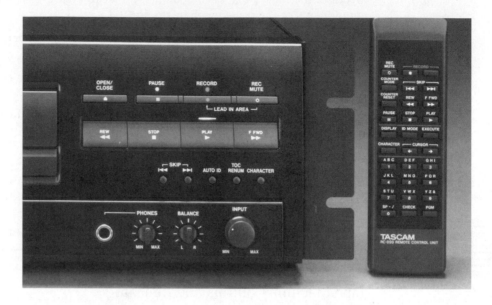

Photo courtesy of TEAC Corp. of America

FAST-FORWARD (FF) The FF control moves the tape forward (in the same direction as Play) at a high rate of speed. In some units, the Fast-Forward control brings the tape into contact with the heads, and you'll hear the chattering of the fast-moving tape. Other machines, though, lift the tape away from the heads, so you have to use "Jog" or "Shuttle" if you want to hear the sounds of the tape in fast motion.

REWIND (REW) Activating the Rewind control causes the tape to move backward, that is, from the takeup spool to the supply spool.

STOP Pressing Stop brings the motion of the mechanism to a halt.

RECORD MUTE Pressing this button mutes sound going into the tape machine.

PAUSE This button will temporarily stop the play mechanism without disengaging the tape from the heads.

OPEN/CLOSE This button toggles the sliding door holding the DAT cassette.

SHUTTLE Some models have a dial that allows you to play the tape at faster than normal so as to find cue points on the tape.

Cueing a Tape

Just as with discs and turntables, you'll need to know where the sound information on a tape begins so that you can put it out over the air or use it in studio production. Digital tape machines have a subcode data stream that provides an ID system that allows you to move from one recorded segment to the next easily. The alphanumeric window displays what the current track number is playing (see Figure 4.6). This system is very convenient for moving you through the tape quickly but you may still need to locate the exact beginning of the taped segment.

Say, for instance, that you have a recording of an interview show. You might insert the tape and move the tape to ID segment #3. Now by using the "jog" or "shuttle" mechanism you can fast-forward it until you hear the correct portion of the tape—over the console's cue speaker, of course! Then, when you press the Play button, the program will begin immediately. Sometimes, there'll be a countdown or cue tone on prerecorded tapes to help the operator in cueing. For instance, the interview show might start with the host saying: "Meet the Community Program for air Sunday, March 17, rolling in five, four, three, two, one, Good afternoon, welcome to . . ." With experience, you'll learn to listen to the countdown on cue, stop the tape machine after "one," and be set to put the program on air.

A DAT machine's tape head places the signal at a specific location on a stripe called a **track.** It is a function of recorder or player configuration, not a property of the tape itself. Remember that a DAT machine is encoding magnetic pulses of data onto the tape. The rotating drum allows the record head to record the data pulses as slanted tracks onto the magnetic tape (see Figure 4.7b). The combination of the rotating head and the forward movement of the tape (as it is pulled by the capstan) allows the machine to record a tremendous amount of information on the tiny, ½-inch DAT. The method of recording is called pulse code modulation or PCM for short. Analog tape machines are different and we'll discuss them later in the chapter.

DAT Playback

The playback process for a DAT machine is almost the reverse of the recording process. Look at Figure 4.9 to see a block diagram of the playback sequence. In the playback mode, tape is pulled across the head in the same fashion as in the record mode. This time, however, the heads pick up the magnetic information embedded on tape and send the signal to the demodulator, which reshapes the modulated signals and returns them back into pulses of 1s and 0s.

Error correction is applied to the signal, then it is sent to a digital-to-analog converter that reconverts the digital numbers into an analog audio

Figure 4.9 The demodulation takes the magnetic pulses on tape and converts them back into binary information.

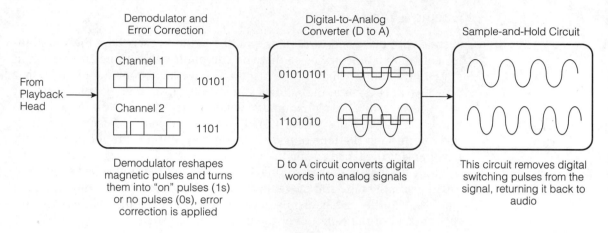

Demodulator reshapes magnetic pulses and turns them into "on" pulses (1s) or no pulses (0s), error correction is applied

D to A circuit converts digital words into analog signals

This circuit removes digital switching pulses from the signal, returning it back to audio

signal. The output is sent to a sample-and-hold circuit that removes switching pulses from the signal and then finally to a low-pass filter that removes extraneous high frequency noise from the recording.

Disk Drive Recording

Recording on a computer's hard disk is really quite similar to recording on a tape recorder. Hard disk drives use iron oxide coating on a spindle and the record heads lay down a series of magnetic pulses along various tracks on the hard disk. Even though the principle is just that simple, the actual execution of the process is a bit more complex.

A hard disk drive has one or more self-contained, glass disks that have been coated with iron oxide and then polished to a high-precision, smooth surface (see Figure 4.10). The record/play heads (one for each side of the different disks) move over the disks without actually touching the surface. The recording occurs when the head's flux leaves a magnetic imprint on the disk. In the record process, data is saved as a string of bytes in specific locations on the drive. The computer keeps a directory of this location in a *file*. The recording process is possible because the magnetic domains (the actual size of the iron particles) are extremely small and because the disk assembly rotates at a very high rate of speed, usually 5400 rpm, 7200 rpm or more. And, because the magnetic domains are so small, hard disk drives can contain a tremendous amount of data. In recent years, the cost of data storage

Figure 4.10 This hard disk drive has four spindles that are coated with iron oxide. Read/write heads move above the surface at a very high rate of speed.

Photo by Fritz Messere

has decreased. Today, hard drives found on home computers typically have a capacity greater than 10 gigabytes (giga = billion).

You'll remember that magnetic tape stores and plays back the audio signal in a stream as the tape is pulled across the tapehead. In comparison, the computer keeps a directory of where the information is stored on the hard disk. In the playback process, the user can access that information (nearly) instantaneously by calling up a file name. Then the data is transferred from disk as the play head retrieves the appropriate data and sends it to the computer's random access memory (RAM). When playing back an audio file, the hard drive head moves across the data along a path determined by the hard drive's file directory. The pulses represent a series of 0s and 1s, and the data is accumulated within the computer in a "buffer," then transferred to the data registers within the computer. From there, the data is converted into

audio pulses by the *digital-to-analog converter* (D-to-A) within the computer's sound card. Modern disk drives have extremely fast "seek" times, meaning they can retrieve the data fast enough to allow the computer to accumulate the audio data and play it back as an audio file in real time.

As disk drives got larger, cheaper, and faster, audio playback via a computer became more of a reality. Today, most radio stations and millions of Americans play back music stored on a computer hard disk drive. It's not unusual to find that a radio station may use 10 or more disk drives to store all its music for airplay.

Digital Audio Workstations

Software that provides recording and mixing capabilities turns a computer into a *digital audio workstation (DAW)* (some manufacturers use a dedicated machine for this purpose). With a DAW, a producer can perform editing functions far more easily and expertly than was possible using splicing and editing. The major advantages of this technology are the automatic functions that can be built into the software by making use of the computer's lightning fast power.

By simply adjusting a control that creates a digital cross-fade at the point where you join two sound elements together in an edit, for example, you can make almost any edit virtually undetectable no matter how tight it is. And if you don't like the edit you have made, you can delete it and start all over again with the original sound sources, which are left intact while you experiment with the editing processes.

Once you have a satisfactory edit, you can store it in a file while keeping the original sound sources intact. The sound quality of all materials remains virtually unaffected no matter how much you work with it or how many versions of a soundfile you record.

Enter Minidiscs

The SONY Corporation introduced the minidisc (MD) in 1992 as a replacement for the home cassette unit. Most American consumers have never really accepted the MD; however, broadcasters have embraced it as a logical replacement for the audio cartridge machine. The sonic characteristics of the minidisc are roughly equal to that of compact discs, and the technology allows you to record, edit, and play back audio tracks quickly. These factors mean that the minidisc has challenged DAT for a place in the radio station control booth.

The minidisc is a magneto-optical recording device about the size of a floppy disk. Minidiscs come with different capacities and can store 60, 74, or 80 minutes of stereo audio in a self-contained format. Recorded audio goes through a similar process as with other digital media. The audio signal is sampled and coded into digital information, but unlike a DAT system, the

Figure 4.11 A minidisc, though smaller than a deck of cards, can store as many as 80 minutes of stereo material.

Photo by Fritz Messere

minidisc compresses the audio signal by a ratio of more than 5 to 1 before it is recorded. This compressed signal is then stored on the optical media in a fashion similar to recording a CD-RW (see Chapter 3).

Minidiscs can be recorded and reused and because the material is stored in a digital format, a file directory is updated each time a recording is made. Titles are stored as part of the recorded information. Unlike CDs and DAT, however, minidisc recorders also have built-in editing features. This allows users to identify and retrieve information very quickly.

Minidiscs have several features that make them quite attractive for radio stations. First, minidisc files do not need to store data in sequential order (Figure 4.11). A table of contents (TOC) is written that keeps the tracks in order, and 255 tracks may be recorded. As a result, it is possible to take segments of the minidisc recordings and edit or change them (see Chapter 6 for an explanation of the editing process). Minidiscs are fairly rugged and can be used over and over. The editing features give minidiscs a real advantage over DAT. DAT files are written in sequential order, and you cannot edit the order of a DAT without first dubbing it or using an editing system with two DAT machines. However, minidisc files are fairly easy to edit and change. Files can be separated or combined easily, too.

Figure 4.12 Almost any computer can be programmed to function as a "digital cart machine."

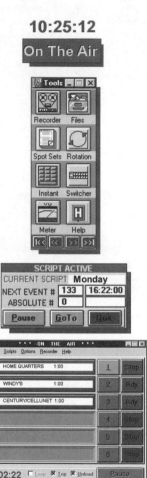

© 1999 Cartworks/dbm Systems, Inc.

The Digital Cart Machine

One of the more popular digital additions at radio stations is the *digital cart machine,* which actually is not a cart machine at all, but really a large hard drive storage system. Some digital cart machines are stand-alone systems whereas others are really computers running a software program that acts like a cart machine (Figure 4.12). Almost any computer can be programmed to function as a "digital cart machine."

Tuning into Technology

DIGITAL SOUND AND AUDIO COMPRESSION

In Chapter 3, we briefly touched on the ideal of audio compression in our discussion of MP3 discs. Both MP3 and minidisc technologies use audio compression schemes. Generally the aim of audio compression is to reduce the amount of data required to store or distribute music. This becomes important as more and more stations gain an interest in providing a program service using the Internet or if the station has a central server for distributing its audio files to production studios. The size of an audio file is important—smaller audio files are easier to stream on the Internet and are easier to transfer between computer workstations.

Uncompressed digital audio files are generally quite large. For example, a uncompressed one-minute stereo recording made on a program like Digidesign's Pro Tools would need approximately 10 MB (megabytes) of storage on a hard drive. The program samples audio at a rate of 44.1 kHZ (kilohertz per second) and with 16-bit quantization, the level of quality is very high. Because we record in stereo, this means that two channels are being recorded. Seventy minutes of music would constitute a file that is 700 MB, approximately the same capacity as a compact disc. Compact discs can record about 74 minutes of audio on them.

Both MP3s and minidiscs compress audio, so the same file of music can be much smaller. The advantage is that more files can be stored in the same space than can uncompressed audio files.

Data files can be compressed in many ways. Some audio compression systems do not result in any discernable audio quality degradation. Some of these schemes are used by digital audio workstations, and are known as *lossless* compression because the music quality recorded will be the same as the original. These systems tend to reduce the data file's size by only 25 percent, however, so the compressed files are nearly as large as the original files. They are not practical for files that need to be transferred via server from one computer to another.

The second kind is called *lossy* compression, and several different types are available. In broadcasting, the most common types of compression are MP3 (MPEG audio layer 3), used frequently to transfer files on the Internet, and Adaptive Transform Acoustic Coding (ATRAC), used in minidiscs. These systems use *psychoacoustic* techniques to accomplish the goal of retaining quality while creating smaller audio files. How? Two basic techniques are used to make the data size smaller. First, as a result of extensive testing, audio engineers developed ideas about how much distortion (change) of the music would be tolerated by the listener before

Continues

it became noticeable. Second, the sound is analyzed to see which sound frequencies were most important and which were less important. Once the signal has been analyzed, compression occurs by breaking the audio spectrum into smaller subbands. Then, by reducing certain subbands, which are less important, the audio file can be reduced in size. Taken together, these compression techniques greatly reduce the size of the audio file.

You can see that the difference in file size is substantial:

- One minute of uncompressed audio = 10 MB
- One minute of compressed audio for MP3 = .83 MB
- One minute of compressed audio for ATRAC (minidisc) = 1.43 MB

These numbers tell an interesting story. As more and more audio files need to be stored and as more and more stations cross the digital threshold, data compression becomes ever more important. Radio stations use large computer hard disks to archive important commercials. Jingles, music and news segments, also stored in the computer will take up a large space.

Most digital cart machines display program elements, such as music cuts, announcements, or commercials, that are in the cue to be played. In some cases, the announcer fires the elements by using a touchscreen or a mouse. Depending on how the digital cart machine is programmed, this may trigger several sequences in a row. Such a set-up is commonly known as *live-assist*.

Digital cart machines are also used to fully automate the station and to program a computer to provide voice-tracking; we'll discuss these options in greater detail in Chapter 8. But the technology allows for human interaction before the fact: The announcer can view the list of music and other cuts and record a voice track that will be replayed later.

Analog Tape Machines

A discussion of analog tape machines for broadcasting centers on reel-to-reel, cartridge and cassette recorders, and reproducers. And, although most radio stations have moved to using digital gear, numerous stations use various pieces of analog gear. We will cover the very basic information here.

Figure 4.13 is a simplified diagram of a reel-to-reel tape machine; it bears a similarity to our diagram of the DAT recorder in its layout of controls and operation. All reel-to-reel tape machines, regardless of their design differences, operate in pretty much the same way.

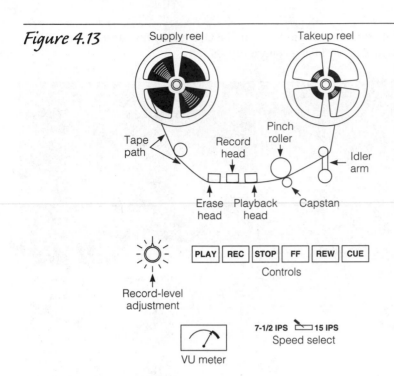

Figure 4.13

The tape path in a typical tape recorder. The control buttons are identified on pages 89–90.

The tape machine draws the tape from the left reel to the right reel. The technical names of the left and right components, respectively, are supply reel and takeup reel. As tape passes from the **supply reel** to the **takeup reel,** it is drawn across the heads, where a signal is implanted on the tape or played back from the tape. We begin with an explanation of the heads and then move on to the tape transport system.

The Heads

Figure 4.14 shows the heads on a tape machine. Reel-to-reel machines have three separate tape heads and each performs a distinct function: *erase, record,* and *play*. The erase head scrambles the pattern of the iron oxide particles and obliterates any information previously stored on them. The record head produces a magnetic field that arranges the iron oxide particles in a particular order, storing the information on the tape. The **playback head** reads the patterns formed by the arrangement of the iron oxide particles and produces an electrical signal carrying the sound information.

The heads are always arranged in this order (from left to right): erase, record, playback. If you're ever stumped when trying to identify a head (you'll need to know the location of the heads during tape editing), try to think the problem out logically. Erase *must* come first; if the erase head were second in

Figure 4.14 Three tape heads (center of photo). Next to the tape heads, the capstan and roller pull the tape across the head at a constant speed.

Photo by Fritz Messere

line, you'd erase whatever had just been recorded on the tape. And it makes sense to have the record head in the second position because this allows the tape to pass over the playback head, which is in the third position. The tape passes the record head immediately before the playback head, so the operator of the tape machine can play back what was just recorded to make sure that there is, indeed, a recording on the tape. You wouldn't have this option if the positions of the record and playback heads were reversed. If you can't recall the logical explanation of their order, just remember that they spell *ERP.*

The Tape Transport Mechanism

Despite the differences among models, the goal of all tape machines is the same: to pass a tape across the heads at a constant rate of speed. For the layout of the tape transport mechanism, refer to Figure 4.13. The components of the drive mechanism perform the same functions as on the DAT machine.

- The supply reel contains the tape that will be drawn across the heads.
- The takeup reel draws the tape up after it passes across the heads.
- The tape guides are precision designed to keep the tape exactly in position.
- The capstan is a revolving metal post that determines the speed of the tape's movement. It turns the next piece of equipment—the pinch roller.
- The tape passes between the pinch roller, which is made of rubber, and the capstan and is pulled along at the proper speed. The capstan and the pinch roller keep the tape moving at a constant speed.
- The tape idler arm (a feature on most larger tape machines but not on our DAT recorder) drops down if the tape breaks; when the idler drops, it shuts down the tape machine's drive mechanism. This prevents tape from spilling out onto the floor if there's a break, and it shuts down the drive mechanism when the tape runs completely off either reel.

Tape Machine Controls and Indicators

Although the style of levers and buttons differs from machine to machine, the controls and indicators perform typical functions.

PLAY Depressing the Play button (or, in some units, flicking a lever) will cause the machine to play back the recording on the tape. The tape moves from the supply reel, across the heads, to the pickup reel. The erase and record heads don't operate when the machine is in play.

RECORD (REC) When Record is activated, the record head impresses a signal on the iron oxide particles on the tape. When the machine is in Record mode, the erase head is also activated.

VOLUME-UNIT (VU) METER The tape machine's VU meter monitors the signal coming into the tape machine so that proper levels can be maintained when recording.

FAST-FORWARD (FF) The FF control moves the tape forward (in the same direction as Play) at a high rate of speed. In some units, the Fast-Forward control brings the tape into contact with the heads, and you'll hear the chattering of the fast-moving tape. Other machines, though, lift the tape away from the heads, so you have to use *Cue* if you want to hear the sounds of the tape.

CUE The Cue control brings the tape into contact with the heads by defeating the tape lifter; it allows you to cue the tape when it's moving in Fast-Forward or in Rewind mode. On some machines, the Cue control is also used

Figure 4.15

This reel-to-reel tape recorder will accept reels as large as 10½ inches.

Photo courtesy of TASCAM, TEAC Professional Division, Montebello, Calif.

if the operator wants to hear the sounds on the tape when rocking (moving) the reels by hand (as when editing tape).

REWIND (REW) Activating the Rewind control causes the tape to move backward, that is, from the takeup reel to the supply reel.

STOP Pressing Stop halts the motion of the reels.

SPEED SELECT This control governs how quickly the tape moves past the heads. The most frequently used speeds on broadcast reel-to-reel tape machines are 7½ and 15 inches per second (IPS); that is, 7½ (or 15) inches of tape is driven past a given point per second. A seldom-used but sometimes available speed is 3¾ IPS. Note that each speed is exactly double or half the previous or next speed.

Cueing a Tape

Just as with discs and turntables, you'll need to know where the sound information on a tape begins so that you can put it out over the air or use it in studio production. Say, for instance, that you have a recording of an interview show. You might thread the tape and fast-forward it with the Cue control on (although some machines play sound in Fast-Forward without using a Cue control) until you hear the chattering of sound on the tape—over the console's cue speaker, of course! Then, you would rewind it to the approximate point at which the sound started, stop the tape machine, and rock the reels by hand until you hear the beginning in cue.

Usually, there'll be a countdown or cue tone on prerecorded tapes to help the operator in cueing. For instance, the interview show might start with the host saying: "Sunday Racing Wrap-up for April 3rd begins in three, two, one . . ." With experience, you'll learn to listen to the countdown on cue, stop the tape machine after "one," and be set to put the program on air. You can also use leader tape to cue.

Heads and Tracks

Now that we've covered the way reel-to-reels function, let's look at a technical detail that can be confusing.

Unlike a digital machine that writes data onto the tape in a diagonal, an analog machine's heads place the signal on a specific location on the tape, a stripe called a **track.** Many tape machines place the signal across the entire width of the tape; sensibly, this is called a **full-track** recording (see Figure 4.16). However, the most common reel-to-reel configuration for broadcasting is known as **two-track.** Two stripes are recorded for stereo; the left track is track 1 (top) and the right is track 2 (bottom). Another type of recording is **quarter-track**. The quarter-track reel-to-reel system can be used to record stereo. Two of the stereo tracks would be recorded with the tape moving in one direction (tracks 1 and 3), and two would be recorded going in the other direction (tracks 2 and 4). This track system is not commonly used in radio. Cassettes have a four-track configuration that allows for either mono or stereo playback of a cassette tape.

How Tracks Work

Each track is placed onto the tape by means of a separate head. However, multiple heads can be situated on the same structure. The element that actually puts the signal on the tape is a tiny rectangle on the structure that holds the head. When you see more than one head, the structure holding them is called a **headstack.**

Machines may contain as many as 32 heads on a stack. These machines are found in recording studios but are not commonly used for general radio production. We consider applications for multitrack recording in radio in Chapter 15.

Cassette Machines

Cassette record and playback units are highly portable, which is why they have come into such common use in radio newsrooms. The size of the tape, however, limits the usefulness of these machines in other areas of radio

Figure 4.16 Tape recording track configurations.

a. Full-track recording.

b. Half-track (or two-track) recording.

c. Quarter-track reel-to-reel recording.

d. Quarter-track cassette recording.

production. Smaller tape size and a slower recording speed (1⅞ IPS) also detract from sound quality.

Noise reduction devices such as Dolby are used on larger units to counteract these problems (see Chapter 15). Another problem with cassette machines, at least from the standpoint of radio production, is that the tape is difficult to edit mechanically. Most news operations dub cassettes onto a computer, a minidisc or a reel-to-reel for editing.

Figure 4.17

Broadcast cartridge.

Photo by Philip Benoit

Cartridge Machines

Although both reel-to-reel tapes and DAT provide high quality, they have some drawbacks. For one thing, it's time consuming to load the tape and find the cue. Cartridge machines were developed as a solution to this problem. They use a cartridge—usually called a *cart*—which is an endless loop of tape (see Figure 4.17).

The advantage of using carts is that the units designed to play them are able to sense a **cue tone** on the tape that will stop the tape automatically after it has played through full cycle. This means, too, that the tape will be all set to start again from the beginning. In essence, the tape cues itself up. This is why cart machines are so useful in radio production. A mono cart machine has two tracks; one track contains only the cue tone. Stereo cart machines have two tracks of audio and a track for the cue tone.

A 60-second commercial often is put on a 70-second cart. The commercial, for reasons to be explained in a moment, is all set to go when it's put into the machine. To play the spot, the operator on air hits the cart machine's play button (frequently the cart machines start switch is automated to start when the audio channel on the console is activated).

The tape, an endless reel, is pulled past the heads; when the commercial ends, the producer lets the cart play until it reaches the cue tone and stops automatically. The cart is then said to be *recued.*

Carts can also be loaded with a number of different spots—for instance, six or seven 10-second station identifications on a 70-second cart. This is a convenient way to play such cuts, and it ensures that they will be rotated throughout the broadcast day.

A cart machine also has a Stop control and a Record control. The Record control puts the unit in Record mode; this also activates the function of the

machine that places the cue tone on the tape. Some cart machines are **play-back only** and do not record.

The cue tone (which you can't hear) is placed on a separate track of the tape when the cart machine is in Record and the Start button is pushed. A stop tone cannot be put on in the Play mode. Newer cart machines have a Fast-Forward control that allows the cartridge tape to be rapidly advanced to the next cue tone. This spares the operator from the inconvenience of having to wait until the cartridge plays through at normal speed before reaching the start of the tape or the next recorded item. As on other tape machines, there is a VU meter to gauge the level of the recording.

Cartridge units have a record head and a playback head but they don't have an erase head, however, because an erase head would erase the cue tone before the cue tone reached the play head, where it would be sensed and the recording stopped.

Like reel-to-reel tape recorders, monaural and stereo cartridge machines have different track configurations. As a result, carts recorded on a stereo machine cannot be played back properly on a mono machine, and vice versa. This is often an important consideration in AM-FM operations, where the carts may be recorded in stereo for the FM and in mono for the AM.

Bulk Eraser

Because the cart machine lacks an erase head, you'll have to use a *bulk eraser* to wipe a cart clean. The bulk eraser, often called a *bulker,* is a large electro-magnet that scrambles the impulses on the iron oxide coating of the tape. The bulk eraser also works with reel-to-reel tapes and cassettes if you want to erase them completely.

There's a technique to using a bulk eraser properly (see Figures 4.18a, b, and c). If you practice it, you can save yourself a great deal of trouble. Essentially, you must move the bulker slowly, in a circular motion, across the flat side of the cart; then wipe it across the front of the cart (the head area of the tape) to ensure that that section is erased. Finally, move the bulker slowly away from the cart before turning it off; suddenly collapsing the magnetic field will impart a noise to the tape. Follow the same procedure for bulking a cassette or reel-to-reel tape—though with the reel-to-reel tape, you obviously won't have to erase the head area. Note that we've described the procedure as one of moving the bulker; of course, you can also move the tape, and on some styles of bulkers, this is easier.

DAT can only be partially erased using a bulk eraser; however, any strong magnetic field can erase an analog tape, so be cautious, and never place tapes or carts near magnetic fields, such as those generated by transformers, amplifiers, or speakers, which could damage or erase your production. Magnetism from the bulking operation can also damage your wristwatch, so be sure to remove your watch before you begin to erase tapes.

Figure 4.18 Operating a bulk eraser.

a. Using a swirling motion, erase the cart across the flat side.

b. Swirl the bulker in front of the head area of the cart.

c. Move the bulker away from the cart gradually before turning off the switch.

Photos by Philip Benoit

Summary

Audiotape is a thin strip of material coated with iron oxide. The oxide particles align to conform to the signal generated by a magnetic head. In this way, sound information is transduced and stored for later playback. Broadcast studios commonly use DAT machines, minidiscs, and computer hard disk recorders for storing information. Digital tape provides high quality recording. Minidiscs use audio compression to reduce the size of audio files, but with slightly degraded sound quality. Some radio stations still use analog tape recorders or reproducers, too.

Multiple tracks are useful for stereo recording and for recording music when multiple inputs need to be recorded and controlled separately.

Cassettes, which are small, enclosed reels, are useful for portable operations and are increasingly used in studio operations. Cartridges (carts) use a continuous loop of tape in a plastic case.

Bulk erasing carts and other analog tapes helps ensure high quality recording.

Applications **SITUATION 1 / THE PROBLEM** The producer of an hour-long news program wants the sound of a Teletype in the background. He has a sound-effects disc with the Teletype sound, but the cut runs for only 3 minutes, and it would be impractical to keep pressing play to keep the sound going.

ONE POSSIBLE SOLUTION He records the cut on minidisc several times and uses the edit function to combine the audio into one longer track.

SITUATION 2 / THE PROBLEM A community bulletin-board segment airs twice every hour at 15 minutes and 45 minutes after the hour. The producer has found a perfect piece of music to introduce the segment, but she notices how inconvenient it is to tie up a CD player twice an hour for 10 seconds of music.

ONE POSSIBLE SOLUTION The producer simply records, or *dubs,* the first 10 seconds of music from the disc onto a cart. The cart is labeled and placed in a rack; it's now very convenient for the console operator to grab the cart and plug it in.

Exercises 1. Using a minidisc, record someone counting from 1 to 20. Then have someone call out a number between 1 and 20; your assignment is to cue the tape up, as quickly as possible, to start at that number. For example, if the number 16 is called out, you'll want to find the part of the tape on which the announcer is reading 13 . . . 14 . . . 15 . . . and pause it there. (You will, of course, do this in cue or in audition.) Then, bring the minidisc up on program and start it. You should hear the tape cleanly start with the number 16. Have several numbers called out until you're proficient at cueing up the tape.

2. Decide which type of machine (CD, cassette, minidisc, DAT, or cart) would be best for the following applications, and explain your reasons:
 - The musical opening to a news program.
 - An interview a news reporter will be doing at the site of a demonstration.
 - A 60-second commercial.
 - A half-hour radio drama.
 - A 10-minute interview segment done in the studio.
 - Multiple station identifications. (You might want to try producing sample station IDs on the type of machine you decide is most appropriate.)

Microphones and Sound

*A*t many radio stations, you will have little to say about the selection of the microphone that best suits the pick-up requirements of the moment. Those who have worked at a variety of radio stations often remark that you will find only a handful of microphone models in virtually any radio station. All on-air and production studios will generally have the same model, though another model may be used for remote and news applications.

So you don't necessarily need to know all the details of microphone use to do your job in a radio station. A person doing production duties in a small radio station will generally use the mic that happens to be hooked up to the console. A reporter will use whatever mic is handed out before going out on assignment. And in many production situations, the simplest of miking techniques and arrangements will be used time and time again.

However, you'll be able to do even a basic production job better with a good working knowledge of microphones. In some cases, a detailed knowledge of microphone use will help you solve a thorny problem. And in the more advanced areas of radio production, such as recording live music, you *must* know mic use inside and out.

We offer a realistic explanation of the situation because many newcomers to radio production become somewhat cynical after plowing through explicit details of microphone use and selection but never using the knowledge during the class or in their first few jobs. Even though this knowledge might not seem essential right now, it just might prove invaluable later.

The Basics of Sound

The microphone, like many other pieces of equipment that we discussed earlier, is a **transducer.** It changes the energy of the motion of sound into electrical

Figure 5.1

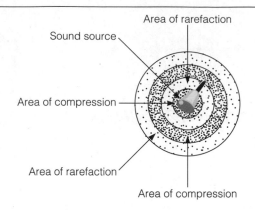

Area of rarefaction

Sound source

Compressions and rarefactions.

Area of compression

Area of rarefaction

Area of compression

energy. The microphone is the instrument that transforms sound into something usable by the record and playback units hooked up to a radio console.

Sound itself is a vibration—a specific motion—of air molecules. What happens is this: A sound source (a cymbal, perhaps) creates changes in air pressure. When molecules are pushed together, they are said to be in **compression.** Areas of low pressure, where molecules are pulled apart from one another, are called **rarefactions.** To visualize the situation, look at Figure 5.1. A sound source causes alternating waves of compression (dense dots) and rarefaction (sparse dots) through the air.

Now, the vibration traveling through the air carries information. The way that the cymbal sounds to our ears is determined by the pattern of vibration. As a matter of fact, the eardrum is a transducer, too. It performs the first step in converting motional energy of vibration into electrical energy in the brain.

The microphone also transduces the motional energy into electrical energy. That energy then might be transduced into electromechanical energy (storage on audiotape), or it might be transduced back into **motional energy** by a **loudspeaker.**

How does a mic do this, and why are certain mics better than others at reproducing certain sounds? To understand these things, let's first explore a bit further the nature of sound itself. The information will come in handy when we try to understand the behavior of sound and the way mics affect its reproduction.

The Elements of Sound

A pure-tone sound is represented by a **sine wave** (see Figure 5.2); you may remember we used one in Chapter 4 in our sampling example. This is one of the most frequently used symbols in the world of sound, microphones, and

Figure 5.2 **Sine wave.**

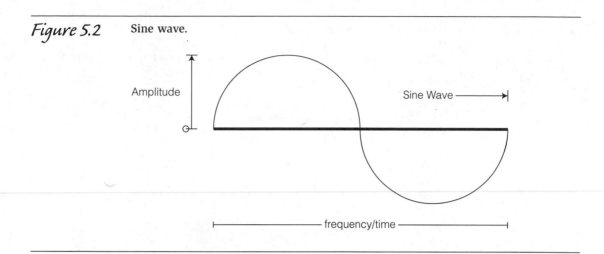

Figure 5.3

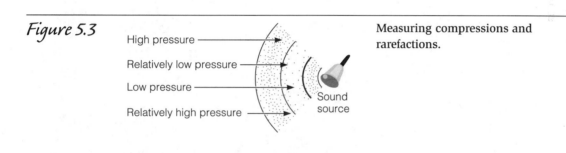

Measuring compressions and rarefactions.

radio—and one of the most frequently misunderstood. A sine wave depicting sound is a graphic representation of the rarefactions and compressions of air molecules. If we were to sample the density of the molecules of a **wave** (pictured in Figure 5.3), we'd find a thick area, then an area becoming thinner, then a very thin area, then an area somewhat thicker, and then a thick area again. A graph of this pattern would look like the one in Figure 5.4(a), which is a plot of the sound pattern, not a picture of it. Thus, the sine wave only represents sound; no sine waves emanate from a sound source. The sine wave can be used to analyze several elements of sound.

CYCLE Each time a wave goes through its pattern and returns to its starting point, it has completed one **cycle.** A cycle passes through a complete rotation every 360 degrees. The time it takes for a wave to make a complete cycle is called an *interval.*

A cycle can be measured from any starting point. The plot of a cycle is illustrated in Figure 5.4(b). Note that, though a sine wave has 360 degrees in a

Figure 5.4 Characteristics of a sine wave.

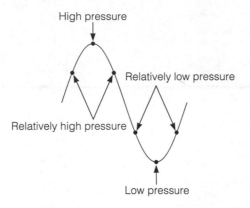

High pressure

Relatively low pressure

Relatively high pressure

Low pressure

a. Description of what a sine wave represents.

One cycle

b. One cycle of a sine wave.

complete rotation, this representation comprises two equal intervals, called *positive* and *negative intervals,* and that each interval is 180 degrees long.

FREQUENCY This is a measure of how often a cycle is repeated in a given period. Formerly, <u>**frequency**</u> was measured in *cycles per second* (cps). In recent years, the term cycles per second has been replaced by the term **hertz (Hz),** named in honor of the mathematician Heinrich Hertz, who first demonstrated the existence of radio waves. We see how frequency plays a role in the nature of sound shortly.

AMPLITUDE In technical terms, the **amplitude** is the height of the sine wave. Amplitude indicates the volume of the sound. The higher the amplitude, the louder the sound.

These elements determine the characteristics of sound, and the sine wave is a visual representation of those characteristics. If nothing else, remember that any sound can be described by one or more sine waves.

The Nature of Sound: Frequency

Why one or more sine waves? Essentially, because sounds consist of combinations of wave patterns or **waveforms.** Although a device called a *tone generator* will produce, by electronic circuitry, a pure wave (when represented on an oscilloscope), most sounds are a combination of many waves of different shapes and frequencies and are called *complex waveforms.*

FREQUENCIES AND YOUR EARS The human ear can hear frequencies from about 35 to 20,000 Hz. This, of course, depends on the age and health of the ear's owner. Older people generally don't hear high frequencies as well as young people do. The low end of the scale is a deep bass rumbling; the high end is a thin whine that's barely audible to people.

HOW FREQUENCY SHAPES SOUND A sound is a combination of various waves—some higher, some lower. The fundamental (that is, basic, most important) frequency of an average male voice, for example, is typically around 300 Hz. But consonant sounds such as *t* and *d* are much higher, perhaps in the 1,000-Hz range. Very high, hissy consonants, such as *s,* can be well into the 4,000-Hz range, whereas the *th* in *thin* can approach 6,000 Hz. Other components of the sounds of human speech can range as high as 9,000 Hz.

The higher-frequency sounds, the consonant sounds, lend intelligibility to speech. If high consonant sounds are not reproduced by any of the transducers in the radio production chain, human speech becomes less intelligible. Music from which the high frequencies are absent sounds muddy and dull; the high frequencies add clarity and vibrance.

Limiting the range of transduced frequencies affects the tone of speech, too. The telephone reproduces frequencies from about 300 to 3,000 Hz. The difference between speech over a telephone and speech over a high-quality mic is readily apparent. Various mics reproduce frequencies with varying degrees of effectiveness.

The Nature of Sound: Amplitude

The amplitude of the sine wave represents the volume of the sound. Another way to measure sound volume is in *decibels.* A decibel (dB) is a very complex measurement but two points about decibels are essential:

1. The higher the decibel reading, the louder the sound. Thus, 20 dB is a whisper; 55 dB is loud conversational speech; 75 dB is city traffic; 110 dB is a loud, amplified rock band; and 140 dB is a jet engine at takeoff. (These measurements are expressed in a particular form called *dB SPL*—decibel sound pressure level.)
2. It is considered that an increase or decrease of 1–2 dB SPL is the smallest change in sound level a human ear can perceive. An increase of 6 dB SPL

is what the human ear perceives as a doubling of the sound's volume. (Think about it. When a sound moves from –6 up to zero on a VU meter, the apparent loudness of sound has doubled.)

A more detailed explanation is this: The ear does not hear in a linear fashion. That is, if you were playing a radio at a level equal to 10 watts of power and you turned it up to a level equal to an output of 15 watts (an addition of 5 watts), you would not perceive the increase as being 1.5 times the original volume. Because it is difficult to measure apparent volume by talking about watts, we use a system that measures sound in a way that corresponds to the way the ear appears to hear sound. Hence, the decibel is a very useful tool to measure significant increases or decreases in apparent volume.

Remember the VU meter and the readings on the top scale? Those volume units correspond to decibels. People often wonder why the VU meter uses 0 dB as the loudest modulation of sound to transmit when common sense suggests that the louder the sound, the higher the dB reading. Actually, it would be very confusing to have a VU meter scale that read, say, from 60 to 120 dB. Therefore, in broadcasting, we have standardized 0 VU to equal a relative sound level that will power our transmitter or provide a proper level to our recording devices. This way, we don't have to work with such large dB numbers.

Remember, the 0 dB reading is relative. A VU meter reading of –3 means that your input is 3 dB lower than the optimum level.

Other Characteristics of Sound

We've pretty well covered the physical properties that make up the nature of sound, but some other areas are also worth considering. **Pitch,** a term commonly used to describe sound, is not the same thing as frequency. Frequency is a physical measurement; pitch is the ear's and mind's subjective interpretation of frequency and loudness, signifying the way we hear a frequency. The human ear just doesn't hear the same way a scientific instrument does. For example, try this experiment. Listen to a siren approach. As sound gets closer to us, its apparent pitch *rises,* but in actuality the frequency doesn't change!

Duration is a characteristic of sound, too. It refers to the amount of time a sound exists and to the amount of time individual harmonics exist within a complex waveform.

Velocity and distance also play a role in the way we hear sound. Sound is not very fast; it travels through air at only a little more than 1,100 feet per second, or 750 miles per hour. Sound travels at different rates through different media; it travels about four times faster through water, for example. But it has to vibrate through a medium; there's no sound in a vacuum.

The relative slowness of sound in air can be illustrated by a familiar example. When sitting in the bleachers during a baseball game, you will see

Tuning into Technology

THE SHAPE OF SOUND

"The biggest change brought about by digital technology," says Rodney Belizaire, a recording engineer with WQEV in New York, "is connecting the eye with the ear."

What he means is that the visual depiction of the sound wave as it appears on the computer screen will soon become recognizable to the person doing the editing. You'll never be able to "read" the waves without knowing what the script is, but if you have even a passing acquaintance with the words, you'll be able to spot them on the screen.

The waveform, often called the "sound envelope," is nothing more than a graphic representation of the amplitude and frequency of the sound.

Amplitude—that is, strength—is what you'll be most concerned with when dealing with the visuals on the computer screen. The waveform is higher on the positive and negative side (remember, sound is a system of rarefactions and compressions, which translates electronically to plus and minus) when the sound is louder.

Almost all computer programs allow you to determine the time frame over which you view the sound. If you view the words *new on* in a frame of one second, the waveform (sound envelope) looks something like the one shown in Figure 5.5.

Most computer programs allow you to display a second's worth of copy. Many let you get far more precise and hone in on a fraction of a

Figure 5.5 *A sound envelope.*

This diagram demonstrates how the waveform reflects the varying amplitude of speech. Below the waveform, we've made letters bigger when in normal speech they are stressed — given greater volume.

You can also see the pause between "new" and "on."

This is a line that sweeps across the waveform when you play it back. It moves in "real time" — that is, if the whole waveform is a second, it goes from beginning to end in a second. If your screen is set to display 30 seconds, the line will take 30 seconds to move across the waveform.

NEW . . . ON ATLANTIC

Continues

Tuning into Technology Continued

Figure 5.6

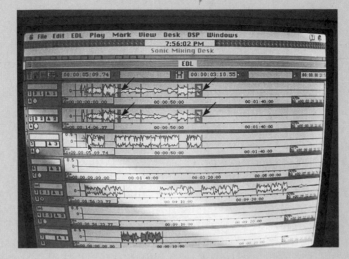

The digital editing process as it appears on a computer screen.

Photo by Philip Benoit

second. What you'll find particularly useful in most standard applications, though, is to display 15, 30, or 60 seconds. That shows you where various sound elements are placed.

Figure 5.6 shows what we mean. This is a commercial for a Kenny Rogers album. The narration is interspersed with cuts from the music. The stereo music tracks are on computer tracks 1 and 2. The announcer's voice is on track 3. Where you see an x, it means that the computer has been instructed to make a gradual cross-fade—lowering one track while bringing up another. The announcer's track actually starts with the words, "New on Atlantic tapes, all your favorite music from . . ." and then segues into a Kenny Rogers cut, then back to more narration, then another cut, and so on.

You can see, even without knowing all the copy, how this commercial is constructed. In later chapters, we'll get into the fine points of editing. But now you can see in one simple illustration how sound, in the digital domain, can be sensed with your ears and your eyes.

the batter complete his swing before you hear the crack of the bat hitting the ball. Because of the slowness of sound, you can perceive echoes (the immediate bounceback of sound) and reverberation (the continued bouncing of sound) in an enclosure with reflective walls. A large room with reflective walls will cause the reverberations to take longer to *decay,* or die out.

Distance also makes a difference in how loud the sound is when it reaches us. When sound travels two times a specified distance, it arrives at only one-quarter of its original intensity. This behavior is said to comply with the inverse square law.

A final characteristic is the sound's quality, or timbre. This, again, is a factor in how our ears and mind perceive sound. It has to do with the way harmonics are combined and with the relative intensities of those harmonics. Those combinations make us perceive a difference between the middle C played on a piano and the same note played on a harpsichord.

Summary of the Basics of Sound

Understanding how sound behaves is a prerequisite to learning about microphones, and much of what you need to know concerns how a mic reproduces sound.

Sound is a vibration of molecules in the air, and it consists of rarefactions and compressions. A sine wave is a graphic representation of a sound wave; it is not supposed to be a picture of the wave.

Sound is measured in terms of frequency and amplitude. Frequency, which tells how often in a given period the sound wave makes a complete cycle, is measured in cycles per second, now called *hertz*. Amplitude is the height of the sine wave. It refers to the loudness of the sound and is measured in decibels. Sound travels through air at about 1,100 feet per second.

Characteristics of sound include pitch (the way we perceive frequency), loudness (the way we perceive volume), and quality or timbre (the way we interpret the complex waveforms).

Now that we've prefaced this chapter with an explanation of sound, let's move on to the ways mics work, the various types of mics, and their uses.

The Microphone: How It Works

One of the ways in which a producer selects a microphone and decides on its use is by determining how the microphone reproduces sound and how it *colors* that sound. (The meaning of this term should become clear shortly.)

Electronics of the Microphone

Sound reproduction is affected by the mechanical and electronic means used within the mic to change the **acoustic** or motional energy of sound—a vibration of molecules in the air—to electrical energy. Certain varieties of microphones are much better adapted to some tasks than are other types. That's why it's important to understand the workings of the three types of microphones most common in radio broadcasting: the **moving coil,** the **ribbon,** and the **condenser.**

MOVING COIL Electricity is formed by moving a conductor through a magnetic field. That's exactly what happens in a generator: Coils of wire are moved through a magnetic field, and electrical current results.

That's also what happens in a moving-coil microphone. The diaphragm in a moving-coil mic (see Figure 5.7a) is attached to a coil of wire. The **diaphragm,** a thin membrane, vibrates as it is driven by the sound waves. The coil attached

Figure 5.7 The three types of microphone elements.

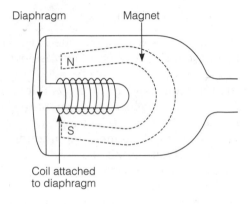

Diaphragm Magnet

Coil attached
to diaphragm

a. In a moving-coil mic, the thin diaphragm vibrates in response to sound energy. The attached coil moves through a magnetic field, generating an electrical current with a pattern that corresponds to the pattern of the original sound.

b. In a ribbon mic, sound energy causes vibrations of a metallic ribbon, which moves through a magnetic field to produce an electrical current.

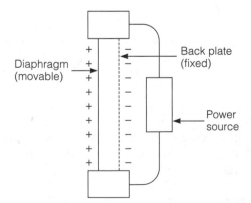

Diaphragm
(movable)

Back plate
(fixed)

Power
source

c. In a condenser mic, sound vibrates the diaphragm. Movement of the diaphragm varies the electrical pattern on the back plate.

to the diaphragm vibrates, too, and the vibration of this moving coil cuts through the magnetic lines of force produced by the magnets within the microphone. The electrical wave produced now carries the imprint of the sound wave by mirroring both the frequency of the acoustical energy and the amplitude of that energy. Moving-coil mics are sometimes referred to as **dynamic mics.**

RIBBON This type of mic has a thin (usually corrugated) metal ribbon suspended between the poles of a magnet (see Figure 5.7b). The ribbon vibrates in harmony with the sound waves. Technically, the ribbon mic responds to a difference in pressure between the front and back of the ribbon; that's why some people refer to this type of instrument as a **pressure-gradient mic.** Ribbon mics are gradually becoming less common in radio.

CONDENSER A condenser mic operates through the use of an electrical element called a **capacitor.** *Condenser* is actually an old-fashioned name for a capacitor, and it stuck as the name for this type of mic. A capacitor stores an electrical charge. In a condenser mic (see Figure 5.7c), a charge is applied to the side of the condenser known as the *back plate;* as the diaphragm vibrates, it changes the distance between itself and the back plate and changes the amount of charge held by the back plate.

Condenser microphones often need a separate power supply to place a charge on the back plate; thus, batteries are used. Some more modern condenser mics draw a charge from the console, a "phantom" power supply.

Pickup (Polar) Patterns of the Microphone

The electronics of a mic also affect the pattern in which it picks up sounds. These patterns, called **pickup patterns** or **polar patterns,** have a major effect on how a particular mic is used. Some mics pick up sounds from all directions, or from the front and back but not the sides, or from the front only. The basic pickup patterns are **omnidirectional, bidirectional,** and **cardioid.** (*Cardioid* is sometimes called *unidirectional,* meaning "one-directional.")

OMNIDIRECTIONAL An omnidirectional mic picks up sounds equally well from all sides, as pictured in Figure 5.8(a). To visualize what a pickup pattern is, it's helpful to know how one can be drawn. The mic is placed on a stand, pointed toward a speaker, and twisted in a circle (kept parallel to the floor). Then the amplitude of the wave it picked up at various poles is measured. As shown in Figure 5.8(a), the amplitude is as great at 90 degrees as at 0 degrees (0 being where the mic faces dead-on to the speaker). Remember, the pickup pattern is a *three-dimensional* representation, so mics hear sound from above and below, too. Although we generally assume that the omnidirectional mic picks up sound equally well from all directions, there is a small glitch at 180 degrees, simply because the mass of the microphone gets in the way of the sound waves.

Figure 5.8 Microphone pickup patterns. Shaded areas represent the shapes of each mic's coverage areas

a. Omnidirectional pickup pattern. b. Bidirectional pickup pattern.

c. Cardioid pickup pattern. d. Supercardioid pickup pattern.

The reason, incidentally, that an omnidirectional mic can be equally sensitive to sounds from all directions is related to the fact that sound is a series of rarefactions and compressions of air molecules. Since the back of the microphone is closed to air, the diaphragm is pulled out by the rarefactions and pushed in by the compressions, regardless of the direction of the sound. The importance of this concept, illustrated in Figures 5.9(a) and (b), will become apparent shortly.

Figure 5.8 (Continued)

e. Hypercardioid pickup pattern.

Figure 5.9 Reaction of a mic's diaphragm to sound. Notice that it makes little difference to the diaphragm which direction the sound is coming from.

a. Diaphragm pulled out by rarefactions (low pressure).

b. Diaphragm pushed in by compressions (high pressure).

BIDIRECTIONAL The bidirectional mic accepts sound from the front and rear and rejects it from the sides. Its pickup pattern is shown in Figure 5.8(b). Notice, too, that the concentric rings indicate sound level in decibels; when the pickup pattern dips toward the center of the circle, it's declining by the number of decibels indicated on the concentric rings. The bidirectional pattern is typical of ribbon mics that have the ribbon open to air on both sides.

CARDIOID *Cardioid* means "heart-shaped," as in Figure 5.8(c). You can visualize this pattern in three dimensions by imagining that the mic is the stem of a gigantic apple. Often, the cardioid pattern is called **unidirectional,** meaning that it picks up sound from only one (*uni-* means "one") direction. Sometimes, the term *directional* is used to indicate the same concept. (For three-dimensional representations of microphone pickup patterns, see Figures 5.10(a) and (b).

Figure 5.10 Three-dimensional representations of pickup patterns.

a. Approximation of how the cardioid pickup pattern extends through three dimensions. If you think of the pickup pattern as forming a huge apple, the mic is like the stem.

b. Approximation of how the bidirectional pickup pattern extends through three dimensions. It consists of two giant pickup spheres on either side of the mic.

Figure 5.11 Mic ports and phase cancellation.

Ports allow entry of sound from rear, resulting in "phase cancellation."

a. Simplified diagram of ports in a mic. The ports let sound enter from the rear and, in effect, cancel itself out.

b. Phase cancellation as a sum of sine waves of opposite amplitudes.

A microphone with a cardioid pattern achieves this directionality by means of holes or ports in the back of the mic. Sound entering these ports is routed through an acoustic network (see Figure 5.11a) that causes the mic to cancel sound coming from the rear. In physics terms, the sound waves entering from the rear are *out of phase* with sound waves entering the front of the mic (see Figure 5.11b). That is, when the waves are combined, the high points will combine with the low points, and the low points will combine with the high, thus canceling each other out. The concept of **phase** is important in advanced radio production.

The cardioid pattern is a function of sound wave cancellation because of porting in the mic and is not a result of the particular electronic element in the mic. Mics with a cardioid pattern can have moving-coil, ribbon, or condenser elements. Mics with an omnidirectional pattern usually have a moving-coil element but occasionally have a condenser.

A special version of the cardioid pattern is the **supercardioid** pattern (see Figure 5.8d), which has a tighter curve in front and a lobe in back. The **hypercardioid** pattern (see Figure 5.8e) has an even narrower front angle and a bigger rear lobe. Supercardioid and hypercardioid patterns, also called *unidirectional,* are generally used for highly directional applications on booms, such as in television studio work, when it is important to reject unwanted noises.

Frequency Response of Microphones

Different mics respond differently to sound frequencies. There are two components of **frequency response:** *range* and *shape.*

RANGE Range simply means the amount of the frequency spectrum a mic can hear. Good mics can hear frequencies all the way up to 20,000 Hz, which is beyond the range of most normal adult ears. A good mic can also hear all sounds equally well, plus or minus about 5 dB (see Figure 5.12). Figure 5.13 is

Figure 5.12

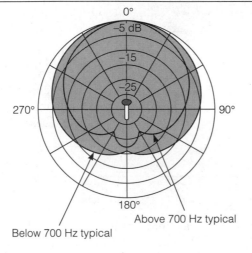

Graph of a pickup pattern supplied by a microphone manufacturer. Scale: 5 dB per division.

Above 700 Hz typical

Below 700 Hz typical

Reproduced with permission of Electro-Voice, Inc., Buchanan, Mich.

Figure 5.13 Graph of a mic response.

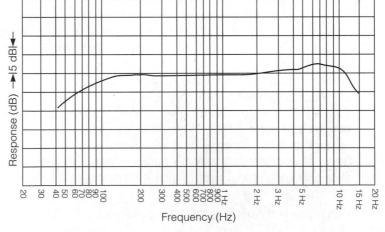

Reproduced with permission of Electro-Voice, Inc., Buchanan, Mich.

a graph of frequency response. How far such a graph extends to the right shows how high a frequency the mic can pick up.

The graph also indicates how well the mic reproduces frequencies. The higher the line, the better the mic reproduces the frequency indicated on the bottom line of the graph. This characteristic of the response curve is known as *shape*.

SHAPE See how the **shape** of the mic response pattern in Figure 5.13 has a bump in the upper frequencies? This is because the mic, by its nature, gives a boost to those frequencies; a mic like this would be useful for speech since it powerfully reproduces the frequencies that lend intelligibility to speech. Such modifications of frequencies also add to the coloration of sound, just as a mic lends a sound a certain quality or timbre.

Often, recording engineers miking music setups will want a mic with a **flat response**—a mic that is capable of responding equally well to all frequencies in the whole audio spectrum. The term **high fidelity** applies well to this characteristic because it means "high accuracy." A mic that responds equally well to all frequencies is high in fidelity; the term also applies to speakers, amplifiers, and so forth.

Cardioid mics tend to boost bass (lower) frequencies as the sound source moves closer to the mic; this is known as a **proximity effect.** That's why some announcers who want a deeper sound move in very close to mics with a cardioid pickup pattern.

What does all this mean to you? By understanding the polar patterns of mics, you'll be able to avoid various problems. For example, a cardioid mic will reject sounds from the rear and will be useful for console operations, because you do not want to broadcast the clicking of switches and rustling of papers. An omnidirectional mic might be the proper choice for on-the-street news interviews, where you want to pick up surrounding noise to lend authenticity to the situation.

In some cases, a producer might opt for a mic that boosts specific frequencies because, for instance, the high frequencies in speech need a boost for intelligibility. Some mics, such as the RCA 77DX and some Neumanns, have variable frequency responses and polar patterns; the varying responses are achieved by adjusting switches on the body of the mic.

Review of Microphone Workings

Microphones are transducers that change the motional energy of sound in the air into electrical energy by means of an electronic element. Three elements are common in radio use: moving coil, ribbon, and condenser.

Some microphones are more sensitive than others to sounds coming from certain directions. A visual indication of this property is called a *pickup pattern*. The most common pickup patterns in mics designed for radio use are omnidirectional, bidirectional, and cardioid.

Frequency response varies from mic to mic. Because some mics have a broader range than others, they can reproduce a wider range of frequencies. Some mics also tend to boost certain frequency ranges.

Physical Types of Microphones

We're using a somewhat imprecise phrase when we speak of "microphone physical type"; it's not a standard term in the industry. It is, however, a good way to classify mics by their intended use. Some of these uses may not usually apply to radio, but we show some examples anyway.

Hand-Held

Mics meant for hand-held use are, of course, small enough to be easily held. Other characteristics of hand-held mics include durability and the ability to reject handling noise. The Electro-Voice 635A (see Figure 5.14a) is one of the most commonly used hand-held mics in broadcasting.

Studio, Mounted

Mics intended for studio use are usually mounted on a stand or boom. They are generally larger than hand-held mics and more sensitive. The Neumann U-87 (see Figure 5.14b) would be very difficult to use in a hand-held situation, not only because of its shape but also because this fine mic is so sensitive that it would pick up every bit of handling noise. Some mics, which are small enough and provide high-quality sound reproduction, can be used in both studio and hand-held situations.

Headset

Headset mics (see Figure 5.14c) offer hands-free operation and are useful in radio for such tasks as sports play-by-play. These mics also work well for rejecting noise surrounding the announcer.

Lavalier

The **lavalier mic** hangs from a string or is clipped to a person's clothing (see Figure 5.14d). Lavaliers have little application to radio but are very common in television.

Shotgun

These mics are used for long-range pickup (see Figure 5.14e) in television and film; **shotguns** have very little use in radio.

Figure 5.14 Physical types of microphones.

a. The Electro-Voice 635A, an excellent hand-held mic.

Photo by Philip Benoit

b. Neumann U-87 (left) and U-89 (right) studio mics.

Photo courtesy of Gotham Audio Corporation, New York, N.Y.

c. Headset mic commonly used for sports broadcasts and other occasions when mic stands would clutter the workspace.

Photo by Philip Benoit

d. Sennheiser MKE 2 lavalier mic, which has few applications for radio.

Photo courtesy of Sennheiser Electronic Corporation, New York, N.Y.

Continues

Figure 5.14 (Continued)

e. Commonly used shotgun
microphone.

Photo by Philip Benoit

We can conclude this discussion of mic type by saying that in radio production you will be using primarily studio and hand-held mics. The way you choose mics depends not only on type but also on all the factors discussed so far in this chapter.

Some condenser mics allow you to change the pickup capsules. These are called *system mics* because you can change the capsule opening and change the use of the mic from a shotgun to a studio type or even to hand-held. This allows a small station to buy one very good microphone system and adapt it to various applications. Unfortunately, most of these condenser mic systems require external or phantom power supplies, and this can detract from their usefulness in certain situations.

Review of Physical Types

The most common mics found in radio are hand-held and studio; sometimes headset mics are used for sports applications. There is some overlap: Some mics can be used for studio or hand-held use, and condenser mics of the type called *system mics* allow you to change the pickup capsule.

Microphone Selection and Use

As we mentioned earlier, you may not always have much choice in selecting mics. You'll use what's available. Even then, however, you'll benefit from learning about mics because you'll better understand how to use the one you're given. When you do have a voice in selection, you'll want to make your choice based on these five factors:

1. Type
2. Pickup pattern
3. Element
4. Frequency response
5. Personality

Selection by Mic Type

This is a self-limiting category because you'll generally be using hand-held or studio mics, and the choices are obvious. As we mentioned, some high-quality mics can be used in either application, but beware of using a cardioid mic with many ports in the stem and back in hand-held situations. You'll be changing the pickup pattern of the mic by covering the ports with your hand.

Changing the pickup pattern in this manner sometimes happens when pop singers cup a mic too tightly and inadvertently cause feedback: Cutting off the ports changes the cardioid pattern to an omnidirectional pattern and thus picks up the sound from the loudspeakers. Feedback, in this case, happens when sound comes out of a speaker, is picked up by the mic and amplified by the console, is fed through the speaker, is picked up and amplified again, and so on—until the sound is amplified into a loud squeal.

Selection by Pickup Pattern

A news reporter doing a great deal of hand-held interviewing will probably find an omnidirectional pattern more convenient than other patterns because the mic won't have to be moved around so much to keep more than one speaker within the pickup pattern (referred to as being *on mic*). In studio applications, mics with a cardioid pattern are usually favored because they cancel out extraneous noise. A two-person interview, with guest and moderator facing each other, can be accomplished quite nicely with a bidirectional mic although using two unidirectional mics allows for greater control if one voice is much more powerful than the other; the volume on one channel can simply be lowered to compensate.

Selection by Element

Certain **elements** do various tasks better than others do (see Table 5.1).

Selection by Frequency Response

There's usually neither the opportunity nor the need to consult a frequency response chart for the intimate details of a mic's sound reproduction. Should you wish to examine a frequency response chart, though, you'll generally find one packed in the box the mic came in. Quality mics come with a chart

Table 5.1	**Microphone Element Chart**		
	Element	**Advantages**	**Disadvantages**
	Moving coil	Relatively inexpensive. Performs well in difficult sound conditions, such as wind. Usually very durable.	The diaphragm has to move a lot of mass, so it can't vibrate as quickly as diaphragms on many condenser models or as some ribbons. This translates into less response to high frequencies.
	Ribbon	Very good high-frequency response in many cases. Coloration of sound perceived by many announcers as warm and rich tones. Excellent sensitivity.	Delicate and easily damaged, especially by wind and severe noise overload. Sensitive to popping of such speech sounds as *b* and *p*.
	Condenser	The very high-quality condensers have extended high-frequency response, along with what are perceived as bright and crisp highs. Versatility, including, in some cases, the ability to undergo extensive changes in pickup patterns and frequency responses; in some condenser mics, the entire element can be unscrewed and replaced with another. Reasonable durability to mechanical shock (certainly better than ribbon mics).	Susceptible to moisture-related damage. Expensive. Somewhat inconvenient at times because of the need for a separate power supply.

individually prepared for the buyer. You don't have to read a chart every time you want to pick out a mic. What you do want is some general knowledge about range and curve shape.

RANGE An extremely high-quality mic, with response as high as 20,000 Hz, is useful in music recording because of its "wide" response.

CURVE SHAPE A mic with a bump in the response curve up around the consonant frequencies makes speech more understandable. But you don't need that speech bump in a mic intended purely for music recording.

Further, some mics have what's called a *bass roll-off* to compensate for the proximity effect. In other words, they deemphasize the bass. A producer who knows that the mic will be used for close-in speech work and wants to negate the proximity effect can activate the base roll-off control on the mic.

More advanced production may call for a detailed examination of frequency response, but for most purposes, it's enough to know whether a mic has a wide—or very wide—frequency response, whether it emphasizes certain frequencies or has a flat curve, and whether it has adjustable responses.

Selection by Personality

The personality of a mic is a quality that can be difficult to define, but it's a factor nonetheless.

Most announcers develop a fondness for a particular mic whose characteristics appeal to the individual. Some announcers like ribbon mics because they add warmth and richness. News reporters often favor a particular moving-coil mic because of its ruggedness and dependability. Recording engineers frequently have high praise for a particular condenser mic that delivers crisp highs when used to record piano music. On the other hand, certain mics may seem temperamental and therefore fall into an announcer's disfavor. Some announcers don't like ribbon mics because of problems with popping *p*'s and *b*'s. When it comes right down to it, choosing a mic because of its personality is just as valid as selecting one for any other reason.

Adding Up Selection Factors

Once again, you might not be in a position to choose mics for particular tasks. But we emphasize that knowing the selection factors may be very valuable in the proper use of the mic and may someday pay off when you need a mic to deal with a particularly difficult situation.

Although we've tried to avoid the catalog approach to presenting information on microphones, Table 5.2 assembles some of the mics most commonly used in radio production and includes some comments on microphone type, pickup pattern, element, frequency response, and personality.

Notes on Microphone Use

Mic use can be extremely simple or extraordinarily complex depending on the situation. Preparing to speak into a studio mic is no more complicated than being sure that you're within the pickup pattern (which will be obvious from listening through the headphones) and not being too close or too far away. It is extremely important that you monitor your voice through headphones whenever possible. Simply monitoring your levels on a VU meter will not tell you if you're popping or speaking off the mic's axis. Make it a rule: Whenever you're ready to switch on the mic, put your headphones on first.

The proper distance for speaking into a studio or hand-held mic ranges from about 6 to 12 inches, though there's no set rule. Actually, the only hard and fast guideline is to work at a reasonable distance based on what sounds correct for a particular speaker and a particular mic.

Setting up several mics in a studio is more complicated. The first thing a producer has to know in this case is how to plug the mics in. Figure 5.15 shows the connectors you will use to feed the mic cable into a studio wall outlet, which in turn will be fed (through existing wiring) into a console. The plugs shown, **XLRs,** are the most common. Incidentally, there is a trick to

Table 5.2 **Microphone Model Chart**

Microphone	Element	Description	
Neumann U-47	Condenser	Cardioid pickup pattern; excellent voice mic; flat response; warm sound; **blast filter;** bass roll-off.	Gotham Audio Corp.
Sony C-37P	Condenser	Omnidirectional/cardioid; four adjustments for bass roll-off; good for voice pickup and musical instruments.	Sony Corp. of Am.
Sennheiser 416 (middle), with 417 and 418	Condenser	Supercardioid; usually boom mounted; flat response; eliminates unwanted ambient sound; excellent for remotes where directionality is desired.	Sennheiser Electronic Corp.
Electro-Voice RE-20	Moving coil	A high-quality mic; the most popular announcing mics in radio; bass boost with close use; good frequency response; durable.	Electro-Voice, Inc.

connecting and disconnecting XLRs. The push-level mounted on the female wall connector locks the connectors in place. (You'll feel it snap when you make the connection.) To remove, press the lever and remove the male end by the connector; don't ever pull on the wire.

You'll encounter other connectors on occasion—most often the phone plug connector, a prong about $1\frac{1}{4}$ inches long, and the miniphone plug, a prong about $\frac{1}{2}$ inch long. In some cases, you will need adaptors to make one source compatible with another. If you want to plug a mic directly into the record input of an audio recorder, for example, you'll need a female-XLR-to-male-phone-plug adaptor.

It's generally best to check with engineering staff about connectors you'll need; the specifications can become quite technical, and a certain level of

Table 5.2	**Microphone Model Chart** *(Continued)*	
Microphone	**Element**	**Description**
Electro-Voice RE-50	Moving coil	Omnidirectional; similar to popular 635A; shock resistant; excellent all-purpose mic; internal wind screen; blast filter; rugged.
Shure SM-58	Moving coil	Cardioid; good studio mic; rugged; **pop filter;** most popular stage vocal mic.
Shure 300	Ribbon	Bidirectional; warm sound; pop prone; very good voice mic.
Shure SM 33	Ribbon	Cardioid; mellow sound, bass enhanced with proximity; excellent voice mic; favorite of many announcers.

Electro-Voice, Inc.

Shure Brothers, Inc.

Shure Brothers, Inc.

Shure Brothers, Inc..

audio engineering sophistication may be needed to make the connection properly.

Usually mics are placed on floor or table stands. After the mics have been mounted, the next responsibility of the producer in the studio is to place them properly. This task, of course, will vary with the situation. A news interview program may require placement of only one or two mics; a music-recording session could require the placement of 20 mics—with a few of them placed on the drums alone!

Because of the wide variety of situations, we address mic placement separately in appropriate chapters. For example, we deal with placement of mics for news interview shows in Chapter 13 and placement of mics for music in the section on music recording in Chapter 15.

Figure 5.15 XLR connectors. The type being held in the hand is a male. The receptacle is a female. They snap together easily.

Photo by Philip Benoit

Summary

Sound is produced by the vibration of air molecules. Sound is a combination of wave patterns consisting of higher and lower frequencies. The intensity of a sound is measured in decibels (dB). Microphones transduce the sound vibrations into electrical current, which can then be fed to a recording device or, through a console, to a broadcast transmitter.

Three basic types of microphones are used in broadcasting: moving coil, also known as *dynamic*, in which sound vibrations cause a coil to move through a magnetic field, thus producing an electric current; ribbon, which features a thin metallic strip suspended between the poles of an electromagnet; and condenser, which discharges current in response to the vibrations of a moving diaphragm.

Microphones have various pickup patterns. Omnidirectional mics pick up sound uniformly from any direction; bidirectional mics pick up sound from the front and rear of the mic but not from the sides; unidirectional or cardioid mics (also known as *directional* mics) pick up sound in front of the mic but not from the sides or rear.

Mics vary in their ability to reproduce sound. The frequency response of a particular mic determines how well it will reproduce a given range of frequencies. Some mics can be adjusted to vary their frequency response. Selecting a mic depends on finding a mic that has the right pickup pattern, physical characteristics, and personality for the particular job.

Applications

SITUATION 1 / THE PROBLEM The producer of a 5 o'clock radio program has a touchy problem: The newscaster, Paul Prince, pops his *p*'s badly. What's worse, the station is WPPG (a hypothetical station name) in Pittsburgh, and the name of the show is Public Radio Profiles. Paul sounds terrible when he gives the station identification and introduces himself and the show.

ONE POSSIBLE SOLUTION Short of speech therapy for Paul, the best solution is to exchange the ribbon microphone for a good-quality moving-coil mic, which is exactly what the producer did.

SITUATION 2 / THE PROBLEM The sports director of a small station started to do basketball play-by-play from the gym of the local high school. But listeners complained that at times they had trouble understanding her because of the crowd noise and the related fact that her voice sounded muddy. The sports director surmised that the omnidirectional mic she had mounted on a table stand just wasn't the right unit for the job.

ONE POSSIBLE SOLUTION Although she didn't have a specialized headset mic, the sports director did have access to a microphone with a cardioid pickup pattern, a durable moving-coil element, and a nice speech bump in the response curve. She replaced the omnidirectional mic with this more suitable unit.

Exercises

1. Put a microphone on a stand, and set up the console to record its output. Have someone walk around the mic in a circle while counting or talking. Do this with three different mics: one with an omnidirectional pattern, one with a bidirectional pattern, and one with a cardioid pattern. Play back the tape, and notice the differences in sound pickup.

 Now, using the mic with the cardioid pickup pattern, record some copy read 16 inches from the mic (speaking directly into it) and then 6 inches from the mic. Notice the proximity effect. If the mic has a bass roll-off switch, experiment with using it, and gauge the effect on the sound.

2. Set up as many different mics as you have available. Have someone read 30 seconds or so of copy into each mic, and record it. (Make sure that person identifies each mic: "I'm reading into the RCA 77DX, 'Four score and seven years ago. . . . '") Play back the tape, and write down (or discuss) your impressions of each.

 Give details on why you like or don't like each mic and what characteristics each has. Make a diligent effort to come up with details.

You're On!

TECHNIQUES FOR EFFECTIVE ON-AIR PERFORMANCE: MICROPHONE TECHNIQUE FOR ANNOUNCERS

Here are some tips for sounding your best on-air.

- You can create a more intimate feel by moving closer to the mic. This is especially true with a super-sensitive condenser mic, but remember that you will also accentuate mouth noise, such as smacking and clicking.

- If you tend to pop your *p*'s and *b*'s, avoid ribbon mics. If you must use one, position yourself so you are speaking across the ribbon, not directly at it. You can't always tell the ribbon orientation from the outside of the mic, so experiment and then learn the correct position for the particular ribbon mic.

- Move back from the mic if you are doing a hard-sell approach. You won't overload the element, and the perspective gained by putting a little distance between you and the mic will accentuate the message.

- Move closer to the mic in noisy situations.

- Move back from the mic if you have a deep, powerful voice and tend to sound muffled.

- As a general rule, you'll want to work about six inches away from most mics. That's about the length of a dollar bill. Distance will vary, of course, by mic and by circumstance, but six inches is a good starting point.

- Keep the same relative distance from the mic . . . don't move in and out unless you have a reason for doing so. (You might, for example, want to create a more intimate effect for one part of the copy.) Beginning announcers often have trouble with this because they move their heads and inadvertently go off-mic or move too close and become muffled.

- Don't grab a mounted mic when it's open. Studio mics often do not have sound dampening for handling, and the audience will hear unwanted noise.

- If you have a problem with popping of plosives, breathiness, or other unwanted speech sounds, try a wind filter (see Figure 5.16). It will block some unwanted noise.

- If you feel you need to deepen your voice, use a cardioid mic and work close to it. But don't get too close or you'll be muffled.

Continues

You're On! Continued

Figure 5.16

Wind filters are made of foam and block some noise caused by moving air.

Photo by Austin MacRae Photography

Characteristics of mics aren't always obvious, and it takes close attention to recognize them.

3. Choose mics for the following applications. You can choose mics from those illustrated in this chapter, or just list the selection factors you'd want for the particular application. For example, a speaker who tends to work very close to the mic and has a bassy, overpowering voice probably should not work with a ribbon mic. A moving-coil or condenser mic would be a better choice. The mic should have a bass roll-off control, and it should have a personality that emphasizes brightness and clarity.

Now, try the same reasoning with the following situations. (There really aren't any right or wrong answers; most are judgment calls.)

- A speaker with a weak, high, breathy voice
- Locker room interviews
- Amateur speakers (guests on an interview show)
- An announcer who's doing a commercial for a classy restaurant
- A screaming disc jockey

PART TWO

The Techniques

SIX

Electronic Editing

*I*n this and the next two chapters, we deal with the mechanics of operating radio production equipment and with the art of *editing*—the process of rearranging, correcting, and assembling the product into a finished whole.

Production, as we've noticed, is something of a nebulous term. Many of us tend to think of radio production as the process of putting together a commercial or assembling a news show. But in truth, any manipulation of sound constitutes production:

- Cutting a small piece out of a long interview for airplay during a newscast is production.
- Making a 60-second commercial is production.
- Running a board while doing a combo operation is production, too—and a very important type of production because the combo operator reflects the overall sound of the station.

We divide the basic production chapters along the lines of the three preceding examples. In this chapter, we spell out the basic mechanics of manipulating sound electronically and physically, and we show some of the patterns this manipulation takes. In Chapter 7, we focus on some of the techniques specific to working in the studio and producing segments to be played back on air at a later date, such as commercials and public-service announcements. In Chapter 8, we discuss the techniques used in on-air work.

There is, of course, quite a bit of overlap among the techniques, but we think you'll find this a logical way to go about exploring the nuts and bolts of radio production. Chapter 8 expands on the foregoing ideas and moves on to the subtleties of using radio production techniques to reinforce a message and to create a particular effect, which is the real goal of sitting down at the console in the first place.

The Basics of Splicing and Dubbing

Splicing, dubbing, and editing are the most basic ways a radio producer manipulates sound. In **splicing,** the sound is physically cut apart and taped back together again. Usually this meaning of splicing refers to audiotape rather than manipulating electronic sound files. **Dubbing** means transferring sound from source to source electronically instead of snipping and cutting. **Editing** is a combination of the two, and more: It is the process of rearranging, correcting, and assembling a finished product. Editing is a general term that applies to both the physical and electronic rearranging of sound.

Some people use the words *splicing* and *dubbing* in slightly different ways. They consider splicing to be a simple, physical repair, and dubbing to be the making of a copy of a sound file or a tape, in this usage as an analog or DAT tape. To acknowledge this distinction, the terms *physical editing* and *electronic editing* are used to express these functions. In this book, we stick to *splicing* and *dubbing* as we defined them in the previous paragraph, but be aware that the terminology can vary.

The terms *splicing* and *dubbing* generally maintain their meanings in electronic editing. We will "dub" the audio from one medium to another and then we will take a section of audio and "splice" it in a different location. Alternatively, in digital audio, we might also "dub" one sound file to another sound file in a computer.

Two related terms pertaining directly to electronic editing are *destructive* and *non-destructive* editing. Destructive editing, which is a lot like using the cut-and-paste function on a word processor, occurs when the splice is made and the sound file is changed. Nondestructive editing (copying) occurs when the original audio components are retained and can be reused if the edit does not work out to your satisfaction.

Splicing and dubbing require the mastery of some specific techniques before those physical skills can be used in the editing process.

Looking at the Waveform

A waveform is a visual representation of a sound file. You may have never looked at one closely before, and it might not be immediately obvious to you what you are looking at and what you are looking for. Here is a sound file with a phrase from a Rolling Stones song highlighted (see Figure 6.1). The phrase is made up of four words, "Good Bye Ruby Tuesday."

The waveform is made up of varying parts; the peaks represent louder sections, and the valleys represent softer sections of the song. You can see the spaces in between the words where there is some musical backing, but not very much compared with the singing.

Sound files sometimes have a rhythm or cadence to them. If you're editing music and the piece has a regular beat, you can pick out the beats easily

Figure 6.1 The waveform corresponds to the words from the Rolling Stones song. Recorded on Peak 3 LE software.

SOURCE: Fritz Messere

by looking for the peaks. The spoken word may have a cadence, too, but it is more difficult to spot. Generally sounds with a good deal of power are easier to spot. These include consonants such as *d, p, t, z,* and *k.* Vowels lack that power and don't create sharp spikes in the waveform. Some sounds will be easy to identify and some sounds tend to run together. The more you practice "reading" a waveform, the more adept you'll become at splicing and editing.

For additional information about editing music and speech, we recommend reading *Audio in Media* by Stanley Alten.

Splicing and Editing a Sound File

Electronic editing can be either destructive or nondestructive, and we'll discuss both techniques in this chapter.

DESTRUCTIVE EDITING The most common reason for cutting a sound file and sticking it back together again is to eliminate a portion of what was recorded. This is true whether you do it electronically or physically. You may be recording an interview for an upcoming newscast. In preparing the story you choose to use only a portion of the interview. What you choose to include in the newscast will be called the "**sound bite.**" You cut the sections you want to include in the sound file (or physically on a tape together). Alternatively, a producer may splice to rearrange portions of a sound file (or a

tape) into a more logical sequence or simply to shorten what has been recorded.

Proficiency at splicing is helpful because it allows you to assemble useful sound files for newscasts and weathercasts. In studios that use audiotape, splicing can also be used to fix broken tapes quickly. In the days before computers, tape breaks were quite frequent, and if you were pulling an airshift, you might have to put a tape back together in a hurry. Today, splicing is frequently used to make rudimentary edits electronically. Stations who broadcast taped segments of people calling in requests follow this procedure even as the show is in progress. We've all heard requests on the radio immediately followed by the song. Chances are that song request was edited before being played on the air.

Editing can be as simple as the previous example, or it can be in a documentary or commercial that contains dozens of edits. Regardless, splicing and editing are techniques you'll use in radio production frequently. These techniques are part craft but also somewhat like an art form. They definitely involve learning and applying some special skills, but manipulating sound also requires a good ear and a little patience. Here are some of the basics.

The steps in splicing are as follows: marking the first edit point, marking the second edit point, cutting the sound file together (or tape), and making the splice. Let's take them in order.

Marking Edit Points

Suppose you have just completed an interview with the mayor, who has told you about an important development. You want to use a brief segment of the interview for an upcoming newscast. You've recorded the interview on a cassette tape at the mayor's office. Now that you're back at the studio, let's edit the interview for airing. The first step is to dub the interview into a computer and create a sound file.

There are many different computer recording and editing programs for both PCs and Macs, or your station may own a stand-alone machine made especially as a *Digital Audio Workstation* (DAW). They all have the same basic features although specific, complex features may differ from one brand to another.

The recorded interview goes like this:

Mayor: We have decided to go ahead with construction of a new cross-town expressway from the junction of Interstate 440 to, as you can see right here on the map, Commercial Street, where there will be a major interchange.

The mayor has pointed to a spot on a map in his office, but because the reference to the map is lost on a radio audience, we don't want to include the mayor's mention of it. The task at hand, then, is to cut out the portion of the sound file where the mayor says, "as you can see right here on the map."

Because the statement would make much better sense if the reference were eradicated, the logical place to make the first edit point would be the word *to* after Interstate 440:

Mayor: We have decided to go ahead with construction of a new crosstown expressway from the junction of Interstate 440 to, *as you can see right here on the map . . .*

 ∧ ∧
 First edit point **Second edit point**

The sound file is seen in Figure 6.2. The first **edit point** is where we want to cut the sound file. To do so, we have to find that point exactly, which means that we have to highlight the waveform on the computer screen.

The computer screen can display the part or the entire file containing the mayor's interview. Usually, a zoom control allows you to set the width of the sound file. In this case, set the width to display the entire file, which is approximately 13 seconds long. Play the sound file until you reach the approximate first and second edit points, then stop. Did you notice where on the

Figure 6.2 Mayor Hazzard waveform before editing. Zoom controls allow the user to increase or decrease the size of the waveform.

SOURCE: Fritz Messere

Figure 6.3 The portion of audio "as you can see right here on the map" is highlighted on the waveform.

sound file the unwanted portion seemed to occur? Play the file again until you can find the approximate point where the mayor says "as you can see right here on the map . . ."

Play the file again and stop the playback when you reach the first edit point where the mayor says *"as."* Note where the point is on the waveform. Using your mouse and by holding the mouse button down, drag the pointer across the portion that you think is "as you can see right here on the map." Release the mouse button. (The correct portion of the sound file that needs to be eliminated may be seen in Figure 6.3.) On most DAW software programs, you can play the section you highlighted by pressing the space bar. (If this does not work, you will need to review the specifics of your DAW.)

Did your highlighted portion encompass the whole phrase "as you can see right here on the map"? Did you highlight too much or too little of the mayor's interview? You can continue to use this technique until you highlight just the portion that you want. Some software programs allow you to set up beginning and ending points, which can be moved separately until

you get just the correct portion of audio that you want highlighted. Cool Edit Pro, the program shown in this example, allows the user to extend the highlighted portion by dragging the marker at the top of the sound file. (Some software programs also support a "scrubbing" feature that allows you to shuttle the pointer back and forth over the edit spot. Check the manual of your system to see what functions your software supports.)

Once you've correctly highlighted the portion to be deleted, you can cut the segment. (If you make a mistake, you may be able to paste the file back together using an "undo" command.) Now the audio file has been truncated with the unwanted portion cut out of the file. The edited file can be saved and is ready for playing during the newscast.

Nondestructive Editing

Though the destructive method of editing works just fine, you might make a mistake in the editing process. Also, some audio programs won't let you undo the edit easily, especially once you move the cursor to a new location in the sound file. Or you might decide, later on, that you chose the wrong edit point. Either way, you would not be able to undo the edit because you changed the audio file permanently. If this were the master sound file, you'd be out of luck!

Nondestructive editing is a better solution because you can edit the file by marking and choosing certain "regions" within the sound file that you want to play back. To create a region in Cool Edit Pro, you highlight the portion of the sound file you want and then click "add" in the region control box.

Try this technique by highlighting the first part of the sound bite:

Mayor: *We have decided to go ahead with construction of a new crosstown expressway from the junction of Interstate 440 to,* as you can see right here on the map, Commercial Street, where there will be a major interchange.

Press Add on the region box to add this phrase. Then highlight the second portion of the sound bite that we want, starting with *Commercial Street:*

Mayor: We have decided to go ahead with construction of a new crosstown expressway from the junction of Interstate 440 to, as you can see right here on the map, *Commercial Street, where there will be a major interchange.*

Once this section is highlighted, add this to the region box.

If we add the highlighted regions in the sequence we want to the regions box, the computer will play only those segments for you, effectively editing the file just as if you had permanently cut the unwanted portions out of the original file (see Figure 6.4).

Nondestructive editing has the advantage of allowing you to change your edit points as many times as you want, without altering the original sound

Figure 6.4 Note the regions "Mayor Part One" and "Mayor Part Two" will play because they have been sequenced in the playlist portion of the software.

file. Another advantage is that nondestructive editing allows you to play segments of the audio file out of their original order. This is the preferred method of computer editing because it provides a margin of safety that destructive editing cannot provide.

Copying, Pasting, and Looping

The very same techniques that are used to identify and highlight parts of a voice sound file, which we shortened in our Mayor Hazzard example, can be used to edit music, or to create sound "loops" as a background or for a musical bed.

Some musical segments would be perfect for commercials or promotional announcements but they might not fit into the time frame needed. In many instances, it just would not be appropriate to fade down the music selection because it would sound odd. With practice, it is often possible to shorten or

Figure 6.5 The highlighted waveform shows a musical segment that has been looped. Note the regularized beat in the selection, making the loop easy to create.

SOURCE: Fritz Messere

lengthen audio segments by isolating and highlighting specific portions of the music segment and pasting them together.

Figure 6.5 shows an isolated segment from a music track that has been highlighted and a loop that has been used to make the segment longer. Note the large wave represents the downbeat of the highlighted segment. Copying and pasting this segment into a new sound file several times produces a longer music bed for an audio commercial.

Most digital audio workstations allow the user to create a region within a sound file called a loop. Just as the name implies, a loop is useful for taking a small segment of music or a sound effect and making it longer. Drumming or other percussive segments of music frequently make exciting background tracks. Looping makes it possible to repeat these rhythmic phrases, thus creating longer portions that you can use in audio production.

Editing music takes practice and patience, but this is a skill that is definitely worth learning. Music editing gives you great flexibility in radio production.

Editing with a Minidisc

You will recall from our earlier discussion that minidiscs are optical-magneto recording devices that allow you to record and rerecord over the same media. You can use minidiscs to record, erase, edit, move, and combine or divide

Tuning into Technology

THE ELECTRONIC EDIT

Every computer program for editing is different, of course, and a short course in one program might be more confusing than helpful.

However, we're going to present a stripped-down introduction to a hypothetical audio editing program that will cover most of the basics. It's the concept that is important, rather than the actual use of a particular program's commands.

So here, step-by-step, is how it's done:

1. The material is "dumped" from the board into the computer memory. You simply plug in the sound source, and the sound (such as the output of a mic or CD player) is fed to what's called a sound card in the computer. A sound card is a device that plugs into a computer and converts sound into binary code (see Figure 6.6).

2. Now, your computer is able to let you manipulate those numbers. It stores the sound you have dumped into the computer; you give it a file name, and you can call it up when you want.

The computer screen displays the sound as a waveform, with which we're already familiar. Most programs allow you to have many tracks, but for the sake of demonstrating the edit, we'll just concentrate on one or two tracks.

You can use a number of "tools" to manipulate the sound. We show a couple of them in Figure 6.7.

3. Remember that computer programs carry considerably more power than just doing a simple cut-and-splice, but we want to show exactly how the computer corresponds to the razor blade. Note that it's a very precise razor blade. You can *determine the shape of the cut* (see Figure 6.8). Suppose, for example, you have made an edit, cutting out the word *tomorrow* from "see you there at noon tomorrow," and you hear that the announcer's last word, "noon," just *stops*. It ends too abruptly because it originally led into the word *tomorrow*.

When you say "noon" at the end of a sentence, we subconsciously taper it off a bit. But if our speech is cut between "noon" and "tomorrow," the ending will sound unnatural. So the producer uses the "electronic razor blade" to choose the type of cut he or she wants to make—in this case, a taper.

Continues

Tuning into Technology Continued

Figure 6.6 Dots = samples. A sound card takes at least 11,000 samples per second. *Dumping to a sound card.*

Sound wave

which is transduced to
analog signal by mic,
which is fed to

sound card, which
samples sound and

produces digitized waveform
made up of binary digits,

which is fed to the main brain
of the computer and
manipulated on the screen.

Continues

Tuning into Technology Continued

Figure 6.7

Magnify tool allows you to make a section larger, say, focus in on two seconds.

Blocking tool lets you highlight a part of the waveform.

Grabber tool lets you move a section.

Tools for manipulating sound.

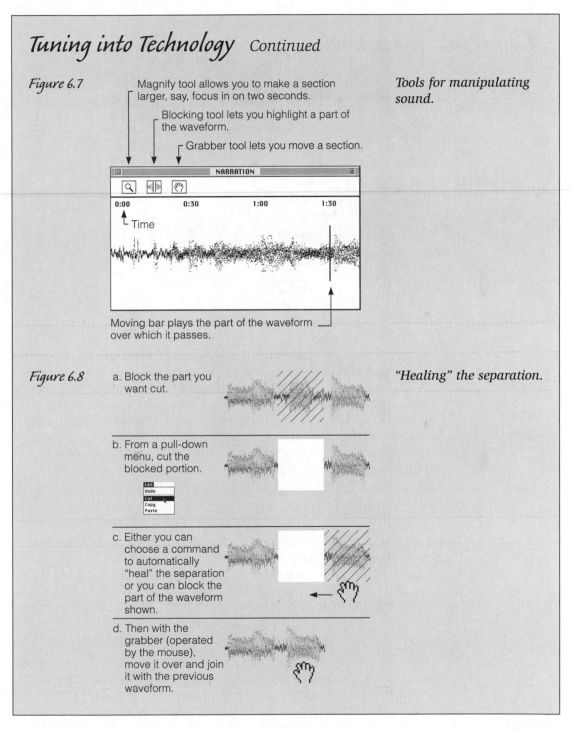

NARRATION

0:00 0:30 1:00 1:30

Time

Moving bar plays the part of the waveform over which it passes.

Figure 6.8

a. Block the part you want cut.

b. From a pull-down menu, cut the blocked portion.

Edit
Undo
Cut
Copy
Paste

c. Either you can choose a command to automatically "heal" the separation or you can block the part of the waveform shown.

d. Then with the grabber (operated by the mouse), move it over and join it with the previous waveform.

"Healing" the separation.

Continues

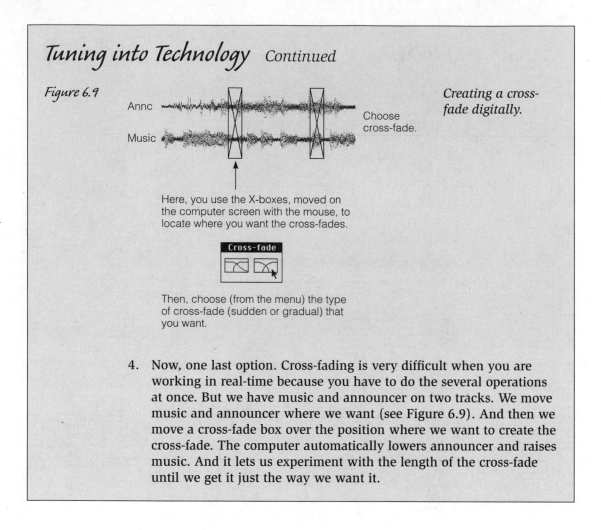

Tuning into Technology Continued

Figure 6.9

Annc

Music

Choose cross-fade.

Creating a cross-fade digitally.

Here, you use the X-boxes, moved on the computer screen with the mouse, to locate where you want the cross-fades.

Cross-fade

Then, choose (from the menu) the type of cross-fade (sudden or gradual) that you want.

4. Now, one last option. Cross-fading is very difficult when you are working in real-time because you have to do the several operations at once. But we have music and announcer on two tracks. We move music and announcer where we want (see Figure 6.9). And then we move a cross-fade box over the position where we want to create the cross-fade. The computer automatically lowers announcer and raises music. And it lets us experiment with the length of the cross-fade until we get it just the way we want it.

tracks. These editing functions provide the minidisc with some flexibility and make it a good, rudimentary editing tool for broadcasters.

Our interview with the mayor can be edited on a minidisc using the following techniques. First, dub the entire Mayor Hazzard interview onto the minidisc. If you started with a blank minidisc, this would be the first sound file dubbed onto the disc. It would automatically be numbered cut 1 by the machine. Now play the interview and practice pressing the pause control at our edit point.

Mayor: We have decided to go ahead with the construction of a new crosstown expressway from the junction of Interstate 440 to < edit point >

Figure 6.10 Minidisc recorders allow the user to name tracks and play them back
instantaneously, making them valuable production tools.

Photo courtesy Teac Corp. of America

After you have the machine paused in the correct location, press Edit on
the machine. It will ask you if you want to "divide" the segment. (Note that
on some machines there may be a jog wheel that needs to be turned to dis-
play the various editing functions. See Figure 6.11.) Press Set, and the ma-
chine will now display *1 < > 2 ? OK* on the alphanumeric display. The mini-
disc recorder is asking you if you want to convert cut one into two cuts at
the paused location. Pressing Enter on the minidisc now *divides* the inter-
view into two interview parts that sound like this:

Cut one: We have decided to go ahead with the construction of a new
crosstown expressway from the junction of Interstate 440 to . . .

Cut two: as you can see right here on the map, Commercial Street, where
there will be a major interchange.

Now we are going to play cut two and press pause at our second edit
point, right after the phrase "as you can see right here on the map." Again
we are going to press Edit and divide the segments by pressing Set and then
Enter. This segment will now be divided between segments 2 and 3.

Cut one: We have decided to go ahead with the construction of a new
crosstown expressway from the junction of Interstate 440 to . . .

Cut two: as you can see right here on the map . . .

Cut three: Commercial Street, where there will be a major interchange.

Figure 6.11 The jog wheel allows the user to perform basic editing functions on this minidisc recorder.

Photo by Fritz Messere

Finally, we are going to combine segments one and three to complete the sound bite. Move the jog wheel until cut one is displayed, then press play and edit. The machine will now display "divide ?" on the alphanumeric display. Rotate the jog wheel until "combine ?" is displayed. Press Set, and the alphanumeric display will display cut one and flash cut two. The machine is asking if you want to combine cut one with cut two. We don't want cut two; instead cut three is the correct segment. When you rotate the jog wheel, cut three will replace cut two as the second segment. By pressing Enter, the machine will edit together cut one and cut three. Our edit is complete. (Note that some minidiscs will ask "ok?" before the edit will be executed. Each machine is slightly different but the procedure is basically the same.)

Now play the sound bite and see how your edit sounds.

Dubbing

Regardless of whether you use a computer, a minidisc, or a digital tape recorder, you will frequently find yourself copying from one source onto another source. This dubbing process is done frequently in radio. For example, you might *dub* a commercial you created on a DAW to a minidisc for airplay. When you "dub," you essentially copy a source in one location to another location or a different medium. But the technology that allows you to dub is

essentially the same as the technology that allows you to splice and edit. So, it is also possible to achieve many of the same goals using electronic editing as we achieved using our editing techniques.

Let's use our Mayor Hazzard example once again, but this time we could accomplish the same goal using electronic dubbing. You could play back the cassette tape and pause the minidisc recorder to eliminate the unwanted portion of the mayor's interview, though careful playback will probably reveal that the edit is not as clean as the splice—there may be some electronic noise at the edit point, and the rhythm of the pause may not be perfect. That's one of the main difficulties with dubbing: It's just not as precise as electronic editing.

Further, dubbing from one source to another too many times can cause the quality of the recording to deteriorate, particularly when you are dubbing with a minidisc, where the audio has been compressed, or when you've recorded on analog tape machines such as carts or reel-to-reels. Every new dub of a recording is known as another **generation**. Dubbing too often can result in a loss of quality, including the introduction of additional noises into the recording process.

Advantages of Dubbing

There are some real advantages to the dubbing process, however. Dubbing allows you to overlap elements. If, for example, you want to edit in a piece of music and talk over it, fading the music out, you will have to use dubbing or more sophisticated features of the DAW. Another plus of dubbing is that it can be accomplished very quickly.

Dubbing will probably account for most of the editing work you'll do. Stations get most of their music on CDs or from a music service, and they dub this music onto a hard disk for playback. Commercials or jingles often arrive on CDs and will have to be dubbed to a minidisc or digital cart for use on the air. News segments recorded in the field will need to be dubbed to a DAW for editing. Dubbing is an important tool in our arsenal of production tools.

Review of Dubbing

Dubbing involves recording program material from one source to another. It is very useful in editing because it's less work than some other forms of electronic editing; however, dubbing isn't quite as accurate in locating editing points. Dubbing is frequently used when elements are overlapped, especially in music.

Summary

Recorded segments are separated and joined together in two ways: by electronic editing (the cutting and pasting of information) and by dubbing (the electronic copying and reinsertion of taped material).

Digital audio workstations greatly improve the process of editing recorded material from that of traditional methods. Both dubbing and electronic editing are nondestructive, but DAW technology allows the user to create virtually undetectable edits easily.

The purpose of splicing and editing is usually to eliminate words or phrases, change the order of phrases and dialog, or shorten or lengthen music beds. Dubbing can accomplish many of the same things, but it is also useful for combining many production elements in a rudimentary fashion.

Applications SITUATION 1 / THE PROBLEM A production manager at a local radio station was given the job of producing a commercial for a local political candidate. As part of the commercial, the candidate discussed his views for 40 seconds. However, the candidate had an unfortunate speech pattern: He interjected "uhhhh" many times during his presentation.

ONE POSSIBLE SOLUTION Because it was the producer's job—in this case—to present the candidate in a positive light, the producer dubbed the audio to a DAW sound file and edited all the "uhhhhs" from the politician's remarks. The job took 20 minutes, but the resulting audio sounded smooth and clean.

SITUATION 2 / THE PROBLEM The producer of an entertainment show did an interview (on location using a cassette) with the head of a local theater group. The producer wanted to weave three cuts of the interview into her script.

The script went along the following lines: "And what does Pat Wilbur, head of the Starlight Theater Group, have planned for this season?" . . . (cut one of interview) . . . "But will attendance be better this year than last year's dismal totals?" . . . (second cut of interview) . . . "So how does Pat Wilbur intend to get those attendance figures up?" . . . (third cut of interview).

What would be the best way to weave those cuts into the script?

ONE POSSIBLE SOLUTION The producer listened to the entire interview several times and made precise notes about where she wanted to cut in and out of the interview.

Because time was short, she decided to dub the three cuts directly onto minidisc, which would be used to play the cuts over the air. (The show was done live.) She put the minidisc machine on Record and Pause, rolled the cassette tape, and started the minidisc as soon as the appropriate section of the interview began, stopping the disc as soon as the desired section of the interview ended. This procedure was repeated for the other two cuts. Thus there were three cuts on the minidisc. Every time the producer wanted to play a cut of the interview, she simply hit the Start button on the machine. The next cut was cued automatically because the segments were recorded in order.

Exercises

1. If you have two or more minidiscs or cart machines available, dub a piece of audio from cart to cart. For example, start with a 10-second music cut dubbed onto a minidisc or cart; take that disc or cart and dub from machine 1 to machine 2. Now dub from machine 2 back to machine 1 (put a new minidisc or a clean cart in cart 1).

 This exercise will accomplish two goals: You hear what affect successive generations of tape have, and you better understand the relationship of these machines (for record and playback) to the console.

2. Interview a classmate or colleague, take three cuts from the interview, and weave them into a script similar to the one described in Situation 2 of this chapter. (What you're doing is assembling a series of **voice wraps.**) Don't be too concerned about the content of the interview or the script; this is just a vehicle for practicing editing techniques. The whole program need not be longer than a minute or so.

 In this exercise, you will assemble the show first by using dubbing techniques; you can dub onto minidisc, DAT, or a DAW, whichever seems easier.

3. Listen to a half-hour of radio, and identify as many editing structures as you can. Write them down; for example: "Introduction to the 4 o'clock news on WAAA: An *establish music, music under, voice up.* This was followed by a *voice wrap* during the first news report. . . ."

Recorded Program Production

*W*e use the term *recorded program production* to refer loosely to any radio production work that is not done live, over the air. In most cases, the recording is done in preparation for use over the air at a later date.

The basic difference between recorded production and live, on-air production (which we cover in the next chapter) is that on-air production is a one-shot affair; there's only one opportunity to get it right. In recorded studio work, the producer has the freedom to do several retakes of the same production element, to try different blends and mixes, and to scrap the whole project and start over again if it's not working out.

Because of these luxuries, much more complex productions are attempted in recorded work. Whereas mixing a narration, multiple sound effects, and a music bed would be next to impossible all in one take, it becomes a simple matter in the recording studio because the tasks can be attempted one at a time, with the various elements divided into logical steps.

Recorded versus Live, On-Air Production

How does a radio producer decide whether a production will be done live or put together in advance? There are three elements to consider: complexity, scheduled airtime, and convenience.

Complexity

A production containing many elements must be done in advance. Commercials are read live, but these are almost always one-voice affairs, with the announcer simply reading copy or **ad-libbing** from a fact sheet.

Scheduled Airtime

A talk show that airs at 5:30 A.M. Sunday will be prerecorded in the studio, usually during normal weekday working hours. Trying to get guests to appear live on a predawn show is not practical.

On the other hand, newscasts generally are not recorded (and when they are, they're done as close to airtime as possible) because they become outdated quickly, as the news changes.

Convenience

If a production calls for the voice of a specific announcer, is it more convenient to record the announcer or to have him or her come in every time that production is aired? The same rationale applies to the need for repetition of a production. Though the use of music and narration for the introduction of a show might be done live if the program is a one-time affair, prerecording the introduction will be far more convenient if it is to be repeated weekly or daily.

Along the same lines, preproducing a piece reduces the chance that an error will be made over the air.

Layout of a Production Studio

In a small radio station, the production studio is usually located wherever it fits; often, it is in the disc library or in an engineering area or even in a corner of the manager's office. In a somewhat larger station, the basic production studio often looks like the one shown in Figure 7.1.

On the other end of the spectrum is the fully equipped, high-tech production studio (see Figure 7.8, page 161). Another variation of the top-of-the-line studio is a setup with **multitrack** mixing capabilities for recording and remixing original music. Today, many of the digital audio workstation programs have multitrack mixing capabilities. We discuss recording and mixing music later in this chapter.

Most large studio setups feature a glassed-in area between the main control room and the studio; in large music production studios, the glass divides the performance area of the studio from the control area. The glass is typically double layered, and the panes are not set parallel to each other or to the studio wall (see Figure 7.2), to prevent internal and external reflections of sound.

The more typical radio-station production studio is a one-room setup, with the equipment usually intended for combo use. Although the studio is intended for off-air production, there generally will be a **hard-wired** link to the main control room so that the output of the production studio can be put live over the air. This arrangement comes in handy when the main control room is out of commission during repairs or other emergencies. The studio

Figure 7.1 Basic production studios such as this one may have a minimum of equipment.

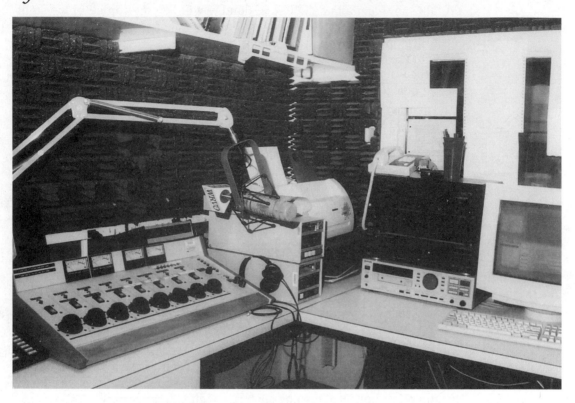

Photo by Fritz Messere

Figure 7.2

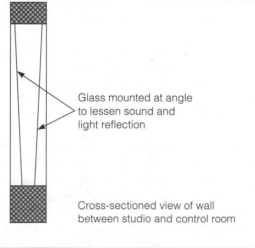

Glass mounted at angle
to lessen sound and
light reflection

Cross-sectioned view of wall
between studio and control room

Double layer of glass
used to separate control
room from production
studio. Air space be-
tween the panes of glass
provides sound insula-
tion from adjacent areas.

may also double as an announce booth, used especially by the news department. The news department may also have its own production area.

Equipment in the Production Studio

In most cases, the production studio's equipment will virtually duplicate what's in an on-air studio, although there may not be as much of it; in some stations, the production equipment may be hand-me-downs from the on-air control room. The minimum equipment usually includes some sort of console, a computer, a mic, perhaps a cart machine or two, and a CD player. In smaller markets you may also find tape recorders and turntables instead of some of the newer gear. The console may be a portable mixer or the portable console the station uses for **remotes.**

A patchbay is almost always a fixture of the production studio. In many cases, the patchbay allows interconnection of the production studio with other studios, with the network, or even directly with the transmitter. More modern facilities may have audio routing switchers that allow you to change signal flow at the touch of a button. There is often some sort of talkback system between studios.

Sound Treatment in the Production Studio

A commercially available sound-deadening material (see Figure 7.3) is commonly used to dampen sound reflection in the production studio. Sometimes, egg cartons are cut up and attached to the walls, serving the same effect.

A carpet is very helpful for deadening sound reflection. On occasion, the carpet is applied to walls to help create a dead environment. Studios designed for music recording often have curtains, which can be spread to deaden sound or pulled back to expose the bare walls when a livelier sound is desired.

Figure 7.3

Sound-deadening material attached to studio walls to reduce unwanted sound reflection.

Photo by Philip Benoit

As we mentioned earlier, the production studio in a small station may serve double duty, and a combined music library and production studio is common.

Working in a Production Studio

Who works in the production studio environment? In some stations, a production manager is in charge of the studio and has the responsibility of overseeing all the station's off-air production. Staff announcers also use production facilities for such duties as commercial production. In smaller stations, salespeople often produce their own commercials. Basically, the studio is used by anyone who has to construct a production for later airplay. In this sense, all staff members assigned such duties are producers.

Anyone who undertakes the duties of a producer is responsible for knowing much more about the process of radio than is someone who acts simply as an announcer or a technician. A producer must understand the methods of constructing a **spot** or program. For example, it may be more efficient to break the production down into a number of discrete tasks, such as doing all the music work first and all the narration next, even though that is not the sequence in which the components will appear in the final product.

An analogy from the movie production business is illustrative. Perhaps a certain restaurant is the setting of the last sequence of a movie, and the film begins in the same restaurant. It makes sense for the producer, who has to move around crew, actors, extras, and sets, to shoot the beginning and ending scenes on the same day. (It's not unheard of for the ending of a movie to be shot on the first day of production.) In other words, the pieces or sequences of a movie can be filmed in any order and then edited together in accordance with the script.

You'll find that the same strategy often proves useful in the radio production studio. And, because time demands on a studio are usually high, you'll be able to get in and out much faster if you learn to plan work in **task-oriented sequence.** If, for instance, you have three similar commercials to produce, it may prove useful to do the announcing for all three first and add the music beds to all three next.

Working in task-oriented sequence will become second nature as long as you make an effort to break old thought patterns that require you to work in real-time sequence (doing the beginning first, the middle next, and the ending last). Always structure your tasks according to the most convenient and efficient method for the best use of the production studio available. Understanding this principle is what separates a producer from someone who just records a sound file or puts something down on tape.

Another factor that will help you develop skill and recognition as a radio producer is an understanding of the basic building blocks of radio and how they relate to studio production. We're talking about music, recorded voice, and sound effects.

Music

Music is a very important element in radio production; indeed, it can be argued that for many stations, music is what radio is all about. In any event, it's important for a producer to have an understanding of music. Good producers have the ability to use music to their advantage, to manipulate music to create an effect. Good producers also understand the kinds and varieties of music and thus can fit productions into the station's overall format. In a production studio setting, you will generally be using segments of music rather than entire cuts.

Sources of Music

The music you will use will almost always be prerecorded on CDs or a disc; it may even have been *downlinked* from a satellite. The use of music is licensed to a radio station by means of a fee paid to music licensing organizations, the largest of which are the American Society of Composers, Authors and Publishers (**ASCAP**) and Broadcast Music Incorporated (**BMI**). Licensing fees also cover the use of music in production work. Popular music (the kind played over the air as entertainment) is commonly used in all sorts of studio production.

Sometimes, though, specific requirements are not filled very well by the popular music available. Specialized musical selections have been developed to meet these needs. Various companies sell **production libraries:** (see Figure 7.4) recorded original music that fits the most common production and time requirements of typical stations. For example, **music beds** run exactly 60 or 30 seconds.

Figure 7.4

Specialized music libraries are available for production use.

Photo by Fritz Messere

Generic vocal selections are available that can be adapted to fit the needs of commercial production for local merchants. Thus, a 30-second cut might start with a group of vocalists singing: "You'll find it all at the mall." The instrumental background would continue, serving as a bed for the local announcer to fill with copy advertising specialty shops and merchants found at the local mall. The vocal would return, 25 seconds into the cut, to close out the piece with: "Do your shopping where you'll find everything you need!" Advertising agencies, which commission the composition of original music for clients, are another source of music. Such music usually takes the form of a jingle, which is incorporated into the client's radio (and sometimes TV) advertising. The beds supplied by ad agencies are very similar to the works furnished by the production library companies, except that the ad agency's musical jingle is specific to one client. Some large companies provide their franchises with standardized commercial beds that can be "localized" at the different radio stations.

Specialized productions generally are easier to work with. (You don't have to do as much adaptation of the music, such as telescoping the beginning and end together for one 30-second spot.) However, the station has to pay for prepackaged production music, and some of it is pretty hokey.

It's safe to assume that most of your production work will be done with popular music whose main purpose is airplay. But you can adapt it for production purposes.

Choosing Music for Production Work

Music can make or break a production. A commercial, for example, can gain significant impact through the selection of background music that reinforces the message. A poor selection, though, can detract from the message or even be at odds with it. For instance, copy that touts the benefits of a relaxing vacation through the Acme Travel Agency won't be reinforced by blaring rock music. No copy will be helped by an over-familiar vocal selection that draws attention away from the message. The selection of music, incidentally, can be a formidable task. Even the smallest radio station may have thousands of recordings in its station library.

Radio stations often categorize music held in their libraries by type (rock, country, jazz, classical, and so on). Still others use a color code or a numerical or alphabetical listing for their music libraries. It is important to understand the broad classifications that stations use so that you can locate music by type quickly and easily. We discuss some broad classifications later in this chapter.

Many stations segregate music libraries into vocal and instrumental selections, and because most production music is instrumental, your choice will be narrowed somewhat. Some stations designate a shelf for good production CDs, which is handy but may entail the risk of causing a few pieces of music to become overused. And there is a very real danger of overusing

popular music. As we indicated, a catchy, popular tune might attract more attention than the message of the commercial; the listener will be hearing the music, not the message. Conversely, a popular piece of music may be just what is called for in a particular situation. In recent years, some car companies have picked familiar music so as to make a connection between specific songs and the car brand.

Many production pieces are chosen by someone who—after years of studio production experience—notices that a certain **cut** on the air would be a particularly good piece for production work. Perhaps it is an instrumental section that conveys excitement, or enjoyment, or some other mood. A great many air people develop their own particular favorites for commercial production though this, too, entails a risk that the music will be used too often.

In any case, the music must reinforce the message, not distract or detract from it. The style has to fit both the message and the station's format.

Styles of Music

A broad knowledge of music is critical to the radio professional. First, even if your intention is to pursue a career in rock radio, circumstances may dictate a two-year stint at a station with a country or adult contemporary music format. Stations with a broad-ranging format may use a variety of music styles in production, and you need to understand the styles and be able to use them effectively. In addition, modern music produces many **crossovers** from one style into another. Some country music, for example, almost sounds like jazz. Being able to recognize elements of various styles will help you categorize music and better use it to achieve effects. Trade magazines and music Web sites can help you learn more about music and music categories.

Here are the characteristics of some of the major styles of music.

ROCK Rock usually features drums and electric guitars. There's generally a distinctive rhythm, which is maintained by bass drum and bass guitar. More avant-garde types of rock music include elaborate electronic effects. The milder rock music selections are commonly used pieces in radio production as music beds. Frequently, snippets of percussive sounds are used repetitively for high-energy commercials.

COUNTRY The twang of country music is its most recognizable attribute, though much of the country music repertoire is orchestrated and virtually indistinguishable from general popular music. The steel guitar was once the cornerstone of country music, but now almost any combination of instruments can be used.

Country music is used in production to achieve special effects (as a music bed for a rodeo commercial, perhaps) and, of course, is used extensively in production on country-format stations.

JAZZ This style of music can run the gamut from traditional big-band dance music to bebop, from Latin to bizarre and highly experimental compositions. Jazz generally uses a syncopated rhythm.

Jazz has many uses in production and is particularly helpful because so much of it is instrumental. The more experimental types of jazz are less useful, though they can sometimes be selected for effect.

CLASSICAL The term *classical music* is something of a misnomer because classical really refers to one type of music in the spectrum popularly understood as "classical." The classical period is typified by the music of Mozart. The baroque period, which preceded the classical, is most commonly associated with Bach, who created multiple melodies that interact contrapuntally. (This type of music is referred to as polyphonic; its sound can be approximated by the familiar round "Row, Row, Row Your Boat.") The romantic period of music followed the classical period and is characterized by the works of Tchaikovsky and by the later works of Beethoven.

For lack of a better term, *classical* will suffice though some people refer to this style as concert music or good music. Classical music occasionally is useful in production, generally to achieve a special effect.

URBAN This music is noted for its heavy bass riffs and highly percussive nature. Urban music has a repetitive beat making it easy to edit. Rap, hip-hop, soul and R&B also fall into this category. Urban beds can frequently cut through programming clutter on pop and contemporary stations but it may not be appropriate for all formats.

GENERAL POPULAR MUSIC This broad category can encompass many others. Essentially, though, general popular music tends to be more melodic and orchestral than rock. Violins and other bowed strings are used, as are woodwinds. Piano is a typical feature of general popular music. Many of the lower-key rock music selections certainly fit into this category. At the other end of the spectrum are the beautiful-music selections of Henry Mancini or the Hollywood Strings. This style of music is especially useful in general production duties because much of it is instrumental.

SPECIALTY MUSIC This category includes polkas, waltzes, and marches, which are used in production work when a specific effect is called for.

Recorded Voice

Voice, the second major element of production, can be recorded by an announcer running a combo operation or by a producer running the console while others speak into a mic or mics.

One common studio production task is the miking of several speakers, for instance, in a round-table discussion. Here, the microphone techniques we discussed in Chapter 5 are useful, along with some other considerations that we discuss shortly. The most important goal of recording voice in a studio production setting, though, is to get a clean recording that accentuates the announcer's voice and delivery. Achieving this goal may involve such considerations as:

- Selecting a mic that deemphasizes peculiarities of a performer's speech, such as *p*-**popping** or excessive **sibilance.**

- Replacing a highly sensitive mic with a less sensitive model to cut down on noise from air conditioning or from the clicking of the speaker's dentures.

- Eliminating table noises (nonprofessional speakers are notorious for tabletapping or clicking pens) by hanging the microphone from a boom rather than attaching it to a table stand.

- Instructing speakers, professional and nonprofessional alike, on positioning and use of the mic. Nonprofessional speakers frequently need to be cautioned about speaking too close to the mic.

Duties of these types are common in all production setups. Whereas in some instances, recording voice in the production studio is a simple affair, other situations are complex. Two of the most common difficulties encountered in production work are miking multiple speakers and communicating with speakers when the mics are open.

Miking Multiple Speakers

One typical function of the radio station's production specialist is to set up and record panel discussion shows. With a number of interviewees in the studio, it is tempting to string up mics for everyone who is likely to open his or her mouth. Most experts agree, however, that the fewer mics you can get away with, the better. An overabundance of mics can cause difficulties in engineering the show (trying to find the right pot to adjust, for example, when you're dealing with six or seven) and in phasing.

It is, however, practical to use two mics when there are two speakers. Perhaps the most common type of interview program involves a single host and a single guest, and recording of the show can be pulled off quite nicely with two cardioid mics, with little overlap of the pickup pattern (see Figure 7.5).

The advantage of this setup is that the operator is free to control the individual volumes and to maintain a comfortable balance. A bidirectional or omnidirectional mic can be used instead, but the loss in flexibility usually isn't worth the convenience gained from a simpler setup. But when there are several speakers, simplicity of mic setup is indeed a virtue. One mic suspended

Figure 7.5

Simple two-person interview, using cardioid mics.

Photo by Philip Benoit

from the ceiling may give better results than an individual mic for each speaker. As we mentioned, phasing problems plague the multiple-mic setup. Moreover, every time you open a mic, the *room tone,* or noise present in the studio, increases.

To understand phasing problems, let's first recall our discussion of directional mics in Chapter 5. Remember that a **directional mic** cancels sound by means of an acoustic network inside the mic; that is, sounds reach the diaphragm at different times and therefore cancel themselves out. The same effect occurs in the studio: Sound arrives at different mics at different times, with just enough difference to throw the phasing off.

This will seem less abstract when you consider that sound does not travel very quickly; although 1,100 feet per second may seem like a pretty fast clip, note how sound lags behind vision. From the top row of the bleachers, you can easily discern the gap between when the basketball hits the floor during a dribble and when you *hear* it hit the floor. Track runners start when they see the smoke from the starter's pistol rather than waiting for the noise, which they hear a split second later. Now, with sound waves making, let's say, 5,000 cycles per second (5,000 Hz), it's easy to see how a small delay can cause the cycles to be out of phase.

The solution to phasing problems is to avoid, as much as possible, any overlap among the mic pickup patterns. Sometimes this entails putting more than one speaker on a mic so as to avoid overlapping pickup patterns. For example, miking six speakers could be accomplished with three mics, each trained on two speakers so that there's little or no overlap of their pickup patterns (see Figure 7.6).

Figure 7.6

Layout enabling six speakers to be positioned around three mics. Separation and proper orientation of the mics could, if cardioids were used, prevent overlap of their pickup patterns.

Photo by Philip Benoit

The concept of phase problems will become crystal clear when you hear an out-of-phase broadcast. In many cases, all that's needed to overcome the problem is some additional separation of the pickup patterns. Moving the mic around will usually solve the problem. Applying a 3-1 ratio here is useful. Generally the distance between microphones should be three times that of the distance from the microphone to the speaker. Remember, phase problems are nothing more than the effects of sounds reaching mics at different times and canceling one another out. Remember, too, that even a tiny difference in the times at which sounds reach a mic can cause phasing problems.

One other difficulty of miking multiple talkers is, of course, the matter of sound levels. A speaker who has an overpowering voice generally does not belong on the same mic with someone who habitually whispers. This situation, too, will call for some trial-and-error maneuvering.

Working with nonprofessional speakers creates a secondary problem with setting the level. Although a professional announcer will usually know enough to give you several sentences of speech to let you set the pot at the proper level, amateurs will not. The typical scenario before a panel discussion goes something like this:

Producer: (*whoever happens to be running the board*): Mr. Smith, could I have a level, please?

Smith: What?

Producer: A voice level . . . Could you just talk for me so I can set your mic?

Smith: What do you want me to say?

Producer: Anything.

> **Smith:** Hello, hello. Is that enough?
>
> **Producer:** (*who hasn't even found the fader yet*): No, no, just talk until I tell you to stop.
>
> **Smith:** But what am I supposed to say now?

To make matters worse, the level Mr. Smith finally gives the producer has absolutely no relation to the booming voice he will use when the tape starts rolling. Though there's no perfect solution to this problem, one of the least objectionable ways of getting a level from amateur talent is to ask each person to count to 20. Granted, the voice a person uses to count aloud is different from the one used in conversation, but the voice level used by a self-conscious speaker to give a snippet of conversation for the level-taker isn't necessarily what's going to come out during the program either. Asking the talent to count does, at least, eliminate the "What am I going to say?" routine and guarantees several seconds of speech. If there's a rehearsal of the program before airtime, use the rehearsal to set levels.

Communicating with Speakers

One consideration of working in the production studio, especially when recording interview shows, is how to communicate with announcers and guests when mics are open. This isn't nearly as big a problem as it was in the days of live radio—when whole programs such as variety shows and dramas were put live over the air—but knowing some simple cues and signals can prevent the inconvenience of having to stop tape to give an instruction. In addition, signals sometimes prove useful when a speaker is going live over the air.

The following hand signals have been around for quite some time, and though you may not have much occasion to use them, they do represent a standard way of communicating in the studio.

YOU'RE ON This signal (see Figure 7.7a), consists of a finger pointed directly at the speaker.

GIVE ME A LEVEL A chattering motion with the fingers (see Figure 7.7b) indicates that you would like the announcer to give you a voice level.

KILL MY MIC Draw a finger across your throat (see Figure 7.7c). If you're using a headset mic, point to the mic, too.

WRAP UP This signal is accomplished by a circular ("winding up") motion of the hands (see Figure 7.7d).

STRETCH Make a motion with your hands as though stretching a rubber band (see Figure 7.7e). This tells the person on-mic to keep talking and stretch out the program.

Figure 7.7 Standard studio hand signals.

a.

a. You're on."

b. "Give me a level."

c. "Kill my mic."

d. "Wrap up."

e. "Stretch."

b.

c.

d.

e.

All photos by Philip Benoit

Remember, these signals aren't foolproof, and not everyone knows them. If they are standard in your station, fine; if you work out signals in advance with talent and guests, they may prove useful.

Sound Effects

We have discussed sound effects in various contexts in other chapters. Here we examine how they are used in studio production. Some of the most useful sources of sound effects available to the producer are CD libraries sold by various firms. These discs carry fairly specific entries and list the number of seconds each cut lasts. For example, the entries in the car horns honking category might be listed this way:

- Number 17: Horn honking, Model T Ford, :05
- Number 18: Horn honking, modern car, :06
- Number 19: Horns honking, in city traffic, :10

Many of these CDs contain dozens of cuts per disc, so counting them is often difficult. Fortunately most professional CD players allow you to move to a specific cut on the disc by using a selector knob or a remote control.

Production libraries are also available as computer files and you can choose a variety of computer file formats such as WAV, AIFF or MP3. Sound effects can also be downloaded from various Internet sites, but you need to make sure that you have permission to use the sounds before incorporating them into your productions.

Sometimes, you won't be able to find what you need, and a sound effect will have to be created. Most of us are familiar with the standard tricks of the trade for producing sound effects, such as crinkling cellophane to produce the effect of flames crackling. Most of us also know that the results—unless one is an expert—are often less than satisfactory. Many experienced production people who are willing to take the time and effort can custom-make sound effects, but in most radio production, that amount of effort isn't expended.

Most of the sound effects you will have to create yourself will consist of standard background noise, such as the hubbub of a restaurant. Common sense and some experimentation will guide you on this; just be aware that you and the microphone hear differently. Your brain can filter out noise in a restaurant, but the mic is likely to pick up every clink of dishes and scrape of silverware. So, when producing a sound effect, be prepared to try some different mic techniques, and don't hesitate to try various sound levels and to fade different effects in and out to create the sound you want.

Combining Elements in Production

The process of mixing music, voice, and sound effects is, essentially, a matter of feeding signals through the console or manipulating them with an editing process to construct the ultimate product.

Industry Update
THE ULTIMATE RADIO RECORDING STUDIO

When Linda Ronstadt or Judy Collins or Tony Bennett performs for radio, they often do it at the combined studios of WQEW-AM and WQXR-FM in New York. Why? Because the stations have built one of the best studios in the industry.

This studio is an excellent example of three of the principles spelled out in this chapter:

- Sound separation. The windows are 1 inch thick (see Figure 7.8). The studio is actually a separate building *inside* another building.

- Isolation. It's built on neoprene shock absorbers so that the studio is not affected by sound vibration. You can actually feel the bounce when you walk across the floor.

- Control over "live" and "dead" spaces. The walls have panels that are reflective when shut and sound absorbing when open.

You probably can't match these technical features in your studio, but you can strive to reproduce the general principles. For example, fairly good-quality glass or a large distance between control room and studio can combine to produce decent isolation.

You may not have the budget to build a building within a building, but you can attempt to keep your studio free of vibration. Don't locate it near an elevator. Hang microphones instead of putting them on desks if vibration is a problem. Adding some padding over the floor can help.

Dual-surface paneling is something you can probably build yourself, but you can also tack up sheets of sound-deadening material and remove them later if you need to alternate between lively and dead environments.

Figure 7.8

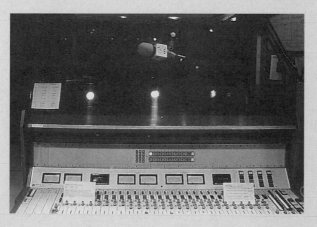

Behind the glass in this studio arrangement is a "floating room" that isolates the studio from vibration and sound.

Photo by Philip Benoit

A major consideration in combining these elements in a production studio setting is to ensure that the final product contains as few generations as possible (that is, the smallest possible number of rerecordings of the same segment).

We discuss the specifics of various production processes in the appropriate chapters, but this is a good place to point out the ways in which you can efficiently construct production pieces; using the minimum number of generations is one such practice. During production, you will find a number of ways to save duplicating your tracks over and over. The principle is to do as many operations in one step as possible; for example, make the whole music bed in one step, if you can, rather than adding elements gradually and dubbing from track to track (or to the tape) several times. (Remember that if you're using analog equipment, each recording pass will build a little noise into your recording.)

Another aspect of combining elements in production is to keep an open mind and use as many of the options available to you as possible. Is there an easier way to do things? Think about it, and don't always use the same routine out of force of habit. Use splicing and dubbing techniques to their fullest in studio production.[1] Remember, you can use a splice on a computer or a minidisc for the following:

- Remove flubs from an existing tape.
- Insert questions or breaks.
- Insert **actuality** sound.
- Tighten up and remove lapses in any program.

You can use a dub to

- Play back a sound source in a more convenient format (for example, putting a short selection of music on cart to make it easier to locate).
- Take the place of a splice when you don't want to do destructive edits (or cut the tape and you're not concerned about adding another generation to the tape.)
- Free up a piece of equipment.
- Mix two or more sources together.

Remember, working in the studio environment will almost always entail striving for excellent quality and efficiency of operation. Although some deviation in quality might be acceptable in live coverage of a news event, something produced in-studio must sound good, with no lapses in mic technique or production values.

At the same time, remember that nowhere is the "time is money" equation more obvious than in the modern broadcast studio. There may be sev-

[1] Some of these suggestions don't apply to certain computer programs, but many of these tips work for electronic and physical splicing and editing.

eral people clamoring to use the studio, so doing your work in task-oriented sequence will be most efficient.

Summary

Many programs are recorded in advance because they are too complicated to be assembled live on air; in addition, program elements such as commercials that will be used over and over are recorded in advance so that the air person does not have to keep reinventing the wheel to produce them.

Production studios vary widely in size and complexity—from small setups in the corner of a room to large operations complete with state-of-the-art equipment.

The most efficient production work is done in task-oriented sequence; that is, production is organized according to the demands of the production schedule, meaning that the work is not necessarily produced in final sequential order from start to finish. It may be more convenient, for example, to produce the end of the spot first, then the middle, and finally the beginning.

Music is an important element in recorded program production. It comes from many sources, including the station's standard airplay library and specially licensed production libraries; sometimes, music is specially recorded for a particular commercial or other spot.

Miking multiple speakers usually involves setting up enough mics and channels so that the console operator can accommodate the natural variance in the power of the individuals' speaking voices.

Applications **SITUATION 1 / THE PROBLEM** The producer was setting up for a show in which he would be running the board for an interview with three guests. He had set up one omnidirectional mic. Everything worked fine, but one of the guests happened to have a very, very soft voice.

ONE POSSIBLE SOLUTION Although it is a good choice under other circumstances, the one omnidirectional mic wasn't right for this situation. Instead, the producer set up two cardioids, making sure that the patterns didn't overlap. The two strong-voiced guests were in one pickup pattern; the weak-voiced guest was in the other. Thereafter, the levels could be matched.

SITUATION 2 / THE PROBLEM The news director of a small station wanted to use a portion of a large office as an adjunct studio during election coverage. Unfortunately, the room was so lively that it sounded as though candidate interviews were being done in the shower.

ONE POSSIBLE SOLUTION The news director bought some heavy-grade cardboard at the local home-supply store. She made a frame of two-by-fours and used the cardboard as a partition, making the room (in effect) smaller. She also taped some old egg cartons to the wall to help deflect ambient sound and deaden the room noise.

Exercises

1. Prepare a commercial for a hypothetical upcoming concert. This very difficult production task is representative of the kind of activity you might be asked to undertake.

 This particular promo calls for the use of four cuts of a popular singer; although you generally don't use vocals for production work, you'll have no other choice when the assignment is to publicize a performance by a singer.

 To produce this spot, pick out a vocalist's album from your personal collection or from your college's or station's production library. Here's the copy you will use to produce the spot:

 APPEARING LIVE AT THE CIVIC CENTER ON JUNE 12, _____
 IN PERSON!

 (*first cut up, fade down*)

 JOIN _____ ON HIS/HER FIRST TOUR OF THIS AREA.
 HERE'S THE MUSICAL EVENT YOU'VE BEEN WAITING FOR.

 (*second cut up, fade down*)

 TICKETS ARE $15 AND $12, AND CAN BE PURCHASED FROM SMITH
 TICKET AGENCY OR AT THE CIVIC CENTER BOX OFFICE.

 (*third cut up, fade down*)

 DON'T MISS THIS CHANCE TO SEE _____ IN CONCERT AT
 THE CIVIC CENTER, JUNE 12 AT 7 P.M.

 (*close with vocal*)

 Your assignment is to produce the foregoing commercial by dubbing the music onto cart and doing the commercial in one take, starting the carts and crossfading as the copy is read (by you or by an announcer).

2. This time, first prepare the music bed by dubbing the cuts onto a minidisc, a computer or reel-to-reel tape. You won't be able to cross-fade, so butt the songs together. Now do the commercial by reading copy over the music bed.

3. Produce the same commercial, this time cueing up one disc at a time and stopping the disc, computer or tape after you've played the cut and read the appropriate piece of copy. Do the same with the other discs.

 There's no right or wrong way to produce this commercial, but trying it with all three techniques will give you an idea of the advantages and limitations of each.

Live, On-Air Production

*O*ne of the surest tests of production ability is to pull an airshift. An airshift usually involves announcing and running the console. This is the point at which all other production techniques come into play; thus, during the airshift, you are using all of your skills to produce the flow of sound that marks the unique character of your station.

You will, indeed, use all the skills we have discussed so far. The primary activity in an on-air situation is mixing sound sources through the console. Those sources, of course, go to the transmitter and over the air instead of to a sound file. It goes without saying that mistakes are to be avoided at all costs. There are no retakes, and a mistake such as a commercial that doesn't play because of an unrecued cart, which would be a mere nuisance in studio production, is a big problem on the air. For one thing, *dead air* is sloppy. To make matters worse, the commercial will have to be rescheduled (called a *make good*) and, in some cases, an apology given to the angry sponsor.

An overall consideration of on-air production is the rapid transition from source to source. This, really, is the essence of on-air performance. Most fast-moving formats center on what's called the *tight board*, meaning that there is hardly any space (in some cases, there is overlap) between sound sources. Experienced on-air producers develop a rhythm, a sixth sense of timing. Developing that sense is largely a matter of practice, though a thorough understanding of the job at hand will help.

Typical Airshift

On-air production is done by three types of radio station employees: the announcer who runs a board combo, the engineer who runs a board for an

Figure 8.1

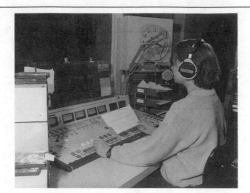

Working combo.

Photo by Philip Benoit

announcer, or a board operator at a station that may have automated part or all of its programming. The setup used at your station will largely be determined by a combination of station practices and union rules. In general, only the largest markets have a separate engineer running the board for the announcer. Combo operations (see Figure 8.1) greatly outnumber engineer and announcer setups, and it is likely that you will be running the board combo in your initial radio jobs.

Duties of the On-Air Producer

An on-air producer—the staff announcer or disc jockey—handles the combo operation. This type of production is complex and stressful, and it usually involves most or all of the following duties:

- Running the console
- Cueing disc and tapes, if music and commercials are not preselected on a computer
- **Riding levels** on sound sources going over the air
- Selecting filler music
- Announcing music, reading commercial copy, and in some cases, reading news
- Taping programs coming in from networks for delayed broadcast
- Answering the telephone
- Monitoring the Emergency Alert System
- Checking for important news items, monitoring the printout or the news computer terminal, and saving appropriate material for others in the station

Figure 8.2

Taking meter readings.

Photo by Philip Benoit

- Doing general maintenance, such as filing CDs, dubbing spots between computer and playback machines, and sometimes (in very small stations) doing the vacuuming
- Taking meter readings (see Figure 8.2)
- Keeping the program **log**
- Playing back news actualities during newscasts
- Performing off-air production work (sometimes done on the audition channel) when a long program, such as a baseball game or taped show, is airing
- In some cases, assembling and reading the local newscast

If you think these duties can be murderous, you're right. Pulling an air-shift can be mentally exhausting. Although listeners might think that playing music and doing a little talking for four hours at a stretch is easy, anyone who's tried it knows that exactly the opposite is true.

In addition to the hard work involved, acting as an on-air producer involves some potentially critical duties. In times of emergency, for example, the on-air personality must communicate very important information to the public. Weather emergencies often call for the on-air operator to relay news and information from local and area authorities.

There are many configurations of emergency systems. Your local authorities may have a system tied in with area stations, be it a radio transmission system or a telephone network. In addition, federal authorities require all

stations in the nation to participate in the **Emergency Alert System (EAS),** a government system established in 1994 that is designed to allow officials to warn the public about emergency situations. The EAS replaced the Emergency Broadcast System (EBS).

The old EBS system linked radio stations to the federal government through a "tree" method, where large stations would re-transmit the alert to regional stations, which would re-transmit it to smaller stations, and so forth. The system could transmit a brief message.

Even though the system was originally designed for notification of national emergencies, broadcasters found that using smaller branches of the tree system allowed transmission of vitally needed weather emergency information.

When the new EAS system was designed, officials decided to take advantage of the local capabilities and allow radio stations to more fully customize their emergency inputs. Now, an EAS alert can trigger several different sources, including weather stations, and the radio operator can receive and rebroadcast highly localized reports. The EAS monitor in the control room is activated by a "databurst," which sends a message that can be digitally stored and replayed moments after reception.

Each radio station must successfully log and receive three EAS alerts a month and transmit alerts three times a month. In addition, a monthly full-scale random test of the system is activated by the federal government.

Monitoring the EAS system is an important duty for the on-air producer. Each station's equipment is slightly different, and you will receive specific briefings from your station's management. In addition, you can learn more about the EAS at its home page: www.fcc.gov/cgb/consumerfacts/eas.html

Remember, although the duties of an on-air producer may be fun, those duties can also involve enormous responsibility.

Typical Schedule

How are these duties integrated into the working day? We've pieced together what is, from our experience, a pretty standard schedule for the morning and evening announcers at a medium-sized station (see Tables 8.1 and 8.2). We've broken down the duties into on-air and off-air tasks.

Both of these schedules reflect the beginning of a typical shift, though there can be infinite variations on the themes presented.

Remember, the announcer is also responsible for introducing the records and must be informative and entertaining in the bargain.

Sound of the Station

The primary responsibility of the on-air producer is to provide programming that reinforces the format and goals of the station. The identifying characteristics of the radio station are encompassed and expressed in what's known,

Table 8.1	Morning Schedule	
Time (A.M.)	**On-Air**	**Off-Air**
5:30–5:59		Arrives at station, warms up **transmitter,** checks with news reporter for update on top local stories, pulls minidiscs and makes other preparations for show, turns on power for console and other equipment.
5:59	Runs sign-on announcement with station ID.	
6:00–6:05	Puts network news over air.	Checks the computer playlist rundown for the morning. Readies the commercial log, and other materials for morning show.
6:05–6:07	Hits local news intro minidisc, cues news reporter, opens reporter's mic, rides level.	Plays reporter's audio cuts.
6:07–6:09	Says hello, introduces show, does some patter about weather, intros first song.	
6:09–6:12	Plays first song.	Puts together sports report from **newswire** computer and local newspaper.
6:12–6:13	Reads commercial.	
6:14–6:15	Reads weather forecast.	
6:15–6:18	Plays song.	Catches up on log entries, answers phone calls, takes some notifications of weather-related school closings.
6:18–6:19	Plays spots on computer.	Looks up next song, cues minidisc, times instrumental opening of next musical selection to allow for talking up to the vocal.
6:19–6:22	Reads sports report, plays spot for sponsor of sports report.	
6:22–6:25	Plays song.	Records ski report phoned in from correspondent, puts previously played minidisc away, cues up "Today in Business" program.
6:25–6:29	Plays "Today in Business tape."	Gets minidisc from news reporter tape for expanded local news report, records local road report phoned in from AAA.
6:29–6:30	Plays commercial, leads into local news report.	

Table 8.2	**Evening Schedule**	
Time (P.M.)	On-Air	Off-Air
6:45–7:00	Runs console for local talk call-in show (screens calls, puts calls over the air, runs second tape-delay system).	
7:00–7:05	Network news.	Reviews computer for music line-up.
7:05–7:07	Reads local news headlines and weather, intros music show.	
7:07–7:10	Plays song.	Starts DAT recorder to record network program for delayed broadcast.
7:10–7:12	Gives time and temperature, ad-libs spot from **fact sheet.**	
7:12–7:15	Plays song.	Downloads current weather conditions from news computer, monitors network for beginning of sports pregame show.
7:15–end	Sports pregame show and local game.	Monitors game for insertion of shift commercials and station ID, files logs, produces several spots.

loosely, as the station's sound. The elements of the sound are not only the types of music played. Also dictating the sound are the pace, content, announcing style, and blending of the program sources.

Pace

The schedules shown in Tables 8.1 and 8.2 reflect a rather slow-paced station. In many of the more frenetic stations, the program elements come fast and furious—a jingle here, a joke there, and then a spot or commercial cluster.

Maintaining a pace means checking yourself to ensure that your on-air segments are not too long (or too short, depending on the station). The delivery, too, will vary according to the pace of the programming at your particular station.

Content

The content of a station is what you say and play. It sounds obvious, but maintaining continuity of content isn't as easy as it might seem. For an on-air producer, continuity of content is maintained by not playing a blaring rock song on an easy listening station, or by not using a rapid-fire, teenager-type delivery when you are host of a Saturday night big band program. Conversely, a hot-hits station wouldn't want the announcer to be too laid-back

between two up-tempo selections. DJs usually develop a feel for matching song tempos and announcing.

Announcing Style

Although the focus of this book is production, on-air operations require a brief discussion of announcing. In combo situations, announcing and production duties are intertwined. The announcer is the producer, and vice versa.

The voice of today's radio announcer is a far cry from the characteristic golden-throated male voice heard on the air during radio's so-called golden age. The announcer of that era was expected to speak more dramatically than is the announcer today. A deep male voice was standard for announcers, and perfect diction was expected. The style of delivery was formal, with artificial variations in pitch and volume that would sound very odd if used in normal conversation.

Today, the deep baritone voice has disappeared in favor of men and women who can communicate effectively with the audience. Radio speech now closely resembles conversational speech. Announcers are expected to convey the impression of one-to-one communication with the audience. To do that effectively, radio personalities must be well versed in the tastes, interests, and lifestyles of the audience the station wants to attract.

Achieving the proper style of delivery is a matter of matching the style of the station's format. A country music station and a classical music station require different styles of communication. Whereas the country DJ may talk over the music at the beginning of a recording and talk about the artists who performed the music being played, the classical announcer will use a more formal style of delivery, leaving a gap between spoken introductions and the beginning of the recordings being aired. And the classical announcer will provide more information on composers than on artists.

To develop the skills that will help you become competent as an announcer, try to get as much practice as possible. If one is available at your school, take a voice and diction class. Take every opportunity to read copy in various radio styles, constantly striving for a conversational style. (It's not as easy as it sounds.) One major-market announcer says he developed ad-lib skills by describing the scenery as he drove his car to work each morning. Keep in mind that very few people are naturals at broadcast announcing. Hard work and constant practice are necessary for nearly everyone (see Industry Update).

Blending the Sound Sources

Some fast-moving rock stations have almost no on-air silence; in fact, some of these stations frequently combine as many sound sources as possible. The weather, for example, is read over the instrumental lead-in to a record;

Industry Update

WHAT TO DO . . . AND WHAT NOT TO

When you are running an airshift, you will be entertaining the audience with your "patter" and engaging them with the rhythm and sequence of what you play.

Or, you may be driving listeners away.

Radio program directors worry as much—perhaps more—about people tuning out than people tuning in. Indeed, "tune out" is a major factor in constructing the format and in choosing (and retaining) talent.

One of the top priorities of a producer who runs a shift and speaks over the air is to keep from irritating listeners. This doesn't necessarily mean not being personally disagreeable; a lot of "shock jocks" would actually be an irritant and tune-out factor to listeners if they suddenly became mild mannered.

The point: Tune-out happens when listeners don't get what they expect. If they want to hear the music and the DJ talks over it, they tune out. If they want to hear the DJ talk and he or she doesn't, they tune out.

Avoid the following "on-air irritants":

- *Too much hype.* Most staff announcers are toning down their deliveries. At the time of this writing, the "growling voice" and "in your face" delivery was out of favor in even the hardest-format stations.

- *Too many reminders about how much music you are playing.* Interviews with disaffected listeners confirm that when you continually stop the music to tell people how much music you are playing— TEN HITS IN A ROW!!—you irritate the audience. Remember that every time you say "less talk," you must talk to do it. If you are in charge of producing these "sweepers" (announcements about the coming music), bear this in mind!

- *Endless "pre-sell" on the music sweeps.* "TEN IN A ROW, COMING NOW, YES, TEN IN A ROW, THE MID-DAY SWEEP, AND HERE IT COMES . . ." may induce a listener to push a button before the sweep starts.

- *Laughing at your own in-jokes.* Air people sometimes like to convince themselves they are funny by chuckling endlessly with the weather reporter, but this doesn't always seem entertaining to the listener.

- *Stepping on the end of songs.* Listeners may actually want to hear the ending and will resent you talking over it or dumping out of it

Continues

Industry Update Continued

completely. Research shows listeners are irritated by missing the ends of current hits. On a related note, don't talk over the end of songs that end cold (without fading out).

- *Getting tricky with the call letters.* What's happened is that radio stations often use "handles" such as "Mix 101" that have no real relation to their call letters. As a result, when stations give the required legal ID (a direct statement of the call letters and place of station location) at the top of the hour, the announcers often try to bury it in a heavily produced montage that touts the station's handle. Listeners get annoyed by this. Just say the call letters, and don't make an enormous production of it.

- *Always talking over the beginning instrumental and butting up to the start of the vocal.* Focus groups say this is an irritant, and it is often heard as a self-indulgent exercise of the announcer's.

- *Insisting that you peg the VU meter with every sound element.* Research shows that listeners are getting tired of ceaseless blasting.

commercials always have background music; another sound source is always brought up as a piece of music fades. You would not, however, want to blend sound sources this way on an adult-contemporary station. And depending on the station's programming strategy, a country station may or may not use this style of blending sound sources.

Making sure your production values and techniques integrate with the sound of the station is one of the keys to successful on-air production. Following are some other suggestions that may prove helpful.

Suggestions for Live, On-Air Production

We can't address every specific situation because content, formats, and equipment vary widely. But here are some general suggestions for on-air work, along with some cautionary recommendations derived from experience (sometimes unpleasant experience).

Console Operation

You're usually better off closing keys and zeroing pots. However, with cart machines or minidiscs, you might want to leave the pot set at the appropriate

level. With CD players and turntables, it's a good idea to zero the pot to avoid cueing over the air. Be extremely careful of pots and keys that control the network lines and telephones. They have a habit of being left open when nothing is on line. When a signal is fed, it can come as something of a shock to the air person who left the pot open.

Establishing a Routine

However you choose to run the console, do it consistently. Get into the habit, for example, of always checking to make sure the mic is not up on the console before you say anything. Incidentally, make it a habit never to swear while you're in the radio station. If you make this a personal rule, you'll never let an obscenity slip over the air. The problems engendered by swearing over the air can be pretty serious, and it does happen, so make it part of your routine to banish cuss words from your vocabulary the moment you get near a mic. Mics can be relied on to be open at exactly the wrong time.

One other caution: Check the patchbay for patchcords that might have been inserted, and make sure that everything that is supposed to normal does normal.

Planning in Advance

A good console operator has to be like a good pool player who thinks several shots in advance to avoid getting into the position of not having a good shot. Think the same way in pulling an airshift. If your station does not have music preselected then pull as much music in advance as you can; get as many segments ready as possible. One phone call or other interruption can set you back significantly, and once you're "in the hole," it's hard to climb back out.

Being Aware of False Endings

A **false ending** on a record is music that sounds as though it's going to wrap up—but doesn't. The announcer, by this time, has probably started talking and will step all over the real end of the song. Sometimes commercials suffer from the same problem. You can avoid embarrassment and confusion by clearly labeling program material that has false endings. You might write *FALSE ENDING,* for example, right on the disc or cart label. (If your station uses a computer or minidisc for cart playback, it is possible to label the sound file with a way to identify such problems e.g. < sound file title—false >)

Many stations label carts with other endings. For example, if a cart ends with music fading out, the words *FADES OUT* are added to the cart label. Often, the last three or four words of the commercial script (called the *out cue*) are written on the label. This can be helpful to the operator in determining when a cart is coming to a close. It makes running a tight board easier, and it also avoids those embarrassing moments of silence known in the trade as *dead air.*

Recueing Carts

Today, computer programs and minidisc players have replaced the cart machine in many radio stations (see Tuning into Technology). Cart players automatically start playing a file when you press *start*. However, we estimate (and this is pure guesswork) that 50 percent of on-air foulups in stations that use analog cart machines are caused by carts that, for one reason or another, have not been recued. If you must remove a cart from a cart machine before it has been recued, make sure to put it in a special place where you'll remember to recue it before putting it back in the rack.

Listening to the Air Monitor

It's a good idea to keep the air monitor playing at a good volume. A low volume from the air monitor won't always allow you to hear, for example, the network line leaking over the air or a CD that is skipping. It is also important to monitor the station's broadcast through the off-air or air monitor source. Usually, audio console monitors allow you to choose between program, audition, and off-air sources. Though most experienced producers know this, many inexperienced operators have been surprised to find that the program they thought was being aired without a hitch was not broadcast at all because a patch was thrown or some other technical problem occurred without their realizing it. Why? Because the neophyte operators were listening to the program output of the board instead of to the off-air source. By the same token, keep your headset volume high enough to hear problems when you're announcing.

Clearing Equipment

Don't let CDs, discs, tapes, and carts stay on the equipment; clear them out as soon as possible. If you don't, sometime you will need a playback machine in a hurry, and there won't be one available. If you're using an analog cart machine, you'll also be more likely to put a previously played cart on the air accidentally. Clearing the equipment as you go along is one of the best habits you can develop for efficient on-air production.

Planning for the Worst

Nowhere is a mistake more evident than in radio, where an embarrassing silence underscores the fact that the on-air producer has lost control. One way to mitigate this problem when it occurs is to keep emergency material on standby (a 1-minute public-service announcement, an extra CD cut, or the like).

You will also want to prepare for engineering difficulties. Learn how to find and run a mic cord in case the control-room combo mic fails and you have to run another one (assuming, of course, no union restrictions bar you from doing this).

Tuning into Technology

AUTOMATED SOFTWARE PROGRAMS

Today many radio stations use automated software programs to play music, jingles, and commercial spots. The programs can be programmed to play sets of music, commercials, entire shows or the whole broadcast day. The software can be programmed by the program director or board operator to pause automatically for a specific length of time or indefinitely, allowing for talk, reading commercials, and playing announcements that are not programmed into the computer.

Figure 8.3 shows a screenshot for a program called OnTheAir. In the preset mode, this program functions like a cart machine so that jingles, **SFX,** or other events can be fired by the board operator at the touch of a keyboard letter. In the playlist mode, OnTheAir can run a partially or fully automated show, sequencing all the events such as music sets, commercial pods, voicers and jingles, one after the other.

Figure 8.3 *The preset mode of this software acts like a cart machine. Segments can be triggered by keyboard letter or by point and clicking.*

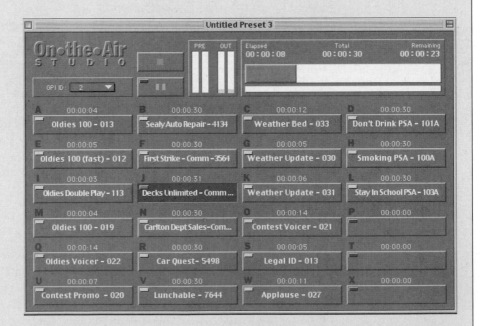

Courtesy of Intelligent Broadcasting Systems

Continues

Tuning into Technology Continued

Figure 8.4 illustrates how the software will automatically play songs, commercials and jingles in a preselected sequence. Note that both run-time and elapse time allows the board operator to gauge whether the show is running on time, early, or late. Program segments can be added, subtracted, or moved around while the program executes the "current" event, allowing for great flexibility in scheduling and tailoring the broadcast day.

Figure 8.4

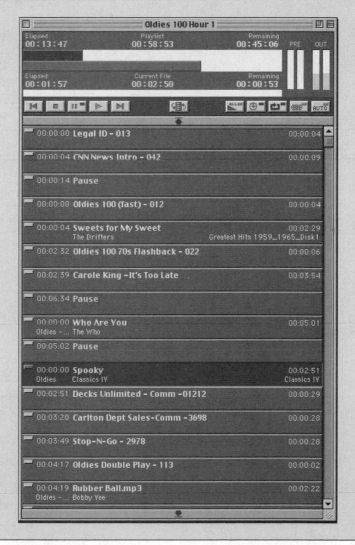

In the playlist mode, OnTheAir provides pertinent information such as total time, elapsed time, current event, and time remaining. Note pauses programmed into the playlist for the announcer to backsell songs.

Courtesy Intelligent Broadcasting System

Continues

Tuning into Technology Continued

Using OnTheAir in the playlist mode could permit radio stations to voice track entire shows by inserting pre-recorded disk jockey announcements after sweeps or before stop sets. The hour playlist shown here shows a live-assist situation.

News, weather, and other events can be updated hourly and stored on the computer's hard drive. As long as the sound file retains the name that matches the preset name entered into the playlist, the computer will play the appropriate newscast on the hour or will play whatever event is scheduled as the program director had scheduled it.

The board operator can program pauses in the playlist and add, delete, or move around the different program segments using the computer mouse. Figure 8.4 shows a music sweep (several selections of music played one after the other) and a jingle (oldies 100 70s flashback) set to play between cuts one and two of the music sweep. There is a pause set for after the sweep, allowing the announcer to "**backsell**" the last song from the music set. The computer will automatically pause, and when the announcer presses the key switch on the console, the computer will start the commercial cluster, then automatically sequence the next music sweep.

In fact, this program would allow the station to run as a completely automated facility. Instead of programming pauses into the sequence, voice tracks could provide the "backsell" and the patter before the commercial cluster. Today, more and more stations are turning to **voice-tracking** as a way to ensure consistency of sound and to reduce personnel costs.

Working with Satellite Services

An increasing amount of radio programming is beamed to the ground by **satellite,** received by special dish antennae at the station, and then rebroadcast over the local station. Such programming ranges from what is still anachronistically referred to as *wire-service* programming to a complete program schedule of music or talk.

Wire services are news-supplying organizations. Wire services, along with network feeds, most often do not enter a station by hard wire anymore. But although satellite reception of news and network programming has been standard practice for about a decade, delivery of entire formats by satellite transmission is a relatively new practice. Even so, it has already gained widespread acceptance.

Basically, when a station receives programming via satellite, it is the final step in a series of actions known as the *satellite feed.*

The Satellite Feed

First, the program material is produced at the syndicator's headquarters and is beamed (in technical terms, **uplinked**) to the satellite. The satellite acts as a relay: It picks up the signal, amplifies it, and rebroadcasts it to the earth. Because of the extremely high position of the satellite, the signal coming to earth covers a wide geographic range, eliminating the need for multiple transmitters to reach remote stations. Satellites can perform this function because they are **geostationary**—parked over the equator in an orbit that is exactly synchronized with the earth's rotation so that the satellite always maintains the same relative position to the ground. Satellites can retransmit several signals from varying networks, and many radio networks, including the ABC Radio Networks, which uses the AMC-8 satellite, use the satellite.

The station receiving the signal uses **downlink** equipment—a large dish often located on station property—to bring the signal into the console and eventually to the transmitter.

Programming from Satellite

Today, many types of program material are available. Here are some examples:

- *Services that provide complete music programming in various formats.* Such services typically have a carefully constructed format and top-class announcers. One example of a successful service is the Westwood One, which beams programming to more than 1400 stations in the United States. Among the diversity of programming that Westwood One provides are the following: CNN Radio News, CBS Radio, BET Radio, CMT Radio, NeXt and NFL sports programming. Westwood One also programs special formats such as modern rock, CHR, and classic rock on its Source Max network.

- *Networks that provide specialty programming in part-time or full-time talk and information formats.* These services are enjoying growing popularity on the AM band, where music programming is on the decline, primarily because listeners who enjoy music prefer higher-fidelity FM stations. Such services include national call-in programs and specialized format areas such as *AdviceLine* from TalkRadioNetwork. One of the most popular weekly call-in shows is *Car Talk* from National Public Radio, which features the comedy antics and advice of Tom and Ray Magliozzi.

- *Services that provide short-form programming for integration into member stations' existing formats.* Some of these programs are fairly substantial, such as a five-hour weekend program called *Open House Party,* offered from Superadio, a Boston-based weekend radio network and Mike Harvey's *SuperGold,* an oldies request show heard on more than 350 stations nationwide every Saturday evening. Thousands of discrete programs are beamed down to stations, including

news-and-information magazine programs, news reports, sports programs, and many business programs.

How to Use Service Material

An on-air producer has many options in dealing with material downlinked from satellite, depending on the particular station's format.

LIVE BROADCAST If the material is to be broadcast live and inserted into a locally produced format, the on-air producer treats the transmission as he or she would any other network program. Engineering staff will have wired the input from the satellite downlink into the console. You simply open a console pot at the time—the exact time—the program is due to start. Newscasts, business reports, call-ins, and special music programs can all be broadcast in this fashion.

DELAYED BROADCAST Often the material is recorded for later airplay; sometimes this function is automated. For example, large all-news stations typically receive a plethora of satellite news feeds from various services and opt to automate a bank of recorders to save this material. News producers then sort through the feeds at their convenience and edit particularly useful material for inclusion in newscasts. If there is no automation, the on-air personality is often responsible for recording the feed while performing other on-air duties. This usually involves patching the feed into a control-room minidisc or DAT recorder and starting the recorder manually.

LOCAL INSERTION In other cases, the on-air producer receives the complete program by satellite and must insert local programming, which usually accounts for a very small portion of the broadcast day. Such programming includes local commercials, news, weather, and locally oriented public-service programming.

Generally, satellite services will provide local affiliates with clear guidelines for the exact times allocated for local access. One common method is to use a clocklike representation called a *hot-clock* or *pie,* which shows each hour's programming and shows when

1. The service will be broadcasting music and commercials.
2. Local affiliates can insert their commercials. Each hour, affiliates might be allowed a maximum of 8 minutes of commercial time, with 2 minutes' worth of commercials originating from the network. Time is also allocated for local station identifications and promotional announcements. Some services allow several minutes of optional time, during which satellite programming is still delivered but local affiliates may opt to insert their own material.

Although inserts can be done manually, automation is an increasingly popular option. Ground-based automation can be programmed to function

via cue tones embedded within the satellite feed, beginning an automatically replayed local program element (such as a commercial) and then switching back to the network on receipt of another cue tone. Increasingly, satellite networks are devising methods to allow the network announcer to feed, through private lines, local IDs and weather forecasts; these are played back on cue, giving virtually complete local customization to the program. (For additional information on computer-based automation, see Chapter 15.)

Summary

On-air production usually refers to running the console live during a broadcast program. When the announcer runs his or her own board, this is known as *running combo.* The duties of an on-air producer are eclectic and usually include such varied tasks as playing or reading commercials, public-service announcements, and news; taking meter readings; operating all control-room equipment; pulling CDs for airplay; and filling in the station *log*—an official FCC document.

Operating a console during a live program is a difficult chore. Some of the operator's responsibilities are to maintain the integrity of the station's sound and to maintain the proper pace, content, and blending of sound sources.

Running the board can be made considerably less complicated if you establish a "safety first" routine: zero pots, close keys, recue carts, and so on. Plan your board operations; think the way a good pool player does, several shots ahead. Above all, be careful around microphones; they have a habit of being left open at inopportune times.

Modern satellite feeds allow the on-air producer to interact with a broadcast fed from one central transmission point. In some cases, all the on-air producer needs to do is insert local news and weather. Sometimes, the producer will have many local time segments that must be filled.

Applications

SITUATION 1 / THE PROBLEM An announcer's music show ends at 7 o'clock, when she has to hit the network. One problem she's been encountering is that the end of the show has been sloppy: She is always having to pot down the last CD in mid-song to hit the net.

ONE POSSIBLE SOLUTION The announcer adopted an upbeat instrumental for her theme song and started the cut, which ran 3 minutes, 20 seconds, at 6:56:40. She didn't put the cut over the air immediately though: The selection was dead-potted until the previous record ended around 6:58:10. The announcer then began her outro (a colloquial radio term for the opposite of intro) patter and faded up the dead-potted cut, talking over it.

Because the instrumental—which had a climactic ending—was backtimed to end perfectly, the announcer was able to hit the net cleanly and give a definite ending to her show. (Many announcers who have a standard theme keep it on cart.)

SITUATION 2 / THE PROBLEM The station had only two cart machines in the control room, but a great deal of the programming was on cart. On-air people had to pull carts out of the machines before they were recued to free up the cart machine.

Unfortunately, these carts had a habit of being played over the air in an unrecued state.

ONE POSSIBLE SOLUTION The program director (who couldn't talk the station owner into buying additional machines) installed a rack clearly labeled UN-RECUED CARTS. Air people were instructed to develop a routine of always placing the unrecued carts in the rack and to recue those carts as soon as they had a chance.

Exercises

1. Do a mock airshift that includes these elements: three disc cuts, two weather reports, a commercial or public-service announcement on cart, and at least 15 seconds of patter.

 Your airshift should use three styles:

 - Dance-band music and a middle-of-the-road approach
 - Fast-paced rock
 - Laid-back, album-oriented rock

 Don't worry so much about the quality of announcing because that's not the real purpose of this exercise. You should focus on production values. For example, would you talk over the instrumental introduction of a rock cut? How about the dance band?

2. Pick three local stations, and describe their sound in terms of production values. Listen for things like music and talk overlapping. Does the announcer talk for only a couple of seconds at a time? Or conversely, does the announcer spend extended periods in patter? Write down your observations, and discuss how the production values reinforce the sound of the stations.

3. This exercise is done strictly to time. You must fit all the elements into a 10-minute segment:

 - Exactly 1 minute of reading news copy.
 - Exactly 1 minute of commercial copy.
 - A CD cut from 2 to 4 minutes long.
 - Exactly 1 minute of community calendar listings from the local paper.
 - Enough weather to get you through the remaining time.
 - Dead-pot an instrumental disc while you are reading copy; the record must end exactly when your 10 minutes are up.

You're On!

TECHNIQUES FOR EFFECTIVE ON-AIR PERFORMANCE: AD-LIBBING

Ad-lib means, literally, to speak "at pleasure." You are saying what comes to your mind rather than what's written on the script. Ad-libbing is a critical skill for radio announcers, and to an extent it is a skill that can be learned and taught.

Here are some principles that can help you ad-lib gracefully:

- *Don't just open your mouth and let the words flow.* You must plan what you are going to say in at least some measure. Inappropriate ad-libs have ruined many a career.

- *Have a well of knowledge from which to draw your material.* It is essential that you are familiar with the music, the artists, and, if you are working in news, with current events. In fact, knowledge of current events is critical to every on-air position because events have a way of working themselves into any format.

- *Use this three-step process:* (1) Plan and encapsulate—sum up what you want to say in a few mental notes, (2) Deliver the ad-lib in bite-size pieces, (3) Keep it short.

- For example, you might be planning a weather ad-lib. Instead of opening mouth and letting fly (or inserting foot), break down what you want to say and encapsulate it:
 - It's still hot and dry
 - But some badly needed rain is on the way
 - It's going to rain all weekend, but right about now most people will welcome that

Now you can take a breath and deliver those three ideas in three or four phrases.

- *Remember to keep it short!* Beginning announcers almost always run too long, sometimes painfully long.

- *Before you say anything, think about whether it's appropriate.* Do you want to say something, or just talk? If it's the latter, play another CD cut.

- *Avoid in-jokes.* They seem funny to you and the person in the next room, but they are generally lost on the listener.

Continues

You're On! *Continued*

- *Practice eliminating pauses and interjections.* Saying "uhhhh" or taking long pauses is annoying. Although everyone needs to collect his or her thoughts from time to time, remember that interjections are more habit than necessity. If you consciously work to eliminate them, you will be surprised at how quickly you can do so.

- *Know the rules.* Beginning announcers are often surprised at how many restrictions and guidelines exist for what will be said on air. Sometimes, station management will go so far as to hand you a Rolodex with lines you are expected to say. Although this is frustrating, there is some reasoning behind it: Station management often has undertaken extensive research to find out what the audience does and does not want to hear. At the same time, remember that in most cases the music, rather than the announcer, is the "star." Find out what management expects you to say and work within the guidelines—at least at the beginning.

- *Know your format.* Ad-libbing requirements vary from station to station and from format to format, but as an example, here are some principles that are relatively constant:

 Country music requires a good knowledge of the material. It's very difficult to fake. And it is hard to fake liking this music. If you hate country, it's nearly impossible to pull it off. Remember that country music fans are intolerant of announcers who mix up names and facts about the artists, and *never* make fun of the music.

 Adult Contemporary often features the announcer in a "facilitator" role, bringing traffic, weather, school closing info, and so on all together in one place.

 In general, ad-libs that draw too much attention to the announcer's personality detract from the format, so you may find yourself required to submerge your personality somewhat.

 In Contemporary Hit Radio or Top 40, there are several types of personalities, including the rock jock, who keeps up a steady patter of information about the artists and the music, and the outrageous jock, who frequently skirts the boundaries of taste by wielding insulting humor. And at the extreme is the shock jock, whose reason for being is to annoy people and attract audiences who want to see how far the DJ will go. Be careful if you try to emulate shock jocks, because unless you have the considerable audience and financial

Continues

You're On! *Continued*

clout of Howard Stern, it is unlikely you will find any station management willing to put up with the headaches you cause. Make it a point to back off when your instincts warn that you are approaching the danger zone. But if edgy humor is required, don't back off too much; keep an eye on other humorists, and see how they make their jokes work and how they get away with it.

- In news or news-talk, there is no substitute for knowledge. You just can't fake an understanding of the news. When it comes to ad-libbing in this genre, be careful. One misstep could bring on a libel suit. Generally, you should follow the plan, encapsulate strategy, and *stick to what you know.* When ad-libbing news or information, don't speculate. You're much better off saying nothing than giving incorrect information. Also, be careful you don't come off as a "know-it-all." Don't speak down to the audience, and be respectful.

More About the Computer in Radio Production

The computer is an essential tool in radio production. In many stations it has replaced both tape recorders and cart machines, although it should be remembered that a computer is only one of several tools necessary for radio production.

Technological wizardry is not an end in itself; rather, it is a faster and more capable method of manipulating information, creating effects, and controlling various work functions. In this chapter, we address computer technology as it relates to both production and operations. In particular, we focus on applications of the computer to computer-generated effects, computer-assisted editing, on-air production, automation, programming, and digital audio broadcasting. In our exploration of computers, we necessarily repeat some material introduced in previous chapters, both for the sake of continuity and so that this chapter can stand alone as an assignment to be read out of numerical order. However, we keep redundancy and redefinition to a minimum. Before zeroing in on the specifics of radio applications, let's briefly introduce the computer itself.

Computer Basics

Few elements of modern life are so shrouded in mystery as the computer. Indeed, it appears as if those privy to the workings of the device deliberately try to mystify the uninitiated with incomprehensible jargon. But the basics of computer operations can be readily understood; although particular **hardware** (the computer itself) and **software** (the programs used to make the computer perform particular tasks) vary widely, most computers do roughly the same types of tasks in roughly the same manner.

As with many modern technological devices, computers operate digitally; that is, they work by means of a series of on and off pulses, with the on-and-off code expressed in digits. (In Chapters 3 and 4, we provided an introduction to digital technology.) The concept of digitizing information as on or off dates to the 1700s. One of the first digital applications was in a weaving loom: Paper punched with holes (later replaced by a card) determined the position of a part of the loom. If there was a hole, the loom would perform a certain operation; if there was no hole, the loom would operate differently.

The on-or-off principle was used in this instance to program the pattern for an entire woven cloth. Later, punch cards were used in a wide variety of applications in manufacturing and calculation.

Speedy calculation—the computer's forte—did not become feasible on a large scale affordable by consumers until the development of printed circuits, a direct descendant of the vacuum tube. A vacuum tube is a device for amplifying or otherwise manipulating a signal. Vacuum tubes were hot, fragile, and large. Eventually, scientists replaced the vacuum tube with transistors, solid-state devices that performed the same tasks as vacuum tubes but that were much smaller and mechanically simpler. Because of these characteristics, millions of transistors could be placed onto a circuit board, the genesis of the integrated circuit.

It soon became apparent that modern scientific techniques could replace the now-cumbersome arrangement of transistors on a circuit board. Using a process involving photography and engraving, scientists could produce an integrated circuit on a chip of material called *silicon;* thus, the silicon microchip was born.

Chips are the brains of the computer, performing the on-and-off tasks—manipulation of digits—that eventually add up to the calculation process. The on-and-off function in each instance is determined by the presence or absence of an electrical signal. A system offering these two choices, on and off, is known as a **binary** process; the computer represents information through this binary coding. A sequence of on-and-off pulses is used to denote numbers and letters.

Because these pulses can be generated, tabulated, and manipulated with lightning speed, operations can be performed with incredible rapidity. The computer thus becomes an invaluable tool for manipulating information. It performs millions of calculations in an instant, does not become bored or distracted, and possesses perfect precision within the scope of its operations.

The brain of the computer (the place where the master microchip resides) is called a **central processing unit,** or **CPU.** It is generally accessed through a keyboard, similar to the key arrangement on a standard typewriter, and the commands and a readout of the information are viewed on a video monitor.

The computer stores and retrieves information from a program in **random access memory,** or **RAM.** The other type of memory in the computer is the **read only memory,** or **ROM,** which is built into the computer at the factory and cannot be changed.

The information in RAM, which usually is where the software program is loaded, along with whatever information you have loaded in or entered from the keyboard, stays there only as long as the computer is turned on, which makes long-term storage in RAM impractical. For this reason, computers are equipped with storage mechanisms, usually in the configuration of a device for writing information on a disc.

The ability of the computer to manipulate information, as we mentioned, is its strength. Simple storage is not a particularly compelling reason to use a computer. For example, 1,000 recipes might more easily be kept on 3-by-5 index cards than keyed into a computer. However, should you desire to sort out all the recipes calling for eggs and parsley, your task would be monumental if done by hand; however, it can be accomplished in a few seconds by the computer, which will patiently but quickly check the ingredients of each recipe for a match with the ingredients you identify.

Such inhuman patience and speed also have applications in the field of radio. As an example, consider how the microchip now enables a producer to store and manipulate a variety of sounds.

Computer-Generated Effects

Musicians and independent commercial producers are taking increasing advantage of the versatility of a device known as a *musical instrument digital interface*, called *MIDI* and pronounced "middy." The **MIDI** controller device (see Figure 9.1) is a digital tool that allows a producer to synchronize any number of electronic musical instruments and other sound-production devices, including standard tape-recording units, with a computer. You can think of MIDI, therefore, as a communications link between electronic musical instruments and electronic controlling or processing devices such as synchronizers and computers. Newer digital consoles have MIDI inputs so the console's faders can be turned on or off from within the computer software program. With MIDI devices, it is also possible to produce entire music tracks or special effects, such as "laser beam" sounds used in a science fiction show.

Figure 9.1

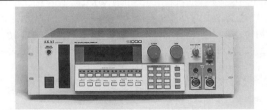

A MIDI controller enables producers to synchronize various sound sources and sound effect devices with a computer.

Photo courtesy of AKAI Professional, Fort Worth, Texas.

Figure 9.2 This MIDI synthesizer is capable of producing the sounds of many different instruments simultaneously.

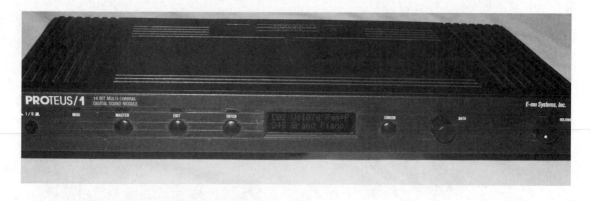

Photo by Fritz Messere

A producer with musical skills can also use the computer as a MIDI controller in conjunction with a **synthesizer** (see Figure 9.2), and a keyboard-like device can produce a wide variety of sounds. Some synthesizers, for example, produce realistic sounds by combining many different tone and frequency generators together. Each generator is called a *voice*, and synthesizers can use them to produce the sounds of grand pianos, horns, drums, cars, and so forth; some can produce many sounds simultaneously. When a synthesizer can both simultaneously play several voices that sound like several unique instruments (say, a bass guitar and a piano) and allow you to control those voices separately, it is called *multitimbral*. Using a multitimbral synthesizer, a MIDI sequencer, a drum machine, and a digital audio workstation, you could reproduce the sound of a small band or create small sound loops for use in commercial beds.

A sequencer is a device that enables you to record different channels of MIDI information into some kind of memory, such as a hard disk. Computers are frequently used as sequencers, and they allow you to record 16 or more channels of information (Figure 9.3).

Although MIDI has many functions that cannot be covered in this broad treatment, here are a few ideas to think about. By using a sequencer, you can control a multitimbral synthesizer or several synthesizers simultaneously. The sequencer does just what the name implies: It sends a sequence of data to the devices, instructing them to play a certain note at a certain time, to make it a certain length, and to make it sound like a particular instrument. In a sense, the sequencer acts like a recording device because often you record your music by playing a synthesizer and connecting the MIDI output directly into the sequencer, which memorizes the instructions necessary

Figure 9.3 This sequencer also has the capability to synchronize MIDI tracks with analog
devices such as a multitrack recorder.

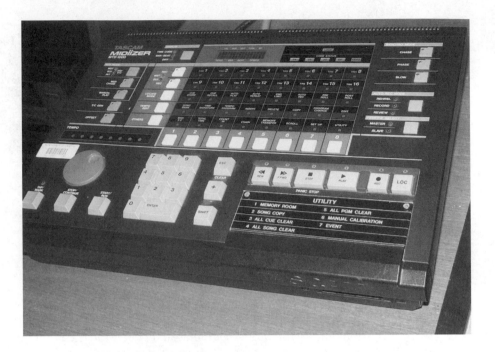

Photo by Fritz Messere

to play the notes including the tempo and the individual timbre and charac-
teristics of the notes.

Let's return to the example of an electronically created small band. Sup-
pose that you wanted to record an original music bed for a local sponsor.
Here's what you might do:

1. Program a drum machine to provide a tempo and a beat that meet the
 requirements for the spot. The sequencer would record that information.
 (Remember that the computer records data in the form of digital bits,
 not in the way we typically think of a tape machine recording a conven-
 tional drum set.)

2. Program the synthesizer to reproduce the sound of an electric piano; the
 piano's part is played on the keyboard and recorded by the sequencer.

3. The synthesizer might be programmed to play a bass guitar, and you
 would play a bass line for our music bed. Most sequencers allow you to
 set pointers to get the tracks to line up correctly.

4. Play back all the channels recorded by the sequencer, which controls the drum machine and all the voices of our synthesizer. If you are satisfied with what you hear, you can dump the audio output to tape or some other recording medium; the music bed for the local spot will then be ready for use in producing the commercial.

Here's a common example of how MIDI controllers can turn many different electronic devices on and off. *MIDI Machine Control* (MMC) is a protocol that was developed to allow hard disk recorders and sequencers to be remotely controlled. Many modern special effects devices such as *reverbs* have MIDI interfaces so you can call up the desired special effect, such as an echo, from your digital audio workstation (DAW). In this way, the DAW could turn on the effects unit only for use with certain tracks such as commercial announcer's voice track, but not for other segments of the sound file, such as the music bed. The capability to control the special effects unit allows a sequencer to turn the unit on and off with precise synchronization for the vocal track.

New computer software programs can take advantage of the computer's ability to use MID files to perform like sequencers. The Industry Update discusses how these functions can be combined into a music creation program.

Many firms specialize in providing sound-effects software to users of MIDIs; one company currently offers about 300 sounds on a ten-disc program that sells for only about $60. The variety of sounds, coupled with the computer's ability to manipulate each sound and to create music and musical effects, makes the MIDI system an attractive alternative to sound-effects and theme-music libraries on LP discs or CDs, which can cost more than $1,000 per year to license.

Computer-Assisted Editing

As noted in previous chapters, digital technology has replaced the use of razor blades and splicing tape in most radio stations. Currently available digital audio workstation technology makes it possible to perform sound editing functions with far greater ease and accuracy than ever before. The use of computer hard disk audio recording essentially eliminated the need for tape as a medium for storing the audio information you will edit.

The typical editing suite in stations that uses such technology features digital storage on hard disk of all information—music, dialogue, and sound effects—in computer memory, with a video display used to chart and manipulate the sounds. Many systems are available for both PCs and Macs. Other systems are proprietary, using their own operating systems.

Such systems rapidly replaced the hand-done processes of physical editing of tape through splicing and dubbing. They are also making computer controls linked to analog tape machines unnecessary. (The word *analog* means a "corresponding image," and it is used to refer to the similar image

Industry Update

SMARTSOUND

SmartSound is a computer-based program that allows a producer to create royalty-free music or sound effect beds for radio commercials or audio tracks for video segments. Using the power of a computer to facilitate logical transitions between music segments, SmartSound is able to build custom audio beds of specified length. There are two modes to the program. In the *Maestro* mode, a wizard-oriented helper program guides you through the process of building a music bed by selecting mood, instruments, length and effects. For example, it is possible to specify a 13-second theme with rhythm and brass and have the software program develop this bed for immediate use. If the music was good but the timing was wrong, you could then specify a 14- or 15-second theme with rhythm and the computer would immediately produce the new variation requested.

The key to making this software work is the use of instrument loops built into the software. But, suppose that SmartSound created a bed that timed out right but had too many components. The *Editor* mode allows you to "see into" the structure of the music bed. The bed consists of a number of "blocks" that contain the loops for the different instruments. The

Figure 9.4 In the editor mode, the producer can arrange music segments to produce individualized music beds.

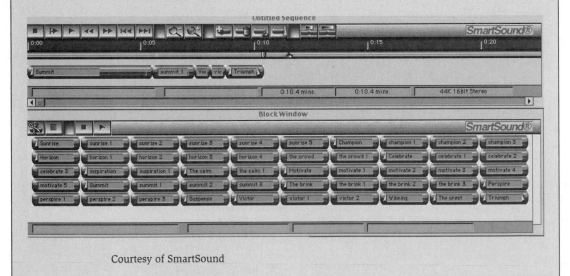

Courtesy of SmartSound

Continues

Industry Update Continued

editor mode allows you to rearrange the sound blocks in the order that you choose, allowing you to customize the specific bed (Figure 9.4).

Dozens of library discs, containing different loop samples, are available. Using the different discs allows you to change your beds with different genres or styles of music, also changing the mood, tempo or theme. For example, some discs focus on acoustic themes while others contain loops for orchestral music or latin rock, still others provide sound effects which allow the user to mix sound elements together while specifying parameters such as bed length, tempo, and style.

The advantage of creating custom mixes for commercial clients is obvious. Frequently custom music is scored, arranged and produced by small audio production houses. If the station has a client who is unwilling to pay for original music scoring but wants a special sound, software packages such as SmartSound provide a low-cost alternative to creating original music scores.

of sound reproduced by standard reel-to-reel tape recorders, cassettes, and cart machines.)

In today's digital workstations, the operator uses one of several methods of locating and retrieving the various sources to be edited together so that they can be manipulated with the aid of a computer monitor to create the desired results. The edit can be made and auditioned, and if the edit point proved to be incorrect or some other aspect of the edited playback was unsatisfactory, the points on the waveform can be changed and the edit redone. As mentioned previously, most DAW software allows you to use nondestructive editing so there is no risk of losing or damaging the original audio material because the process that takes place on the screen can be reversed without damage to the original sound file. The operator can repeat the process again and again until a satisfactory edit is achieved. Usually the audio material in use during the editing process is stored on the hard disk in a sound file while the edits are stored separately in the computer memory as a "virtual track" or as a "scratch track" (a separate temporary file on the hard drive), so there is no risk of destroying the original through mistakes in editing.

Once the edit has been satisfactorily made, the resulting new material can be stored for eventual use in whatever way is intended. An obvious question arises: How can sound be represented on a computer screen?

Most DAW systems create a waveform on the computer screen as we discussed earlier in the book. When the editor recognizes the portion of the waveform that corresponds to the material to be deleted, the **mouse** of the computer is used to delete that portion of the wave pattern. Again, if an error

is made, the information is redisplayed and the process repeated until the edit is achieved. In most modern systems, the edited version of the sound file is stored temporarily by creating a virtual track.

Computer technology also is very convenient for eliminating noise that may occur on a recording. By looking at the sound pattern on the computer screen, you may easily identify the noise as the pattern that falls only above the center line (see Figure 9.5a)—unlike the waveform of natural sound, electronically produced noise is different in character. In many cases, it has only a positive or negative waveform, and for reasons that are beyond the scope of this chapter, the pattern often falls visually on only one side of the center line.

To edit out the noise, the producer can simply select the portion of the sound pattern (see Figure 9.5b) that represents the noise and instruct the computer to "remember" that pattern and to delete it wherever it is present on the recording. Other software packages can remove pops and clicks from analog recordings or reduce sibilance in speech.

This representation, sometimes called a **sound envelope,** is much easier to work with and manipulate than you might at first imagine. For example, suppose that, in producing a station promo, you begin by playing back a recording of an announcer speaking; let's assume that the announcer has recorded the words "WRVO Public Radio." As you play back the words, you will see the varying patterns displayed as the words are spoken. Because you can stop, start, or reverse the words, you have the ability to monitor how the waveform changes with the spoken words. (The same can be accomplished in dealing with music.) The steps in a typical digital editing sequence are illustrated and described in Figure 9.6a–g.

Suppose that you want to remove the word *public* and make the ID simply "WRVO Radio." Here's one way to approach the task:

1. You would move a computerized pointer to the part of the wave that indicates the end of "WRVO" and electronically mark that spot by entering the appropriate computer command.

2. You would then repeat the process by marking the waveform before the beginning of "radio."

3. Through a series of commands (which would depend on the particular menu provided with your software), you would then instruct the computer to eliminate the word *public* and splice "WRVO" and "radio" together. If there were too much or too little space between the words, you could call up the previous menu and rework the edit.

4. Your options don't end here. You could add reverb to the words, mix music beneath them, or speed up or slow down the pace of the words.

New-generation equipment can accomplish all these effects and more. Macintosh computers, favorites of producers who use MIDI programs to interface with computers and synthesizers, can be used to interface with a digital editing system. Many broadcasters also use a variety of PC-based editing systems.

Figure 9.5 A sound pattern that includes noise.

a. The noise is the portion of the waveform that falls on only one side of the center line.

b. By selecting the noise with the mouse and blocking it, you can instruct the computer to "learn" the pattern and delete it whenever it occurs.

Photos by Fritz Messere

Figure 9.6 Modern digital systems allow you to edit words or music.

a. To edit a commercial at this digital editing station, you first save the material for the commercial spot on a hard disk. The notation at the top of the insert shows that 3½ minutes of recording time take up nearly 44 megabytes of disk space.

b. Each time you find our "in" and "out" points, you highlight the areas or "regions" on the computer screen.

c. You save these edit points as "regions" and give each region a name so you can identify it for editing purposes.

Continues

Figure 9.6 (Continued)

d. Once each region is saved, the computer will display it in a "playlist." You can develop many "rough cuts" by dragging region titles from the upper left corner of the screen to the bottom half of the screen. When you press "play" the computer will play the list from start to finish.

e. The computer lets you choose the type of transition as well as the duration and volume for each of the segments in the playlist. Note that exact times can be seen for each item on the playlist. You can organize and change the play order until you are satisfied with your commercial.

f. Menu items across the top of the screen give the workstation great flexibility to merge and mix sound sources together without destroying the original recording or files.

Continues

Figure 9.6 (Continued)

g. Icons along the top of
the screen give you
access to various
software functions.

Photos by Philip Benoit

The Dyaxis II digital audio system, for example, interfaces with Macin-
tosh computers and allows the user to visualize splicing and assembling func-
tions on the computer's screen; the system's windows and menus mimic a
standard audio console, allowing you to mix, pan, cross-fade, edit, and so
forth. (In current usage, the term *digital editing system* means a system of
hardware that can control all functions of standard editing, whereas a *MIDI*
generally refers to a device used to hook synthesizers, controllers and other
sound-generating sources into a computer. There is obviously some overlap
in the functions.)

The Dyaxis II system and many other editing controllers allow you to
work with what's known as the SMPTE time code. (*SMPTE* stands for Soci-
ety of Motion Picture and Television Engineers.) The time code is electroni-
cally laid down on tape and identifies a precise address on the tape 30 times
per second. Although originally developed for editing videotape, SMPTE time
coding is increasingly used in audiotape editing.

At present, a computerized visualization of an audio console would be dif-
ficult to use while running an airshift, but the technology has almost reached
that point. Many stations have begun using touchscreen automation assist sys-
tems (see Figure 9.7), which allow announcers to select from a number of
sound sources merely by touching the appropriate spot on a computer screen.

Touchscreen systems allow on-air talent to execute a variety of functions
with great ease; some of these are listed on the screen shown in Figure 9.7.
For example, a news announcer can call up fast-breaking copy and read it di-
rectly off the screen; alternatively, the announcer can put the network on the
air simply by touching the appropriate part of the screen.

Figure 9.7 This computerized system allows the on-air announcer to select from a variety of sound sources by simply touching the appropriate spot on a computer screen.

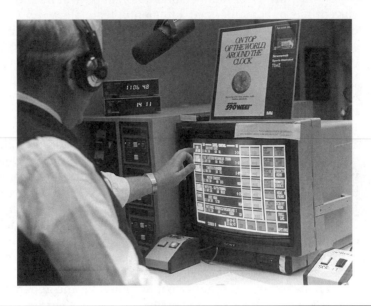

Photo by Philip Benoit

The traditional radio console, incidentally, is becoming smarter thanks to microchip technology. Some modern digital consoles use computer software to recall particular settings. For instance, you might have a particular setup for leading into the news: playing a music cart backtimed for the last minute before the news, lowering the volume on the music and opening the mic to promo the songs coming up after the news, music up, music cross-fading to stinger, stinger ending, and network pot opening. All this can be programmed into the board's memory, with the correct levels coming up each time. If a level is too high or too low, the adjustment can be made and stored in memory.

Smart consoles, of course, have many applications in off-air production, too. An edit can be rehearsed many times, and settings corrected until the result is perfect.

Computers in Automation

Probably the most immediate and visible application of computer technology to radio is in the area of automation and live-assist automation. **Automation** basically means an apparatus for running programs with a minimum or absence of onsite human labor. **Live-assist** refers to automatically sequenced

commands designed to help the person running the console execute a series of commands.

A brief history of radio-station automation will help you understand the current role of computerized automation technology. Automation first came of age in the late 1950s and early 1960s via what now appear to be cumbersome methods of automatically cueing sound sources. The development of the cart machine and its eventual widespread use in the 1960s greatly enhanced the promise of automation: The cart could recue itself and could be loaded into various mechanical devices capable of transporting and playing the cart.

In the early to mid-1970s, cartridge **carousels** became extremely popular. The carousel was a circular device that rotated and brought the carts into contact with the playback device; usually, the carousels were synchronized with reel-to-reel tapes (supplied by a syndicator), which had to be changed by hand every few hours.

Automation appeared to be the answer to the problems faced by many stations, large and small. It drastically cut back on personnel costs and generally provided high-quality program material. The prerecorded voices of the announcers were of the highest quality, and the music was carefully selected according to ostensibly heavily researched criteria.

But station owners found that automation, the apparent answer to any station's financial woes, could actually drive listeners away. Audiences soon tired of the transparently canned format of many of the syndicated programs offered for automation systems. Many stations brought back live announcers for the entire schedule or for certain high-listener periods and used automation for slow times such as overnight shifts.

Just when automation appeared to be on its way out, though, computer technology brought it back to the forefront of radio operations. Modern automation uses computer technology to accomplish tasks difficult or impossible to do with older-generation systems involving complex hardware and mechanical relays. The on-air function can use traditional automation, or it can use sophisticated computer programs to interface with satellite-delivered programs. Such programs use microcomputer hardware in conjunction with software packages that control station programming (see Figure 9.8).

For example, in stations where programming is received by satellite, the computer system senses cue tones that are fed along with program material. The tone is separated from the program signal and fed to the satellite-interface equipment. Such tones then activate local program elements, which are integrated into the satellite-fed programming.

Here are some examples of what cutting-edge automation technology can do:

- A satellite feed beams down modern music in a tightly controlled format; music is back-announced by a highly professional announcer located at the system headquarters in a major city. As one song is about

Figure 9.8 Automation software can be triggered via the audio console. This software tries to create the look of a cart machine.

Photo by Fritz Messere

to end, the satellite beams down a 35-Hz tone, which activates a cart machine at the local station airing the satellite-fed program. The cart says, "You're listening to [local station's call letters]." Then the satellite feed takes over, with the announcer saying, "That was [name of song and artist]."

What's happened is that the automation system has customized the satellite broadcast service, ensuring that the automation doesn't have the canned quality. Certain automation systems even have a method for the announcer to feed a local weather forecast to the particular market; that forecast would be recorded and called up by the automation system at the appropriate time.

- A radio newsroom features a central computer with several terminals; reporters and editors can tie into a single system and exchange information with one another, as well as accessing network and wire-service

news feeds. There's no one running back and forth trying to find copy; it's all instantly accessible. In addition, reporters carrying portable computers can feed pages of copy back to the newsroom via telephone.

- An automation system based on storage of digital tape allows as much as a week's worth of continuous programming, with the whole system operating untouched by human hands.

As in many other areas of radio operations, in automation too, digital technology is revolutionizing the industry at a rapid clip. Whereas traditional radio station automation systems have depended heavily on program elements recorded on tape cartridges that played according to instructions received from satellite- or computer-controlled interfaces, new systems eliminate the tape cartridges. Systems like Maestro, from Computer Concepts Corporation, allow for unlimited use of program slots in the broadcast day. All commercials, songs and voice tracks can be stored, sorted and logged by the system. This is possible because the system uses digital storage of audio on hard disk. Such digital systems also control the sequencing of program events so the program director could shuffle music sweeps, vary spot sets and cross-fade in and out of jingles. When searching for specific program elements, such as music, it is possible to search by song title, category, or length. Many systems allow the program elements to be coordinated between a satellite source and the local "stop sets" so that the transition is undetectable to the listener.

A common problem with satellite automation systems is that it's difficult to precisely time all program elements to fit the periods allocated for local inserts such as commercials, IDs, and information reports. Modern digital devices, such as the one in Figure 9.9, take care of such problems through the use of expansion–compression programs that stretch program elements that are too short and shorten them when they are too long. This results in local breaks that precisely fill the time allowed by the satellite program system. When a program element is missing because of an error, backup announcements of the correct length are automatically substituted so that the gap is not noticeable to listeners. The ability to play two recorded sources simultaneously allows for a live feel to the automated system, for example, by making it possible for the end of one commercial to overlap the start of another.

Such computer-driven digital systems also are linked to traffic (scheduling) and logging functions so that a time-linked record is kept of all program elements that are aired. Billing can be done automatically with verification of the time at which the client's commercial ran, and all program elements are logged. For example, Smarts Broadcast Systems has a radio billing and traffic system that generates daily logs for the station. Program material such as spots and jingles can be assigned into particular stop sets or fixed in station break positions. The software will automatically generate standard co-op tear sheets and billing information for the sales staff.

Figure 9.9 This automated program controller provides an interface between various station-based audio sources and the station's automated programming service.

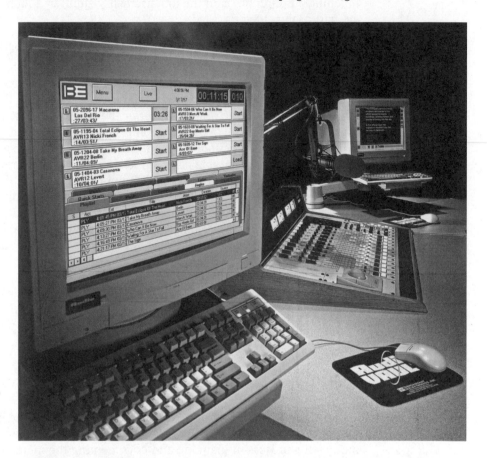

Photo courtesy of Broadcast Electronics, Quincy, Ill.

In the area of traditional station-based music programming, digital systems are capable of generating music playlists for various periods such as a day or a month at a time. Music can be categorized by artist and style of music and automatically scheduled to play only in **dayparts** that are appropriate to each selection.

Although some would argue that automation is not in the best interests of the industry as a whole—in fact, jobs are lost as a result of the expanding technology—automation does offer certain advantages to radio employees and to listeners. For employees, live-assist automation makes things easier on the person who runs the console. Now he or she may have to push only

one button to trigger a sequence of five or six events. Computer-driven systems make it possible for many time-consuming tasks to be accomplished by touching a button or, as in the touchscreen system, by touching an appropriate part of the video monitor.

An increasing number of radio professionals will have to become computer literate and comfortable using the new technologies. There is a perceptible trend toward requiring announcers to run combo, even in large markets; for example, a number of CBS owned and operated stations are requiring talent to work combo as a money-saving measure.

What benefits does automation offer the listener? Points can be made on many sides of the issue, but many listeners do enjoy the concept of top-quality satellite programming supplemented, thanks to computer control, with local inserts. Even small markets can have top-quality music formatting and announcing coupled with locally originated material.

Some small-market personnel originally assigned to spinning discs (the same records available anywhere in the country) have had their job focus changed to local news or community service when the station has changed to satellite services. In some markets, jobs of announcing staff have simply been eliminated.

News and public-service programming, however, can benefit from computer technology. KCBS in San Francisco is one example. The station is equipped with more than a dozen terminals and special news software. Though not strictly a form of automation, the system does provide a method of speeding operations by computer.

Computers in the Programming Function

Although the word *programming* has many meanings in the context of radio production and operations, the activities comprehended by one specific definition—the process of planning and documenting the material aired over the station—are greatly speeded up and enhanced by computer technology.

Scheduling music, commercials, and other program elements is extremely time-consuming and complex. But the situation is eased considerably by specialized software. Radio station WHDH in Boston, for example, uses Columbine programming software and an IBM computer to accomplish the following tasks:

- Keep track of all program elements and provide a printout (log).
- Make a record of all commercial availabilities.
- Ensure that commercials for directly competing products (two airlines, for example) are not scheduled within a certain time of each other.
- Provide salespeople with a way to program a flight of spots immediately and to let the sponsor know the airdates.

- Automatically generate bills for spots aired.
- Allow sales management to compare records of individual salespeople and to use projections (quotas) for each salesperson.

The possibilities for computer use in all areas of radio—producing special effects, editing, on-air production, automation, and programming—are virtually limitless. But even the most devoted apostles of high-tech are quick to warn that gadgetry is not an end in itself. The computer can perform work faster and can make it easier, but it cannot make good radio. Good radio is made by the skill of the producer and is played out in the brain of the listener. Radio, after all, is center stage in the theater of the mind—and imagination will never be supplanted by gimmickry.

Digital Audio Broadcasting

Any discussion of computers and their applications to the digital audio systems would be incomplete without considering the ultimate outcome of these efforts to improve the audio product—the delivery of radio programming to listeners.

Digital audio broadcasting (DAB) involves a fundamental change in the way radio signals are transmitted and received. As you know from our discussion in Chapter 1, currently both Sirius and XM radio broadcast systems provide more than 100 channels of direct satellite service to consumers. Several terrestrial-based systems are now under development, too. The FCC is also studying the question from the perspective of whether it is feasible to transmit local digital broadcast signals without affecting current AM and FM stations.

Previously, a major issue in considering the viability of terrestrial distribution of digital audio broadcasting was the question of assigning it to some portion of the band of frequency spectrum—that is, whether the technology can use portions of the existing frequency band now assigned to radio broadcasting or if it will need new allocations of the already crowded frequency spectrum.

Such a system would give each radio station the capability to simultaneously broadcast an analog and a digital version of their programming. The ramifications of such a move are immense. For example, a digital system would significantly improve the quality of the AM broadcasting signal, making it more suitable for music formats. Similarly, the quality of FM broadcasting would increase to the level of CDs. However, there may be downsides to a terrestrially based system as well. Tests will determine the suitability of the in-band, on-channel system.

Digital audio broadcasting offers many advantages over the current analog-based system. Perhaps most important, it will allow radio listeners to enjoy

the full benefits of digital audio. Currently, all the benefits of the high-quality audio produced in the production studios of radio stations are limited because the signal must ultimately be fed through analog equipment for transmission. The effects of such benefits as increased dynamic range, freedom from noise, and the crispness of sound inherent in digital audio are severely hampered by traditional radio transmission.

There is also the potential for various additional services to be delivered via digital radio transmission. Some are exotic, such as still video, presumably to be married in some way to radio programming. Other uses under consideration include the transmission of text and graphics for news applications, for information about music and artists, or for marketing and promotional purposes.

The full impact of the digital revolution in radio broadcasting still remains to be worked out in the marketplace. As for the preparedness of the industry to meet the technical challenges of this technology, however, the industry is undoubtedly ready to develop the technology that will fully exploit the promise offered by digital audio in radio programming.

Radio of the future promises to differ significantly from radio of the past. Will the changes also be improvements? The answer to that question depends on the same key factor that has been responsible for the long record of success compiled by the radio industry as a whole—the talent and vision of the people who produce and deliver the programming to listeners.

Summary

The modern computer uses hardware (the system itself) and software (the programs) to accomplish its goal. The computer can calculate at incredible speed.

One particularly useful function of the computer in radio is to create effects, including music, using a musical instrument digital interface known as a MIDI. You don't have to be a skilled musician to use a synthesizer and a MIDI; the programs for creating music are user friendly.

Computer-assisted editing is finding greater acceptance in radio, though it is far from the norm. In computer-assisted editing, the information is stored digitally and manipulated through visual representations on a computer screen.

Perhaps the most visible impact of computer technology in radio is in automation and live-assist. Automated gear can be incredibly flexible, and live-assist can allow an operator to handle many complex tasks by touching one button or, in some cases, just by touching the computer screen.

Computers have an important role in the programming function. Today, even small stations use computers to generate logs and schedule program elements.

Digital audio broadcasting—the process of encoding audio into digital language—may allow increased fidelity on a fairly small bandwidth. This improvement could be a boon for the ailing AM radio industry.

Applications SITUATION 1 / THE PROBLEM The producer wanted to put together a station promo package featuring a chorus chanting the station's call letters. Unfortunately, only two announcers were on duty, and volunteers for a chorus were nowhere to be found.

ONE POSSIBLE SOLUTION Using a DAW and sound-processing equipment, the producer laid down two voices in digital storage, changed the characteristics of the voices slightly, laid them down again on new tracks, repeating the process until he had what appeared to be a chorus of more than a dozen voices.

SITUATION 2 / THE PROBLEM The production manager of a station that was interfaced with a satellite service did all of her production on a digital editing unit. Her most recent effort, though, needed some work. Unfortunately, a voice-only commercial cut to fill a 60-second hole ran only 57 seconds. There was no time to call the announcer back in to recut the spot.

ONE POSSIBLE SOLUTION One aspect of digital storage is the ability, in some hardware, to speed up or slow down the playback. Slowing down a playback excessively would distort the voice, but stretching it by 3 seconds was hardly noticeable—much less noticeable, certainly, than 3 seconds of dead air on an all-hit music station.

Exercises 1. If the appropriate equipment is available, record the following effects. The content is not the central issue; what is important is to note how manipulation of the sound changes the effect produced. Produce and record:

- A series of notes or tones of steady pitch, with a fast attack followed by a diminution of volume
- A series of notes of steady pitch, where the tone builds up to a crescendo at the end
- A series of notes of steady pitch, with no change in volume—just an abrupt on-and-off attack
- A series of notes in which the pitch changes rapidly or warbles
- A hissing noise similar to the white noise of a running shower or the static of snowy television

2. Again, if the equipment is available, draw representations of the waveform (envelope) pictured on the screen for each production in Exercise 1. (Do

them to the best of your artistic ability, but remember that drawing skill is not the point here.) Show the drawings to, and then play the sounds for someone who is not familiar with this exercise, and see if he or she can match the pictures with the sounds.

3. The following is a pen-and-pencil exercise for those who do not have access to computerized equipment. Write a paper (your instructor will specify length and format) focusing on whether, in your opinion, the technological revolution in radio has a good influence or a bad influence on the medium. For example, do you feel that technology is replacing the human touch in radio? Do you believe that it has fostered an over-reliance on gimmickry in production? Or do you feel that the types of technology available are improving radio, freeing people to be more creative?

Regardless of your viewpoint, argue your case by using information from this chapter, information you have gathered in other classes and through research, and the following:

a. Facts gathered from trade journals. *Broadcasting and Cable, Electronic Media,* and *Broadcast Management/Engineering* will probably be most helpful, and these are widely available in libraries.

b. An interview with a local veteran of radio, preferably an on-air personality.

PART THREE

The Applications

TEN

Achieving an Effect

*I*f you'll permit us to stretch a point a bit, think of Chapters 6, 7, 8, and 9 as an art lesson in which you learned the basic brush strokes. It's now time to explore ways to create light, shadow, substance, and mood.

As a radio producer, you will be called on to create a variety of effects using the basic skills we explained previously. But producing an effect calls for more than a learned-by-rote recall of mechanics: It involves imagination, experimentation, and a certain amount of trial and error.

This is not to say that producing an effect is entirely a seat-of-the-pants affair. Specific techniques must be mastered, and technical expertise must be matched with creativity. This chapter serves as a bridge between the first nine chapters, which dealt with techniques and mechanics, and the chapters that follow on radio drama and on dramatic elements in radio production, commercial production, and news and public-affairs production. This chapter also reviews many of the elements discussed earlier and touches on some of the aspects to be dealt with later. The mix of elements is important because the marriage of technology and art—the ability to create an effect—is the heart of radio production.

What Is an Effect?

When we refer to the overall mood, impact, and appeal of a radio production, we use the term *effect*. We don't mean a specific sound effect (such as the screeching of a car's brakes).

Modern communication theory points out that getting a message across depends on more than the validity of the message. Reaching people with a message also involves pulling their emotional strings—creating a mood of

excitement, perhaps, or a feeling of identification. These emotional activators often can be turned on and off by means of radio production techniques.

A commercial to spur ticket sales for a football team, for instance, would certainly seek to create a mood of excitement: the sound of a kickoff, followed by the roar of the crowd, supported with upbeat, vibrant music. To create this example, the producer would have to know how to dub in sound effects, either taking them from a sound effects collection played back on a CD or recording the desired sound at a game, using basic microphone techniques. All the production techniques, of course, hinge on proper mixing and routing of the signals through a console. Essentially, the producer would use production skills to assemble and form the structure of the commercial, but an understanding of creating an effect would be necessary to produce the subtle message, the nuances, responsible for the impact and drama of the message.

Kinds of Effect

The focus of the message—and the effect you want to create—won't always be the same, even in quite similar situations. Assume, for example, that the radio station's sales manager, who needs a commercial for a restaurant, wants your help in creating an effective 60-second spot.

Soft music, you say? The sound of tinkling glasses, coupled with a mellow-voiced announcer? Perhaps. If the restaurant is an elegant one (or tries to be), your choice of soft music would be correct. But restaurants are as different as people. Digging a little deeper, you may discover that this particular client's restaurant has an ethnic flair; if so, might a polka, waltz, or other specialty selection be more effective? Perhaps this is a fast-food establishment. You, the producer, would most likely seek to convey a sense of fast action; thus upbeat, quick-tempo music would be the logical choice.

Music, like any other production element, must support the theme. You will be wise to etch this principle deeply within your thinking because straying from the overall theme is the most common mistake of the novice radio producer. Every production element must support the theme, or it will detract from the message.

How Production Elements Support a Theme

The upbeat music in our fast-food restaurant commercial conveys a specific impression: that of speed, excitement, and vibrancy. This production element supports the theme of a message for a fast-food establishment; it would certainly detract from a commercial for an elegant restaurant.

Such themes aren't always so readily apparent. There's no obvious guideline on how to produce a commercial for a personal computer, for example.

In fact, the approach eventually adopted might evolve after months of sophisticated market research aimed at discovering what approaches trigger the emotions of typical computer buyers. Obviously, such intricate planning won't be left up to you, the producer. On many occasions, however, the sales manager and the client know exactly what mood and effect they want. It will be up to you to achieve that effect and to choose production elements that support the theme. There are many production elements other than music and sound effects, but let's focus on those two for the time being. Later in this chapter, we discuss sound quality, voice quality, and so on, and explore their proper use. The production elements of music and sound effects can support a theme and bolster the message in many ways. Here are some brief examples illustrating how these elements fit into the overall scheme of things.

Creating Excitement

Soft-drink commercials depend on the capacity of radio production to create excitement to make their product appeal to a market that seeks thrills, activity, and youthful enjoyment of life. The music chosen—apart from the lyrics, which tout the benefits of the beverage—must support this mood of excitement.

Think, too, of the music you've heard at the introduction of sports play-by-play programs. Was the music a leisurely, sentimental ballad? Of course not. It was up-tempo, hard-driving music that implied, *The program that follows is going to be a fast-moving, exciting event.*

Creating Immediate Identification

What does the sound of a stopwatch ticking conjure in your mind? If you're like millions of other Americans, you will think immediately of the CBS News program *60 Minutes.* And that's exactly what the producers would like you to think of.

Why? Because the familiar stopwatch theme is one element that immediately distinguishes *60 Minutes* from its competition and creates a certain amount of loyalty among viewers and listeners. In any medium, that is the name of the game. The sponsor of a commercial wants that commercial to stand out; the producer of a talk show wants listeners to distinguish that show from the competition and wants it to have some sort of tag they can identify with.

An important point: Whatever production element is chosen for the task of creating immediate identification, it must support the overall message. The sound of cannons firing, for example, would certainly attract attention, but it wouldn't do much to demonstrate that the upcoming news program is going to be important and dignified. In fact, such confusion within the message would detract from the identification factor; listeners to a news show that opened with the sound of cannon shots probably wouldn't mentally link the show and the signature.

Evoking an Emotion

What does the sound of automobile horns blaring mean to you? Chances are it evokes the feelings you experienced the last time you sat, hot and frustrated, in a traffic jam. The producer of a commercial for an airline trip to a Caribbean island could use this factor effectively. Sound effects are one of the most effective tools for evoking an emotion.

Summary of Effects

The goal of radio production is to achieve an effect. The goal of achieving an effect is to be able to reach a certain group with a message. In many cases, the group and the message may be spelled out for you by an advertising manager or the client who wants you to produce a commercial. We offer a more complete discussion in Chapter 12.

When reporting to the producer of a news or sports program, you will be asked to use production elements that support the show's theme and create listener identification. As we discussed in Chapter 1, the producer in modern radio is responsible for reinforcing the station's particular sound—the quality that distinguishes it from its competitors up and down the dial.

Remember, you may be responsible for production in a variety of different jobs at various radio stations. You may be a staff announcer who produces commercials and public-service announcements after your airshift. (The airshift is also, of course, a product of radio production.) You may be a news reporter responsible for piecing together a half-hour's worth of news items and integrating them into an overall theme. Your job in the sales department at a small station may involve hands-on production. You may be the program director, in charge of ensuring that everything that goes out over the air strengthens the format, the sound.

But regardless of the job title, you will be using the basic production equipment and techniques described in the preceding chapters to achieve the effects discussed so far in this chapter. And as we've seen, you will be using various production elements.

How a Producer Uses Production Elements

We have briefly touched on how the production elements of music and sound effects are used to create an effect. Other elements can serve the same purpose. We now examine each element and show how and why it creates an effect.

Music

The observation that music reaches deep into the human psyche won't surprise you. Music has moved people to march to war and has waltzed couples

into matrimony. Music of all types is instantly available to the radio producer. The sources from which you will draw music include these:

- Your station's general-airplay music library. The station has paid a fee to various licensing agencies for use of the music, and you can use these records in your production.

- Certain types of records for which you must pay per **needle drop**—that is, whenever a cut from such a CD is dubbed for use in a production. This situation is more common at recording studios that are not affiliated with a radio station and do not pay a licensing fee for general-airplay music.

- Music beds supplied by a national advertiser for use by local affiliated merchants or businesses. For example, a lawn-mower manufacturer might supply to its distributors a commercial in which the company's jingle is included at the beginning and end of a 60-second spot, with a 15-second hole of background music—a bed—over which an announcer would read copy for the local merchant's store. (More on this in Chapter 12.) These cooperative, or co-op, advertising materials come in a wide range of structures.

- Original music composed specifically for a certain purpose, such as the type of jingle music used in beds, jingles produced locally for businesses, and music composed for use in themes of shows or productions. You may, from time to time, become involved in the recording of such music. (We examine that aspect of radio production in Chapter 15.)

Music is such an evocative tool that it is used in a great many radio production tasks; unfortunately, it is also frequently misused and overused. Here are some brief rules of thumb to help you, the producer, use music properly in the aesthetic context.

Do use music

- When you can find a logical reason to do so; when it creates a mood and reinforces a theme.

- When the music has a logical purpose and fits into the format of your station. A hard-rock music background for a public-service announcement will not complement the sound of an easy-listening station. As we discussed in Chapter 1, the producer must respect the integrity of the station's format.

Do not use music

- *Strictly as a reflex.* Many times you'll be better off without it. Suppose, for instance, that every other station in town uses a brief musical opening (sometimes called a **stinger**) for newscasts. Do you, as a producer, feel compelled to do the same? No, of course not; a "cold" opening can certainly be effective and, in this case, will set you apart from the competition.

- *Indiscriminately.* This warning applies specifically to the novice radio producer who is tempted to use currently popular music within announcements or other productions whether or not it serves to reinforce the message.

A final note: Be cautious of using vocals as background for a produced announcement. Although lyrics that proclaim something to the effect of "I'll be your friend forever, just give me a call . . ." might tempt the producer of a public-service announcement for a community health agency, mixing vocals with a voice-over can make both the lyrics and the announcer unintelligible. Cross-fading and other technical operations, however, can sometimes mitigate the problem.

Sound Effects

The example of blaring car horns used in an advertisement for a Caribbean vacation shows the value of appropriate sound effects. (Note the word *appropriate.*) A sound effect is generally considered to be any sound element other than music or speech. Sound effects (SFX) can come from

- *Special sound-effects libraries; CDs the radio station purchases and buys the rights to use.* Sound-effects libraries are almost always on CD, although there are software packages of sound effects available, too.

- *Sound effects recorded by the producer.* This practice sounds simpler than it really is. The old-time radio trick of crackling cellophane to simulate the sound of flames often sounds exactly like crackling cellophane. A door slamming, as another example, won't always sound like a door slamming. With certain microphone placements, and certain doors, it can sound like a gunshot instead. Thus, recording your own sound effects will take some experimenting, both with producing the sound and with placing the microphone to record it.

Regardless of how a sound effect is produced, its appropriate use can add to the message. Inappropriate use can make the message seem hackneyed, amateurish, and off the mark. There are two good reasons for using sound effects.

Do use sound effects

- *To save time and words.* Another vacation-oriented commercial might start with a blast of wintry wind to reinforce the message. Use of the sound effect has saved the producer some verbiage; there's no need for an announcer to say: "Don't you hate winter and the latest stretch of miserable weather?" The sound effect, lasting only a second or two, has created the desired image.

- *To inject drama.* Audiences have come to expect a bit of drama in all media. A bit of drama that reinforces your message can grab the attention

of your target listeners. Can you picture, for example, the kind of audience and the kind of message that would be matched up in a commercial that features the sound effect of a baby crying? of a sports car engine roaring? of a rocket taking off?

Do not use sound effects

- *Just because they are there.* The producer should not even consider using a sound effect in the absence of a definite need and purpose for that effect.

Keep in mind that overuse of sound effects is one of the most common mistakes made by newcomers to radio production. You will surely mark yourself as an amateur by falling into this trap.

Sound effects are an excellent production tool, but if they're used just for the sake of using them, they are inappropriate and can detract from the message. Use a sound effect when it's logical and serves a purpose. Chapters 11 and 12, on radio drama and commercial production, respectively, expand on the ways sound effects communicate a message effectively.

Coloration of Sound

Coloration of sound is a nebulous quality that cannot always be singled out. This production element is difficult to define. However, you will understand it when you hear it. Eventually, too, you'll use sound coloration techniques to produce an effect in your own production work.

Some examples may be helpful. Compare the overall sound quality of a loud, fast-talking-DJ type of radio program to that of a news and public-affairs interview program on a station with a more leisurely format. You'll know there's a difference even though you can't quite articulate it.

Well, one reason the loud DJ maintains such an intense sound is the electronic compression of the signal; this is done quite scientifically, we might add, and it involves boosting the volume of softer sounds so that the entire presentation is intense (and so that, the program director hopes, the signal will stand out more than the signals of competing stations do when the listener scans up or down the dial). Heavy compression would not be appropriate in a slow-moving talk show because the machinery would insist on boosting the periods of silence between questions and answers, creating an annoying "pumping" effect.

Compression is just one example of a process by which sound is altered to achieve coloration of sound. A mild **echo** is often electronically applied; we cover this effect more thoroughly in Chapter 15. FM stations, which transmit high-resolution signals, often favor high-quality microphones that reproduce a wide spectrum of sounds, including breath and mouth noises of the announcer, making the voice seem very close up and intimate.

Microphones can have a powerful effect on the coloration of sound. As you might remember from the discussion of sound quality (or timbre) in Chap-

ter 5, the way sound patterns are reproduced affects the way we perceive those patterns. Often, the coloration is actually a desirable type of **distortion.** We present examples of sound coloration in Chapters 11, 12, and 14, which deal with drama, commercials, and remote and sports production, respectively. We discuss some technical methods of achieving coloration in Chapter 15.

A radio producer should be prepared to confront the coloration concept. Don't be surprised when the program director asks you to produce a brighter sound or requests a promotional spot with a more personal feel.

Timing and Pace

Whether you are producing a music program, a news show, or a commercial, timing and pace will directly affect the mood and the message. This production element is one of the most critical in the entire spectrum of radio production. Yet timing and pace have some effects you might not, at first thought, be aware of. Try this comparison:

- Listen to a commercial for securities or other investments. (Such commercials are quite common on radio talk shows, especially talk shows dealing with business issues.) Note the very slow, deliberate pacing. Why? Because we've developed a negative image of fast talkers. The announcer who sells us major investments must be trusted.

- Contrast the foregoing approach with soft-drink commercials. Trust, here, is really not a factor. An image of a lifestyle is being sold, and that image generally represents a youthful and fast-moving crowd.

We cite these examples in the hope that you will develop a critical ear when it comes to determining the timing and pace of your own work. Keep in mind, always, that the pace creates an effect and must reinforce the message.

Walter Winchell, the legendary broadcaster whose radio career peaked in the Great Depression era, entered radio after experience as a newspaper gossip columnist. Initially, he was given little chance of success because radio announcers at the time were expected to have a slow, mellifluous delivery. Winchell, however, broke the rules with a rapid-fire, staccato delivery: "Good evening, Mr. and Mrs. North and South America, and all the ships at sea, let's go to press . . . Flash! . . ." His delivery was breathless, punctuated with the dit-dit-dit of a telegraph key, and it accomplished exactly what he wanted. It implied that Winchell had a fastmoving program, figuratively grabbing the listener by the lapels and shouting, "Wait 'til you hear this!" That is, timing and pace reinforced Winchell's message.

Veteran broadcaster Paul Harvey is an acknowledged master of timing, and his technique will help us make an important distinction. Harvey keeps up a varied, energetic pace, but he also captivates his audience by use of the well-timed punch line, usually preceded by a dramatic pause. "And the man woke up the next morning to find," Harvey might say, "that he'd been spraying the annoying mosquito not with insecticide . . . [pause] . . . but with . . . [agonizing pause] . . . a can . . . of *blue spray paint!*"

Timing and pace are also major elements in the production of a music program. In many laid-back album-oriented rock stations, the whole format is built around low-key timing and pace. Compare that with the frenetic, non-stop approach of the fast-talking-DJ top-40 station. Both are trying to project an image.

Voice Quality

This production element doesn't necessarily imply a qualitative difference between good and bad voices. *Voice quality* is the overall image that an announcer's voice projects.

Often, a producer chooses the announcer to be used for a particular production. Sometimes the producer is assigned a particular task and must use a designated voice (or his or her own voice) to maximum effect, perhaps making some subtle changes in delivery.

In any event, matching a proper voice and delivery to the message at hand is the important element here. Many aspects of selection and delivery are reasonably obvious. A news moderator's voice calls for a measure of dignity. A spot designed to convince young people to shop at a particular store might well benefit from a young voice and an intimate "chummy" delivery. Think of other examples. Do advertisements for medicines generally carry a strong, authoritative voice? Why?

Another aspect of voice quality is the lack of distraction. Voices used on the air, it's generally agreed, should not have defects (not necessarily pathological speech defects) that will detract from the message. One of the most common distractions is improper breathing by the announcer. Overbreathy voices, except when they are a well-known novelty, sound amateurish. Often, inexperienced announcers can be heard gasping for air between phrases. Such gasping sounds might not be apparent in everyday speech, but a mic can be merciless. The cure for this is to maintain generous breath support—a good tankful of air—instead of trying to talk until all breath is expended. Plan where to take breaths; breathe at natural pauses in the copy. Don't just read until you can't read any more.

Sound of Words

A radio producer often is responsible for writing the copy that is read on the air. We address specific copy techniques in the next section and in the appropriate chapters (notably, in Chapters 12 and 13, on commercials and news), but one point must be considered here: writing for the ear.

Words can evoke moods. Note how the words *dine* and *eat* create different moods; likewise, with *invest* and *buy.* The physical sound of the words also has an effect. *Businesses* is not a great word for the ear because the three *s* sounds make the word hissy and unattractive. Doesn't *firms* sound better?

Industry Update

ACHIEVING AN EFFECT AND THE BOTTOM LINE: PRODUCTION PROMOTION

"On top of events, active, forceful, the source for news and information." Is there any doubt that this is the ultimate description of an all-news radio station?

Getting that image across through the vehicle of the production studio is the job of Bill Tynan, director of on-air promotion for WCBS-AM, an all-news station in New York City (Figure 10.1).

Tynan calls many of his promos "proof of performance" pieces, meaning that they show the audience they made the best choice.

A favorite technique is to edit together snippets from coverage of a news story and have an on-air promo ready the next day. Tynan's promos, for example, have featured breathless reporters giving on-scene

Figure 10.1 *Bill Tynan, director of on-air promotion for WCBS-AM in New York City, produces a promo that helps build the image of WCBS as the source for news.*

Photo by Carl Hausman

Continues

Industry Update Continued

reports from the World Trade Center bombing*—juxtaposed with announcer copy that reinforces the idea that WCBS was there.

One word of caution, though, is applicable to almost all production and promotion operations: "Don't be too self-congratulatory," Tynan says. "You don't want to come across sounding like 'Gee, wasn't it wonderful there was a bomb in the World Trade Center and we were there first.'" Tynan notes that the computer vastly simplifies his particular type of production work. During a typical promotion piece, he might have to crossfade seven or eight cuts. BC (before computers), he would have had to dub those cuts to cart, do three cross-fades onto another cart, and then cross-fade those carts for the final mix. Now, he can simply load the cuts

* Author's note: This interview was conducted before the September 11, 2001, attack on the World Trade Center.

Figure 10.2 *Visual readout of a promotional spot for WCBS-AM in New York City.*

Photo by Carl Hausman

Continues

Industry Update Continued

into the computer, call them up, put them where he wants them, and program the cross-fades. Figure 10.2 shows the visual readout of one of his spots, and Figure 10.3 shows an example of one of his scripts.

Figure 10.3 *A script for a promo at an all news station.*

"A PROPANE TRUCK SLAMS INTO AN OVERPASS IN WHITE PLAINS SHATTERING THE CALM OF NIGHT!"

> **Man:** "trees were on fire, people were screaming, you thought the end of the world was coming!"

"THE WCBS TEAM WAS THERE IN THE WEE HOURS OF THE MORNING TO BRING YOU COMPLETE COVERAGE!"

> **Lamb:** "a fireball swept up from I-287, igniting houses . . ."

> **Jeff:** "neighbors thought a bomb had gone off when the exploding truck lit up the early morning sky . . ."

> **Schld:** "a lot of these people are very happy and lucky to be alive . . ."

> **Quinn:** "it was a nightmare for residents, now it's a nightmare for commuters . . ."

> **Busch:** "pick up the south bound New York State Thruway, that's moving very well . . ."

> **Tom K:** "seriously consider metro north if you're gonna be coming down there . . ."

"FOR THE LATEST ON ROADWAY REPAIRS AND ALTERNATE ROUTES, STAY WITH WCBS NEWSRADIO 88!"

Courtesy of WCBS-AM.

Copywriting

Here are three general principles of copywriting:

1. Remember that you're writing for the ear, not the eye. Use active verbs whenever possible. Long sentences and intricate constructions have no place in radio. Keep your sentences short and conversational. Avoid references such as "the latter option." (The listener can't refer to the copy and decide which is the former and which is the latter.)

2. Remember that your writing must be *read*. That sounds obvious, but it isn't. It takes practice to write in a rhythm that can be read easily by someone else. Be particularly careful about your use of commas and dashes; incorrect usage can make the copy virtually unreadable.

3. Pay close attention to technical format. Each station has a more-or-less standard way of writing copy. Some stations, for example, use all-capital letters for anything to be read over the air. Most stations use various abbreviations, such as SFX for sound effects. But the technicalities vary from station to station, so be sure you follow local form. Otherwise, the copy you produce can be very difficult for an announcer to decipher.

In summary, production elements are features that are useful in creating an effect and reinforcing a message. Many are obvious; some require a bit of thought. All have an impact on how a radio production will affect an audience.

Production elements also blend into one total package; that's obvious because most radio productions contain a variety of elements. In judging various elements, you, the producer, must always determine whether they make sense within the context of the message. Does this sound effect get the point across? Will the music make the message stronger, or will it be a distraction? Does the announcer's voice convey the right message? Do the words convey the full message? Are the words written for the ear? The key to successful production is not to leave these decisions to chance.

Using Elements of Sound to Achieve an Effect

Until now, our discussion has been largely theoretical. At this point, we consider exactly how the production techniques you've learned from preceding chapters come into play. The job of a producer usually involves being half artist and half technician. You will use highly sophisticated electronic equipment to translate what you want to do into the technical form of a finished product, something that can easily be played back over the air.

Problems in production often arise when the producer thinks he or she is too much an artist to have to bother with the technical side of things. Similarly, production values suffer when a producer enamored with complex equipment forgets that he or she is in the business of communicating. A musician must know how to blow a horn and finger the valves properly but must also have the artistic ability to play notes that convey meaning; though machines can be programmed to play trumpets, they generally don't do a very good job. With that in mind, let's see how someone who is a radio producer, rather than just someone who knows how to run the equipment, performs some simple operations.

Recording a Voice

You have learned the chain of events that allows you to record a voice on a computer, minidisc, or tape. Now, start thinking like a producer. You want to

record a two-person news interview program (one moderator and a guest). Will you use the same type of mic used for recording classical music? Do you need the same type of quality and pickup pattern? What about the effect of the equipment on the participants? Although the conveniently located studio mic suspended from a boom can do the job, will this large instrument hanging in midair—between the moderator and the guest—have an intimidating effect? You bet it will.

People unfamiliar with radio generally regard the microphone with the same distrust as they would a dentist's drill. As a producer, you must take this into account. You are likely to find that the best results are achieved with two mics mounted inconspicuously on table stands or even with two good-quality lavaliers. There's more to selecting a microphone than addressing the technical considerations we discussed in Chapter 5. See if you can come up with some other examples.

Recording Music

You've progressed to the point of being able to cue a CD, make it play, and route the signal through the console and into a minidisc. Now, let's imagine an actual production.

You have been assigned the task of cutting a 30-second public-service announcement (PSA) for a local community health hotline. The music you want to use contains some lyrics and some entirely instrumental portions.

The lyric you want to use is "I'll be your friend forever, just give me a call. . . ." But you can't just run the song under the announcement for two reasons:

1. There are more lyrics following the ones you want to use at the beginning of the spot, and they will make your reading of the script unintelligible.
2. You want the spot to end with a musical climax: to be precise, the instrumental climax that just happens to be at the end of this 3-minute piece of music.

How would a producer working combo approach this dilemma? One possible strategy is to record the final 25 seconds of the song onto a tape cartridge. Because you know (by reading the time on the CD or by timing the piece yourself) that the cut is exactly 3 minutes long, you simply start the CD and the timer simultaneously and start recording when the timer reaches 2:35. You have determined that the opening lyric takes about 9 seconds (and you have timed the copy you will be reading). At this point, you can recue the minidisc, and follow this sequence:

- Start the CD and fade it up on the console. Of course, you've already taken levels and know how high to put the volume.
- Start the timer as the CD begins playing.
- Record the first 5 seconds of the lyric.

- Start the minidisc 5 seconds into the CD before you open the mic. Remember, you have 4 more seconds before the lyric will finish. The spot is now set to finish exactly when you want it to: 30 seconds from the beginning of the spot.
- Open the mic and read the copy.

When the important line of lyrics ends, begin to fade down the CD and to read your copy. While reading the copy, execute a cross-fade. That is, fade up the minidisc as you fade down the CD. Done gradually, and underneath the cover of your voice, the cross-fade may not be detectable. Remember, at this point, the music should not overpower your voice. Be sure to use headphones to monitor your mic.

When you have finished reading your copy, bring up the music to the correct level on the VU meter to finish the spot.

You've created a perfectly timed spot that includes the beginning and end you want. And all the production elements reinforce the message and create an effect. In particular, the music reinforces the message. The result is a package that puts the point across, with all the production elements enhancing the message. (Incidentally, you can make this PSA in several possible ways. Another way of doing things that might prove easier is to record 40 seconds of the song on minidisc. That way you won't have to start the disc during the spot; however, you will have to keep accurate time before the spot begins. Yet another possibility would be to record the musical selection on a computer and set the playlist function of the DAW to play back the the first 9 seconds and the last 20 seconds by marking these points as nondestructive edits and using the cross-fade function on the computer workstation.)

Summary

The ultimate goal of radio production is to achieve an effect—that is, to create an image in the mind of the listener, to communicate a message.

Production elements in a piece of production support a central theme to achieve an effect. For example, upbeat music in a restaurant commercial conveys vibrancy and excitement. Production elements are also used as signatures to create immediate identification in the minds of the listeners.

Music is a common production element used to achieve an effect. Music is best used when it explicitly contributes to the communication of an idea. Using music just for the sake of having it is often distracting and counterproductive.

Likewise, sound effects must be used judiciously. Sound effects can be very effective when their use is logical and supports the central theme; when they are used just because they are available, sound effects become pure gimmickry.

Coloration of sound, another contributing factor in achieving an effect, refers to the technical ways sound is manipulated. Other contributors to achieving an effect are timing and pace, voice quality, and the sound of individual words.

Applications **SITUATION 1 / THE PROBLEM** The producer was given a tough and very important assignment: Produce a commercial for men's cologne. The talent—a woman—seemed to read the copy correctly, but the client didn't like the spot even though he couldn't spell out what didn't ring true about it. His only comment was, "It doesn't sound like she's talking to me."

ONE POSSIBLE SOLUTION After giving it some thought, the producer changed microphones. Using a higher-quality mic with a cardioid pickup pattern, he instructed the talent to move in closer. The result: greater presence and a more intimate feel for the commercial.

SITUATION 2 / THE PROBLEM The producer at an FM station was in charge of preparing a public-service announcement calling for air-pollution abatement. According to the script, the announcer was to read copy outdoors with birds chirping in the background. But when this was tried, the portable equipment didn't produce very good quality: The birds, which really were chirping in the park where the spot was taped, were barely audible on the final product.

ONE POSSIBLE SOLUTION Realizing that the way things sound to the ear is not necessarily how they sound to the microphone, the producer recorded only the birds on one tape. This gave her the option of varying the volume when she mixed the announcer and the background sound effects through the console.

The announcer's voice track presented another problem. It sounded terrible when recorded on the portable equipment, whose quality just couldn't match the studio mics. This lack of quality would be sorely apparent when the spot was played on air. But recording the announcer's copy in the studio made the whole spot sound phony. It sounded not like an announcer standing outdoors but like a studio recording mixed with sound effects.

The producer remembered what she had learned about the physics of sound and realized that the problems stemmed from the microphone's being in a very lively part of the studio, near several bare walls. Some experimentation resulted in the relocation of the microphone in a dead area. Without the sound bouncing off the walls, the sound was flatter, and the listener could much more readily imagine that the entire spot had been recorded outdoors. Now the producer was finding that she could achieve the effect she wanted, within the technical restrictions of radio equipment. One problem remained, however.

Though the bird noises she'd recorded in the park worked well for the background, they weren't of sufficiently high quality to be brought up full, as she had wanted to do in the beginning of the spot. She felt the production needed to open with a couple of seconds of solid sound effects, which would then fade down under the announcer.

She solved this problem by finding the appropriate sound effect in the station's sound-effects library. The only entry she could find ("Bird Calls") would not have been appropriate for the background of the entire spot, but it

was perfect for an attention-getting opening. To create the whole package, she used the birdcall from the CD and cross-faded it to the ambient sound she had recorded.

The ultimate result? A high-quality public-service announcement that achieved the desired effect.

Exercises
1. Construct a script for a 60-second public-service announcement. For this exercise, be sure to include the following:

 - One sound effect
 - A music bed
 - Narration

 Be sure that everything in your PSA has a purpose. Nothing must seem to be thrown in for its own sake.

2. Under the supervision of your instructor, produce the PSA.

3. If a music library is available to you, have class members select music they feel is appropriate for the following:

 - The opening of a news program
 - Background for a beer commercial
 - Background for a fashion show

 Discuss these selections, and discuss class members' impressions about the three scenarios. (Conceptions of a good beer commercial, for instance, will vary from person to person.) Note the difference in class members' conceptions of both the scenarios and the proper selection of music.

4. Cast celebrities for voice-over parts in the following hypothetical radio productions. (Remember, the celebrities will be heard and not seen.) Write down your choices and your reasons for making them.

 - A commercial for aspirin
 - A commercial for an elegant restaurant
 - A public-service announcement for saving wildlife
 - The part of an insane murderer in a radio drama
 - A commercial for high-priced, somewhat frivolous women's accessories

 Discuss your reasoning with class members and your instructor. During your discussions, try to state as directly as possible what it is about each celebrity's voice that would create the proper effects and get the various messages across.

Drama and Dramatic Elements in Radio Production

*T*he purpose of this chapter is not to demonstrate what is almost an obsolete art form but rather to introduce the principles of radio drama that are present in other forms of radio production.

This very short chapter contains only one exercise. Instead of the usual complement of exercises, we have provided a full-length radio drama in Appendix B. Production of the drama can serve as a class project; merely reading it will give you insight into the structure of drama and dramatic elements. If time doesn't permit (production of a radio drama is a big project), the exercise at the end of this chapter will suffice.

Radio drama per se is no longer very common in America, and that's unfortunate. Old-time radio drama, as its devotees can attest, involved the audience in a way that television cannot. A radio drama creates images in the mind that can furnish a much more vivid picture than can be produced by even the most sophisticated television production company.

Radio drama, too, is an excellent way to learn the mechanics of editing, miking, and mixing. You'll find the production of the drama provided in Appendix B to be exceptionally challenging but quite instructional as well. An understanding of radio drama also provides an insight into techniques of inserting dramatic elements into commercials and—in limited applications—into news and public-affairs programs. That's the essential focus of this chapter.

The Structure of Drama

Drama is a composition that tells a story through action and dialogue. It generally involves a conflict: person versus person or person versus society. A drama, in its broadest form, has a plot; usually, the plot has a beginning,

middle, and end. A drama includes dramatic techniques, such as suspense and exposition.

Let's review the preceding description and see how each term relates to radio drama and to dramatic elements in radio production.

Action

Because radio is not a visual medium, action must be portrayed through sound. Action in a prizefight, for example, would be dramatized on radio with the ringing of the bell, the roar of the crowd, and the smacking of gloves. The dialogue could provide a description of the fight.

Dialogue

Spoken words are very important in radio drama for obvious reasons. Words provide most of the information and meaning in a scene, and they describe most of the action. The prizefight scene, for example, could be fleshed out with dialogue from a ring announcer or conversation in a fighter's corner.

Plot

The plot is the story line. All action and dialogue must advance the plot; that is, each scene of action or dialogue must move the plot along and reinforce the message.

Beginning, Middle, and End

Drama usually has a sequence of events and a conclusion. Although dramatic elements within radio production don't always have a complete beginning, middle, and end sequence, there almost always is some sort of resolution, or solving of the problem. In dramatic terms, this is known as the *denouement,* which is the resolution of a conflict.

Conflict

Conflict in drama doesn't always have to be a struggle between two people, which is what we usually call *melodrama.* Conflict can consist of a person's struggle to overcome headache pain, a type of conflict that is portrayed frequently in radio commercials. (Resolution, of course, would come from the sponsor's pain remedy.)

Suspense

Suspense is what compels us to keep listening. To achieve suspense, plot writers refrain from providing conflict and resolution at the same time. Will

Mrs. Smith's headache pain be cured? We usually have to wait through about 20 seconds of product pitch to find the answer.

Exposition

Details must be revealed in a logical and realistic fashion. The process of imparting information is known as *exposition,* and it's an important part of all types of drama.

Think about it: Gracefully giving the audience all the information it needs to understand an unfolding scene is a very difficult task. In plays written centuries ago, a popular form of exposition consisted of having two maids, through supposedly casual conversation, set the scene while dusting the master's house. This type of exposition, a clumsy recitation of facts, came to be known as *feather-duster* exposition, and modern writers usually avoid it.

More graceful exposition techniques usually involve a short dramatic scene. Let's say the producer of a radio commercial wants to set a scene that supports a family's need to buy a home computer to help a child with math homework. Would it serve the client's purposes to have mother and father—in the role of "maids"—discuss Junior's poor report card? Perhaps, but the scene could be set more effectively and quickly with, for example, a short classroom scene, where Junior demonstrates his lack of mathematical acumen by botching a problem at the chalkboard.

Role of Dramatic Elements in Commercial Production

Even though you may find little occasion to produce the kind of full-scale drama included in Appendix B, you will certainly have the opportunity to incorporate dramatic elements in commercials you produce.

"Oh, my head is killing me!"

How often have you heard that line, or one similar to it, in an advertisement for a headache remedy? It's the start of a common drama—a slice of life, so to speak—that can be played out effectively. Note how much more effective it is to use the dramatic scene than to have the announcer prattle on about the fact that Mrs. Smith has a headache. Drama, in effect, serves two purposes in a radio commercial: to capture attention and to compress time.

Capturing Attention

All of us are interested in how life unfolds. Why else do soap operas, reality programs and other similar dramatic forms draw such rapt interest?

In the radio commercial, a dramatic scene engages the listener and drives home a point. For example, a comedic scene featuring some incompetent

Figure 11.1 Script for a commercial that uses dramatic elements to attract attention.

(PHIL WHISTLING "DECK THE HALL." SOUND EFFECTS OF PAPER RUSTLING AND BOX BEING SMASHED ABOUT ON TABLE . . . SOUND EFFECT CARRIES THROUGHOUT.)

LEW: HEY . . . WHAT ARE YOU DOING?

PHIL: I AM BUSILY WRAPPING A WONDERFUL CHRISTMAS GIFT IN A DEC-ORATIVE FASHION. HOW DO YOU LIKE THE LITTLE . . . OOPS, I CUT A LITTLE HOLE IN THE TABLECLOTH THERE. OH WELL . . . I'LL PUT A VASE THERE AND NO ONE WILL NOTICE.

LEW: LOOK, YOU'RE WASTING YOUR TIME WITH THAT MESS. IF YOU WOULD JUST . . .

PHIL (INTERRUPTS): WAIT. PUT YOUR FINGER RIGHT THERE AND HOLD IT. THEN WHEN I SAY "LET GO," TAKE IT AWAY REAL FAST. OK . . . LET GO.

(SOUND OF VIOLENT RUMPLING OF PAPER AND SMASHING OF BOX. GIFT ENDS UP ON FLOOR.)

LEW: LOOK . . . INSTEAD OF GOING THROUGH ALL THAT, WHY DON'T YOU TAKE YOUR GIFTS TO COUNTY SAVINGS BANK?

PHIL: COUNTY SAVINGS WANTS MY GIFTS?

LEW: THEY'LL WRAP THEM FOR YOU. FREE. THEN YOU CAN PICK THEM UP IN TIME FOR CHRISTMAS . . . ALL NEATLY WRAPPED.

PHIL: THEY'LL DO THAT FOR ME?

LEW: YOU AND ANYONE ELSE WHO BRINGS IN THEIR GIFTS BEFORE DECEMBER 16TH.

PHIL: YOU DON'T SAY? HEY, YOU DON'T SUPPOSE THEY KNOW HOW TO MAKE A NICE SCOTCH TAPE BOW DO YOU? I WAS JUST ABOUT TO . . . (FADE OUT)

mechanics attracts the listener and sets the stage for the upcoming spiel that tells why Joe's Garage does a better job than the bunglers depicted in the commercial. Note how the commercial reproduced in Figure 11.1 uses a similar dramatic scene to attract attention.

Compressing Time

Which approach seems more effective from a radio producer's point of view?

1. John works at a newspaper; he is a reporter, and the pressure is very intense. Right now he's working under a tight deadline. The pressure gets to him sometimes and results in heartburn and an upset stomach.

2. SFX (sound effects): TELETYPES, OFFICE COMMOTION.

 Voice: John, deadline for the fire story is in 5 minutes!

 John: Boy, this pressure really gets to me sometimes . . . heartburn, acid indigestion . . .

Notice that scene 2 would take about half the time needed for scene 1. Similarly, a sound effect of clapping thunder and pouring rain takes much less time than announcer's copy telling how bad the storm is.

Figure 11.2 shows a commercial that compresses its premise by using dramatic elements. In Chapter 12, we deal with the concepts of attracting attention and compressing time, as well as with other facets of radio commercial production.

Role of Dramatic Elements in News Production

The goal of drama is to tell an interesting story in a compelling way. The goal of news is not so different.

Although a news producer must be extremely careful not to mislead listeners or to falsify information for the sake of dramatic impact, judicious use of dramatic elements is certainly acceptable. Documentaries usually contain some dramatic elements; a story on beachfront pollution, for example, can be bolstered with the sound effects of the plaintive call of seagulls.

Contrast, an important facet of drama, is also used as a dramatic element in documentary production. Thus, a politician's claim that tax revenues are insufficient could be directly juxtaposed to a city official's contention that most of the city budget is squandered on salaries for no-show employees or in other wasteful ways. Playing the two cuts back to back, without comment, increases the dramatic value and makes a point that no amount of narration could. Music is also an important element of documentary production though it is rarely if ever used in hard news production, except in newscast openings.

Remember that narration of news, public affairs, and documentaries can use dramatic elements, too. Don't be afraid to try new ideas in news production. Dramatic elements, as long as they are tasteful and not deceptive, can significantly freshen up what might otherwise be a stale area of radio production. The sound of police and fire trucks racing to a scene, for example, can be cut into a news report to give it extra impact.

Figure 11.2 Script for a commercial that uses dramatic techniques to compress time.

(OPEN WITH SOUND EFFECT OF CAR BEING DRIVEN DOWN ROAD)

WIFE: IT'S SO HARD TO SHOP FOR A HOME IN SUCH A SHORT
 AMOUNT OF TIME.

HUSBAND: YOU'RE RIGHT. AND WE REALLY HAVE TO FINISH BY TOMOR-
 ROW . . . OR WE HAVE TO COME BACK ANOTHER TIME.

WIFE: (SIGHS)

ANNOUNCER: YOU DON'T HAVE TO GO THROUGH ALL THAT AT JOHN HOLMES
 REALTY AT 143 WEST SECOND STREET. AT JOHN HOLMES
 REALTY, WE DON'T RUN YOU ALL OVER TO LOOK AT EVERY-
 THING THERE IS FOR SALE . . . WHAT WE DO IS SIT YOU
 DOWN IN OUR COMFORTABLE LOUNGE AND LET YOU LOOK
 OVER OUR ILLUSTRATED GUIDE TO HOMES ON THE MARKET.
 YOU PICK THE HOMES THAT FIT YOUR NEEDS AND PRICE
 RANGE, AND THEN WE'LL GIVE YOU A TOUR USING OUR
 MODERN VIDEOTAPE EQUIPMENT. SO IF YOU FIND THAT YOU
 DON'T LIKE THE WALLPAPER, YOU'LL KNOW IT BEFORE
 DRIVING THERE. WHEN YOU SEE THE HOME YOU'D LIKE TO
 GO AND LOOK AT, WE'LL TAKE YOU THERE FOR A CLOSE
 LOOK. IT'S A SIMPLE PROCESS TO BUY A HOME AT JOHN
 HOLMES REALTY. COME AND SEE US AND WE'LL SHOW YOU.

Technical Considerations of Radio Drama

The most immediate consideration in producing radio drama or inserting a dramatic element is to create the illusion of place and movement. By *place*, we mean the location of the actors; by *movement*, we mean their physical movement through space.

Giving the Illusion of Place

Acoustic characteristics are important in determining place. For example, would you believe that a lively, reverberating sound was coming from someone on a beach, even with seashore sound effects in the background? No, it wouldn't be convincing (just as the lively studio made the outdoor scene in the Applications section of Chapter 10 sound unnatural).

Would you believe that someone was shouting from across the lawn if the actor was miked 3 inches from his mouth? Would an intimate conversation sound natural if it was being picked up by a mic several feet across the room?

The proper illusion of place is determined by mic technique. The producer will have to move actors farther from and closer to the mic to achieve the proper effect.

Giving the Illusion of Movement

Radio drama often entails movement of the actors, so it's important that the mic setup give the illusion of movement. A script element that requires an actor to leave the room and slam the door, for example, will have to sound believable. As we suggested earlier, actually having an actor slam the studio door may not give the effect desired because the mic doesn't hear the way ears do. A better approach might be to have the actor take small steps, moving just a few feet away from the mic; the door slam can be dubbed in or done live by a studio assistant.

In any event, there must be an illusion of movement within the scene, and the movement must be played to the mic to achieve a realistic sound.

Making the Background a Fabric of Believability

The sounds we hear (or ignore) as everyday background noise would be far too intrusive for a radio drama. That's because in real life we focus our attention on certain sounds and exclude other sounds from our attention. In radio drama, it is very important to plan the background sound effects to create a fabric of believability. If we need to move through busy streets, the sound effects must take us from one location to another. Often, the inexperienced producer mistakenly sequences sounds one after another instead of weaving and blending them together. Have the sounds move in and out of perspective. This weaving of sound is accomplished with preplanning and careful execution of audio levels. It is a vital element of dramatic believability.

The proper perspective is a function of more than just loudness (or in the case of stereo drama, of spatial position). Perspective also includes the way a character would hear sound. A movie sound effect best exemplifies this. In a boxing film, the sound of the blows is far different when the view of the camera (perspective) represents the person being hit. The blows are

often portrayed, visually and aurally, in slow motion, as crashing, catastrophic explosions. When the camera serves as the observer, the blows are not portrayed so dramatically.

Mic Techniques to Achieve Illusions of Place and Movement

Creating illusion of place is largely a function of the physical shape and construction of the studio, but as we mentioned earlier, the distance of the actors from the mic plays a major role. The ideal setup for radio drama in which actors must deal with place and movement is to suspend the mic from a boom (see Figure 11.3) and group the actors around it. This eliminates hazards of tripping over wires and bumping into floor stands.

An omnidirectional mic is best, although bidirectional patterns can be used. A high degree of presence is usually felt to be a desirable attribute in radio drama, so a sensitive condenser mic might be a wise choice. The technical device pictured in Figure 11.4 can also prove to be quite handy in creating an illusion.

Sound Design

Always keep in mind that radio drama is an illusion. It doesn't just happen: It has to be created. A certain amount of technical skill and planning is a necessity for the producer who wants the listener to believe in that illusion. The process of developing a preproduction idea of what the production will sound like is called *sound design*. Drama production, from conception to completion, is a long process and must be planned with the final product visualized at every stage.

Summary

Although radio drama as a distinct art form is long past its prime, drama and dramatic elements are common tools in a wide range of radio production tasks. Many successful commercials are actually miniature dramas or comedies.

A dramatic element generally has the traditional structures of drama: action; dialogue; plot; a beginning, middle, and end; conflict; suspense; and exposition.

Dramatic elements are commonly used in radio production; they are particularly popular in radio commercials. Dramatic elements can attract attention, and they can compress time by expressing many thoughts in a small dramatic scene. Dramatic elements have some place in news production, though it is essential that they not be used to mislead the listener.

Among the radio producer's major considerations are creating the illusion of place, giving the illusion of movement, and making the background a fabric of believability. Achieving illusions of place and movement can be accomplished through mic techniques.

Figure 11.3

Actors grouped around a boom-mounted mic.

Photo by Philip Benoit

Figure 11.4

Here's the simplest way to create the illusion of a telephone conversation in radio drama: Have the engineer put a phone handset on a stand and wire it into the board.

Photo by Philip Benoit

Applications SITUATION 1 / THE PROBLEM A producer was given the assignment of producing a 15-minute documentary on the effects of government loan programs on local farmers. It soon became apparent that the collection of interviews she intended to gather would prove to be extremely dull. One interview in particular, a question-and-answer session with a farmer and the farmer's accountant, promised to be deadly.

ONE POSSIBLE SOLUTION To liven things up, the producer took two steps. First, the narration was done not in the studio but on site at a local farm; background audio lent a dramatic texture. Second, instead of questioning the farmer and accountant, the producer convinced them to talk with each other, to dramatize a frank discussion of how the government's loan policies had affected the farmer's operation. The goal was to listen in on a conversation between the farmer and the accountant, not to question them.

SITUATION 2 / THE PROBLEM A producer at a New England radio station was given the task of developing commercials for a glove manufacturer and retailer. Previous ads had featured nothing but announcer's copy extolling the toughness and warmth of the gloves; those commercials did not appear to be effective. The sponsor's instructions were, "Give me something with a little more zip."

ONE POSSIBLE SOLUTION In search of that elusive zip, the producer came across the information that the gloves really were tough. The fishermen who operated in the Atlantic coastal waters favored them almost exclusively.

The producer took a portable tape recorder out onto the fishing boats and interviewed some of the fishermen wearing the gloves. The fishermen (who were compensated for their endorsement) spoke of how tough their job was on gloves and how a good pair of gloves made life on a fishing boat a lot easier. One fisherman also described an incident in which his gloves had helped him weather a brutal storm.

With the ambient noise and some dubbed-in sound effects, the producer was able to use the dramatic scenes to produce a compelling commercial that met the client's needs.

Exercise Create a 30- or 60-second spot that tells the story of your first day in college. Consider telling the listener about such first-day encounters as registration, dining-hall eating, finding your classroom, meeting a friend or roommate, getting lost on campus, and discovering third- and fourth-year students. Do this using only sound effects and music. (Hint: Voice can be used as a sound effect when we don't hear any particular person speaking.)

Commercial Production

*C*ommercial production, as far as managers and owners are concerned, is at the core of radio's main purpose: to make a profit. Like it or not, that's how commercial stations survive. It is extremely important that commercials, which are the tangible result of the sales effort, be done well. As a producer of radio commercials, you will have three responsibilities:

1. To produce commercials that stimulate sales
2. To produce commercials that please the client
3. To produce commercials that fit your station's sound

The producer of a commercial (who can be anyone at the station—a sales manager, a staff announcer, or a production manager) must translate those goals into a radio production that will capture the attention of an audience and be a successful sales tool for the client.

In this chapter, we address all the elements that make up a commercial, including general sales appeal, content, and production values. It's important to have a rounded view of the commercial because most radio professionals will deal with commercial production at a variety of levels at different points in their careers. Keep in mind that your function in putting together a radio commercial will include any or all of the following:

* Writing the script or putting the concept together
* Narrating the commercial
* Doing the hands-on production work
* Convincing the client that your approach is the proper one

The last duty is a common bugaboo of the commercial production field; the producer is often caught in the middle between the salesperson and the client and must act as the final arbiter of what is effective and what constitutes good production.

You may have a great deal of responsibility in determining what elements and production values will make the commercial effective. This is likely to be especially true if you function in both sales and production capacities, which is common in first broadcasting jobs (and sometimes is the only way to make a decent income).

What Makes a Commercial Effective?

We are convinced, after more than a half-century of involvement with broadcast advertising, that there are no hard-and-fast rules for determining a commercial's effectiveness. In fact, rules that occasionally get handed down from on high are often proved wrong. Several years ago, top advertising agencies determined that humor was not an effective way to help sell a product; as proof, they pointed to large firms whose very entertaining commercials didn't move the products. But then a funny thing happened: Humorous commercials began to be the crux of very successful ad campaigns. Old-time comedic teams such as Bob and Ray and Dick and Bert began creating extremely successful commercials, and the old "humor is no good" theory went down the drain.

Even though there are no firm rules, we feel that the most important principle of radio advertising is that commercials, like programming, must engage the audience's attention. Some effective commercials have done this by being mildly irritating: several years ago a successful TV campaign admonished people because they had "ring around the collar." The important thing about "ring around the collar"—or any other commercial for that matter—is that it engages attention and appeals to a fundamental human drive. Consider that the dreaded ring always was discovered in a public and often posh environment, such as a cruise ship (never while playing touch football though). There was always a scene of the poor housewife squirming in humiliation as her husband's ring around the collar was loudly pointed out. But, of course, she discovered the right detergent and all her problems were solved—within the space of 30 seconds. Why was such an obvious piece of tripe so effective in selling the product (and it must have been because the commercials ran for years)? Essentially, it appealed to a basic human emotion: the desire not to be humiliated in front of one's family.

You might protest that such tactics don't work on you, but it might be worthwhile to examine your buying habits and determine what role advertising has had in your purchases. Be aware that although people often adamantly deny that they are persuaded by advertising, research shows otherwise. The story of motivational research in advertising is beyond the scope of this book, but *The Hidden Persuaders* by Vance Packard and *Confessions of an Advertising Man* by David Ogilvy will provide some additional insight.

There are no magic formulas for producing effective commercials; even the major advertising agencies, backed with millions of dollars for research, bomb sometimes. Conversely, commercials that fly in the face of research and established practice have done spectacularly well sometimes.

Although you generally won't be able to research the effectiveness of the commercials you produce (except for getting feedback from local merchants), you can take advantage of the basic appeals that appear again and again in broadcast advertising by including the elements of effective commercials in your productions.

Elements of Effective Radio Advertising

Essentially, a radio commercial has to be effective in terms of sound. There's no picture, so the sound must compensate.

That's not necessarily a disadvantage. A picture in the mind can be infinitely more persuasive than can a picture on the screen or in a print ad. Writer and producer Stan Freberg demonstrated this attribute quite effectively in a well-known promotional spot produced for the Radio Advertising Bureau. He created an imaginary scene, complete with sound effects, in which he drained Lake Michigan, filled it with hot chocolate, added a mountain of whipped cream, and had the Royal Canadian Air Force drop a 10-ton maraschino cherry on top. Freberg then challenged potential advertisers to "try that on television." (Can you imagine the sound effects Freberg would have used?)

The point is that all the imagination of the listener is brought to bear on the message through the use of music and simple dramatic techniques—many of them the same ones we outlined in the previous chapter.

Remember, too, that radio advertising can and should be geared toward a target audience. One of the great advantages of radio is that its audiences are usually clearly defined. Want to advertise acne medicine? Buy some time in the evening hours of the local top-40 station. An advertiser with a Mercedes-Benz dealership would be wise to check out an all-news station. The beer company advertising directly certainly will buy some time on the local station that carries the baseball games.

You, the radio producer, can take advantage of both elements of radio advertising (the ability to create mental pictures and the targeting of advertising) to create effective commercials. But it means that you must think in terms of radio. This sounds obvious, but it's not.

For one thing, the producer of radio commercials is often at odds with the client. This is because many merchants have the idea that the only effective commercial consists of an announcer reading as many store items and prices as can be crammed into a 30-second spot. We're not overstating the case. If you are in charge of at least some of a commercial's creative concept (as is often so, especially if you are involved in the sale), this is a situation you will probably experience time and time again.

The producer dealing with such a client faces a ticklish situation. The easy way out is to give the client what he or she wants, which might not be particularly effective, meaning that the account could soon be lost. Alternatively, the producer can lobby for a more enlightened approach, which could conceivably produce much better results and bring about an increase in advertising. However, keep in mind that even the most cleverly constructed commercial can fall flat.

In the long run, you and the client will both be better off by shying away from the approach of listing the entire contents of the client's store. Here are two examples of how Lew O'Donnell and Phil Benoit, who once owned an advertising agency, handled the problem. We're not saying that these are the best approaches or the only approaches; they're simply alternatives that were effective.

A Shoe Store Advertisement

A local merchant had, for years, run back-to-school ads listing 10 or 11 brands of children's shoes and their respective prices; results were middling. Although the shoe store owner initially opposed the idea, a radio campaign was developed in which the nostalgic excitement of back-to-school time was recreated in the minds of the parents (see Figure 12.1).

A Car Dealership Advertisement

Another merchant, the owner of a car dealership, was convinced to alter his advertising from a recitation of cars and prices to an approach that encouraged potential customers to browse on Sunday. The script (see Figure 12.2) also conveyed a low-key attitude. Notice how major advertisers avoid the listing approach. Grocery store chains, for example, may note one or two specials, but the thrust of the commercial is, "Our stores are friendly and convenient, offering the largest selection at the best prices. . . ." Much of this message can be communicated through dramatic technique or through music. But almost any approach will be better than the crammed-in list. For one thing, a radio listener might not even comprehend a list of products and prices, even though they are effective in a newspaper ad. Second, a list of products and prices doesn't exploit the strengths of radio advertising.

What does exploit radio advertising's strong points? Essentially, any ad that creates mental images and proves a benefit to the consumer. That benefit may be tangible (saving money) or perceived (avoiding the humiliation of ring around the collar).

Practical Approaches to Radio Commercials

In this section, we discuss the specific appeals radio advertising can make, as well as the nuts-and-bolts construction of a radio commercial.

Figure 12.1 Script of a commercial that uses an appeal to nostalgia to persuade its audience.

ANNOUNCER: REMEMBER THE EXCITEMENT OF GOING BACK TO SCHOOL WHEN YOU WERE A KID? THERE WAS THE SLIGHT SADNESS THAT SUMMER WAS OVER, BUT THERE WAS ALSO THE SENSE OF ANTICIPATION. . . . NEW BEGINNINGS AND A FEELING OF GOOD TIMES AHEAD FOR THE NEW SCHOOL YEAR.

ALONG WITH THAT SENSE OF EXCITEMENT CAME THE TIME WHEN YOU WENT SHOPPING FOR NEW CLOTHES. THEY ALWAYS HAD A SPECIAL KIND OF "NEW" SMELL TO THEM. AND WHEN YOU SMELL IT TODAY, YOU PROBABLY THINK OF GOING BACK TO SCHOOL.

BEST OF ALL, THOUGH, WAS GETTING NEW SHOES. YOUR OLD RELIABLES HAD JUST ABOUT MADE IT THROUGH THE PAST YEAR. AND NOW IT WAS TIME TO GET THOSE BRAND NEW ONES THAT WOULD GET YOU OFF TO A GOOD START.

WELL, VONA SHOES, 122 WEST SECOND STREET, IS THE PLACE THAT CAN BUILD SIMILAR MEMORIES FOR YOUR CHILD. AND WHILE THEY'RE AT IT THEY'LL SEE TO IT THAT YOUR CHILD GETS QUALITY AND A GOOD FIT. THE TOP BRAND NAMES IN CHILDREN'S FOOTWEAR IN VONA'S EXTENSIVE INVENTORY MEANS THAT YOU'LL FIND THE SIZE YOU NEED AND YOU'LL GET VALUE.

THAT'S IMPORTANT FOR YOU. BUT FOR YOUR CHILD, THERE WILL BE EXCITEMENT AND THE FUN OF GOING TO BUY SHOES FOR BACK TO SCHOOL.

A TIME FILLED WITH SIGNIFICANCE IN A YOUNG LIFE.

VONA SHOES . . . WHERE THEY UNDERSTAND YOU.

Advertising Appeals

Here we provide a rather cold-blooded listing of some of the emotional triggers that are frequently used in advertising. These appeals aren't usually discussed in this manner, but if they are to be used, you should recognize them for what they are. Although there's no universal agreement about the effectiveness of all these appeals because advertising is an area of few cut-and-dried truisms, we believe that the following appeals represent motives used in modern advertising.

Figure 12.2 Script of a commercial that tries to lessen the pressure of the car-buying process.

ANNOUNCER: SHOPPING FOR A CAR IS AN IMPORTANT PROCESS. ONE THAT TAKES TIME AND THOUGHT. YOU LOOK AND YOU TALK. . . . YOU DEAL AND YOU DECIDE. BUT THERE ARE TIMES WHEN YOU WOULD LIKE TO BE ALL ALONE AT A CAR DEALER'S LOT AND JUST TAKE YOUR TIME TO LOOK OVER THE SELECTION OF CARS WITHOUT TALKING TO A SALESPERSON.

WELL, AT BURRITT CHEVROLET ON BRIDGE STREET IN OSWEGO, WE UNDERSTAND THAT NEED. SO HERE'S A SUGGESTION. COME ON SUNDAY. ALL OUR CARS ARE ON THE LOT . . . AND THERE'S NO ONE THERE. YOU CAN BROWSE TO YOUR HEART'S CONTENT.

OF COURSE, ONCE YOU'VE HAD A CHANCE TO LOOK OVER OUR FINE SELECTION OF BRAND NEW CHEVROLETS AND OUR GREAT A-1 USED CARS, YOU'LL PROBABLY WANT TO COME BACK FOR A TEST DRIVE.

THAT'S WHERE OUR SALESPEOPLE CAN COME IN HANDY. THEY'RE AROUND THE OTHER SIX DAYS OF THE WEEK, AND THEY'LL BE HAPPY TO SET YOU UP WITH A TEST DRIVE, AND THEN THEY'LL WORK WITH YOU TO COME UP WITH THE BEST DEAL AROUND ON THAT CHEVY OR USED CAR.

SO PLEASE . . . BE OUR GUEST. VISIT BURRITT CHEVROLET ON WEST BRIDGE STREET, OSWEGO. DO IT ON SUNDAY AT YOUR OWN PACE. THEN COME BACK ON MONDAY, OR TUESDAY OR ANY OTHER DAY, AND FIND OUT WHY WE'RE THE DEALIN'EST GUYS IN TOWN.

We refer to a number of well-known television commercials to illustrate the appeals because spots aired on network television will be familiar to almost all readers; radio commercials are usually done on a local or regional basis and would therefore be less useful for this discussion.

Each of these commercials is aimed at an individual. Too often we tend to think of our audience as a group of listeners, but actually our audience is made up of individuals. Think about when you listen to radio. You listen, perhaps, in your car on the way to work or with a headset radio at the beach. Commercials should always address an individual and get him or her involved in the message. This is far more effective and appealing than the stereotypical "Hey, all of you out there in radioland" approach.

APPEAL TO PERSONAL FULFILLMENT The army's promise to help you "be all that you can be" typifies this appeal, which offers a subtle promise that the sponsor's product can help you be the person you always knew you could be. A credit card firm, for example, devotes a commercial to a woman in a college classroom, fulfilling her personal ambitions because, apparently, she was able to charge her tuition bills. Although we might quarrel with the approach of the credit-card commercial, isn't it more effective than reciting a list of all the places where a credit card can be used (even though it might be everywhere you want to be)?

APPEAL TO AUTHORITY Don't we all want a person who knows how to take us by the hand, figuratively, and tell us about a product? Notice how former senator Robert Dole used the authority appeal in encouraging men to seek treatment for sexual dysfunction.

APPEAL TO THE BANDWAGON EFFECT "More and more people every day are discovering . . ." appeals to a desire to get in on a trend. This is a powerful human emotion. Be in with the desirable people! Use the same products as the "in" crowd! Do you recognize several major advertising appeals that stem from this approach?

APPEAL TO FEAR OF REJECTION This is subtly different from the band-wagon effect because it illustrates the negative aspects of not being on the bandwagon. Commercials dealing with personal hygiene products are, without a doubt, the ultimate exploiters of the fear of rejection appeal. Note how people turn away from the poor unfortunates with bad breath, dandruff, and so on. You don't want to wind up like them, do you?

APPEAL TO SEXUAL SUCCESS This appeal can be as blatant as a well-known commercial that implied that a certain brand of toothpaste would whiten your teeth, making your smile more attractive. This category overlaps a number of other appeals, including personal fulfillment and fear of rejection. In many cases, the message is so obvious as to be offensive to some: Consider the stocking commercials featuring what is ostensibly a career woman—but people just can't stop looking at her legs.

APPEAL TO REINFORCEMENT OF LISTENER'S EGO "You know that this product is better because you're an intelligent . . ." is a common approach. In effect, the commercial gives the listener a chance to use the product or service and prove that he or she is, indeed, as smart as the commercial maintains. Remember the series of commercials about a particular Swedish car that pointed out how safe their vehicles are?

APPEAL TO PRESTIGE "Don't you deserve a [fill in name of car]?" Were it not for an innate need for prestige, such items as luxury cars and designer clothes probably wouldn't sell at all. The appeal to prestige hits that sensitive

nerve that prods us to prove, through our cars, clothes, and club member-ships, that we're a little better than other people.

APPEAL TO VALUE AND QUALITY This appeal cuts across several cate-gories, including prestige and reinforcement of ego, but the effect of this ap-proach is to convince the listener that the product or service is worth the price. Car commercials often state that the consumer can save money in the long run by buying a high-quality car that will hold up. Other commercials touting brand-name products use the same appeal. Sometimes direct com-parisons are used.

APPEALS TO OTHER EMOTIONAL TRIGGERS Nostalgia, family ties, guilt, loyalty, tradition, and even simple acquisitiveness all play roles in reaching listeners.

Execution of Radio Commercials

The various techniques for reinforcing the appeal of a commercial make the message effective. Most of these techniques have been covered in other parts of this book, but here we deal with some of the specific applications to radio commercial production.

MUSIC IN RADIO COMMERCIALS Music is very effective in establishing a commercial's mood or an overall set of conditions—perhaps even the atti-tude of a person acting out a dramatic element. For example, music that fea-tures other singers joining in is a strong motivator for the bandwagon effect. (Think of soft-drink commercials, which use bandwagon tactics heavily.) A commercial that appeals to nostalgia can quickly set the scene by using old songs. In this case, music becomes a sort of shorthand way of communicat-ing a message. For example, it's far more efficient to set the stage with some dance-band music than to load up the precious time with spoken copy de-signed to indicate the time frame.

Music, then, is very helpful to the commercial producer in creating a mood and reinforcing a message. However, music is not always a favorable attribute in a commercial. As we already noted, popular songs can be over-used. And to make matters worse, a currently popular song may detract from the message because listeners tune into the song and ignore the thrust of the commercial.

Music for commercials can come from sources other than the station's airplay library. To review, music can be obtained from

- *Generic commercial music libraries.* These collections feature music and lyrics for a wide variety of applications, such as "Do your shopping downtown," or "Your business is important to us." This type of produc-tion music is often quite useful, but it can become repetitive, and the

Figure 12.3 Script of a commercial that uses a donut.

```
                                                    RADIO SCRIPT
                                                    JOAN MAYER
                                                    30 SECONDS
                                                    CO-OP

USE WITH TAPE CUT #2

MUSIC OPEN: (10 SECONDS)

FADE MUSIC UNDER

ANNOUNCER:   THAT'S RIGHT, THERE IS NO BETTER WAY TO GET INTO SPRING
             THIS YEAR THAN TO BUY YOURSELF A COMPLETE COORDINATED
             SUIT AND SHOES OUTFIT BY JOAN MAYER. YOU'LL FIND A
             WIDE SELECTION RIGHT NOW AT_____.
             A JOAN MAYER OUTFIT MAKES IT EASY TO SAY "I'M READY,"
             READY FOR SPRING. THE WIDE SELECTION OF TWO-PIECE
             SUITS IN LIGHTWEIGHT DACRON WITH COLORS TO MATCH AND
             COORDINATE WITH OUR QUALITY BRAND OF SPRING FOOTWEAR
             MEANS THAT YOU'LL HAVE NO TROUBLE FINDING THE OUTFIT
             OR OUTFITS THAT MAKE YOU LOOK YOUR SMARTEST FOR
             SPRING. SO STOP IN SOON AT _____ AND MAKE
             YOUR SELECTIONS FROM OUR SELECTIONS.

MUSIC UP:    (5 SECONDS)
```

lyrics tend to be on the corny side. Moreover, once a lyric becomes associated with one retailer, it loses its usefulness for other applications.

- *Jingles from a national advertiser's ad agency.* When large manufacturers provide a contribution to local merchants' advertising budgets, the result is known as cooperative, or co-op advertising. The same types of jingles are used by large organizations that have local franchises. Most of this prepared music comes in a form known as a **donut,** whose "hole" is filled in by the local merchant's copy. Figure 12.3 shows an example of a script for a donut co-op ad.

- *Original music produced locally.* Local advertisers or advertising agencies often engage recording studios to compose original music for radio advertising. This usually isn't as difficult or as expensive as you might think, and some locally produced music can brighten a spot considerably. Some radio stations use musically talented staffers and freelancers to produce musical spots in-house.

In the use of any music, the producer will generally follow the guidelines expressed in Chapter 6; the editing structures (blending music and voice) are used extensively in the production of commercials.

VOICE IN RADIO COMMERCIALS The producer's role in dealing with vocal execution in commercials often extends to doing the actual announcing or choosing an announcer. The producer is also responsible for ensuring that the correct phrasing is used. Although guidance in announcing skills is beyond the scope of this book, it is important for the producer to know that anyone who reads copy must stress key words. The meaning must be clear; if the goal of the commercial is to express value, the word *value* must receive its proper stress.

Technology has had an impact on commercial production. Today, a producer can bypass the large recording studio. The Industry Update describes how it's possible to produce commercials in the comfort of your home.

Today, the announcer must be believable. In the most basic terms, someone portraying a senior diplomat should not sound like a 21-year-old. Another aspect of believability is consistency of the message: Does the announcer extolling the virtues of the friendly neighborhood bank sound friendly? Remember that booming bass tones don't make an announcer's delivery believable. In today's radio, the communicator, who communicates with an audience rather than orating at them, is supplanting the announcer.

Another aspect of choosing an announcer is the compatibility of the announcer's voice and delivery with the approach of the message. For example:

- The *hard-sell* approach requires an announcer with an authoritative, strong voice (not necessarily a deep voice though).

- The *sincere* approach calls for an announcer who is casual and does not have the disc jockey type of artificial delivery. An announcer with the singsong artificiality commonly found in top-40 radio (especially small-market top-40 radio) would be an extremely poor choice for a commercial requiring sincerity, such as a spot for a bank.

- The *whimsical* approach often borders on the comedic. This approach (remember Lake Michigan being filled with hot chocolate?) requires an announcer with a good deal of flexibility and acting ability. An offbeat voice often fills the bill quite well. An affected, booming, announcerish voice does not work well in this type of commercial, unless it's a parody of affected, booming announcers.

Industry Update

THE HOME SOUND STUDIO: TECHNOLOGY MAKES BIG-TIME SOUND AVAILABLE TO SMALL PRODUCTION AGENCIES

"Today, you can have—in your home—a studio that can produce phenomenal quality," says Jay Flannery, president of Class A Communications in Liverpool, New York. "Quality that you couldn't have touched for $100,000 even ten years ago."

Flannery, a veteran of the Syracuse, New York, radio market, is one of thousands of independent producers who have set up shop in their homes, using their personal computers as the engine that drives their production studios. Using audio editing software programs, a minimum of radio gear, and a special card inserted into the computer, the new breed of producers has replaced roomsful of expensive and cumbersome analog equipment. Flannery's business is diverse, spanning commercial production and audio training cassettes.

Flannery estimates that a newcomer to the home-studio business can have a pro-quality studio up and running for about $15,000 to $20,000. That's a considerable amount of money, of course, but as Flannery points out, in the world of startup businesses, that's what a florist would pay for one delivery truck.

At the heart of the system is a computer running audio editing software. Flannery is reluctant to dictate specific purchase recommendations because the computer evolves so rapidly that any recommendation put into print could be outdated by the time a book hits the shelves. But he does recommend that a neophyte producer follow two recommendations: First, buy the fastest system you can afford with the biggest hard drive you can get—a bargain in any event, he says, because disc storage prices have dropped severely in recent years. Second, if at all possible, use your audio editing computer only for audio editing; other programs can interfere with storage and processing.

There are many good audio editing programs (mentioned elsewhere in this book) and Flannery recommends you take your time and compare features based on your individual needs.

You will need to purchase a "sound card"—a computer card dedicated to handling audio operations—and you shouldn't try to skimp. Do your homework, Flannery recommends, and buy a good card. You can plan on spending at least $500 on the card.

Continues

Industry Update Continued

A mixing board is essential, as are minidiscs and a microphone. If you have the money, digital boards and decks are terrific, but old-fashioned analog boards will work.

A wonderful investment is a keyboard and some music software. A program called Cakewalk Home Studio 8 allows even nonmusicians to pick out tunes on a keyboard and layer them into good-sounding music beds.

But what about the challenges of working in a home environment, rather than in a soundproofed studio? Flannery says it's less of a problem than you might expect. Although he occasionally must rerecord a segment because of a dog barking or a car backfiring, he points out that with careful planning you can find a quiet spot and a quiet time to record in almost any home or apartment.

- Any *dramatized* element in a commercial requires an announcer with acting ability. Proficient announcers are not necessarily good actors, so careful screening must be done when casting a commercial that contains dramatic scenes.

The major point here is that, to take advantage of the different approaches available in radio advertising, the producer must be able to match the proper style of delivery to the message.

Suggestions for Producing Effective Commercials

The basics of producing good commercials are closely tied to the basics of any good radio production: a clear message and clean production. The elements we spell out in this chapter will help you define the message and structure it properly. Finally, we add some specific suggestions concerning the specialized case of radio commercial production.

Know Your Audience

Some commercials fail because the message does not reach the intended audience. Make sure that your script addresses its target audience and conveys the message in a clear fashion. If your commercial makes a claim, try to identify what aspect of the product or service fulfills the claim.

Avoid Gimmicks

For some reason, producers—and local merchants—seem to fall in love with echoes, sound effects, and so forth. A commercial that depends on gimmicks often has its essential message weakened. In addition, producing all your commercials with gimmicks becomes repetitive.

Although electronic effects and sound effects certainly have a place in commercial production, be sure, before you use them, that they reinforce the message and have a direct bearing on the commercial itself.

Summarize the Thrust

You should be able to summarize the thrust of a commercial in a few words: "The clerks in this store are very knowledgeable about their wares," or "This bank is friendly and wants to give you personal attention." The shotgun approach—mentioning every possible benefit of a product or service—usually doesn't work very well in a radio commercial, primarily because of the listener's short attention span and because time is limited. If the message seems scattered or fuzzy, rewrite the commercial.

Don't Blast the Listener

Some producers have become enamored of the idea that louder is better, and they take considerable pains to make sure that every sound element peaks the VU. There's no question that you should strive for bright technical quality, but excessive loudness and abrasiveness can often detract from the message.

Read the Spot to the Client

If you're in the position of writing the spot and getting approval from the client, you can wind up with a better product by reading the script to the client rather than handing over a piece of paper. Why? Because people tend to pick at words instead of grasping the whole concept. They also tend to drastically overestimate the amount of copy that can be squeezed into a given time frame, and reading your spot aloud leaves no doubt in the client's mind that it is, indeed, 30 seconds' worth of copy.

By reading the spot aloud to the client, you project the thrust of the commercial as it should be presented, and you don't get involved in a 10-minute argument about the choice of a particular word. Some salespeople choose to bring along a roughed-out tape of the produced spot; this approach has pros and cons, and its effectiveness will probably depend on your individual situation.

Don't Force Humor

If there's any doubt about whether a spot is funny, it's probably not. Nothing falls as flat as a failed attempt at humor.

Achieve High Technical Quality

Strive for the best possible technical quality in your commercials. Commercials tend to stay unchanged for quite a while, and they get frequent use, so use the best production technique possible, and put the spot on a new cart if your station uses cart machines. (Checking the rack in many radio stations often turns up commercials produced years ago.) If the commercial is on a bad tape to begin with, the quality will only deteriorate.

It's a good idea to save copies of all commercials in the event of hard disk or cart failure; otherwise, you'll have to reproduce the whole spot. Incidentally, always save hard-to-reproduce production elements, such as jingles or elaborately created sound effects, in case you want to recut the commercial with a new slant while retaining some of the original production elements. If your commercial was produced on a DAW, save the playlist (also called an edit list) as well as the raw soundfiles.

Don't Overuse a Particular Piece of Music

There's a tendency to seize on a piece of music that works well for production purposes and to use it constantly. It is a tendency to be resisted. If you use music from your station's airplay library, keep alert for new selections that would lend themselves to production work.

An index of the music beds used for various productions is sometimes a good way to ensure that a particular piece does not get overused. Tape an index card to the back of a CD cover, and list the spots and dates you used certain cuts. (Imagine how embarrassing it would be to find that you and another producer had recently used the same cut for two different banking commercials.)

Keep the Message Simple

Too many ideas in one commercial, as we've discussed, can muddy the whole concept of the spot.

Avoid the "Big Five"

In general, steer clear of what we call the Big Five mistakes of commercial production, some of which we have already touched on. To summarize, avoid the following:

1. *Lack of focus.* The listener must be given a simple message that doesn't wander from idea to idea.

2. *Poor technical quality.* This includes commercials that are too loud, too soft, or badly produced. Take pains to recut or redub a commercial when it doesn't sound as good on the air as it sounded in production.

3. *Lack of completeness.* As we pointed out in Chapter 11, a message is more effective if it has a beginning, a middle, and an end. A commercial that just sort of peters out, ending without a satisfying conclusion, loses some of its impact.

4. *The assembly-line approach.* We all develop certain working habits, but when a producer makes several commercials that sound the same, there's a serious problem. The commercials will lose impact, and clients—who, after all, have ears, too—will complain. Make an effort to vary your approach from time to time. Use different announcers and production music.

5. *Fear of experimentation.* Don't shy away from trying a new approach just because it hasn't been done before in your station or your city. You may make mistakes, but never allowing yourself the freedom to experiment limits both your creative potential and the potential benefits to your advertising clients.

Radio advertising offers a viable outlet for your creativity—an outlet that will permit your creativity to be strongly appreciated. And though advertising can sometimes be a pretty cold dollars-and-cents affair, radio advertising producers have shown that creative advertising, done honestly and in good taste, can be effective.

Production Applications in Station Promotion

Closely related to commercial production created for a station's advertising clients is the production that a station creates for its own promotional efforts. Known in the industry as *station promotion,* this is an area that has recently assumed greater importance than ever before.

Competition for the attention of radio audiences has never been keener. First, our society is saturated with a wide variety of media forms. Each does its best to get audiences to spend time consuming the information or entertainment it offers. Second, every radio station on the air faces stiff competition for listener attention and loyalty within its market and medium. Unless a station succeeds in attracting the attention of a significant number of listeners, the revenue it generates from advertising will fall off, and the station will ultimately fail.

Even in public broadcasting, audiences are critical. Listeners are a major source of financial support, and major underwriters of programming are reluctant to support programming that doesn't attract enough listeners.

The bottom line is that stations can't rely anymore on their programming alone to ensure an adequate base of listeners and, hence, advertisers. Station

promotion is a major tool in generating the listener interest that produces loyalty to a station's programming.

Production is a key element in creating promotional vehicles that help stations build their identity and create excitement and interest among listeners. There is a fundamental difference between the kinds of production techniques used for commercial production and the work done for station promotion. As we mentioned earlier, it is generally wise to avoid the use of gimmicks in commercial production. The idea is not to have the production techniques call attention to themselves. Rather, you want to focus audience attention on the sponsor's message.

In promotion, however, the elements of production are more central to the success of the effort. The heavy use of such effects as reverberation, sound effects, sound coloration through **flanging,** shifting the pitch of recorded elements, and the punch that is added by the skillful blending of many different and often unusual sound elements is what attracts the attention of the audience. In many instances, the copy used in promotional spots may be virtually nonexistent. The only words in some promotional spots are in single spoken lines (known as *liners*) that function as a slogan. The line "More music less talk," for example, might be the only copy used. This might be followed by the station call letters or another kind of identifying name followed by some reference to the station's spot on the radio dial. "Hot 106," for example. This might be followed by a musical jingle.

The key to making such spots effective is the way the elements are blended and the effect produced by the overall sound of the spot. You might, for example, start the spot with a sound effect created electronically, add flanging to the announcer's delivery, and insert the sound of tympanies between the voice-over and the jingle. All this might be recorded over a music bed from a production music library that has been "time compressed" so that it ends just as the jingle begins. The whole thing might be under 10 seconds in length when it is ready to air.

It is difficult to recommend specific techniques that might be employed in promotional production situations because the field is open to so much experimentation and creativity. The key to becoming a successful producer of promotional production is to become well versed in the kinds of audio effects that can be produced within the capabilities of your studio equipment. The availability of multitrack recording equipment and access to good libraries of sound effects and production music can be enormously beneficial. Increasingly, digital audio workstations are broadening the creative possibilities for promotional production considerably for those stations fortunate enough to have them.

Whether you operate with state-of-the-art technology or the modest equipment and facilities that still characterize many fine radio stations, your creativity as a producer can be the major ingredient in production for station promotion. Listen to as many different stations as you can. Whenever you have the opportunity, ask producers how certain effects are created. Above all, perfect your production skills. Lastly, experiment.

Promotional production that is skillfully integrated into the on-air schedule can significantly help you create the identifying elements that together make up the sound of the station. No other area in the field of production offers more creative challenges and rewards to radio producers.

Summary

Producers of commercials must meet a number of goals, including producing commercials that stimulate sales, producing commercials that please the client, and producing commercials that fit your station's sound.

Many elements help make a commercial effective. Often, those elements run deeper than what you might at first imagine. For example, it is not enough simply to run lists of merchandise and prices in a radio ad. Radio requires entry into the theater of the mind.

Many appeals are involved in radio advertising, including appeals to personal fulfillment, to authority, to the bandwagon effect, to fear of rejection, to sexual success, to reinforcement of the listener's ego, to prestige, to value and quality, and to other emotional triggers.

Music is an important tool in radio production, but it is helpful only when it reinforces the central theme of the spot. The voice of the announcer obviously plays a critical role. It is not enough, however, that the announcer has a good voice; he or she must also have a voice that is appropriate to the particular spot.

Commercials should have a narrow thrust; that is, you should be able to summarize the commercial in a sentence. If it is too complex for capsulation, it is too complex to be a radio commercial. Simplify.

Production for station promotion focuses on creating excitement among listeners that helps attract them to the station and that helps distinguish your station from its competitors. The key to success in production for station promotion is an extensive knowledge of audio production techniques and creativity in their use.

Applications

SITUATION 1 / THE PROBLEM The production director of a radio station was putting together a commercial for an ice-cream parlor. The client insisted on copy that touted the old-fashioned atmosphere of the store; the copy included a physical description of the ice-cream parlor and a dissertation on old-fashioned value. As it stood, the commercial was flat, talky, and unfocused.

ONE POSSIBLE SOLUTION About 15 seconds of the copy was deleted, and a bed of Gay Nineties music was substituted. The banjo and piano music, which was bright and cheerful in addition to conveying a sense of period, augmented the message, which now could be clarified and refined.

SITUATION 2 / THE PROBLEM A local bank, one of the station's largest customers, had become extremely unhappy with the lack of results from its radio

advertising. The commercials, which were elaborately produced, with music and narration by the station's young morning woman, stressed the honesty and dependability of the bank and its people. But the message didn't seem to get across.

ONE POSSIBLE SOLUTION The music and fast-paced delivery were scrapped, and new commercials were cut. The new spots featured the voice of the station manager, a woman in her late 50s, who stressed, in a conversational, low-key tone, that the bank and its people were honest, dependable, and an asset to the community. Now, the production values supported the message.

Exercises

1. Replace the following announcer's copy with a shorter dramatic scene or sound-effects sequence. Your goal is to shorten the message, focus it clearly, and give it greater impact. This assignment can be done either as a hands-on production exercise or as a mental exercise with the solution scripted out.

 Rolling Hills Apartment Complex is more than a place to live. It's a place to enjoy—there are tennis courts, a swimming pool, and a golf course. You can enjoy all these facilities, and families with children are welcome. Everyone can have a lot of fun at Rolling Hills. . . .

 (*Hint:* Would sound effects work here?)

 (*Hint:* How about a dramatized scene of happy residents?)

2. A bank has come to you with a desire for commercials to entice more young professional customers. Write a 60-second commercial that meets this need. One hook might be a young doctor saying that she doesn't have time to manage her money thoughtfully and the people at the bank are a great help. Could sound effects or dramatic elements help clarify this message? If time and lab facilities are available, produce the spot.

3. Write a treatment (a description of the approach and production elements) for each of the following situations. Tell why you think each will be effective.
 a. A shoe store that wants to reach blue-collar workers with a message about its tough workboots.
 b. A drugstore that has a new line of cosmetics for men. The store's manager wants to reach young adult males and convince them that it's all right to use cosmetics. (Would a well-known local athlete be a good choice to pitch cosmetics?)
 c. A hardware store that wants to attract apartment dwellers rather than just homeowners. (What products at a hardware store would be of interest to apartment dwellers, and why should they go to a hardware store to buy them instead of to a department store?)

You're On!

TECHNIQUES FOR EFFECTIVE ON-AIR PERFORMANCE

Fitting Your Copy into the Allotted Time—How Announcers Can Read to Time

A great deal of recorded program production involves laying voice into a commercial, PSA, or promo; and that task almost always involves working within rigid time constraints. A 30-second spot has to be exactly 30 seconds, and a 10 second announcer's lead-in to the start of a vocal has to be equally precise. Some commercials, for example, come with a "hole" in the middle where the local announcer inserts copy. (These commercials, appropriately, are known as *donuts*.) But it's not as difficult as it seems. Here are some techniques for developing your own internal clock.

- First, recognize that this skill comes with experience. Keep practicing.

- Develop a familiarity with music and music phrasing. Listen critically to music, or take a music appreciation course, and you'll be able to identify key changes or the distinction between a trumpet and a French horn solo. This will be helpful because you'll find that music beds now are laden with cues. You'll be able to rehearse your copy and note that you have to finish the first narration when the key changes, and finish the whole reading about two seconds after the trumpets enter.

- Learn to time yourself in ten-second intervals. If you can accurately gauge ten seconds, timing thirty seconds or sixty seconds will take care of itself. Practice with copy and a stopwatch. Count how many words you typically read in ten seconds.

- Mark your copy with time cues. Write hints to yourself on the copy.

- Learn how to compress copy. There is often too much copy and too little time to read it. This is a problem particularly in local commercials, where merchants may want an absurd amount of detail squeezed into 30 seconds. You and your salespeople can educate them, but it's a safe bet that you will be spending much of your career trying to compress 45 seconds' worth of copy into 30 seconds. This isn't easy, but there are a couple of tricks to it:

Continues

You're On! *Continued*

- Keep all the elements of the copy in proportion. Think of it this way: When an orchestra speeds up a piece of music, it speeds everything up . . . the quarter notes, the half notes, the rests, and so forth. They remain proportional. You must do the same thing with your copy; don't change the phrasing or eliminate natural breaks between words or phrases. Speed everything up. Don't alter the melody and rhythm of your voice.

- Read ahead in your script. Reading ahead allows you to speed up the copy, but to retain its natural cadence. When you read aloud the same word your eyes are hitting in the copy, you become a reading machine and sound like one. But when you read a few words or a sentence ahead in the copy, you are reciting phrases and will be communicating, not repeating words. It takes practice, but it's not as difficult as it seems.

Radio Production for News and Public Affairs

News production is a critical portion of the work done in a typical radio station. For one thing, news is a very visible part of many stations' product, so the production values stand out clearly. And because news is aired frequently on most radio stations, particularly on the AM band, the news producer is called on to do news production and to change production values at a quicker pace.

It isn't always possible to change the content of a news story every hour or half-hour, but it is possible to change the production or editing structure. For example, the news producer may decide to eliminate an actuality quote used at 8 A.M. and instead read the quote as part of the news story at 9 A.M. The producer might also elect to use two actualities within a story instead of one and recut the news story for the next hour.

The hectic pace of news requires that you be able to do the work quickly. In addition, you must do the work well: The radio network news may play immediately before or after the local report, and the producer must offer production that doesn't suffer by comparison.

When starting out in radio, expect to wear many hats. Virtually everyone involved in radio has, at some time, been required to do and understand news production. Air personalities in smaller stations often are expected to be able to come up with acceptable newscasts; even salespeople will be called on to discuss the newscast in detail.

Regardless of your particular role in preparing news programming, the important thing for you to remember is that radio is a medium of sound. More and better sound doesn't necessarily guarantee a good newscast, but it does add to radio's impact and appeal.

What do we mean by "more and better sound"? Essentially, the goal of radio news programming is to offer something more than an announcer

reading the copy. Additional sound elements—such as an interview conducted with the subject of the story; a live, on-the-scene report from a radio station staffer; or the noise of a riot taking place—add to the variety and maximize the impact.

These attributes relate to the strengths of radio and the qualities radio news can stress. Radio is unsurpassed for timeliness—getting the story on the air quickly. Radio is also a personal medium, a one-on-one method of communication and, as such, can effectively relate the human-interest values in a story. Further, the personal medium of radio can bring a listener into close proximity to a story, directly on the picket line or at the scene of the fire. Sound sources can help a great deal in this regard.

Again, sound sources do not make the newscast. Good journalistic principles must be followed, and the voice and delivery of the on-air person must be appropriate. The news producer—whether he or she is the actual gatherer and reader of news or the executive in charge of the station's overall news effort—is responsible for a wide variety of duties. The total gamut of these duties (which may be split among several people) involves news gathering, news writing, assembling the elements of a newscast (including stories and sound elements), and news reading and reporting.

Let's now take a look at these duties and examine how production plays a role in their execution.

News Gathering

One limitation of radio news is that the newsperson is often tied to the studio. In smaller stations especially, the news director may be the only newsperson. Although a good reporter will make every effort to get out into the field, at least to make rounds at the police station, city hall, and so forth, much news gathering must be done from the studio. In larger stations, street reporters do on-the-spot news gathering.

In either event, news gathering consists of obtaining facts from which stories are written. It consists of collecting actualities, the recorded segments of news events or news makers. An actuality can be an interview segment or a recording of the **wild sound** resulting from an event, such as a funeral march or the wailing of fire sirens. Although the terminology varies across the country, wild sound or interview actuality is often referred to as a **sound bite;** however, that term is more widely used in TV than in radio. *Sound bite* generally refers to an interview segment. News gathering for radio also involves a great deal of recording from the telephone.

In smaller stations, much of the news gathering is done by perusing the local paper. Although it's not generally admitted, many local newscasts involve the announcer reading directly out of the paper. Sometimes the listener can even hear the pages being turned! More often, though, stories are rewritten. In small and even medium-sized markets, the radio newsperson won't have many sources at all other than the newspaper, though overreliance on

the paper must be avoided. For one thing, papers are wrong on occasion, and when the paper is wrong, you are wrong. In addition, most newspapers are quite sensitive about the reuse of their material by another profit-making organization. Many newspapers are copyrighted and could take legal action against a station that makes a wholesale appropriation of its material.

Another drawback of relying too heavily on the newspaper is that radio news is expected to be "up to the minute," whereas newspapers are generally several hours out of date by the time they reach the reader. It's important for a radio news staff to develop its own system of news gathering (sources, calls to the police, and so on) because listeners generally aren't tolerant of old news, which has about as much appeal as yesterday's newspaper.

News Writing

Words—their order, their meaning, and their rhythm—can be considered to be a production value. The style of writing influences the sounds, and writing does, of course, put the whole package together. Writing also involves the way sound elements are assembled.

Although a treatise on news writing is beyond the scope of this book, it is important for a news producer to remember that what is written must sound right when it is read aloud and must be conversational. Stilted, ponderous writing has no place in radio. Be aware that the listeners have only one opportunity to understand what is being said; they cannot look back, as they can with a newspaper article. Clarity is critical.

Another difference between newspaper and radio writing (and another reason for not reading from the newspaper) is that newspapers use the **inverse pyramid** writing style, in which the important who, what, where, when, and why are listed in the first few sentences. Its advantages in the print media notwithstanding, this format is generally both confusing and boring to the listener. Radio news demands shorter sentences and active verb tenses, and this style of writing is really quite different from newspaper journalism. To repeat a popular and worthwhile phrase, radio writing is written for the ear, not the eye.

For example, a newspaper **lead** might read, "Twenty-four-year-old John Smith, of 91-B Mechanic St. in Centerville, was killed in an accident today near the Jefferson Street on-ramp to I-100, when his car collided with a truck that was traveling the wrong way on the ramp, police said." That sentence (which is not extremely long as newspaper leads go) would be confusing to listeners, who would be better served by, "A local man died today when his car collided with a truck police say was heading the wrong way on an expressway off-ramp." Now, the details can be presented in ear-pleasing, bite-sized fashion.

Sentences in broadcast news writing should be kept short (20 to 25 words, or fewer). Attribution is usually put first. In other words, "State Police Captain David Smith said today that there is no word on the fate of the

missing hunter," rather than, "There is no word on the fate of the missing hunter, said Captain David Smith of the state police."

Proficiency in news writing will come from journalism courses and on-the-job training, so we won't expand on it here except to remind you that, if you don't know how to type at this point in your career, you must learn. Many radio stations simply won't hire newspeople who can't type; in any event, typing is a skill that will come in quite handy in almost any broadcast career.

News Assembly

An important responsibility of a news producer is to fit the pieces of the newscast together and decide what will go on the air. (We're talking here about a newscast, though we examine other facets of radio news production later in this chapter, along with more specific details of newscast structure.) The assembly process can involve both choosing stories and story order and choosing the sound elements.

Choosing Stories and Story Order

What goes on the air? What goes on the air first? Often, the responsibility for answering these two questions will fall on you, and it requires a sense of news judgment. Running a story first makes it, in effect, the lead story and imbues it with additional importance. Although news judgment is a subject better addressed in journalism classes, the radio news producer must be aware that it is often necessary to shuffle news stories from hour to hour to provide variety in the news. A story is often pushed up in the rotation simply because it is new. The time element is an important consideration because radio is a medium that thrives on timeliness—radio can provide news more quickly than any other medium can.

Choosing Sound Elements

Next, you may select an actuality and integrate it into the copy. In addition to the actuality and wild sound described earlier, you will often have access to reports filed by journalists in the field. These reports usually come in the forms of **voice reports,** or **voicers,** and **voice-actuality** reports.

VOICE REPORTS These straight news items are reported by a journalist and signed off in a fashion such as, "This is Jane Roberts reporting for WXXX News." Voice news reports usually run between 30 and 90 seconds, though there's no hard-and-fast rule.

VOICE-ACTUALITY REPORTS A voice-actuality report is constructed in the manner of a voice wrap, the editing and production structure explained

Industry Update

A QUICK PRIMER ON RADIO NEWSWRITING

One of the more common complaints we hear from those in a position to hire radio news personnel is that the applicants simply lack writing ability.

We urge you to take as many courses as you can on broadcast news writing. But for now, it will be to your advantage to acquaint yourself with the basic principles in this Industry Update. Because production equipment is used by almost everyone now, the line between producer and reporter is blurred. But it's safe to say that if you want to go into radio news you must know how to write, and today, the need for writers is greater than ever.

To start with, remember this essential fact: The writing style you use for broadcast will not be the same style used for written reports, term papers, newspaper copy, or anything meant to make a direct path from paper to eye to brain. Broadcast copy makes a path from eye to mouth to ear, so it must be different in style, punctuation, and sentence structure.

Don't try to write broadcast copy using the same punctuation and sentence structure you'd use in a term paper or business report; you'll wind up with unreadable copy. Conversely, don't use broadcast style to write your reports or papers: The work will come back disfigured by red scrawls scolding you for *Incomplete sentence! Poor sentence structure! Paragraphs too short! Ideas not fully developed! Do not use contractions!*

The first thing you should remember about broadcast news writing is that you're not exactly writing. You're committing speech to paper. You are, in short, telling a story, a story that will be spoken. You must use words and phrases that can be spoken naturally and relay the story in the form *we're used to hearing people use when they tell a story.*

For example, suppose you just received a letter informing you that you've won a full scholarship to Harvard Law School. You pick up the phone to call your father. After, "Hello, Dad," would you be likely to say this:

> After four years of diligent work, my efforts were rewarded. I received a letter from Harvard Law School today. "We are pleased to inform you that you have been awarded a full scholarship covering all tuition, fees, room and board," the letter said.

We doubt it. No one speaks that way—not even the professors at Harvard Law School. More than likely, the conversation would sound like this:

> I'm going to Harvard Law School—for free! The hardest four years of my life finally paid off. *A full scholarship.* The letter I got today says the scholarship covers tuition, fees, and room and board.

Continues

Industry Update Continued

What we've seen, of course, is another comparison between print style and broadcast style. And it is obvious that the first example, although lucid in print, is absolutely unreadable if you try to say it out loud. The first example does not tell a story conversationally; the second does.

With that in mind; let's see how broadcast stories are "told" on paper.

Script Conventions for Radio

What we'll do here is "build" a radio story from top to bottom to illustrate the way a radio script is put on paper. The goal of this section is not so much to demonstrate techniques of writing, as such, but rather how the standard story is constructed and scripted. (Remember, stations vary widely in their particular script formats, but most are variations on the following theme.)

So, to follow the chain of events from the very beginning, we'll start with the paper and typewriter, then begin working at the very top of the script page and work our way down the page to the ending.

Paper and Print

Even with the spread of computers into radio newsrooms, hard copy will probably always be part of the news writing process. Many smaller radio newsrooms are not yet computerized and may never be. The investment simply cannot be translated to the bottom line. (You'll even find a few radio newsrooms that have not yet graduated to word processors.)

This is not entirely a function of economics. Modern computer systems perform many functions that are not needed in a small radio newsroom, such as calling up graphics or listing the dozens of events found in a half-hour newscast (see Figure 13.1).

Although news software is becoming popular in medium and large radio stations, in smaller stations most copy winds up on paper, anyway. Even the bravest newscaster reading from a computer-driven prompting device would be reluctant to go on-air without hard copy clutched in his or her hand in case of a computer crash.

So because broadcast news writing still involves words on a page, remember that those words have to be easily readable. That means a lot of white space on the page, as few corrections as possible, clearly made corrections when they are necessary, and a large, clear type. Many stations use a special large typeface, sometimes called Executive or Orator.

It's very hard to read copy that is crammed tightly on the page, so most radio and TV stations triple-space their copy. Some stations double-space, but triple-spacing is more the norm. Triple-spaced copy is more easily

Continues

Industry Update Continued

Figure 13.1 *Computerized news packages are found in medium and large market stations. These programs perform many advanced features, such as performing full test word searches.*

SOURCE: Screen shot of E-Z News courtesy of Automated Data Systems

readable than double or single-spaced, and it leaves room for last-minute corrections to be penciled in. Wide side-to-side margins are also helpful.

SOME NEWSCASTERS FIND COPY WRITTEN IN ALL CAPS TO BE MORE READABLE. THAT MAY BE SIMPLY BECAUSE THEY ARE USED TO SEEING COPY TYPED THAT WAY; IT'S SOMETHING OF A TRADITION IN NEWS WRITING. THERE IS NO UNIVERSAL STANDARD; SOME STATIONS USE ALL CAPS, AND SOME USE STANDARD UPPERCASE AND LOWERCASE. AT LAST CHECK, AP RADIO AND REUTERS, THE

Continues

Industry Update Continued

TWO MAJOR WIRE SERVICES AND ALL THE TELEVISION NETWORKS USE UPPERCASE AND LOWERCASE. WHAT'S YOUR OPINION?

The choice will usually be made for you because you're obligated to follow whatever system is used in your particular newsroom. If you have a choice, we would suggest uppercase and lowercase, a format that appears to be the growing trend in broadcast copywriting. Although some announcers contend that copy written in all caps is more readable, most of us are used to seeing uppercase and lowercase English in almost every other written work. Furthermore, writing in uppercase and lowercase makes it easier to determine whether a word is a proper name.

THE FIRE IN OVERLAND, OHIO . . .

can cause a second of doubt and hesitation for an anchor who might wonder if "Overland" is a town or if the writer is trying to make some distinction between "over land" and "over sea."

The fire in Overland, Ohio . . .

can't cause such confusion.

One last word about paper and typing: In radio, there is often no need for multiple copies of the script, and the increasing use of computers allows copies to be stored electronically and called up at will. Having two copies of the script for radio is usually enough. Often, the script is typed on plain paper, but sometimes you will use special carbonless script paper to produce the copy. Plain paper is usually photocopied or a copy made while typing, using an old-fashioned sheet of carbon paper.

The Header

Most broadcast news departments require writers to put some basic information right at the top of the page: the slug, which is a *very brief description,* usually just a key word, that identifies the story, the *writer's name or initials,* and *the date.* The exact location of these entries varies from newsroom to newsroom; some departments put the three slug items on separate lines, flush against the left margin:

NURSES
HAUSMAN
9/17

or across the top line:

NURSES HAUSMAN 9/17

Continues

Industry Update Continued

The header provides a means of quickly identifying the story itself and finding who wrote it, in case something about the story is questioned or another reporter needs additional information and must talk with the writer. The date is essential for a number of reasons, including the fact that scripts are kept for archival purposes, and you'll need to know when the events described happened when referring to the archives. For example, this story concerns a nursing shortage at a city hospital and features an actuality from the hospital administrator as she addressed the city council. If you do a follow-up story next month, or next year, you'll need to know when the meeting took place.

A second important reason for including the date is that all scripts look pretty much the same, and you need a reliable way to tell an old story from a new story. *Always* double-check the dates of local and wire-service copy before you read it. (A sad-but-true story illustrates the reasoning behind this warning. A janitor once found a two-year-old piece of wire copy behind a desk he had moved when waxing the floor. He put the paper with the rest of the pile on the desk—that day's news copy, of course—and it was read on the air. The story referred to a bill being vetoed by a president who was no longer in office.)

A very good idea that is put into practice in some radio newsrooms is to mark, on the script, the time of the newscast during which the story was read. You can hand-write or type this at the end of the header. Most radio news stories are rewritten during the day, so keeping track of the newscast time will help you see how the story has evolved through several rewrites and will also save confusion if a listener or management has a question about the story "on the 7:30 A.M. newscast" and you need to figure out what version went over the air.

So your final header might look like this:

NURSES HAUSMAN 9/17 7:30 A

We recommend this format.

The Story

Now comes the body of the story. Drop down two triple-spaced lines and begin writing:

NURSES HAUSMAN 9/17 7:30 A

The administrator of City Hospital says the nursing staff is in critical condition. Jane Smith appeared before the City Council last

Continues

Industry Update Continued

night to warn that a severe shortage of nurses is causing a health-care crisis. Smith says almost a third of the nursing positions at City Hospital are currently unfilled. And, she says, everyone suffers because of the shortage.

Tape Cues

An actuality from Ms. Smith is in a computer sound file or on a cartridge (a special type of tape that automatically recues itself and starts instantly). But you need to indicate certain information about the tape. The reader of the script needs to know three things:

1. That there *is* a sound file (or a tape) and it should run at *this point* in the story. The script should contain an advisory listing the name of the file (tape), the title with which it is labeled. In this case, it would most likely be "Smith." ("Smith" would be written on a peel-off label and affixed to the cart. If there are two cuts from Ms. Smith, the carts would be labeled "Smith 1" and "Smith 2.") (Modern news software shows the actuality within the script and includes the title of the actuality as well as the time and outcue.)

2. The time of the sound file (tape). This is important so that the newscaster can be ready to start reading at the appropriate time—when the taped segment ends. If it's a long actuality, say, 20 seconds, the newscaster may elect to use those 20 seconds to perform some last-minute emergency chore, such as quickly proofreading a story he or she just pulled from the typewriter.

3. The outcue. An outcue is a written transcription of the final words spoken on the tape. This is the newscaster's cue to begin reading the rest of the story.

It is also helpful, but not always necessary, to know the incue for the actuality. This immediately reassures the newscaster that the correct tape is being played and, conversely, warns the newscaster if the wrong cart has been "fired," giving him or her the opportunity to cut the tape quickly and avoid a prolonged period of embarrassment.

Inserting the actuality advisory into the script is sometimes done this way:

NURSES	HAUSMAN	9/17 7:30 A

Continues

Industry Update Continued

The administrator of City Hospital says the nursing staff is in critical condition. Jane Smith appeared before the City Council last night to warn that a severe shortage of nurses is causing a health-care crisis. Smith says almost a third of the nursing positions at City Hospital are currently unfilled. And, she says, everyone suffers because of the shortage.

TAPE: SMITH . . . RUNS :20

INCUE: "LAST NIGHT WE HAD . . ."

OUTCUE: " . . . CAN'T GO ON MUCH LONGER."

There are myriad variations on methods of indicating tape cues, but most involve a recognizable combination of the items shown.

One not so common but very effective method is to type out the entire actuality on the script. This way, if the tape does not roll, the newscaster can simply read the quote as if nothing had happened, ad-libbing the "she saids" as appropriate. A complete transcription of the actuality would look like this when incorporated into the script:

NURSES HAUSMAN 9/17 7:30 A

The administrator of City Hospital says the nursing staff is in critical condition. Jane Smith appeared before the City Council last night to warn that a severe shortage of nurses is causing a health-care crisis. Smith says almost a third of the nursing positions at City Hospital are currently unfilled. And, she says, everyone suffers because of the shortage.

TAPE: SMITH . . . RUNS :20

"LAST NIGHT WE HAD ONE ELDERLY GENTLEMAN WAIT AN EXTRA HOUR AND A HALF FOR HIS PAIN MEDICATION. WE JUST COULDN'T GET TO HIM. WE WERE STACKED UP WITH THREE EMERGENCY CASES AND WERE SHORT FIVE NURSES ON THE SURGICAL FLOOR. I'M AFRAID, REALLY AFRAID, THAT THE NEXT TIME THIS HAPPENS IT'S GOING TO BE WORSE THAN LEAVING AN OLD MAN IN PAIN. HE JUST MIGHT DIE WAITING . . . AND I LITERALLY THINK THE STRESS IS KILLING THE NURSES. THIS CAN'T GO ON MUCH LONGER."

Some major news organizations, such as network radio news centers, transcribe all actualities used during the newscast. They usually don't do this on the script, but rather on a separate form that includes

Continues

Industry Update Continued

other information about the actuality. The transcription is available to the newscaster (kept in a separate pile from the script) that serves as an emergency paraphrase in case the tape fails. This practice, unfortunately, is becoming increasingly rare as budget cuts eat into news operations.

Story Tags

The final step is to conclude the story with a sentence or two, known as a tag. It is generally considered poor form to simply end with an actuality and go to the next story. Doing that confuses the listeners and makes the story seem oddly incomplete. Besides, in this case, more detail is still begging to be written. We know there's a nursing shortage, and we know that the administrator is complaining about it, but why is there a shortage and is anything going to be done about this situation?

So here's how those questions might be answered and the story concluded:

NURSES HAUSMAN 9/17 7:30 A

The administrator of City Hospital says the nursing staff is in critical condition. Jane Smith appeared before the City Council last night to warn that a severe shortage of nurses is causing a health-care crisis. Smith says almost a third of the nursing positions at City Hospital are currently unfilled. And, she says, everyone suffers because of the shortage.

TAPE: SMITH . . . RUNS :20

INCUE: "LAST NIGHT WE HAD . . ."

OUTCUE: " . . . CAN'T GO ON MUCH LONGER."

City Hospital administrator Smith says she simply can't attract nurses because of what she calls a double whammy. She says there is a statewide shortage of nurses . . . and claims that City Hospital cannot compete for those nurses because of poor working conditions and lower than average salaries.

City Council chairman Arthur Lake says he'll establish a task force to look into the option of hiring an outside firm to recruit nurses from other cities.

###

Here are some points about the script worth discussing:

Continues

Industry Update Continued

1. The ### at the end indicates that the story has ended. In other words, it shows the reader that there is no second page. Most radio stories do not run longer than one page, but when they do it is *imperative* to indicate that there is more copy to follow. Some news writers put

(more)

at the bottom of the page. Others draw an arrow indicating that the story is continued. If the story on which we're now working were on two pages, it might be so indicated in this manner:

NURSES PAGE 1 OF 2 HAUSMAN 9/17 7:30 A

The administrator of City Hospital says the nursing staff is in critical condition. Jane Smith appeared before the City Council last night to warn that a severe shortage of nurses is causing a health-care crisis. Smith says almost a third of the nursing positions at City Hospital are currently unfilled. And, she says, everyone suffers because of the shortage.

TAPE: SMITH . . . RUNS :20

INCUE: "LAST NIGHT WE HAD . . ."

OUTCUE: " . . . CAN'T GO ON MUCH LONGER."

City Hospital administrator Smith says she simply can't attract nurses because of what she calls a double whammy. She says there is a statewide shortage of nurses . . . and claims that City Hospital cannot compete for those nurses because of poor working conditions and lower than average salaries.

(more)

NURSES PAGE 2 OF 2 HAUSMAN 9/17 7:30 A

A City Council chairman Arthur Lake says he'll establish a task force to look into the option of hiring an outside firm to recruit nurses from other cities.

###

2. If you must split a story into two pages, never break a sentence. Always end one page with a complete sentence.

Continues

Industry Update Continued

3. Notice that we re-identified the speaker in a slightly abbreviated form after the taped actuality ran. Making a second reference after the actuality helps clarify the story in the listener's mind. Radio listeners are often distracted or for some other reason miss part of a story; perhaps they just drove through a tunnel or only now tuned in to the station. In any event, using a shortened second reference after the actuality gently reminds the listener who has just spoken and keeps the listener on track.

Some news organizations ask the writer of the story to time the script. The running time, including the actuality, is frequently written in the upper-right corner. You can approximate the script time by reading the copy out loud or counting lines. Line-counting depends on your personal typewriter and margin setup, and is generally less accurate than reading aloud. Many computer programs will time the story based on the newscaster's typical reading speed.

Lead-in to Voice Reports

It is quite common for this type of story—a report on a city council meeting—to be filed by a field reporter, taped in its entirety, and left for the morning newscaster. The story will generally be protected and concluded with the station's standard outcue. A standard outcue is what reporters are instructed to say at the conclusion of their piece, such as "Mike Michaels reporting from City Hall for WXXX News."

Mike Michaels's report, a voice-actuality or V-A (sometimes called a wraparound), might read like this:

City Hospital administrator Jane Smith warned the City Council that a severe shortage of nurses is causing a health-care crisis. Smith says almost a third of the nursing positions at City Hospital are currently unfilled. And, she says, everyone suffers because of the shortage.

"LAST NIGHT WE HAD ONE ELDERLY GENTLEMAN WAIT AN EXTRA HOUR AND A HALF FOR HIS PAIN MEDICATION. WE JUST COULDN'T GET TO HIM. WE WERE STACKED UP WITH THREE EMERGENCY CASES AND WERE SHORT FIVE NURSES ON THE SURGICAL FLOOR. I'M AFRAID, REALLY AFRAID, THAT THE NEXT TIME THIS HAPPENS IT'S GOING TO BE WORSE THAN LEAVING AN OLD MAN IN PAIN. HE JUST MIGHT DIE WAITING . . . AND I LITERALLY THINK THE STRESS IS KILLING THE NURSES. THIS CAN'T GO ON MUCH LONGER."

Continues

Industry Update Continued

City Hospital administrator Smith says she simply can't attract nurses because of what she calls a double whammy. She says there is a statewide shortage of nurses . . . and claims that City Hospital cannot compete for those nurses because of poor working conditions and lower than average salaries.

City Council chairman Arthur Lake says he'll establish a task force to look into the option of hiring an outside firm to recruit nurses from other cities. This is Mike Michaels reporting from City Hall for WXXX News.

You will frequently write scripted intros for a voice report or voice-actuality. The intro often is a simple "handoff" to the piece, but often it is used to update the story, making it more current by reporting on the status of protected items in the recorded piece. For example:

NURSES MICHAELS VA INTRO PAGE 1 OF 2 HAUSMAN 9/17

City officials are meeting today to start looking for solutions to what's been called a health-care crisis in the making. Council president Arthur Lake is holding a meeting with the City Hospital administrator at this hour. Lake and the City Council got an earful about the situation at last night's meeting, and Mike Michaels was there.

TAPE: MICHAELS

RUNS: :58

OUT: SOC

MICHAELS REPORTED THAT CITY HOSPITAL ADMINISTRATOR JANE SMITH WARNED THE COUNCILORS THAT A NURSING SHORTAGE AT THE HOSPITAL IS JEOPARDIZING PATIENT CARE AND CAUSING ENORMOUS STRESS AMONG THE NURSES. THE CITY COUNCIL IS GOING TO SET UP A TASK FORCE TO INVESTIGATE NEW METHODS OF RECRUITING NURSES.

You'll note several points relating to the intro.

1. The time element (last night) is written in the intro and not the V-A. Therefore, the V-A could be used in the 11 P.M. report and the 7:30 A.M. report. What's on tape won't spoil because it's been intelligently protected. The intro can be adjusted to compensate for the time element.

Continues

Industry Update *Continued*

2. The intro does not repeat Mike Michaels's first sentence. It sounds very awkward to have the same words repeated.

 Mike Michaels says there's a health-care crisis brewing at City Hospital.

 Michaels Tape: "There's a health-care crisis brewing at City Hospital. Last night . . ."

3. However, the introduction does make a declarative statement about the news event. This is usually considered much better practice than simply saying, "Now, Mike Michaels has a report about the nursing shortage at City Hospital."

4. In addition to the information you would expect (the time, the name of the label on the tape, and the fact that it ends with a standard *outcue*), this introduction includes a brief summary of the story. Writing this kind of intro takes time, a commodity in short supply in broadcast journalism, so many newsrooms don't follow this practice. But it is highly recommended. If the tape doesn't roll, the newscaster can simply read the summary—and no one listening will be the wiser. (Another alternative is to have Mike Michaels leave a copy of his script handy, assuming the report was fully scripted and not partially ad-libbed. You can cover by ad-libbing from Michaels's script.)

Punctuation

Some broadcast news writers use marks of ellipsis (. . .) to indicate the pauses in a story.

> More bad news from the State House today . . . state taxes are on their way up again.

The jury is still out on whether ellipses are the right form of punctuation for broadcast news. (Ellipses is the technical term for the three dots, but most people in the news business just call them dots. Actually, dots is probably more correct because the term *ellipses* can imply, if you use the literal sense of the term, that something is missing from the printed material. That is the true technical use of marks of ellipsis. But that's not why they are used in broadcast news writing.)

Some news writers like using dots. Mike Ludlum, former executive director of news for CBS radio stations and the former news director of all-news radio stations in New York and Boston, finds them useful. "Dots work very well to show the flow of the writing," he says, "and to indicate effective pauses and emphases."

Continues

Industry Update Continued

But Ludlum also notes that many news anchors prefer incomplete sentences with periods to reproduce the conversational style so often used in broadcast news writing.

More bad news from the State House today. Taxes are on their way up again.

In summary: Either technique is fine. Use what's standard in your department or station. Dashes are all right, too, and are especially useful for setting off a clause in the middle of a sentence.

A long day—and a soggy one—for runners in the Marine Corps Marathon.

Commas are used pretty much as they are in standard print writing: to separate clauses and items in a list. There are elaborate and highly specific formulas for comma use in standard written English, but for broadcast news writing it's probably best just to use a comma where you would normally pause when speaking out loud. Which of the following two examples rolls off the tongue more easily?

The officers who saved the woman from the fire have been identified as Tom Roberts Melvin Hastings and Bob Griffith all of the 14th precinct.

The officers who saved the woman from the fire have been identified as Tom Roberts, Melvin Hastings, and Bob Griffith, all of the 14th precinct.

Actually, this sentence is a bit long. Let's use dots to break out another phrase and make the sentence more readable.

The officers who saved the woman from the fire have been identified as Tom Roberts, Melvin Hastings, and Bob Griffith . . . all of the 14th precinct.

The use of an apostrophe for forming contractions is also the subject of some debate—not about the apostrophe, but about the contraction—although most news writers use contractions freely because they make the phrases more conversational. As a general rule, contractions are fine—recommended, in fact—*except* when there's a possibility of misunderstanding.

You'll note that the previous sentence includes "there's," and this sentence uses the contraction "you'll." If spoken aloud, there would be no question that the writer meant "there is" and "you will." But be careful with "can't."

Continues

Industry Update Continued

The school board president says she can't grant the wage increase sought by union clerical workers.

This is a particularly difficult sentence in which to read "can't" and have it clearly understood. The word might easily be misunderstood as "can," which will obviously change the meaning and probably anger or perplex some members of the audience. Better to use "can not." Spell it out as two words, just for emphasis. It's even better to recast the whole sentence so that you can avoid the can–can't problem altogether.

The school board president says there's absolutely no way she can grant the wage increase sought by union clerical workers.

Words

Some words and sentences sound stilted when read aloud. Others are tongue-twisters that may cause the newscaster to stumble, hiss, or pop.

The formula is simple: If you can't comfortably read it out loud, or if it sounds unnatural when spoken, don't write it on paper.

A giant pall hangs over Washington as the House writhes in internecine party warfare.

Nobody uses "giant pall" in conversation except, perhaps, for newspaper headline writers. Very few people can say "House writhes" without stumbling or spitting, so don't write it. "Internecine" is a word best saved for your master's thesis. Few people know what it means, and even those who do would find it inappropriate for news copy.

Jargon and Technical Words

Along the same lines, be wary of technical terms or jargon. You may know what a CAT scanner is, but many in the audience won't. Saying that CAT is an acronym for computerized axial tomography won't help because few people know what that term means. So define it in lay language.

Riverdale Memorial Hospital has filed for funding to buy a CAT scanner, a multimillion dollar machine that visualizes the inside of the human body without using X rays.

Slang is acceptable in some situations, but be sure, if you use a slang term, that it's a word that people understand, that it does not make your English sound substandard, and that it is not offensive.

Continues

Industry Update Continued

Active versus Passive

Broadcast news writing is usually more effective, direct, and understandable when it is in the active voice rather than the passive voice. A sentence is in the active voice when the subject performs the action.

Mayor Leavitt delivered the report.

A sentence is in the passive voice when the subject of the sentence is acted on via the object, using a word such as "by." (This is an informal definition specific to our example and not grammatically correct in all cases.)

The report was delivered by Mayor Leavitt.

In general, attempt to write in the active voice. An occasional use of the passive voice is acceptable, however. Sometimes, the passive voice is preferable for variety, but the active voice generally carries the story forward with more vigor. You can use quite a lot of simple, active-voice subject-verb-object sentences in broadcast news writing. *When all else fails, stick to the basics, especially in a confusing story laden with heavy detail.* Subject-verb-object constructions are easy to write and easy to understand.

"Says" and the Use of Present Tense

The word *says* is part of two common scripting conventions. One is to use the present tense whenever possible. If you look back over the radio script slugged NURSES, you'll see "says" used several times. "Says" is generally a better choice for broadcast copy than "said" because it is in the present tense—and radio and television are "now" media. But be aware that there is something of an inherent inaccuracy in using the present-tense "says" because what someone said yesterday is not necessarily what someone says today. Use "says" under most circumstances, but if you are quoting a controversial statement or a statement pegged to a particular time, use "said."

Senator Smith says his opponent is a fraud and a liar.

Better pin that down to a time and place because Senator Smith might not be saying that today, especially if he has recently heard from his opponent's lawyer.

Continues

Industry Update Continued

Senator Smith—in a speech last night before the West Side Veterans of Foreign Wars annual banquet—said his opponent is a fraud and a liar.

Also use "said" if the statement is placed in time or space, regardless of whether it is controversial.

As he stood before the Memorial Day crowd, the mayor said that the threat of nuclear war must be eliminated—forever.

There is another problem with "says" or "said." We get tired of writing it. We *assume* that people get tired of hearing it, but there is some debate about whether anyone in the audience really notices. So we hunt for alternatives.

Note that in one section of the radio script, we used "claims" instead of "says" or "said."

She says there is a statewide shortage of nurses . . . and claims that City Hospital cannot compete for those nurses because of poor working conditions and lower than average salaries.

"Claims" is an entirely different word from "says." It implies a degree of skepticism—which is probably warranted in this case. As a reporter, I would feel a slight discomfort in using "says" in the clause that alleges that City Hospital has poor working conditions because the statement is just that—an allegation. "Claim" implies that this is an unproven statement made by a person or group. In a statement of plain fact, however, "claim" can lend an unintended air of suspicion.

State College President Martin Gold claims enrollments are up this year.

Is there some suspicion that he's lying? If so, "claims" is all right, but if not, it adds an unintended twist of skepticism to the story. Stick with "says" most of the time. Although you might be tempted to use "claims," "declares," "pronounces," and so on, "says" is usually your best option.

One more consideration about verb tenses is important. Even though "says" is an example of the basic principle of keeping broadcast copy in the present tense, don't shift tenses so that they create a silly sentence or distort reality.

A man is dead this afternoon after committing suicide this morning.

That's a real example that, though not misleading, sounds just plain idiotic. But here's another real example.

Continues

Industry Update *Continued*

A Bronx woman is shot to death . . . and police continue their manhunt.

This one *was* misleading because the woman was shot a full day before the story aired. The lead might induce people who heard yesterday's news to believe that another Bronx woman was shot. So when something important happened, please don't get cute with the tenses. Just say that it happened and tell when it happened.

Numbers and Abbreviations

Some characters that are perfectly plain in written English are jarring to the newscaster who has to read them aloud. Numbers, symbols, and abbreviations may be tongue-twisting or might take a split second to decode mentally, so news writers have developed specific conventions to deal with them.

Numbers

Usually, you can simply round off large numbers. A city budget of "almost fifty million dollars" is reasonably accurate if the figure is $49,887,211.12. You can also round off distances. "A 200-mile trip" is all right even if you know it is really 202.5 miles. But don't round off specific statements of important fact where the number really makes a difference. You would not, for example, round off figures in an airline disaster (unless the numbers were estimates of deaths, in which case, you say they are estimates).

Spell out numbers from one to twelve, and use numerals after that. The same scheme is handy for ordinal numbers, except most writers use numerals after eleven: first, fifth, eleventh, 12th, 20th, and so on. Ages are usually given before the name: "19-year-old Mark Smith." By the way, it's usually best to use the numeral when indicating ages. Use "4-year-old," and not "four-year-old."

Symbols and Abbreviations

Symbols and abbreviations are usually distracting in copy meant to be spoken. For example, the $ symbol is best left unused; write "five hundred dollars." Parentheses are rarely if ever used. Spell out "percent." Quotation marks are hardly ever used because broadcast quotes are paraphrased or orally attributed.

Abbreviations can stop an anchor dead in his or her tracks if they're unfamiliar to him or her, so be careful. Be *especially* careful if you are

Continues

Industry Update Continued

writing copy to be read by people new to your area. TPK may be a standard abbreviation for "turnpike" in your city, but an out-of-towner may have no idea what it means.

Short of Mr., Mrs., Ms., and Dr., you're well-advised to spell out everything.

Names

Broadcast news writers generally do not use middle initials. However, there is a notable exception: If you are reporting that a man named Frank Jones died in a traffic accident, it's best to give as much information as possible, including the middle initial and the complete address. Why? Because there may be dozens of Frank Joneses in a major city—even in a medium-sized city—and reporting the death of Frank Jones could very well panic the friends and family of Frank A. Jones, Frank B. Jones, Frank C. Jones, and others.

Again, remember that the conventions mentioned here are not universal. Don't think that a script differing from the specifications outlined in this chapter is "wrong" or, for that matter, that what you have read here is "wrong." Every station's script format shows many idiosyncratic variations.

So use whatever format is common in your department or station, but be prepared to adapt to different ways of doing things when you move on. That, of course, will be hardly any trouble at all once you've learned the basic principles. As for the technicalities, they can be picked up in an afternoon.*

*Portions of this Industry Update were adapted from Carl Hausman's book *Crafting the News for Electronic Media: Writing, Reporting and Producing*, published by Wadsworth in 1992.

in Chapter 6. A voice actuality is simply a report from a journalist with an actuality segment inserted. It is signed off in the same way as a voice report.

News Reading and Reporting

In small stations, the role of producer is combined with the roles of reporter and news reader. Again, the broad topics of news reading and filing reports are beyond the scope of radio production as discussed in this book, but it's important to remember that they do play a role. Inflection and tone are as eloquent as the choice of words. Pace of the delivery certainly is a production value. Another production value is the quality and style of the ad-lib

type of report filed by journalists in the field, which may involve using the telephone or two-way radio. As a news producer, you should be aware that this kind of ad-lib report is done with some frequency in radio news and is the kind of thing radio does better than any other medium.

Many radio stations have used timeliness to their advantage by calling themselves "newsleaders" or "the news authority" in the community. Such slogans need to be backed up with good coverage and accurate reporting, but time and again, radio has demonstrated its ability to go live at a moment's notice. Often, this can be done with a simple phone call. Anyone who has ever listened to "All Things Considered" or "As It Happens" knows of radio's superior ability to cover breaking stories immediately.

Gathering, writing, assembling, reading, and reporting the news are the basic tasks that constitute the structure of news programming. These tasks can be integrated into various types of programs, which for the sake of discussion, we group into public-affairs programming, newscasts, and talk shows. (Talk shows are often a part of public-affairs programming, but they are different enough to merit separate discussion.)

News and Public-Affairs Programming

Although it has no precise definition, **public-affairs programming** differs from news in that it is less immediate. Public-affairs programming is usually directed toward a specific topic, which is examined at greater length than is possible in a news report. The role of a producer in public affairs can involve selecting the topic for discussion or examination, choosing guests, making all the organizational arrangements, and even setting up the mics.

The mainstay of public-affairs programming is the interview or talk show, which we discuss in detail shortly. Public-service announcements also are the public-affairs producer's responsibility.

Public-service announcements, known as PSAs, are generally short announcements, similar in structure to commercials, that are provided at no charge on behalf of nonprofit organizations. PSAs are usually 30 or 60 seconds long, have the same structure as commercials, and can be approached with the production techniques we described in Chapter 11.

One purpose of the PSA is to draw attention to a message. You wouldn't want to tamper with a newscast by adding music or staged dialogue, but the public-service announcement can certainly benefit by attention to production details.

Newscasts

In radio, the newscast is often a 3- to 5-minute program inserted into the music programming of the station. In most cases, the station offers the

Figure 13.2 Computers receive news stories from a wire service at WRVO-FM, Oswego, New York.

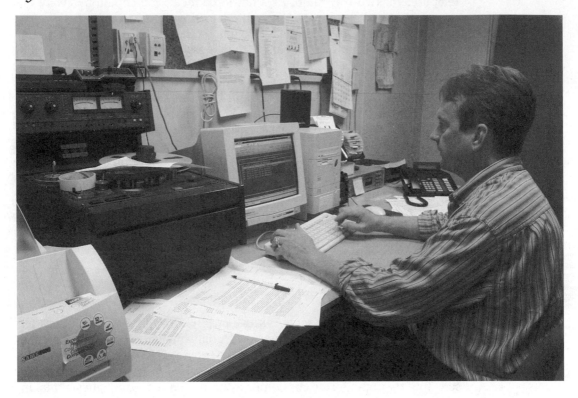

Photo by Fritz Messere

newscasts on the hour or on the half-hour, though the local news may follow the network news and may therefore be presented starting 2, 3, 4, or 5 minutes after the hour, depending on when the station breaks away from the network newscast. (Radio networks structure the newscasts so that local affiliates can break away gracefully at various points.)

The newscasts produced locally are usually put together in a newsroom, which contains a variety of equipment to facilitate construction of the newscast (see Figure 13.2).

The equipment in a typical newsroom includes means for recording from the telephone, a vital part of radio newsgathering (though some stations choose not to use telephone interviews). There are usually cart machines, a computer or minidisc for recording audio and editing, and a wire-service computer in the newsroom. In some cases, the newscast is done directly from the newsroom, so a mic and console are found in some facilities.

The content and structure of the newscast vary greatly among stations. Following are some of the typical mixtures and arrangements.

Exclusively Local News

Many stations carry network newscasts and have their news staffs devoted entirely to local news. News staffs typically gather, write, assemble, and read the newscast over the air. The local news in such stations usually includes two or more pieces of actuality. Much of the local news coverage is rewritten from the paper; if staff size permits, local meetings are covered (usually in the evening), and a voicer is left for the morning reporter.

Local News with Wire Copy

Many stations integrate international, national, and state copy into locally originated newscasts. By and large, radio stations get their state, national, and international news from wire services, most notably Associated Press (AP) and Reuters. There are other news services, many available as Internet services, and some are syndicated through the mail.

Although today the transmission is via satellite, the name *wire services* is still used, a reminder that all news was once fed over telegraph and telephone wires. The wire services offer special feeds to broadcast outlets—feeds that differ from the service given to newspapers. Essentially, the stories are shorter and written in broadcast style. The stories are often constructed in such a fashion that they can be updated quickly, with new information plugged in. The wire services specify where the new information is to be inserted.

The offerings of wire services include extensive news summaries, which are fed at predetermined times during the day; briefer summaries, which provide a couple of minutes' worth of copy; headline summaries; stock reports; agricultural news; commentaries and feature pieces; sports; and weather. Wire services also feed special features that relate to current news items. A newsperson can use these features, which are fed well in advance of an upcoming event, to bolster a station's coverage of a major news story, such as a political convention. Wire-service material is slugged (a **slug** is a brief identifying or clarifying phrase) with the time of transmission, along with other relevant facts (see Figure 13.3).

Wire services provide what's known as a *state split;* that is, the circuits of the services are turned over to state bureaus, and state news is fed to the appropriate stations. Much of the news is gathered by local affiliated stations and phoned in to the wire services. Traffic fatalities, for example, are almost always phoned in by local affiliates. The weather is also delivered in a split. Several forecasts will be fed, and the local newsperson picks out the appropriate forecast. (It might be slugged, for example, SEVEN WESTERN COUNTIES.)

Figure 13.3 Sample of wire-service copy. (Associated Press.)

AP V0901 RD INT—2ND MORNING DRIVE NEWSWATCH 12–15 6:54A

ENGINE PROBLEMS CITED IN CRASHES . . . BAD SIGNS IN BASEBALL . . . TAX CUT COMING

 (MORRISVILLE, NORTH CAROLINA)—ONE ENGINE APPARENTLY QUIT ON THAT AMERICAN EAGLE COMMUTER PLANE THAT CRASHED TUESDAY IN NORTH CAROLINA. OFFICIALS SAY THE FLIGHT RECORDER CAPTURES THE CREW TALKING ABOUT A "FLAMEOUT" AND ABORTING THE LANDING. FIFTEEN PEOPLE DIED IN THE CRASH.

 (FRESNO, CALIFORNIA)—WITNESSES SAY BOTH ENGINES WERE OUT WHEN A LEARJET CRASHED INTO A FRESNO, CALIFORNIA, NEIGHBORHOOD YESTERDAY. OFFICIALS SAY BOTH CREWMEN DIED IN THE CRASH AND AT LEAST 15 PEOPLE ON THE GROUND WERE HURT. THE PLANE HAD BEEN TAKING PART IN A NATIONAL GUARD WAR GAME.

 (WASHINGTON)—PRESIDENT CLINTON SPEAKS TO THE NATION TONIGHT. HE'S EXPECTED TO PROPOSE A MIDDLE-CLASS TAX CUT FOR FAMILIES EARNING UNDER 100-THOUSAND DOLLARS A YEAR. AIDES SAY THE TAX BREAK COULD COST 50 (B) BILLION DOLLARS OVER FIVE YEARS.

 (NEW YORK)—A NEW POLL INDICATES ALMOST SIX IN TEN AMERICANS ARE WILLING TO PAY MORE TAXES, FOR JOBS AND TRAINING, TO HELP PEOPLE GET OFF WELFARE. THE SAME "NEW YORK TIMES"–C–B–S NEWS POLL FINDS STRONG SUPPORT FOR LAWS REQUIRING WELFARE RECIPIENTS TO WORK.

 (RYE BROOK, NEW YORK)—THE TWO SIDES IN THE BASEBALL STRIKE ARE HARDENING THEIR POSITIONS. TALKS BROKE OFF YESTERDAY, AND TODAY OWNERS MEET IN CHICAGO, WHERE THEY'RE EXPECTED TO IMPOSE A SALARY CAP. THE PLAYERS VOW TO FIGHT THAT MOVE IN THE COURTS.

 (WASHINGTON)—JIMMY CARTER SAYS HE'LL TRY TO END THE BOSNIAN WAR, IF BOSNIAN SERBS MAKE GOOD ON SOME PROMISED CONCESSIONS. HIS ANNOUNCEMENT FOLLOWS MEETINGS WITH BOSNIAN SERB OFFICIALS IN GEORGIA. THE WHITE HOUSE SAYS CARTER IS WELCOME TO TRY, BUT NOT AS A REPRESENTATIVE OF THE U–S.

Continues

Figure 13.3 (Continued)

(BRUSSELS, BELGIUM)—NATO'S DEFENSE MINISTERS ARE RENEWING THEIR SUPPORT FOR U–N PEACEKEEPERS IN BOSNIA. CLOSING OUT MEETINGS IN BELGIUM, LEADERS SAY THEY'VE TOLD THEIR GENERALS TO FIND WAYS TO BACK UP THE PEACEKEEPERS. BUT PLANS ARE ALSO BEING MADE FOR EVACUATION IF IT BECOMES NECESSARY.

(LOS ANGELES)—PROSECUTERS TODAY CONTINUE TRYING TO FIND OUT WHAT O.J. SIMPSON SAID DURING A LOUD, EMOTIONAL JAILHOUSE CONVERSATION WITH A MINISTER. THE DEFENSE SAYS THE CONVERSATION SHOULD BE PRIVATE, BUT A GUARD OVERHEARD IT, AND THE JUDGE MUST DECIDE IF HE CAN REVEAL WHAT WAS SAID.

(WASHINGTON)—AUTHORITIES SAY A FEDERAL GRAND JURY HAS BEGUN CALLING WITNESSES TO SEE IF THERE'S ANY CONNECTION AMONG ATTACKS ON ABORTION PROVIDERS AROUND THE COUNTRY. AN ABORTION RIGHTS ACTIVIST SAYS IT'S ABOUT TIME. BUT AN ANTI-ABORTION LEADER CALLS THE PROBE A "WITCH HUNT."

(UNITED NATIONS)—UNICEF SAYS IT'S WINNING THE BATTLE AGAINST CHILDHOOD DISEASES. THE AGENCY SAYS (M) MILLIONS OF CHILDREN HAVE BEEN SAVED UNDER A COMPREHENSIVE MEDICAL CAMPAIGN LAUNCHED IN 1990. IT SAYS PNEUMONIA AND MALNUTRITION REMAIN MAJOR KILLERS.

AP V0980 RH 1AL—11TH NEWSMINUTE 12–15 10:43A

CLINTON WORKING ON TAX CUT . . . BASEBALL DISPUTE REACHING KEY POINT

(WASHINGTON)—PRESIDENT CLINTON IS PUTTING THE FINISHING TOUCHES ON PLANS FOR A MIDDLE-CLASS TAX CUT. CLINTON UNVEILS HIS PROPOSAL IN A NATIONWIDE ADDRESS TONIGHT. THE REPUBLICAN PARTY CHAIRMAN SAYS CLINTON IS JUST FOLLOWING THE G-O-P'S LEAD ON TAX CUTS.

(RYE BROOK, NEW YORK)—BASEBALL OWNERS AND THE PLAYER'S UNION ARE APPROACHING WHAT COULD BE A WATERSHED IN THE CURRENT STRIKE. THE OWNERS MAY IMPOSE A SALARY CAP AGAINST THE PLAYERS TODAY. THE PLAYER'S UNION SAYS IT WILL FILE AN UNFAIR LABOR PRACTICE CHARGE IF THAT HAPPENS.

Continues

Figure 13.3 *(Continued)*

(UNDATED)—FEDERAL INVESTIGATORS ARE WORKING ON A PAIR OF PLANE CRASHES. IN NORTH CAROLINA, THEY'RE PONDERING WHETHER ENGINE TROUBLE CAUSED A COMMUTER PLANE TO GO DOWN. IN FRESNO, CALIFORNIA, THEY'RE PROBING THE CRASH OF A MILITARY LEARJET. THE TWO CRASHES KILLED 17 PEOPLE.

(BETHLEHEM, OCCUPIED WEST BANK)—CHRISTMAS PREPARATIONS HAVE BEEN BRIEFLY INTERRUPTED IN BETHLEHEM'S MANGER SQUARE. IT HAPPENED TODAY WHEN ISRAELI POLICE FIRED SHOTS IN THE AIR WHILE CHASING PALESTINIAN STONE THROWERS. NO ONE WAS HURT.

(SARAJEVO, BOSNIA)—U–N AND BOSNIAN GOVERNMENT OFFICIALS HAVE THEIR DOUBTS ABOUT THE SERBS' LATEST PROPOSAL. THEY SAY THERE'S NO SIGN THE SERBS ARE MAKING GOOD ON OFFERS TO FORMER PRESIDENT JIMMY CARTER TO CEASE FIRING. AMONG OTHER THINGS, THE SERBS WANT CARTER TO ENTER THE PEACE TALKS.

Wire services are very useful, and they provide material that a local station couldn't easily obtain anywhere else. Unfortunately, the excellent job done by wire services, combined with the fact that many radio stations are badly understaffed, leads to the rip-and-read syndrome, wherein the newscast gets no more attention than reading 5 minutes of whatever's available. (Wire services were printed out on paper on a teletype machine before the days of computers. The term "rip-and-read" is a holdover from the time when the board operator would run into the newsroom and rip the copy off the wire about a minute before he had to read it over the air.)

In small stations, the rip-and-read approach to news often results in a newscast's being torn from the wire service printer and read by a staff announcer rather than by a full-time newsperson. Rip-and-read often sounds exactly like what it is: a half-hearted and somewhat sloppy approach to a station's news commitment.

If you use wire-service material in your newscasts—and you almost certainly will at some stage in your radio career—proofread the wire copy in advance. Keep an eye out for state and regional stories that directly affect your community. (The rip-and-read newscasters often overlook state and regional stories that might relate, for instance, to the health of a local industry or to a current or former local resident.)

Wire services provide such an excellent resource that many people involved in radio news production often overlook some important working principles. Here are some brief suggestions on using wire services effectively in radio news production.

ACQUAINT YOURSELF WITH THE SCHEDULES AND WORKINGS OF THE SERVICE Very often, the schedule of transmissions isn't posted; if that's the case, track it down and learn it. The wire services provide working manuals, pronunciation guides, and other descriptive literature that can be very helpful but that often don't filter down to the newspeople. Asking for and reading through this material will be beneficial.

CHECK COPY FOR TYPOS AND PRONUNCIATION PROBLEMS During a reading on the air is the wrong time to puzzle over a typo. Typos do happen on wire-service feeds. You may even encounter garbled material.

Likewise, don't take the chance of stumbling through an unfamiliar name or word. Use a dictionary if you're in doubt, and ask someone at the station for advice on how to pronounce names of local people and communities. Wire services generally provide pronunciation guides for difficult-to-pronounce words. Learn to use these guides, and you may save yourself and your station some embarrassment.

ALWAYS VERIFY THE TIME OF TRANSMISSION ON A STORY YOU WILL USE If you print your news in hardcopy, one piece of paper looks just like another. That's why it is important to check through copy to make sure that an old and dated story doesn't get included in copy scheduled to go on the air. Monitor wire copy to be sure an update on your story has not been sent.

News with Wire Copy and Network Audio

In addition to newscasts, some wire services and networks provide voicers, actualities, and voice actualities to affiliated stations. This kind of arrangement allows you to be very creative, provides more flexibility in sound, and gives the newscast a very professional sound. Correspondents report the news from all over the world, and actualities from breaking news stories are fed as soon as they are gathered.

A wire service, such as AP, will feed a description known as a **billboard.** The billboard describes the piece; tells its length; and states whether it is a voicer, a voice actuality, or an actuality. The individual pieces are counted down ("Rolling in three . . . two . . . one . . . In Washington today, there was . . .") so that the person in the newsroom can start the cart machine at the proper time or can edit out the countdown cue on the computer.

Remember, the audio service is a different entity from the wire-service copy, which comes in via a satellite feed to a computer; the audio service is an extra. This type of product is also available from private organizations

Figure 13.4 Promotional Web site for a college radio news service.

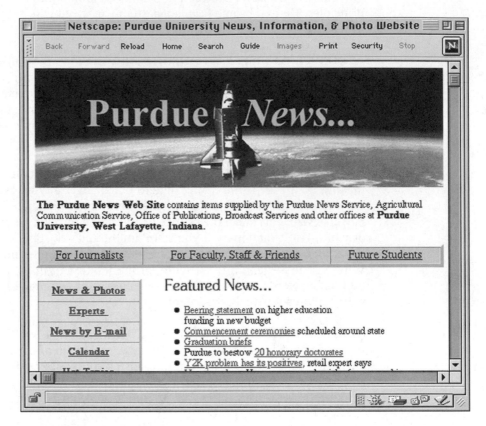

Courtesy Purdue University News with NASA photo

seeking to provide news features free in return for the publicity. Colleges and universities often run such services as a part of their public-relations operations (see Figure 13.4).

Talk Shows

Talk programs can run the gamut from news-oriented, issue-focused community-affairs programs to celebrity interviews. Often, though, they come under the jurisdiction of the news or public-affairs department.

Most often, the talk show is prerecorded and features a host and one or more guests discussing a prearranged topic. The two most common forms are the one-on-one show and the panel discussion. A popular variant is the call-in show.

In the *one-on-one talk show,* an interviewer and a guest discuss a topic; the interviewer often runs her or his own board, with the guest on a separate mic in the same studio. Sometimes an engineer runs the board.

The *panel discussion* features a moderator and several participants. Here, proper miking and a good moderator become major considerations. Aside from following the mic techniques outlined in this book, you can deal with the problem of miking a panel discussion by keeping the number of interviewees as small as possible. Some panel discussions on radio are truly awful because they are impossible to follow. A clamor of disembodied voices makes things very tough on the listener.

It's important, in a multiperson discussion, that the producer or moderator identify each speaker frequently during the program and avoid, whenever possible, having two or more people speak simultaneously. (This happens more often than you might think.)

The *call-in show* is a talk program designed to include the listening audience. Often it is presented around a previously announced topic of discussion, but sometimes listeners call in and speak about whatever is on their minds. What's on listeners' minds is not always suitable for airing, however, so a tape-delay system is often used. That is, the program is recorded live and fed back over the air several seconds later. Producers of call-in shows often screen calls in advance, weeding out cranks and clarifying the topic with the callers. A board operator handles the tape-delay system, monitoring the signal that goes out after the delay.

Special Events

The news and public-affairs producer often is responsible for special events production. We cover many of the technical aspects in Chapter 14. Keep in mind that you may be called on to cover a wide variety of events, such as store openings, county fairs, and press conferences.

Production Techniques for News and Public Affairs

Certain techniques are most appropriate in particular types of productions. In this section, we discuss some of the techniques that are particularly relevant to news and public-affairs programming and that are not covered elsewhere in the book.

Interviewing

Although a complete discussion of interviewing would be more appropriate in a performance course, certain principles relate directly to production. Interviewing is actually a news production technique because the way a question is phrased will determine the product that results. Here are some suggestions.

ASK SIMPLE AND DIRECT QUESTIONS Try to put yourself in the place of the listener and determine what the listener would like to ask. For example, in questioning the spokesperson for a utility that is raising its rates, be sure to ask how much the rate hike will cost an individual listener. It is also important to phrase the question so that it is not vague or overwhelming; that way, the answer you get is less likely to be evasive or too long.

PHRASE QUESTIONS THAT INVITE BITE-SIZED ANSWERS, BUT DON'T ASK YES-OR-NO QUESTIONS A plain yes or no will not provide you with much actuality. On the other hand, questions that invite ponderous answers are bad because the answers can be too unwieldy to edit. Here's an example:

Do ask: How much more will a homeowner be paying in property taxes after revaluation?

Don't ask: What impact will revaluation have on homeowners in the area, and how do they and the city council feel about the situation?

ASK FOLLOW-UP QUESTIONS In a talk show, it's important to pursue a line of questioning if an interesting conversation develops. Formulate questions on the basis of previous answers. Don't fall into the trap of coming into the interview with a list of prepared questions and sticking to it no matter what. This practice is a common mistake, resulting in an interview that will appear to the interested listener to be almost laughably bad. The listener isn't tensely clinging to a list of questions; he or she may be genuinely interested in the responses obtained and probably wants to hear an intelligent follow-up.

FILL LISTENERS IN This is very important in a radio talk show because statistics tell us that listeners tune in for a shorter time than do television viewers. The producer or moderator should frequently mention the names of the guests and identify the topic.

Story and Actuality Editing

Knowledge of editing is essential for newscasts. Editing allows you to inject some variety because you can take different pieces of interview segments, rearrange these actualities, and rewrite the stories around them. In addition to offering variety, editing the actualities allows you to shape the story to be told in the quickest and most succinct way possible.

One of the biggest problems for beginning news producers involves creating a story and editing an actuality from a news interview. What part of the tape should be used on air? Which part should serve as information that will be written into a news story?

Although there are no hard-and-fast rules, it may help to remember that fact usually is better written into the story, whereas reaction and comment are better used in actuality. For example, the listener is less interested in hear-

ing a politician recite by how many votes he or she won than in hearing the politician's reactions to winning and her plans for after the election.

Using Sound Sources in Radio News Production

The use of sound sources as background in radio news production is often overlooked. Sound bites can really dress up a news story. Traffic noise, for example, can be a helpful adjunct to a story about highway construction.

If you've been assigned to do a live, on-the-scene voice report, it is generally helpful to have local noise in the background because it will make the story more immediate for the listener. If you're covering a fire, for example, wouldn't it be much more effective to have the noise of the fire engines and roaring flames in the background? Oddly, some news reporters (accustomed to studio conditions) seek a quiet place to voice their report.

Think of sound elements that can be used in your radio reports (without, of course, being overdramatic or misleading). Plan in advance for the sound bites you want to pick up.

Using the Telephone to Maximum Benefit

At one time, it was a common practice among radio news reporters to feed tape over the telephone by using a pair of alligator clips connected to a tape recorder and to a telephone (see Figure 13.5). This could be done quickly from a remote location. Today, it is increasingly difficult, however, to find public phones with mouthpiece connections that detach in the way shown in Figure 13.5. A better solution is to use a tape recorder, such as the Marantz PMD221 portable cassette recorder (see Figure 13.6), which can easily be connected to a phone by means of a modular jack on the machine.

Another option allows you to circumvent plugs entirely: the acoustic coupler. These devices connect the tape recorder's speaker to the telephone mouthpiece and amplify the tape recorder's output.

The widespread availability of cellular telephones holds considerable promise for radio newspeople in the field. This technology offers many advantages. An important one is that because you can easily use your cellular phone from virtually anywhere, you don't have to search frantically for a phone when you want to get a story back to the studio. The audio quality of newer digital cellular phones is also far superior to that of wire-connected phones. Some cellular phones are capable of being connected to tape recorders, though in some models this can void the warranty on the phone. Perhaps the most significant advantage of cellular telephones, however, is the capability they offer in allowing newspeople to report live directly from the scene of a news story.

The telephone, of course, is also a news-gathering tool—in fact, one of the most important news-gathering tools. Although you can't always get celebrities to come to the studio or grant an in-person interview, it's surprising how available they can be to a phone call. Or a routine story, even a state story

Figure 13.5

Tape machine output cord with alligator clips, used to feed a recording directly into a telephone receiver. The reporter simply removes the mouthpiece and attaches the clips to the two prongs in the mouthpiece end of the receiver.

Photo by Philip Benoit

Figure 13.6

The Marantz PMD221, a commonly used cassette machine that allows radio news reporters to record and play back tape via phone lines. A modular jack built into the machine provides a direct connection to a telephone.

Photo by Philip Benoit

taken from the wire service, can be given added importance by carefully done telephone interviews.

Recording from the phone is a common practice in radio news and definitely should be exploited by a news producer. You must inform all parties that a recording is being made. Check with your news director for guidance

on legal and procedural policies concerning telephone recording at your particular station.

Using Modern News-Gathering Technology

Although the industry is in a state of flux concerning the role of computerized technology in the newsroom, modern gear is making inroads into radio operations. Here are some points to consider.

Digital editing (described fully in Chapter 9) is becoming the standard practice in the modern newsroom, and the versatility of the equipment promises improved newscasts. The newsroom of the future may depend on digitally stored sound and computer-generated readouts of audio information rather than on carts, cassettes, and grease pencils.

Word processing has gained wider acceptance in radio news, although a few stations still use standard typewriters. The primary advantage of word processing is, of course, the speed with which corrections and additions can be made; further, many news-oriented setups allow more than one staffer to have access to a story. The most sophisticated of these systems allow wire-service material to be fed directly into centralized computer systems that many different staff members can access through the use of video display terminals (VDTs). This aspect of computer use in radio news operations is gaining increasing acceptance in modern radio newsrooms.

According to Georgeann Herbert, Chicago's Newsradio 78 WBBM's managing editor, a primary advantage of the computer system is that it captures wire-service material and feeds it into a computer memory where it can be used by a number of different people at the same time. A writer can work on an update of the story for the next hour while another writer edits the copy for the anchor currently on the air. Locally generated stories can also be handled in this way. These systems allow many functions to be performed by various staff members (see Figure 13.7).

If, for example, news developments take place in a story that is about to be aired, a writer can quickly update the story and flash it immediately to a screen in the on-air studio. The on-air news reader can then delete the original version of the story and substitute the updated version by reading it directly from the screen. Updated headlines can also be written and immediately related to the anchorperson while he or she is on the air. Bulletins can also be handled in this way.

Modern transmission gear has had a major effect on radio news-gathering practices, and technology's influence continues to grow. Today's radio reporter is often equipped with a portable transmitter for feeding live reports back to the station; major stations have a series of boosters located throughout the city to ensure quality transmission. Cellular telephones have also made it possible for smaller stations to report live from the scene of a breaking story. Satellite feeds have had a noticeable effect on news and

Figure 13.7 News software makes it easy for a producer to update and rearrange the stories in a newscast.

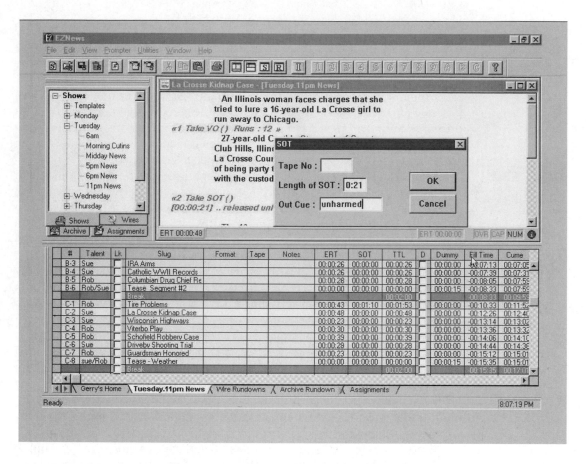

Screen shot courtesty of E-Z News.

public-affairs programming. Modern news and information formats allow local breakaways, which create the appearance of an integrated news program.

Making the Newscast a Cohesive, Unified Whole

The elements should follow logically, and the pace and style of delivery should be varied to reflect story content. This sounds obvious, but many newscasters don't alter their deliveries relative to the story. Thus, the piece

on the polar bear cubs born at the zoo is delivered in the same style as the report of the two-fatality auto wreck. Avoid a joking style in general, and be particularly wary of light-hearted readings of serious stories.

In essence, the newscast is an entire story, and though the individual elements vary in content, the items should follow gracefully. Within the newscast, you will want to strive for completeness; don't leave the listener hanging, waiting for an answer that never comes. On a related note, don't leave actualities hanging; in other words, don't play an interview segment and then move directly into another story. Have some copy after the actuality, even if it simply identifies the speaker. Incidentally, it is always a good idea to identify the speaker of an actuality before and after it's played. One of the radio news producer's primary responsibilities is to avoid confusing the listener.

Responsibility is a word often repeated in radio newsrooms. Providing the news is a heavy responsibility, and it's important not to forget that. Newspeople don't have to be stuffed shirts, but they do have to realize that they're in a serious business. But even though it's serious, it can also be fun. News—and in particular radio news—is one of the fastest-moving and most exciting of all professions.

Summary

Radio newspeople have a great advantage over their competitors in other media because radio is relatively simple and immediate; stories can be gathered and relayed with great speed.

Radio news writing has its own style. Sentences are shorter than in newspaper stories, and attribution comes first in a sentence.

Wire services provide valuable news and information that can be integrated into a station's news effort. However, it is important for a news producer to avoid the temptation to "rip and read."

Interviewing skills are essential to the radio newsperson. Among the most important points to remember when conducting interviews are to ask follow-up questions, ask simple and direct questions, and ask questions that invite concise responses. Yes–no questions, though, are best avoided.

Don't be afraid to use sound sources in radio news production. As long as they are not used to distort the facts, sounds of crowds chanting, fire engines racing, and the like are appropriate—and enormously evocative.

Don't forget that the telephone is one of your most useful tools. You can record from the telephone, and you can feed recorded stories back to the station with the phone.

Modern word-processing systems can capture wire-service material in computer memory and allow many different staff members to work on stories simultaneously. Such systems allow for rapid updating of stories and instant airing of new developments.

You're On!

TECHNIQUES FOR EFFECTIVE ON-AIR PERFORMANCE

Interviewing for Radio News

Asking a question and getting a straight answer is a more complicated process than you might expect. Interviewees frequently have vested interests and seek to answer your questions in a circuitous way.

Although the answer might not be an abrupt departure from the path of truth, it could involve a trip down a more scenic sidestreet. Sometimes, though, interviewees will tell you an outright lie, or they may flatly refuse to answer a question or may evade an issue. Journalists in radio and other media have developed a variety of specialized techniques for extracting information when confronted with these circumstances. Essentially, journalistic interviewing is a three-part process. The experienced questioner uses the following approach:

- Assesses the motivations of the person being questioned, because those motivations play a strong role in determining the ambience of the interview and the type of information that will be provided.
- Determines the appropriate structure for the interview.
- Uses specially structured questions to evoke a meaningful response.

Sometimes these questions lead directly to the point. Other times, they are open-ended "discovery" questions designed to get and keep the interviewee talking.

Note that these are generalized categories, not prescriptions. Many journalists have their own styles, and this chapter doesn't purport to inform you of the "only" way to do interviews. But these methods are good starting points.

Motivations of Interviewees

Why does someone talk with a reporter in the first place? It's an important question because the character of the information you receive is determined, in part, by the circumstances that brought you into contact with the interviewee. Those circumstances include the interviewee's *professional obligation, personal or professional gain, inadvertent entry into the public eye,* and *the desire to confess or divulge information.*

Professional Obligation

Some people are compelled to speak with the news media because it is their job to do so. Police departments, for example, have designated public

Continues

You're On! *Continued*

affairs officers. The military often calls the person with that duty a public information officer or PIO. Public relations professionals for profit-making and nonprofit organizations are also compelled (to an extent) to speak with the media; after all, that is a function explicit in the job description.

A person bound by professional responsibility to speak with a reporter may do so with some reluctance depending on the circumstance. For example, police departments are required to furnish certain facts to the media, but there is no law requiring them to do so *enthusiastically* or to provide you with additional facts that will make the story complete. And although police departments will generally dispense information to the press over the phone, the officers involved often find it a bothersome chore. They sometimes "forget" to inform you of major incidents.

When a public relations representative is compelled to speak with a journalist purely because of professional obligation, he or she may frequently provide incomplete data. No PR person, for example, will welcome an inquiry about toxic wastes found on the company's property. It is likely that you will receive perfunctory answers and that the PR representative will not volunteer potentially damaging information. Remember, there are very few cases where anyone is *obligated* to give you a complete story. No law says a PR representative has to spill his or her guts just because a reporter is on the phone.

So, to characterize information provided as a professional obligation, remember that what you receive

- May be perfunctory in nature.

- May be incomplete because the person answering your questions will probably feel no motivation to lead you to the heart of the story.

- May be intentionally misleading if your inquiry involves a negative angle.

Personal or Professional Gain

Some interviewees appear before cameras and mics for the sole purpose of promoting their organization, their product, or themselves. There is nothing inherently wrong in this. However, a journalist has an obligation to present the information in a balanced manner and to ensure that the facts aired are a matter of legitimate public interest—and not just a free advertisement for the person being interviewed.

Public relations people will usually adopt a markedly different attitude when speaking with a journalist about a subject promising personal or professional gain, as opposed to those circumstances where they

Continues

You're On! *Continued*

grudgingly deal with the media to fulfill a professional obligation concerning a story they don't particularly want publicized.

PR professionals can be quite solicitous, sometimes quite charming, and will often provide you with valuable information. For example, good PR people (who often were reporters themselves, before entering the much more profitable field of public relations) know *what* reporters need and *in what form* they need it. For example, on the day when there is a major confrontation in the Middle East, public relations representatives from major universities across the nation are likely to be on the phones to major news media, attempting to line up interviews with the universities' Middle Eastern affairs experts. Such an arrangement can benefit everyone. The reporter, who was scrambling to come up with an angle and an analysis, has an expert dumped in his or her lap. The university receives nationwide publicity, and, so the theory goes, gains credibility in the eyes of potential students and their families.

But remember that information provided to you under such circumstances may not always be top quality. To continue the example of the university and the Middle East, remember that the PR executive is under pressure to place faculty on news programs and may provide you with an "expert" who is less qualified than someone you could have sought out on your own.

This, of course, is not a broadside against PR people. They simply have a job to do, and everyone wants to be presented in a favorable light. Representatives of almost all businesses feel their organizations will benefit financially from favorable publicity. Politicians, for obvious reasons, want good publicity. But even though information provided to you for personal or professional gain is not necessarily duplicitous, remember that such material is not provided merely for the sake of giving you information.

Inadvertent Entry into the Public Eye

Some people become caught up in events simply because of happenstance. They witness a tragic accident or come home from work to find their homes burned to the ground. Crime victims, too, are unintentionally thrust into public scrutiny.

Such sources of interviews are under no obligation to provide you with information. Nor will they carry the ideological baggage of the political candidate who provides information for his or her personal benefit, so they are not likely to provide you with *instrumental* material.

But veteran journalists know that people thrust into the public eye nevertheless do present two credibility problems: They often are *inexpert* witnesses, and they are frequently *reluctant* to provide information.

Continues

You're On! *Continued*

We can once again borrow some historians' techniques of sifting and weighing information when evaluating the inexpert evaluation provided by an interviewee suddenly asked for an interview. Historians who chronicle battles, for example, sometimes use a colloquial phrase called "the corporal on the battlefield syndrome." This refers to the typical problems encountered in the recounted memories of someone who viewed an event from a *limited perspective*. The corporal, for example, may exaggerate the fierceness of the fighting because it was his first taste of combat. Or, he could overestimate his unit's role in winning the battle, basing his estimation on the justifiable exhilaration felt by a group of soldiers who fought shoulder-to-shoulder in a life-or-death situation.

Desire to Confess or Divulge Information

Many people come forth with material because they simply want to get something "off their chests," or, perhaps more commonly, they feel they have knowledge of a situation that should be brought to the attention of the public.

When interviewing such people, remember two critical points:

- First, there is a temptation to believe that when someone says something negative about himself or herself, the information is true. It is likely, of course, that such negative information bears a greater ring of truth than positive information. But sometimes people do confess to things they have not done, for reasons usually known only to themselves. So it is wise not to take an "unburdening" entirely at face value.

- Second, when someone discloses information to you voluntarily, you need to know *why* the admission is being made. Does the person have an ulterior motive, an "ax to grind?" If so, the information is suspect. For example, you may speak with someone from the law enforcement community who offers the information, on condition of anonymity, that a prominent official is under investigation, but higher authorities are hushing up the investigation.

 This informant may be offering you this information because he or she is legitimately outraged that a high official is getting away with something. Providing such information could rightly be considered a public service. However, there is also the possibility that your interviewee has a personal grudge against the person allegedly "under investigation" and is using you and your station as a weapon.

 Now that you're more aware of the ways in which an interviewee's perspective and motivations can alter the character of information you receive, you are ready to plan the *basic structure* of the interview.

Continues

You're On! Continued

Appropriate Structure for an Interview

Several factors are involved in determining how the interview will be structured and carried out. Among them are *the intended use of the interview, the availability of the subject,* and *the cooperation of the subject.*

Intended Use of the Interview

There are three primary types of news interview: interviews meant for use as *background,* as an *actuality or sound bite,* or as a *talk show.*

The *background interview* is conducted simply for the purpose of compiling information that may be useful in the story's production. This information, though, will probably not be used directly on air. For example, a medical reporter might call physician friends and ask them about general trends and new information in the medical field. Everyone is aware that these sessions are simply conversations, meant for "brainstorming" and not for attribution. The physicians certainly would never speak freely or give strong and provocative opinions if they expected to be quoted. Likewise, reporters do not use material from such encounters as literal fact; they *always* verify the information with an on-the-record interviewee, because, when people are not quoted they are not held directly accountable for their statements—and this opens the door for them to exaggerate, slant, or even lie.

The *actuality* or *sound bite* interview is designed to produce a segment of audiotape that can be inserted into a radio voice-actuality, or inserted directly into a newscast read by the anchor. The goal of an actuality or sound bite interview is to evoke an answer that is short, to the point, and able to stand on its own. You can use several techniques (discussed in the following section) to elicit a usable actuality or sound bite response.

A *news talk show* interview must usually run for a specified period of time and must have a flow, a sense of continuity. That is, it moves from one subject to the next with some sort of progression. The guest on a talk show can speak at much greater length than during an *actuality* interview.

Availability of the Subject

The same quality that makes people newsworthy also limits the amount of time they have available to the news media. This, in turn, affects how you will structure the interview.

How will you arrange to meet the interviewee? Will you visit the interviewee in person at a remote location, have him or her come to your station, or do the interview over the phone?

Continues

You're On! Continued

An in-person interview at a remote location, often the subject's office or the site of an event in which the subject is participating, is usually the ideal choice for broadcast news gathering. For one thing, it captures the subject in his or her native environment and provides some of the physical or aural trappings that add color to the interview. Often, too, this is the only way you'll gain access to the person.

Having the interviewee visit the station is not a common option in most news-gathering operations. Although certainly convenient for the reporter, most newsmakers simply do not have time to make themselves available in this manner. The most frequent exceptions, of course, are guests who appear on talk shows. Talk shows may or may not be a news-related production, but don't forget that you can usually arrange to use cuts from the talk show in a newscast should the program involve a newsworthy guest.

Often, a journalist must resort to a telephone interview. Radio stations, which usually have limited staff, frequently exploit this method of news gathering. A telephone interview is also much more convenient for an interviewee, and it may be the only method that will gain you access to him or her.

But telephone interviews have significant disadvantages. Because recorded phone conversations are instantly recognizable as such, some journalists feel they don't convey the immediacy or presence that makes radio such a powerful medium. Some radio stations go so far as to forbid the use of phone interviews altogether, and insist that a reporter gather every piece of actuality in person, using a high-quality microphone and recorder. However, most stations allow the use of phone interviews when that is the only logical alternative, such as for interviewing a local citizen trapped in an overseas war zone.

Cooperation of the Subject

For various reasons, interviewees might not want to speak with you or may be willing to cooperate only to a certain extent. The structure of the interview, then, may revolve around this factor. Two particular problems arise:

1. Getting a subject on mic. In rare cases, you'll have to "ambush" the person on the street. A street is legally considered a "public forum," meaning that a reporter has a greater right of access to the subject than if the person were on private property. The ambush interview should be considered only when repeated attempts to arrange a

Continues

You're On! *Continued*

standard interview have been rebuffed. Remember that an ambush often arouses sympathy for the subject, whom the public may perceive as the "victim" of the ambush.

2. Circumventing a "no comment." Media-savvy public figures frequently have no reluctance to exercise their constitutionally guaranteed right to keep their mouths shut. Although some critics argue that airing a "no comment" can make an innocent person appear guilty, many news veterans observe that people who exercise their no-comment option can and do avoid accountability for their actions.

Setting aside that argument, which cannot be resolved here, remember that a "no-comment" does not make particularly informative or compelling news. When structuring an interview, there are three primary methods of getting past the no-comment stone wall:

- If the subject refuses to consent to an interview, inform him or her that you will *report* the refusal. This is a highly effective method of attitude adjustment. It may not necessarily circumvent the no-comment, but quite often it does prod the interviewee to talk.

- If, on-mic, the interviewee replies "no comment," ask *why* he or she is refusing to comment. Should the interviewee respond, the explanation of the no-comment might actually be the answer you wanted in the first place.

- A variation on the "no comment" routine is the "no interview" dodge. If you cannot even get the interviewee on the phone—let's assume Mr. Big is always in a "meeting"—inform Mr. Big's secretary that you would like your phone call returned *at a specific time.* Be sure you are there to receive the call should it indeed be returned. Should Mr. Big not return the call, give this tactic one more try—but be certain to inform Mr. Big's secretary that if your phone call is not returned, you will air that fact. (An alternate option: Find out the name of Mr. Big's boss and ask Mr. Big's secretary to transfer the call to that office. Mr. Big may suddenly materialize.)

After you have (a) determined the motives and perspectives of your interviewee, and (b) determined the proper structure for the interview, it's time to actually execute the interview. The act of producing usable answers is a direct result of asking properly phrased questions. Certain techniques can help you gather reliable, direct, and compelling quotes from interviewees.

Continues

You're On! Continued

Questions to Evoke a Meaningful Response

A "meaningful" response means, quite simply, an answer that will serve your purposes and the purposes of the viewing or listening public. A meaningful response must be

1. Useful within its technical context—for example, a meaningful part of a voice-actuality.

2. A direct response to the question and to follow-up questions.

3. Illuminating to the listener or viewer.

Technical Context

A rambling answer will be of little use to you if you need a 20-second reply for insertion into a 90-second voice-actuality. Also, the interview segment won't be very functional if it is too complex or too simplistic for the audience. And if you are interviewing a guest for a longer segment, such as a talk show, you must elicit responses that will sustain the listener's or viewer's interest for an extended period, perhaps half an hour or even an hour.

Following are suggestions for making the message fit your medium:

- When asking a question for a brief sound bite, don't be reluctant to ask the same question several times. You may get some quizzical looks from your interviewee, but you will also obtain varied responses and, sometimes, *better* responses.

 If you're interviewing for radio, you can obtain several alternative audios for radio newscasts. When you use the technique of asking the same question several times, you can actually alter the questions slightly, so it appears that you're asking a different question when you actually are not. Alternately, you may elect to inform your interviewee in advance.

 "Sometimes, I ask the same question more than once," you might say, "so don't be surprised if you hear me repeat myself. I do this just in case there's a technical problem."

- When you want a *short* answer, ask a *short* question! If you are looking for a ten-second sound bite, ask the mayor, "What's the most pressing item on tonight's city council agenda?" Don't ask, "Mayor, could you explain the priorities you've established for tonight's city council meeting—how do you plan to deal with all the items on the agenda, and how did the schedule get so packed in the first place?"

Continues

You're On! Continued

- If you want a *simple* answer, ask a *simple* question! For example, you'll probably want to ask a physician, "How does cholesterol harm the body?" Unless you're producing a piece for a specially trained audience, don't start with, "Doctor, what is the mechanism by which cholesterol contributes to atherosclerosis?" The latter question raises some interesting points about the entire interviewing process. Regardless of the type of interview—sound bite, talk show, or background—the *beginning* question sets the tone for the entire interview. If you start the interview on a complicated theme, you probably will never get your expert back on a simple track.

- Remember that no matter how much knowledge you have obtained during your research, your audience will essentially be starting from ground zero. Note, too, how the question about the "mechanism by which cholesterol contributes to atherosclerosis" forces the interviewee into deeper waters than you or your audience might care to venture. By asking about the "mechanism" by which cholesterol does damage, you are inquiring about a complex and still poorly understood process, but your physician interviewee will probably begin his or her answer from that point. It will be virtually meaningless to the audience, who simply wants a general idea of what cholesterol might do to their abused arteries.

- If you are doing a talk show (that is, a show with an opening and closing and a predetermined length) remember that a talk show is essentially an imitation of a social situation. This means that the audience expects to be introduced to the guest. The topic should start general and become more specific; the conversation should begin more formally and then become more personal; the questions should become more pointed as the conversation wears on.

 There are two reasons for observing this convention: First, if you lead with an abrupt, challenging question, you may appear rude and boorish. Worse, you may force your guest into a defensive shell and be faced with 29 uncommunicative minutes of remaining program time.

 This isn't always the case, of course. On occasion, you will want to cut right to the heart of the matter. That depends on the interview and the interviewee. But most experienced interviewers know that it's safer to warm the interviewee up with some slow pitch and to save the hardballs until the end.

Continues

You're On! *Continued*

Extracting a Direct Response

People evade questions for a variety of reasons. Sometimes, they are trying to hide something. More often, they are simply uneasy and afraid of being misinterpreted, and they may avoid your question or become inclined not to elaborate on the subject. It is a journalist's job to elicit a meaningful response despite these obstacles. Usually, this is a three-part task, involving *obtaining a direct answer, focusing the issue,* and *stimulating further response.*

Obtaining a direct answer means getting the respondent back on track. In these days of media advisors and public relations counselors, shrewd public figures are often taught to evade a question by giving the answer they want—irrespective of the question that was asked. For example, you are forced to ask a direct yes–no question because you are getting nowhere with your interview with a political candidate. You come right out and ask.

Q: Do you plan to fire the aide who leaked the information about your opponent?

A: We're going to run an honest, straightforward campaign. It's important that we keep our efforts on track, because economic conditions in this city . . .

You're responsible for getting the interview back on track. "I'm sorry," you might say, "but I didn't quite understand your answer. Are you firing him or not?" This is one tactic. There are others. To sum up those tactics:

- *If the question is not being answered, say so.* Start by simply repeating the question. If that does not work, mention that the question was not answered and ask it again. Should you still not get an answer, directly ask the interviewee why he or she is ducking your question.

- *Do not get drawn into a debate with your subject.* This strategy—making you a part of the issue—is a method of evading a question. For example, your interviewee may respond to your question by giving a basically irrelevant response, and then asking you, "Is that fair?"

- *Don't ever let the interviewee ask questions; that's your job.* Just turn the question around again, or say, "My feelings aren't important. What is important is your action on the bill before your committee. . . . Now, once again, do you intend . . ."

Continues

You're On! Continued

Focusing the issue means getting the interview back on track when your interviewee has wandered off the subject, either accidentally or on purpose. Sometimes you need to focus the issue simply because your interviewee is speaking gibberish. Two techniques are particularly useful.

- *Use a paraphrase to force a clear response.* If you are not getting a clear answer, sum up what you *think* the interviewee said and repeat it back to him or her. Then ask, point blank, "Is this what you are saying?" For example, if a public official has just told you something to the effect of: "We need to reevaluate the enhancement capabilities lost to us in the number of transactions which take place in certain economic categories, and reconsider the revenue structure of . . ."

 You should paraphrase what you think you heard: "Mr. Representative, did you just say you favor an increase in the sales tax?" This method will allow you to force an answer in plain English.

- *Use a transition to get back to the subject.* Guests, especially on long-form interviews such as talk shows, may accidentally or purposefully wander into the areas *they* want to talk about. You can get them back on the subject without appearing abrupt or obstinate by relating what *they* want to talk about to what *you* want to talk about. For example, the head of a city hospital, an administrator charged with running a sloppy operation, may be more interested in shifting the subject to the fact that the city council has yet to draw up a firm budget for the year. Link the two subjects and force a transition back to your original topic:

 Hospital Manager: " . . . since January, and still no action."

 You: "Does the lack of a firm budget have anything to do with the charges that you are almost six months behind in your billings?" Maybe there *is* a link between the two; maybe not. But you've prevented your guest from wandering off on a self-serving polemic.

 Stimulating further response is necessary to keep the interview rolling and to allow you the time and opportunity to dig for real answers. A number of techniques have proven successful.

- *Don't ask dead-end questions unless you are forced to.* Most books on interviewing advise you not to ask yes-or-no questions because such questions won't stimulate further response and will produce an awkwardly short answer. That, to an extent, is true, but there are times when you must call for a yes or no. If your interviewee is evading an issue, don't be afraid to pose a yes-or-no interrogatory.

Continues

You're On! *Continued*

- *Master the art of out-waiting your interviewee.* If you receive a curt, nonresponsive answer to your question, don't switch to another subject just because you feel the need to keep the conversation moving. Let the tape recorder roll, keep the microphone in the subject's face, and *wait.* Usually, he or she will break down before you do.

- *Be careful about letting your subject catch on to your pattern of taking notes.* In other words, don't let the interviewee know when you have become excited by the information, because he or she will probably clam up. Former basketball star Larry Bird, for example, reads reporters very well; when they stop writing and look up at you, he maintains, that's a good time to shut up because the subject is getting "too deep." Interviewees are generally quite concerned about what you write—with good reason—and can make your job difficult when they ask, "aren't you going to write that down?" Just the opposite situation can arise when interviewees make a stunning statement and you scramble to write it into your notebook.

 They'll be struck with the magnitude of what they just said and will move to retract or mitigate it.

- So when you are doing a notebook interview—that is, newsgathering that does not involve the immediate presence of a microphone—don't tip your hand by letting your interviewee discern your writing habits. One way to hide your note-taking pattern is to write all the time, even if you are just doodling in the notebook. This gives the interviewee no clue as to what you think is important and what is not, and avoids the "aren't you writing that down?" and the "wait, I didn't mean" syndromes.

Portions of this feature adapted from Carl Hausman's book *Crafting the News for Electronic Media,* Wadsworth, 1992.

Applications **SITUATION 1 / THE PROBLEM** A news reporter was assigned to cover a potentially violent job action at a local plant. Arriving on the scene, she found that picketers had been instructed not to talk to the press and police would not let her pass police lines to do an interview. The obvious approach was to read her notes into the microphone, but that seemed a particularly dull way to cover the story.

ONE POSSIBLE SOLUTION The reporter placed herself as close to the police lines as possible and voiced her report with chanting and other wild sounds

in the background. Later, a scuffle broke out, and she recorded wild noise from that altercation and edited it into another report, which she produced back at the station.

Situation 2 / The Problem The news producer on duty Sunday afternoon found that there was nothing going on—and he had a half-hour newscast to fill in 2 hours. The only items available were feature stories in the local paper, but another organization's feature stories are not easily rewritten and adapted to a local radio newscast.

One Possible Solution One state story fed by the wire service dealt with the governor's plans for improving the quality of public education in the state. It was a substantial and interesting story but had no local angle. The news producer checked through his files of telephone numbers and called:

- The principal of a local high school
- The head of the local teachers' union
- A student at a local state college

He asked for their reactions to the governor's proposals and recorded the actuality off the phone. Now, he had a good lead story for the upcoming newscast.

Exercises

1. Have another student read over a newspaper article. Then interview him or her about the article, as if your partner were a spokesperson for one of the parties involved in the article. (Your partner should keep the clipping handy for reference.)

 Try to present a logical discussion of the subject. Because your partner is not really an expert on the topic, he or she will be unresponsive on occasion, but that is exactly the situation you'll run into from time to time in radio news. Your goal is to convert the discussion into a graceful interview, 3 to 5 minutes long.

2. Take the interview you've created, edit out a section, and write up a voice wrap. Make the voice wrap deal with a particular newsworthy segment of the interview, and make it about 60 seconds long.

3. Next, come up with two new leads (new heads and orientations), and redo the story. Rewrite it and recut it as if you were freshening up the story for two upcoming newscasts. Incidentally, mechanical practice on equipment you're likely to use will be valuable, so if you have the opportunity to practice, use it. Record an audio feed, for example, and practice taking audio off the telephone. Becoming familiar with the operation of portable cassette machines will be beneficial, too.

Remote and Sports Production

*R*emote and sports production form only a portion of the radio station's program day, but these areas put radio production people in the proverbial hot seat. Remote work, whether it involves covering a news conference or a football game, is a difficult undertaking that requires a great deal of preparation. Knowledge of equipment and production techniques also comes into play; the operational aspects are important in getting the signal back to the station.

Remote broadcasts often include sporting events, which is why we include a discussion of sports coverage in this chapter. Other common remotes include having a staff announcer play records from a car dealership, a new store, a restaurant, or some other business. The goal in such cases is to give the client (who has paid a fee to have the remote originate from his or her business) exposure and increased business. Less frequently, remotes involve news coverage, such as live broadcasts of press conferences. Music presentations are sometimes done remotely; usually, however, concerts are recorded on site and are not fed live over the air.

Considerations of hardware and technical facilities will largely be determined by the equipment your station has on hand and by the technical qualifications of your engineering staff. Rely on your station's engineers for technical advice; they are the experts and will make many of the choices and installations.

Your role as a producer involves the planning, execution, and character of these events. Although the engineering staff can give you help with the technical arrangements, you, the producer, must have an understanding of all the program elements and the kind of effects that make remote broadcasts successful. Together with a basic knowledge of radio production equipment, your knowledge and planning will be the key ingredients in a good remote broadcast.

In essence, your responsibility is to put the remote together in a way that produces the best quality and provides the sound you need to keep up the standards of your station.

Remote Radio Equipment

Most remote equipment is pretty much the same as that found in studio applications, though the smaller models are obviously favored. Older remote consoles usually have turntables built in, and often, especially in smaller stations, double as studio production facilities while housed at the station. Today, portable computers with fast hard drives can provide audio source capabilities needed for remote studio production.

Submixers are also used in remote productions, especially when a number of different microphones must be used and the inputs on the console are limited, as they usually are. Submixers are usually referred to as *portable mixers*. Portable mixers, such as those manufactured by JK Audio, Shure, and Sony, are especially useful in news remotes. They are essentially small audio consoles (some are the size of a brick) that can accommodate several mic or line inputs. Volume controls allow the operator to set a correct mix level (see Figure 14.1).

Incidentally, some portable mixers can be ganged; that is, several inputs can be combined in one mixer, and the output of that mixer can be fed into another mixer, along with other audio sources. This is a particularly useful tactic when you are confronted with the prospect of trying to run ten mics into one console.

Cart machines or minidiscs are generally not brought to the remote site because the playing back of spots is done at the studio. Newscasts are generally done at the studio, too. Back at the studio, the signal from the remote usually comes in on a remote pot, and the board operator handles coordination of other program elements originated from the studio. Sometimes program material from a remote location can be microwaved either to the station or directly to the transmitter. Microwave units are becoming increasingly common in radio broadcasting; larger stations may have dozens of such minitransmitters in strategic locations throughout the city.

Telephone Lines

In small and medium-sized markets, the link is still by land line, usually a telephone line known as a broadcast loop (or the station may use a standard telephone connection provided by the sponsor). The *broadcast loop* is a high-quality transmission line, rented from the telephone company, that connects the remote broadcast site to the station. Lines of different quality are available, depending on the frequency range they can carry. Most sports remotes and remotes from special locations, such as state fairs or conventions, will require a broadcast loop.

Figure 14.1 Some remote mixers combine audio functions with a telephone unit to simplify connections.

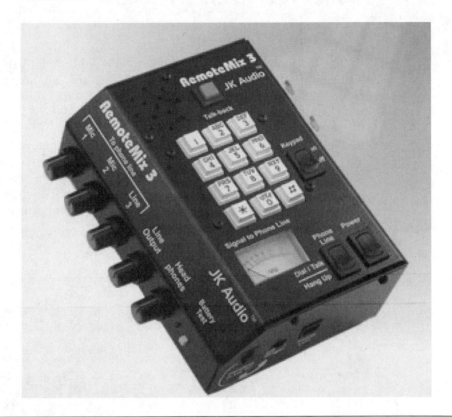

Photo courtesy of JK Audio

Many stations have a standard policy concerning the type of loop typically ordered; when in doubt, ask the station's chief engineer about the ordering procedure. When the line is installed, one end of it will, of course, terminate at the station. The other end, called the **telco drop,** will terminate at the site you select for your broadcast. There, your engineering staff will hook up the equipment to the telephone line termination. Usually, the operation is not complicated, but it is best left to technically qualified people. As producer, however, you will have to find the terminal block left by the telephone company. This isn't always easy—especially in large environments such as state fairs—so it's essential to check well in advance on the location of the terminal. A crew of production people frantically scrambling to find the terminal a half-hour before airtime is not an uncommon sight in the typical remote broadcast.

Tuning into Technology

GETTING THE SIGNAL FROM THERE TO HERE

What's the most popular way of getting a remote signal back to the station (or to the antenna)? A survey conducted by *Radio* magazine* says specialized two-way transmitters, such as the "Marti" unit (a trade name for a point-to-point transmission system) is first, with 54 percent usage in the top 100 markets (see Figure 14.2).

Second, oddly enough, is the cellular phone (17 percent). Although it does not provide very good sound quality, it is extremely handy and is often the tool of choice to do voice-only remotes from the remote location. New cell phone units, with improved fidelity are increasingly popular.

Next, with 9 percent, is a standard telephone. Special broadcast phone lines account for about 5 percent.

Figure 14.2 This complete remote unit uses cell phone technology for transmission.

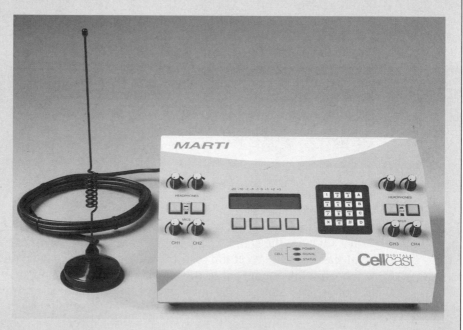

Photo courtesy of Marti Electronics

* "Five Ways to Jumpstart Remotes," *Radio*, May 22, 1998, p. 14.

Continues

Tuning into Technology Continued

Only 1 percent of remotes are done with switched digital service, that is, digitized information sent over a phone line. (This survey took into account only the types of remotes we usually associate with store openings. Regular program service, such as broadcast of sporting events, is more commonly done with special broadcast lines, satellite, or switched digital.)

Interestingly, digital services can be far cheaper than satellites. A brand of digital service device called Switched–56 requires a device at both ends of the telephone lines (two of the devices are pictured in Figure 14.3), and each unit costs several thousand dollars, but once in place the cost of transmission is quite low. The quality is very high and is indistinguishable in most cases from satellite feeds.

These systems work by compressing digital information and using special formulas for coding the information so that it requires a limited amount of space on the telephone lines.

Does this type of service have day-to-day impact on operations? Well, it gives some rather extraordinary flexibility to production people. At WCBS in New York, for example, the announcer who voices their station

Figure 14.3 *Digital remote equipment. A Switched-56 makes it possible to digitalize remote feeds, thus improving quality and reducing costs.*

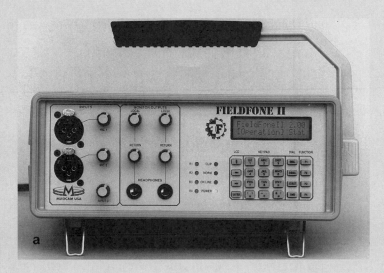

Photo courtesy of MUSICAM, USA Holmdel, NJ

Continues

Tuning into Technology Continued

Figure 14.3 (Continued)

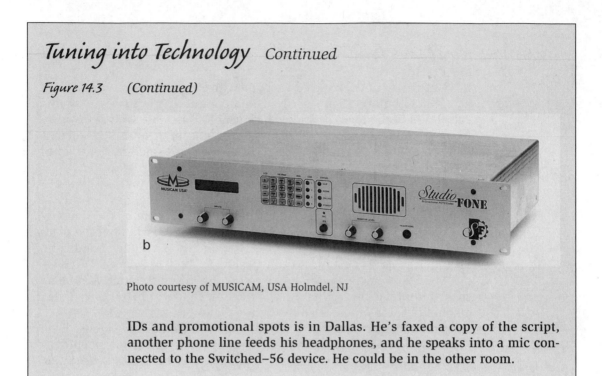

Photo courtesy of MUSICAM, USA Holmdel, NJ

IDs and promotional spots is in Dallas. He's faxed a copy of the script, another phone line feeds his headphones, and he speaks into a mic connected to the Switched–56 device. He could be in the other room.

Other Equipment

A cellular telephone is handy, too, so that the remote on-air person will have a backup method of communicating with the studio. In broadcasting from a store, you may elect simply to use an available telephone—if the store owner will let you—and keep the line open to the board operator at the station. In less accessible locations, the telephone company can install a separate telephone when the transmission line is installed.

Although the remote announcer can communicate back to the station by talking over the air line when the remote signal is in cue (back on the station console), that type of operation can be risky because the communication could wind up on the air. Sometimes, though, the remote announcer and the station board operator won't be able to take time out to chat, and some system of signals or protocol should be worked out in advance to avoid confusion. We examine this shortly.

Microphones are, of course, part of the equipment needed for a remote broadcast. You will do well to use rugged moving-coil mics because remote work can be rough on equipment. Determining whether or not to use a cardioid mic depends on the physical environment and on how much background noise you want included. Overuse of microphone directionality can

Figure 14.4

Carl Hausman illustrates the use of a mic with a wind filter for outdoor assignments.

Photo by Philip Benoit

detract from the broadcast; after all, if you are on remote from a store, you want it to sound like a store, not a studio.

Mic technique is also a consideration outdoors. **Wind filters** (also known as **pop filters**), such as the one shown in Figure 14.4, are useful in eliminating wind noise, which on a mic doesn't sound like wind at all but more like the rumble of a foundry. Be aware that ribbon mics are much more susceptible to wind noise than the moving-coil types are. When using a microphone for field production, choose a mic with a built-in shock mount to reduce hand-holding noise.

In some instances, you might want to add a mic to pick up wild sounds. In a basketball game, for example, mics are often placed near the backboards to capture the genuine sound of the game. Separate mics on the crowd also provide color and give additional flexibility to the balance of announcer and crowd noise because the volume of the mics can be controlled separately on a console or submixer. Sportscasters frequently wear a headset mic, a combination microphone-headphone, that allows the announcer to hear himself or cues from the studio.

Picking up a speaker is often a problem in remote news coverage, whether it is for a remote broadcast live or for recording on the scene. You will be at an advantage if the speaker at a press conference, for example, is

standing or seated at a lectern. By placing your mic on the lectern, you can usually obtain reasonably good audio quality.

Placing your mic on a lectern often involves taping it to a group of other reporters' mics, so a roll of masking or duct tape is an essential element in your package of remote equipment. If there is no other mic on the lectern, and you don't have a table or floor stand, you can improvise with the tape and attach the microphone in a jury-rigged manner. Be careful whenever you tape a mic to a lectern, though, because unless you want to dismantle it during the speaker's remarks, you will be pretty much committed to staying for the entire presentation.

Be sure to pack enough cable to reach your recorder, mixer, or other equipment. We offer more details on planning and packing for a remote later in this chapter.

Another way to pick up audio from a speaker is to tap into the public address system. (PA mics are generally not the best quality, however, and you may wind up with a poor-quality signal.) Many PA systems were set up with this function in mind. If you can't have advance access to the PA block, make sure to bring a variety of connectors; although most PA terminals have standard XLR outputs, some do not.

A variation on the PA terminal is the *multiple,* which is often set up by savvy public-relations people to allow reporters to tap into audio. Public-relations people often provide this as a way to keep the lectern free of a forest of microphones. Professionally supplied multiples often have both mic-level and line-level outputs for the conveniences of broadcasters.

In sports applications, headset microphones are used. In addition to providing excellent noise cancellation (because of the physical qualities of the mic and because the element is close to the speaker's mouth), these are ideal when the announcer will be in a noisy situation, such as a ringside seat in a boxing arena. Headset mics also leave the announcer's hands free and don't crowd the table, a definite asset when you have many statistics and other items to keep track of (see Figure 14.5).

Some headsets are wireless and transmit an FM signal. The director's private line can usually be fed into one earphone, simplifying contact between production and talent—an option primarily used in television. Some have a built-in cough switch to turn the mic off if the announcer needs to cough, clear his or her throat, or communicate with someone off-air.

Planning the Remote

A remote must be well planned. Indeed, one of the major sources of trouble in remote broadcasts has been and continues to be lack of advance planning. Remember that a great deal of detail work is necessary for proper execution of remote broadcasts and that quite a bit of pressure is associated with these events. Much advertiser money is at stake, along with the prestige of the station. In many cases, rights for a sports broadcast have been purchased in ad-

Figure 14.5

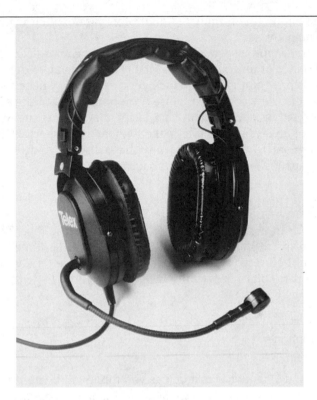

Many announcers prefer a sealed headphone-microphone combination when working in a noisy environment.

Photo courtesy of Telex

vance, so the producer must be prepared to protect the station's interests by providing a well-considered and airworthy product.

The first step in planning is to secure the contractual arrangement, which might involve a merchant signing a contract with the sales department, or the administration of a college contracting with your station for rights to a sporting event. This is the time to make sure you understand the conditions that will exist at the site from which the program will originate. It is essential at this point to have a clear understanding of what will and what will not be provided for the broadcast: Will you have access to electricity? telephones? a physically secure enclosure for your equipment?

Preparing the Site

The next step is to survey the site. This should, ideally, be done twice: before and after installation of the phone line. On the first visit, you can familiarize yourself with the area and make a rough plan showing the locations for various pieces of equipment. During this visit, you will also want to determine the availability of power and to assess external noise and wind conditions. Another purpose of the initial visit is to determine exactly where you

want the phone line terminated and to prepare explicit instructions for the phone company.

On the second inspection, made closer to the air date, you verify that the phone line (or other transmission facility) is in place, and you ascertain that conditions have not changed since your first visit. Check to make sure, for example, that new sources of noise have not been introduced or that the recently erected broadcast booth isn't facing directly into the wind.

It's not always possible to make two checks, especially if you are planning a remote to another city, but the truism of better safe than sorry certainly applies to remote radio broadcasting.

Preparing the Equipment

For the lack of a connector, the broadcast could be lost. The same caveat applies to microphones, cables, and power cords. Take an inventory of equipment before you leave for the site and immediately after you arrive. Although particular needs will vary, your inventory list will probably resemble this one:

- Console or mixers
- Microphones
- Wind filters
- Cable (at least twice as much as you think will be needed)
- A variety of connectors and adaptors (male to male, female to female, and male to female)
- Power cords and adaptors for two-prong and three-prong outlets
- Tape (electrical, masking, and duct)
- Portable and accurate electric clock
- Portable radio for local pickup of the signal
- Recorders, if used
- Headphones
- Mic stands and clamps
- Screwdrivers, scissors, and other tools

Incidentally, an adequate supply of tape is very important for safety considerations. To avoid imposing a hazard on yourself or others, tape mic cables securely to the floor, as shown in Figure 14.6. Better yet, string them from the ceiling if possible.

Preparing a Communication System

One of the most embarrassing and unprofessional situations in broadcasting can develop when the remote announcer and the board operator back at the

Figure 14.6

Using tape to secure cable to the floor is a good safety measure.

Photo by Philip Benoit

station can't figure out who is supposed to do what. Much of this confusion can be avoided by planning out a protocol in advance.

Your role as producer may include acting as either remote announcer or board announcer; if so, work out in advance what will be aired at the studio and when. Is the weather to be read from the studio? If not, how will the weather forecast find its way to the remote announcer? The board operator and remote announcer should have a clear understanding about such matters. The remote announcer can also keep the production flowing smoothly by giving cues to the station board operator, such as, "In a moment, we'll go back to the station for the local news, but first let's talk to Joe Robinson, who is manager of the . . ."

Preparing the communication system also can involve establishing the separate phone line we mentioned earlier. Although the individual details will vary, advance thought about the site, equipment, and method of communication is always a necessary part of remote radio production. Next, let's examine some of the particular requirements germane to sports broadcasting.

The Sports Remote

Planning for the sports remote is important, too. The producer of a sports event, who in smaller markets may double as the announcer, will be responsible for assembling, for the announcer's use, rosters of players, color information, and statistics; he or she will also be responsible for the physical setup. Practice is very helpful. If you can possibly arrange it, try sample coverage (record it on site for your reference) of a similar sporting event, preferably one held in the same location.

In preparation for the sports broadcast, check all connections and mics. Be especially careful of the location of the crowd mic, and be prepared to move it or have another one already strung up; one raucous or obscene fan can badly foul up all your plans.

Talk to the announcers about who will handle the starts and stops of the broadcast: who will announce the commercials, who will start talking when the remote starts, and who will be responsible for communicating with the studio in the event of equipment problems or other difficulties. Plan who will toss the program back to the studio for play of taped segments, such as commercials and station identifications.

Finally, be aware that outdoor sporting events are subject to rainout and rain delay. Work out in advance when and if the program will go back to the station in the event of rain delay. Will the board operator be ready to resume regular programming? Will the announcers fill with talk and feature pieces?

All sporting events offer unique challenges to the producer. Following are some suggestions for the individual problems posed by various sports.

Baseball

The possibility of game delay is one of the biggest factors in planning for a baseball game, so use the preceding guidelines to make contingency plans. As producer, remember that baseball games have many portions of little or no action, so selecting an eloquent and conversational announcer is essential.

From a technical standpoint, the sounds of a baseball game don't always travel back to the point of the announcer's mic. (This is a problem common to many sports.) A shotgun mic or a **parabolic mic** (a mic positioned in a reflective bowl) can be used to pick up the crack of the bat or the slapping of the ball into the catcher's mitt.

Hockey

The producer of radio coverage for a hockey game has to select very good air people. The action is so fast that it's difficult for an inexperienced announcer to keep on top of it. An action mic adds interest because the sounds of the hockey game aren't very loud. But be careful because hockey fans can be raucous and can shout things that are inappropriate for broadcast.

Football

Producers of radio football coverage should be aware that their listeners are among the most technically oriented fans in sports. In-depth analysis is usually called for, and you'll need someone who can handle this task. Further, football sportscasts benefit from a fairly large staff; if you can find someone to keep track of statistics, downs, and penalties, you'll help the announcers do a better job.

Basketball

Basketball is subject to many audio problems. A gymnasium packed with cheering people is a difficult environment from which to broadcast; a half-empty gym can be even worse because of reverberation problems.

In high-school coverage, you probably won't have access to a press box; even in many college games, coverage is done from a table set up on the gym floor. The mic must be selected with an ear toward eliminating noise from people next to the announcer and toward decent *acoustics* at the floor level.

One option is to use a directional mic or headset mic for the announcer and have a separate crowd mic. The two can then be mixed to provide a better-sounding balance. You may suspend the mic from the press box or even elect to string mics from the structure holding the backboard; this will add some interesting sounds to the coverage.

Basketball involves a great deal of statistical information, so the announcer(s) must have the ability to keep numbers straight. For example, listeners will want to know how many fouls or rebounds a certain player has as the game progresses, and it takes a well-organized announcer—or an announcer with some competent help—to have those stats at his or her fingertips.

Field Sports

Sports played on an unenclosed flat field, such as field hockey, soccer, and rugby, usually are difficult to cover for a number of reasons. First, bleachers or seats to lift the announcer above the action and offer a proper perspective may not exist. Second, wind noise is often a factor when there is no stadium to block air currents. Crowd noise is also a problem because there may be no place to hang a crowd mic. Spectators may be hundreds of feet away or, conversely, 5 feet from your mic. Power and line availability can also be problems.

In field sports, one of the best options available is to have a parabolic or shotgun mic on hand to pick up **ambient noise** from the crowd and from the athletes. (Wind filters are usually a great help.)

You could build a small platform to elevate the announcer if no vantage point is available. The top of a building usually works in a pinch. If you can't build a platform and the playing area is far from any structure, the bed of a pickup truck is better than nothing.

Boxing

An auxiliary mic is handy to pick up action sounds, as well as instructions in the corner between rounds. Of course, some of the things said in a boxer's corner are not appropriate for airing. The same caution goes for the remarks of ringside spectators. A directional mic is in order because the announcer is within a few feet of spectators, not in a press box.

A Final Note

The day of a remote is typically a tense one for the people responsible for its execution, and the degree of tension is usually in inverse proportion to the amount of advance planning.

The most important factor in doing a remote broadcast, especially a sporting event, is getting there on time. Arriving on time is a frequent problem in coverage of major sports. Why? Because what is normally a 10-minute drive to the stadium can take 2 hours on game day, when the thoroughfares are choked with traffic. If the event is in your hometown, you'll have a good idea of travel time to the site on game day. If it is an away game, try to book accommodations within walking distance, or plan to leave very far ahead of schedule to ensure that you're on site in time for the broadcast.

One broadcaster of our acquaintance recalls with horror the day he was scheduled to announce play-by-play for a major college game. Traffic was terrible, and he had the distinctly unpleasant experience of hearing the national anthem over his car radio as he waited in traffic, vainly trying to get to the stadium on time.

In conclusion, we'd like to bring up the planning issue again. Problems can and do occur, but advance preparation can make the difference between an inconvenience and a horror story. Having backup equipment can make the difference between executing a quick repair and not going on the air at all.

Summary

Sports and remote production are usually small parts of the job of a typical radio producer, but they tend to be expensive and important affairs that require careful planning.

A variety of remote equipment is available, including portable turntables. Planning in advance is extremely important. Remember, a great deal of advertising money is at stake. The most common source of problems seem to be the coordination of the telco drop or other transmission facility. Be sure to check this out carefully.

For producing a remote, the rule of thumb is to calculate every piece of equipment you might conceivably need, double that amount, and pack it. Be aware that you will need a communications system back to the studio. Work out all the details in advance.

Sports present a wide range of production problems. The most immediate problem in any sports event involves selecting a competent announcer. After that, the producer must be concerned with arranging mic placements that eliminate extraneous noise.

Finally, plan to be in place well in advance of the scheduled start of the event. More than one remote has been ruined because key personnel were stuck in traffic.

Applications **SITUATION 1 / THE PROBLEM** The producer for a remote inside a grocery store had a great deal of difficulty with noise from the air-conditioning system directly above her location. The setup couldn't be moved, so a directional mic was substituted. Now, however, there was no ambient noise whatsoever; the goal of the remote was to present a program from the new grocery store, but the broadcast might as well have come from a closet.

ONE POSSIBLE SOLUTION A mic was suspended from the ceiling over the cash registers, and the ambient noise was fed into a mixer. A proper balance was struck between the announcer's mic and the ambient mic. Now, there was a sense of location to the remote.

SITUATION 2 / THE PROBLEM Live reports from the local golf tournament sounded flat and entirely lifeless.

ONE POSSIBLE SOLUTION The radio producer borrowed a technique from television and used a parabolic mic to pick up the swish of the clubs swinging and the plink of the ball dropping into the cup. Now, when the announcer said, "We're standing near the 18th green, where Lee Leonard is about to putt for an eagle . . ." listeners could hear the ball being struck and dropping.

Exercises

1. Test out the sound qualities of various locations by taking a portable tape recorder and mic into various areas and business establishments. Try recording a test tape (with permission from the manager) in an auto dealer's showroom, a supermarket, a locker room, a restaurant, a shopping mall, an open field, and other locations you want to try.

 Briefly jot down the characteristics you feel each location has, and note the problems each might present for a remote broadcast.

2. Write down some of the special problems you think might be encountered in the following situations. Then propose possible solutions. For example, consider the situation of a booth at the fairgrounds. You may encounter such problems as a rowdy crowd or a heavy wind from the west. To solve these problems, you should (1) ask the fairgrounds manager to station one of the police officers on duty near the booth, and (2) put the remote console against the west-facing wall to keep wind from hitting the mic and, possibly, from dislodging the tonearms (this does happen).

 Now, think of problems and solutions for the following:

 • Coverage of a high-school swim meet

 • Remote from the construction site of a new building

 • Remote from the opening of the Lilac Festival, held in a city park

3. Plan and execute a remote from the hallway or adjacent room outside your production studio. You and your partners can invent any situation you want, but there is one ground rule: You cannot iron out problems by opening the door and conversing. Any communication must be done by wires that you and your instructor or lab assistant run yourselves, or by intercom or telephone. Set up mics and portable computer, if possible, and run their output back from the hallway or separate room into the board on the production studio. Assign some duties, such as playing commercials or reading the news, to the board operator in the studio.

FIFTEEN

Advanced Radio Production

This chapter on advanced production will serve as a jumping-off point for exploration into other specialized areas. Multichannel recording of music, for example, is a specialty within itself, and we can offer only a basic introduction to it in this chapter. As part of that discussion, we deal with stereo recording and briefly explore the relationship of a stereo signal to radio broadcasting. Engineering and other technical operations are specialties, too. Without writing a primer on electronics, we nevertheless introduce a few basic terms and concepts that might be useful to radio production people interested in expanding their knowledge in these areas.

The applications of audio in other media form a wide-ranging field, and though those applications typically involve the principles dealt with in this book, many are outside its scope. For a comprehensive guide to these applications, as well as to more advanced applications of the principles put forth in this book, we suggest *Audio in Media,* by Stanley R. Alten; you will find this book an excellent continuation of the information presented here.

Multichannel Recording

Mutichannel recording can be accomplished in several ways. Today, many digital audio workstations (DAW) programs incorporate multitrack production capabilities within their software setup. These software programs may allow you to mix as many as 128 tracks of audio, although you'll need a high-powered computer for that much capability. DAWs can take the place of multichannel recording consoles in some situations. However, these systems are limited by the number of tracks that can be recorded simultaneously.

323

Because of this limitation, some radio stations have incorporated multi-channel recording equipment in their studio operations. Multitrack systems allow high-quality recording and mixing of music and other complex audio projects, such as adding sound tracks to multimedia presentations.

Multichannel means pretty much what the name indicates: The console and recorder are capable of isolating a number of channels, depending on the channel configuration of the console and the track configuration of the record-playback system. It's important to make a distinction between tracks (which are associated only with tape machines) and channels (which may be associated with either tape machines or consoles).

A separate audio source can be placed on each of these channels and mixed into the final product. In music recording, for example, drums may be isolated on one, two, or more channels, the lead vocalist on another channel, and guitar on yet another. This allows the producer to balance the sound sources properly during recording and to remix the sources afterward. Multi-channel audio consoles typically offer a variety of sound-shaping effects that can alter the coloration of the sound. Digital audio programs with multitrack capabilities may provide sound-shaping with individual control for each track.

Common formats for multichannel recording include arrangements of 4, 8, 16, 26, and 32 tracks. In high-quality recording facilities, 24- and 16-track are two of the more popular formats in recording studios, whereas 4-track and 8-track studios are more common in broadcast stations. In 16-track recording, 16 tracks are placed onto the tape. Modern recorders are usually digitally based systems. Each track can carry one or more audio sources. Figure 15.1(a) pictures a console used for complex multitrack recording. Figure 15.1(b) shows a tape machine using 2-inch-wide audiotape, which is used in multitrack recording. Figure 15.1(c) shows virtual tracks on a digital audio workstation.

Why is multichannel used? Because it gives greater flexibility and control. In music recording, for example, recording on multichannel offers a distinct advantage. If the recording of a music ensemble were done simply on one track (or on two tracks in stereo, as we discuss later in the chapter), the result of the initial recording would be the final result. If the mic position caused the horns to sound too loud, little could be done. With multichannel recording, however, the horns are miked separately, and their volume can be increased or decreased during the following session, called the *mixdown*, when the musical elements are remixed.

But the advantages of multichannel recording don't stop there. Suppose that the horn part was hopelessly bungled during the recording. When each instrument is separately miked and recorded with multichannel, another musician could be brought in to rerecord nothing but the horn part, which would then be mixed into the final product. Such flexibility also allows a singer to cut several versions of a song until the desired sound is achieved. A singer can also **overdub** her or his own voice, adding a harmony part, for instance, to a previously recorded song.

Figure 15.1 Equipment for multitrack recording.

a. Multitrack recording console.

b. Tape machine using 2-inch audiotape.

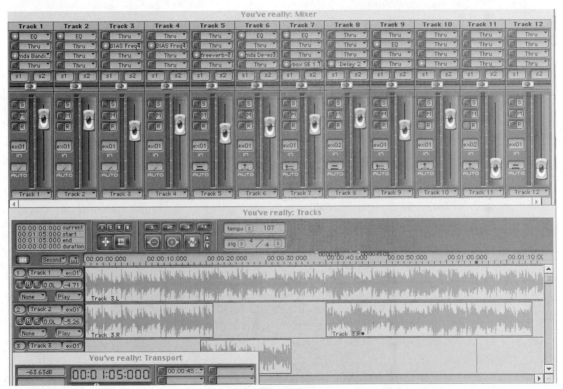

c. Deck's digital audio workstation with 12 of 24 mixer channels displayed.

Figure 15.1a, b, photos by Philip Benoit, Figure 15.1c screen shot courtesy of BIAS, Inc.

Multitrack has another advantage in that multichannel consoles allow sound shaping; that is, a variety of electronic devices can be used to alter the quality of the audio signal both during the recording and after the mixdown.

Before discussing those features, let's look at a typical console setup. The console pictured in Figure 15.2(a) is an 8-channel model with 24 inputs that can be assigned to any or all of the 8 channel outputs. Even though it offers less channel capacity than a 16-track model does, it functions according to the same principles. Always remember that, regardless of the intricacy of the hardware, the principle is the same; namely, in a multichannel mixing console, you usually have a double-duty board. One side of the board controls inputs. The other side controls outputs. This structure relates to the function of a recording engineer and a recording producer; basically, the engineer makes sure that the inputs are correct and the meters are reading properly, whereas the producer, sitting to the right, governs the mix and remix of the output of the console.

Input Modules

The input side (see Figure 15.2b) of the board takes in the signals from the mics (or other sources) and sends them through a series of circuits. A signal is routed through a series of circuits known as modules, the controls for which are located in vertical columns. There are modules for each channel on each side of the console. The circuits in the input modules (not listed in the order of signal flow) include the following.

THE VERTICAL/SLIDE FADER Multitrack consoles use vertical/slide faders rather than circular pots, ostensibly because the position of a bank of slide faders is easier to perceive at a glance than are the positions of several dials. Most producers also find it easier to control many faders than to control many dials.

INPUT SELECTION CONTROLS These include mic-level and line-level selectors. In addition to selection of sources, multitrack consoles offer a trim control—a fine-level adjustment of the input volume that allows you to keep sliders in the optimal control area.

SOUND SHAPERS Equalizers and filters are types of **sound shapers;** both are located on the input modules. An **equalizer** alters the frequency pattern of an audio source; it can, for example, boost a certain range of frequencies. A **filter,** on the other hand, eliminates frequencies of a certain range. An effects or auxiliary pot may be found on an input module as well. Effects or auxiliary pots allow the engineer to apply special effects, such as reverberation, to a specific channel.

Figure 15.2 Typical console setup.

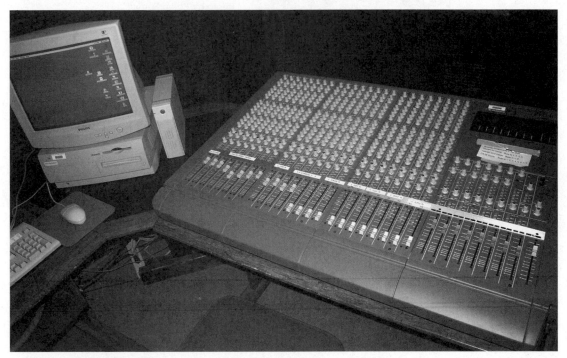

a. Multitrack console with 24 inputs and 8 channel outputs.

Photo by Fritz Messere

b. Input side of a multitrack console.

Photo by Philip Benoit

Figure 15.3

Output buses.

Photo by Philip Benoit

PAN POT The **pan pot** varies the amount of signal sent to each side of the stereo signals. Panning the pot to the left will send more of the signal to the left channel, and vice versa. A pan pot is used in the final mixdown.

SOLO The **solo** mutes other inputs so that the channel being soloed can be heard alone.

BUS DELEGATION This controls sending the signal from the input modules to the board's output modules, which are known as *buses*. A **bus** is a junction of circuits. Any number of input channels can be routed into a particular bus in the output section of the console. Remember in Chapter 2, we learned about program and audition on a radio board? They, too, are buses.

Output Buses

Output buses (see Figure 15.3) send the signal to the tape machine and to the monitors (though there are additional controls for the monitors, usually above the output buses). The bus feature allows the signals assigned to each bus to be altered in volume, and some effects can also be added at the output level. When effects are added at the output bus, the effect will be applied to all signals on that bus. The important thing to remember is that the output buses correspond to track numbers on the tape.

Monitor Controls

On the multitrack board controls, the signal flow to the loudspeakers is governed by the monitor controls.

Further Note About Multichannel Consoles

The variety of hardware available for multichannel recording is mind-boggling, and a discussion of multichannel usually winds up surveying the latest technical wonders on the market. However, the important thing about multichannel recording is not the technical features offered. What you should remember is that multichannel consoles have an input section and an output section. The input circuits shape the audio signal and assign it (and any other inputs you designate) to a particular output bus. The output bus is a circuit junction that feeds a particular track on the tape machine. A multichannel board can send signals to a recorder through the same pots that are used for mixdown. Some channels can be premixed; drums, for example, often are put on only 1 or 2 of the 16 tracks even though 4 separate channels may have been used for recording the drums. Because of its ability to shape sound and assign particular signals to certain tracks, the multichannel recording system gives great flexibility to the recordist and allows remixing of the program material.

Although hardware may vary, the principle won't. If you understand the principle, you'll be able to adapt with a minimum of instruction to the particular configuration of any multichannel console.

Role of Multitrack Recording

Radio stations more and more frequently use the multitrack recording capabilities of digital workstations for operations such as recording commercials. Jingles and recording and mixing music presentations are frequently done on multitrack recorders, in either analog or digital formats. Multitrack recording also has wide application in a number of related audio areas, but it is

Industry Update

A SIMPLE MULTICHANNEL CONSOLE

Radio production studios often use complex multichannel consoles, as described in this chapter. Some stations use consoles that were designed, in large part, for music recording, and some are very complex.

To paraphrase Einstein, a piece of apparatus should be as simple as possible, but no simpler. And that seems to be the trend in radio production. Simple multichannel consoles are becoming quite popular.

Figure 15.4 shows a diagram of a console similar in design to the control-room console we demonstrated in Chapter 2. A simplified explanation is offered here.

Continues

Industry Update Continued

Figure 15.4 *Multichannel console functions.*

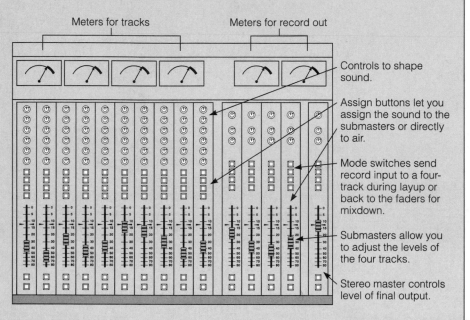

Layup means that sound sources are assigned to the fader (and through the sound processing equipment on the module) and then to the submasters; there are four submasters–two for each stereo channel.

This means that if you assign the board to layup, you simply:

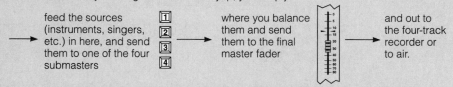

Mixdown means that you record a tape making no effort to mix it as you record. You feed the tape *back through* the board, assigning each track of the tape to a fader. Then, you can take as much time as you want to use the sound-shaping features on each module. You do not commit to sound shaping during the recording process. You do the sound shaping during rerecording.

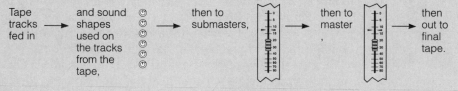

primarily the domain of the music recordist. Music recording is sometimes encountered by radio station personnel.

Although multitrack mixing does offer great flexibility in music recording, it is not the only way to record music. Some musical presentations are recorded simply by mounting a pair of microphones (or a stereo mic) above a musical ensemble. Most music recording is in stereo, so we deal with stereo recording and miking next. Then we wrap up the discussion of music by demonstrating mic techniques used in multitrack recording.

Stereo

Any console routes signals into one or more master channels. For stereo, there are two master channels, usually designated as the left and right channels. Stereo gives a sense of depth and locale to the program material, in much the same way as two ears or two eyes give a sense of depth.

Stereo is popular because the balance between left and right gives a feeling of location in space. In a symphony orchestra, for example, violins are seated to the left, horns are centered, and cellos are on the right. In a stereo reproduction, the sound of the violins emanates primarily from the left speaker, giving the listener the same sense of spatial orientation. Horns will be heard from both speakers and cellos will be in the right speakers. This sense of spatial orientation occurs because your ears are attuned to decoding the very slight difference when sound reaches the ears. That's why you're able to tell the approximate position of someone speaking to you, even if you're blindfolded.

A feature of multichannel recording that we've not yet mentioned is that it allows you to artificially assign a spatial relationship to a particular sound. Do you want the guitar to come from the left and the sax to come from the right? It's a simple matter of manipulating the pan pot controls.

Stereo consoles used in broadcasting are able to process the stereo signal; they have a separate VU meter for each master channel. Operating a stereo broadcast console is essentially the same as operating a monaural console, but you can control the left and right channels with one pot instead of two.

There is a significant difference between stereo and monaural recording processes, however. We've presented the information in this chapter in a specific order, leading up to a discussion of music-recording mic techniques because the explanation of stereo mic techniques should clarify the roles of sound, stereo, and mixing. Understanding the basics of music recording helps illuminate all areas of audio.

Recording Music

There are two ways to record music in stereo: **total-sound recording** and **isolated-component recording.** Total-sound recording involves, for example,

setting up two mics (one for each stereo track) and recording a symphony concert. As we mentioned, this method is a one-shot deal: Your product is essentially the final version. In isolated-component recording, you set up a number of mics on various sections of the orchestra and mix the inputs with a multichannel console.

Which do you choose? Total-sound recording is often used for symphony concerts because the mics pick up the ambiance of the concert hall. It is also simpler to set up mics, and—some people contend—this approach does not impart an artificial sound to the music. Total-sound recording also eliminates a lot of problems associated with multiple mics, such as phasing. Isolated-component recording is more common in the recording studio and is most often used for popular music.

Both methods can produce excellent results. For many radio production applications, isolated-component recording is more useful because the music (or other program material) can be remixed—a highly practical feature for recording commercial jingles and voice-overs.

Total-Sound Recording Microphone Techniques

When confronted with an orchestra or a chorus, producers usually place the mics on the ceiling above the audience section, facing, of course, the orchestra or chorus. Cardioid mics are quite commonly used, but in middle-side recording, a bidirectional mic is mixed in. The most popular methods of orienting the mics are called *coincident, spaced-pair,* and *middle-side.*

COINCIDENT MIKING Setting up **coincident mics** (see Figure 15.5a) involves crossing two cardioid mics, usually at about a 90-degree angle. This imitates the way the ears hear and results in the kind of sound you would hear sitting in the middle of the house. Why? Because the mic for the left channel picks up most of the sounds from the left side of the stage, the mic for the right channel picks up most of the sounds from the right side of the stage, and the sounds emanating from the middle are balanced between the two. If the mic angle is too narrow, the spatial illusion is lost; if the angle is too wide, there will be a hole in the middle of the orchestra.

SPACED-PAIR MIKING When the mics are parallel, usually 1 or 2 feet apart (see Figure 15.5b), you get a very broad sound. Having **spaced-pair mics** heightens the stereo effect though the mics are subject to some phase-cancellation problems because their pickup patterns have quite a bit of overlap.

MIDDLE-SIDE MIKING The technique known as **middle-side miking** involves using a bidirectional mic to pick up sound from either side, with a cardioid mic facing the middle (see Figure 15.5c). Middle-side miking results in an extremely spacious sound, but it requires a special device known as a *phase inverter* to add the signals together properly.

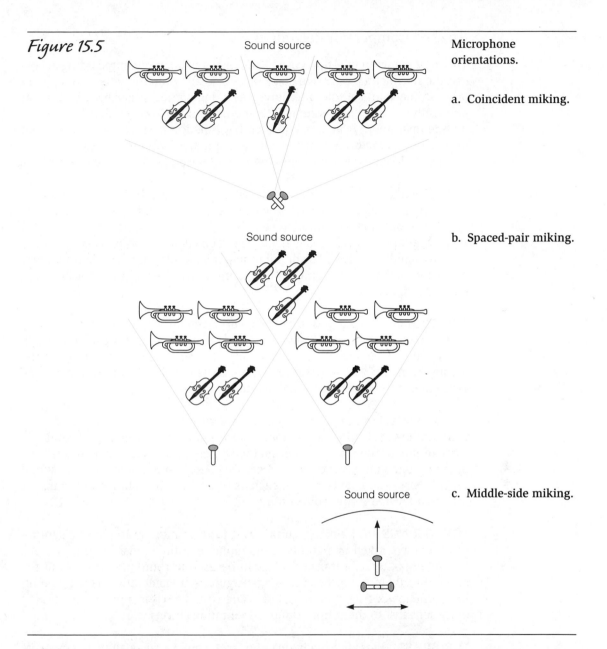

Figure 15.5

Microphone orientations.

a. Coincident miking.

b. Spaced-pair miking.

c. Middle-side miking.

These techniques can be used successfully in a variety of applications for total-sound recording. In addition, they can be used to mic one instrument in isolated-component recording, though most instruments are generally picked up with one mic because the pan pot on the console will be used to orient the instrument spatially.

Isolated-Component Recording

The most common question posed about isolated-component recording is how can the mic pick up only one instrument? Isolating instruments from one another in the sound studio often involves using baffles or isolation booths, or physically moving one instrument to another room. However, the use of a mic on one instrument results in considerable isolation from the sounds of other instruments, a factor that is often surprising to the first-time recordist.

The following mic techniques are useful in isolated-component recording.

FOR SINGERS Most popular vocalists are comfortable with a relatively close mic distance, whereas classical singers prefer a larger distance. In any event, the distance is almost always less than 1 foot, with the mic placed roughly at mouth level. It is generally not considered good practice to let the vocalist handle the mic. For popular singers, an acoustic filter is frequently put between the vocalist and the mic to minimize the possibility of mic popping or sibilance.

FOR DRUMS Miking drums can be a very complex affair, involving as many as a half-dozen mics. Many recordists favor a separate mic for each unit (high hat, cymbal, snare, tom-tom, and so on), whereas others prefer to mike the whole drum set from above, often with a crossed pair. It's largely a matter of experimentation and individual judgment.

FOR PIANOS In the method shown in Figure 15.6, one mic is pointed toward the lower strings and another toward the higher strings. This results in a broad mix of the sound. Other methods include pointing a mic toward the open top of a grand piano. Some recordists stick a mic into one of the sound holes. Sensitive condenser mics, such as the AKG C451B shown in the figure, are often favored for piano recording.

FOR STRINGS An electric guitar (and for that matter, an electric synthesizer) can be miked by pointing a microphone at the loudspeaker that is fed by the guitar. Special transformers can be used to route the signal from the guitar directly into the console. Acoustic guitars are generally miked by pointing a mic toward the sounding hole. The AKG C451B is a good choice; it is quite sensitive to the subtle sounds of vibrating strings.

FOR BRASS Brass is usually miked near the bell because all the sound exits from the bell. An EV RE20 is a good choice because this durable moving-coil mic won't be overpowered by the full sound of a trumpet. In addition, its characteristic warm sound tones down some of the trumpet's blare.

FOR WOODWINDS Most of a woodwind's sound exits from the finger holes (not from the bell), so that is where the mic belongs. The Neumann U87 is

Figure 15.6

Miking a piano.

Photo by Philip Benoit

Figure 15.7

Woodwinds are best picked up by placing a mic near the finger holes.

Photo by Philip Benoit

very sensitive to the warm breathiness of a clarinet and gives an excellent response (see Figure 15.7).

FOR ENSEMBLE WORK With small rock groups, you can easily place a mic on each instrument. With larger ensembles, you'll want to designate a mic for sections: one for the violins, another for the brass, and so on. It's largely a matter of experience and experimentation.

Electronic Equipment and Its Use in Radio Production

Radio is an ever-changing field, and the equipment used can be highly complex. We now introduce some of the more advanced radio gadgetry and some of the more interesting applications of technology to producing radio and

creating an effect. A radio production professional must stay current with advances in equipment. Read journals, attend conferences, and talk to colleagues; in many areas, radio is very much a state-of-the-art profession, and it pays to keep abreast of developments.

Equipment

First, let's look at hardware.

EQUALIZERS These devices are a fixture in a recording studio and have many applications in all aspects of broadcasting. Essentially, an equalizer alters the frequency response of an audio signal. It can be used to boost or to cut down certain frequency ranges. On one common type, called a **graphic equalizer** (Figure 15.8), the controls allow you to set a graphic representation of the response curve you would like to create. By looking at the positions of the faders, you can tell which frequencies within the audible range have been enhanced or diminished. Each equalizer control is usually an octave higher than the preceding one.

Also commonly used in audio is the **parametric equalizer.** The difference between a graphic and a parametric equalizer lies essentially in the amount of selected frequency that can be manipulated. A parametric equalizer allows you to select one frequency and boost or cut just that frequency or that and surrounding frequencies. You accomplish this by choosing the range above and below the selected frequency you want to EQ (EQ is part of radio lexicon, a verb meaning "to equalize"), using a bandwidth control. For example, you could remove an unwanted 60-Hz hum from a remote broadcast better with a parametric equalizer because you would adjust it not to cut adjoining frequencies (which might be desirable because they add depth to your remote broadcast sound). Trying to accomplish this with a graphic equalizer might make the remote sound tinny and weak.

The purpose of an equalizer is to change the character of an audio signal. An R&B or rap recordist who wants to make an instrumental piece sound more bassy and powerful, for example, could use an equalizer to boost the bass frequencies.

FILTERS Sometimes a producer wants to delete a whole range of frequencies. A hiss, for example, can often be eliminated by a **low-pass filter,** which allows lower frequencies to pass but chops off selected higher frequencies. A **high-pass filter,** which will cut low frequencies, might be used to eliminate a rumble.

A filter that is set for a single narrow frequency range is called a *notch filter.* Some electronic components called *noise gates* act as filters when there is no audio signal in the circuit. For example, a noise gate is frequently used in studios where a background noise such as air conditioning, though lower in intensity than an announcer's voice, would otherwise be heard whenever a mic was open and no one was speaking. A noise gate acts as an on-off

Figure 15.8 This graphic equalizer also displays the frequency spectrums of the different audio bands.

Photo by Fritz Messere

circuit—a gate, in other words—and is triggered by the volume change between the announcer's voice and the air-conditioning noise. Whenever the announcer stops speaking, the gate closes, preventing the noise from passing through the circuit. When the announcer begins speaking again, the gate opens and passes the audio (at which time the announcer's voice masks the background noise).

COMPRESSORS AND LIMITERS These devices are often found in the equipment rack in radio control rooms (see Figure 15.9). A compressor shrinks the **dynamic range** of the audio signal. Low-volume parts are boosted; high-volume parts are lowered.

Compression has a number of factors that can be set and varied, including the **attack time** (the length of time it takes for the compressor to kick in after a particular sound affects it) and the **release time** (the length of time the compressor takes to let the signal return to its previous level). A **limiter** is a compressor that severely restricts high-volume noises and has a high ratio of compression. Limiting is useful for keeping sudden loud sounds from overmodulating the signal. (In fact, the Federal Communications Commission demands that radio stations keep their signals within certain tolerances to avoid overmodulation.) Compression is often used in radio stations to maintain a relatively constant signal that won't sink low enough to "fall off the dial."

Figure 15.9 Compressors reduce dynamic range in audio, making it easier to control loud sounds and overmodulation.

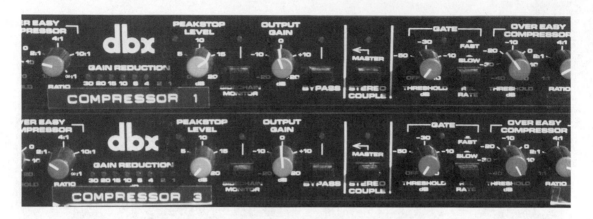

Photo by Fritz Messere

EQUIPMENT FOR NOISE REDUCTION A number of devices produced by **Dolby,** a trademarked name, reduces noise. In professional units, such as Dolby S, the frequency spectrum is divided into several bands, then preemphasizes (raises in volume) each band by a certain degree during recording, which lowers the noise floor relative to the signal. Dolby units in professional applications are usually rack-mounted and installed in the audio chain between the output of the board and the recording device. Dolby SR is frequently used in the motion picture industry.

Another noise-reducing device goes by the trade name *dbx*. The dbx has a more pronounced effect than Dolby does and uses a more intricate logarithmic formula for expansion and contraction of the sound. The dbx system can provide as much as 30 dB of noise reduction on analog tape recordings.

Both Dolby and dbx are processors that must be used in both the record and playback process. Therefore, if a tape is not recorded with either of these two devices, playing a tape back with either dbx or Dolby switched in the circuit will make the tape sound distorted. In addition, Dolby-encoded tapes cannot be played properly with dbx processing, and vice versa.

Digital tape recorders and DAW workstations do not suffer from the same noise problems as analog tape machines do. Therefore, Dolby and dbx are not usually found on these units.

EFFECTS PROCESSORS With multichannel effects processors, you can alter the sound in a variety of ways. These units usually provide a number of standard effects such as *reverberation,* creating multiple, blended repetitions of

sounds to the original that add depth to a sound. *Echo* (sometimes called a slap-back echo) is a distinct delayed repetition of the sound, whereas a *chorus effect* is a recirculated sound using a short delay of time between the original and the delayed signal. With *flangers,* you can create a mirror image of a sound and then shift it slightly; this throws the two sounds out of time and phasing and creates a bizarre effect that's been described as something like water rushing through a voice.

Most effects processors allow you to mix and match these effects in many different combinations, creating numerous possibilities for you to make a special effect. However, these special effects need to be used wisely (and not too often) or they will lose their impact on the listening audience.

SPATIAL ENHANCERS By mixing and subtracting components of the stereo signal, **spatial enhancers** produce a signal that gives the impression of having greater presence or a larger spatial environment. The intent is to reproduce more closely the effect of the concert environment. Units made by Aphex, BBE, and others provide psychoacoustic enhancements to audio signal processing. A radio station uses these spatial enhancers along with compressors or peak limiters to give it a unique sound.

Techniques

Here are some advanced techniques for special effects (some of which use complex equipment, and some of which don't) that a producer might find useful.

REVERB Some production people claim that reverberation, or **reverb,** is the single most important special effect available. It differs from echo in that reverb is accomplished with a discrete unit, an electronic device that produces an electronic delay and adds it back to the signal. Many reverb units have a control called *depth,* which allows the producer to vary the amount of original signal mixed back in. Reverberation is useful for increasing the impression of the room size, and it is frequently added to increase vocal clarity in a production. Reverb is both a technique and a reference to a particular piece of hardware, a reverb unit.

ECHO This effect can be created with a tape recorder if you do not have a special effects unit. Echo is the feedback of the original signal from the playback head, passing back through the audio chain into the tape machine's record head. In essence, it produces the same effect as yelling "Hello" into a stony cavern. By controlling the volume of the playback head through the board, you can produce differing amounts of echo. When using a tape recorder, a slower tape speed will create a longer echo.

FORWARD ECHO With **forward echo,** the echoes appear before the original sound and lend excitement. In a rock format ID, for example, forward

echo can lend excitement because the echo builds up before the call letters are given.

Accomplishing a forward echo is as simple as playing a tape backward on tape 1 and rerecording it on tape 2 with the tape-2 pot open. Subsequently playing tape 2 backward will give you an echo building up to the announcement—not away from the announcement, as in a normal echo. Some DAWs allow you to create this effect.

PAN POTTING Also known as **channel bouncing,** this technique takes full advantage of stereo's unique ability to capture the attention of a listener who is not expecting an announcer's voice to move from one location to another within a spot. Pan potting can also be used to create a dramatic effect of motion (such as a train whizzing by).

Panning can also be used with reverberation to make the background sound change while keeping the main stereo image the same. These effects can be used by bringing the reverb unit into the board as a separate input and panning the reverb signal back and forth at a constant rate.

CHANGING SPEEDS Many tape recorders are equipped with pitch controls, which are actually speed controls. They can vary the pitch between 6 and 12 percent. Many direct-drive turntables allow you to accomplish the same function. Many DAW programs provide pitch shifting capability.

One application of changing speeds is to slow down a recorded voice. In a commercial for a medicine, for example, the copy might begin, "Are you feeling out of sorts?" The effect would reinforce the message.

DOUBLETRACKING An interesting special effect that is relatively simple to produce, **doubletracking** involves recording a voice and then altering a copy of that narration—perhaps by equalizing or by slightly changing the speed. Both voices (giving the identical narration) are played back together. The effect gives the voice an eerie, attention-grabbing aspect and is similar to **flanging,** an effect frequently found on an effects processor.

GATING Noise gates can be used to produce crisp sound by reducing the natural reverberation in a sound effect. Sound effects, drum rolls, cymbals and similar sounds can be successfully modified using noise gate techniques. Voices that have been gated can be pasted over and over into a DAW to create a stuttering effect that is commonly used on urban and modern rock stations.

NORMALIZING DAW software frequently allows you to normalize all the tracks in an audio file. This can be a useful tool to bring several different audio sources, pasted into the soundfile, up to the same audio level.

We've presented only a limited amount of information on the technical end of radio, but there's a purpose behind our approach. Very often radio instruction becomes a discussion of hardware, and though that's interesting on

some levels, it can be counterproductive. Super-sophisticated equipment and the equally sophisticated talk that surrounds it seem to cloud the issue of radio production.

Radio production is, in our opinion, an art form. Like any art form, it requires a thorough understanding of the techniques and tools of the trade. But it is more than stringing equipment together and using gadgetry to produce an audio novelty.

To those of us who have spent much of our lives involved with radio, the medium is a very personal form of communication. It's a communication medium that enters the house, travels with us in the car, and even keeps us company while we jog. Radio production is the art of achieving the effects that make radio such an intimate, magical medium.

Summary

Multichannel recording is used when many sound sources must be recorded, mixed, and remixed separately. A typical multichannel board has input modules on one side and output buses on the other. The input side takes in the signals from the mics; the output buses send the signal to the tape machine and the monitors. Each side has a variety of sound-shaping controls. Today some digital audio workstations (DAW) can take the place of a multichannel board for radio production.

The most popular techniques for recording stereo are coincident miking, spaced-pair miking, and middle-side miking. Total-sound recording is accomplished by placing one or more mics in a central place to record the sound as the listener would hear it. Isolated-component recording involves placing separate mics on each sound source and mixing the inputs together; this allows much greater flexibility and offers a chance to repair bad takes when the music is being performed.

A wide variety of electronic components are used to shape the signal, including equalizers, filters, compressors, limiters, noise reduction equipment, special effects units, and spatial enhancers. Techniques used in advanced radio production include effects such as echo, reverb, forward echo, pan potting, and doubletracking.

Applications

SITUATION 1 / THE PROBLEM The producer of a program was recording a church choir for later playback. She miked each vocal section separately and planned to mix the program. The director of the choir listened to a test recording and was not pleased with what he heard. "The choir," he said, "sounds like a group of jingle singers."

ONE POSSIBLE SOLUTION Why did the sound vary so much from what the choir director was used to hearing? Because close-up miking of the sopranos, the altos, the tenors, and so on did not allow the reverberation of the music

through the architectural spaces of the church; consequently, the effects of the acoustics—and the sound of the church choir—were altered.

The producer opted for a crossed pair of cardioid mics above the tenth row of pews and was able to achieve a richer, more realistic sound.

SITUATION 2 / THE PROBLEM A group of jingle singers and musicians were performing a commercial for an ice-cream parlor. Gay Nineties music was called for, with a banjo and piano. Unfortunately, the sound coming through the mics featured the booming, rich tones of the studio's grand piano, which had mics pointing toward its raised top.

ONE POSSIBLE SOLUTION The producer repositioned the mics to a spot directly above the hammers. Now, a lot of hammer was heard, and the piano sounded much more honky-tonk than grand.

Exercises

1. Mic a piano in several ways, noting the effects of different mic placements.

 Position the mic(s) at any or all of the following locations, noting how the mix of mics at various locations changes the character of the sound, too:
 - Behind the soundboard on an upright piano
 - In one of the sound holes inside a grand piano
 - Pointing at the raised cover
 - Above the keyboard
 - Above the strings

2. If multichannel recording equipment is available, record a musical group under the supervision of your instructor or lab assistant. Remix the recording twice using whatever equipment is available. The goal is to make two recordings of the same program material that sound radically different because of the mix.

3. As a variation of Exercise 2, split the class into two groups, and let each, separately, record the same performers doing the same musical number. See if the two versions are identical.

Production, Programming, and the Modern Format

*T*here's a fine line between production and programming. We've pretty well defined all the parameters of production in the preceding 15 chapters, and we have touched on the designs of current formats and how they relate to production.

But as the already segmented radio audience becomes supersegmented, production techniques play an ever-increasing role in station programming. **Programming,** for our purposes, simply refers to the selection and arrangement of music, speech, and other program elements in a way that appeals to the station's listeners.

This chapter specifically deals with the radio audience, the basics of the narrowcasting format, and production techniques used in specific formats. We have placed this highly detailed, programming-oriented chapter last in the book because it serves as a starting point for the practice and study of other aspects of radio. Those aspects include music selection, delivery style, and blending of elements—those factors we often refer to as parts of the programming effort. In addition, the chapter deals, by necessity, with some management functions, including an understanding of audience development and measurement.

We start with a close-up of the modern audience before discussing production specifics.

The Audience and the Format

Why bother elaborating the nature of the audience and how that audience is measured? Primarily because identifying and capturing an audience is the heart and soul of on-air and off-air production.

We did touch on the format in Chapter 1. But detailed examination of **formatics** would have been premature before laying the groundwork for a thorough understanding of on-air and off-air production practices. Now that we've built the foundation, we can examine the superstructure of radio: *the audience* and *methods of measuring audience.*

The Audience

Pop quiz: The success of a radio station depends primarily on the number of people who listen. Right? The answer: Not exactly. In fact, program directors are as likely to complain about too much "wasted" audience as they are about too few listeners!

Although that may sound unlikely, it's a good illustration of the predicament of many of the modern media. A radio station sells an audience to an advertiser (or, in many cases, an agency representing advertisers). Radio has become a medium designed to reach certain audiences to the exclusion of others. Prove it to yourself: In most major American cities, you have access to 20 or more radio stations. How many different stations do you listen to? Two or three at most? But a large, ill-defined audience is not a particularly attractive commodity for an advertiser who might be selling:

- Cosmetics to young women
- Expensive foreign autos to rich businesspeople
- Auto parts to young men

This is not to say that size is unimportant. If you have a clearly defined audience, the bigger the audience, obviously, the better. But in these days of the supersegmented audience, the programmer or producer wants to be able to "capture" the right demographic.[1]

A profitable demographic can mean that a station can have a smaller audience than another station in the same market but make more money. For example, the all-news station WINS in New York City was, at the time this was written, in *seventh place* among New York City stations in audience share.[2] (Share means the percentage of listeners tuned in, a term that we define more closely later in this chapter.) But it was among the *top* stations in market advertising revenue, handily outdistancing rock and current hit radio (CHR) stations that command much larger audience shares.

The reason, obviously, is the type of listener: An all-news station typically gathers an older, more affluent, business-oriented market than does a

[1] As you remember from earlier discussions, "demographic" means a statistical representation of a population. We use it here in an informal sense to represent the composition of an audience.

[2] Figures from *New York Radio Guide* (www.nyradioguide.com/ratings.htm) for the Spring 2002 ratings book.

CHR station and can therefore charge more per spot. In this case, the more affluent listener translates into more money for the station.

Methods of Measuring Audience

Because numbers and the people who comprise those numbers are important tools in the radio salesperson's arsenal, it's not surprising that the methods of measuring audience are fairly complex.

Our purpose here is not so much to offer a primer on ratings as it is to establish a common vocabulary for understanding some of the audience measurement factors that affect a station's sound and, therefore, its programming and production strategy. In other words, when we start throwing around terms such as "TSL," "reach," and "cume" when discussing format-specific production, it won't seem like an arcane conversation in a foreign language.

So we quickly define and identify audience **rating services,** the companies that collect data about radio station listenership; the *total survey area* and the *metro survey area,* the landscape on which ratings are taken; the units of measurement, including *ratings, share, average quarter-hour persons, cume, reach, time spent listening, turnover,* and *persons using radio.* Though we don't refer to all these terms and concepts in this chapter, it is necessary to understand those that we do discuss before others can be defined.

AUDIENCE RATING SERVICES Several firms provide information about listenership, but the Arbitron company is the major player in audience measurement. Arbitron's primary tool is a diary in which listeners record their day's listening.

The diary method is one reason stations go to such lengths to make their station's "signature" memorable. Have you ever noticed, as you drive through different areas, how many stations bill themselves as "Kiss (frequency)" or "Lite (frequency)" when their call letters may bear only a passing similarity to the spellings of Kiss or Lite? Part of the reason, of course, is to develop the station's identity in general. But another major factor is that Arbitron will generally accept Kiss or Lite in a diary entry as proof that the listener was tuned to that station.

A sample ratings report is shown in Figure 16.1. None of the ratings services reports actually looks precisely like this, but we've incorporated aspects of several so that any ratings report will look fairly familiar to you once you know what to look for.

A ratings report would generally include more than one station so that comparisons among stations could be made, but we've listed only WAAA to make the illustration simple. The hour-by-hour report lists shares and the estimated number of persons listening as totaled by the average quarter-hour (AQH) method. The (00) means that numbers listing "persons" should be multiplied by 100—or, simply two zeros added. Looking at the first column,

Figure 16.1 This is an example of a ratings report for hypothetical station WAAA.

Station WAAA

Hour By Hour
Metro Survey Area AQH (00)

	5AM 6AM	6AM 7AM	7AM 8AM
WAAA			
P12 + SHR	9.7	9.4	8.0
P12 +	136	136	125
W18–34	26	24	24
M18–34	60	62	58

WAAA TOTAL MON–SAT 6 AM–10AM ALL ADULTS 25–49

AQH AND CUME ESTIMATES
ADULTS 25–49

	AQH PRS (00)	AQH PRS RTG	AQH PRS SHR	CUME PRS (00)
WBBB	157	1.9	10.2	1980

5AM-6AM, you can see that the P12 + SHR (people older than 12 share) is 9.7 percent. The figure is then broken down into estimated listeners, the total number of persons 12 and over (add two zeros), and the numbers of estimated listeners in various age and sex groups. (W18–34 is women aged 18–34.) Most ratings reports list several age and sex demographic groups.

Another type of report breaks down the total day's listenership for another hypothetical station. AQH PRS (00) means average quarter-hour persons, along with the ratings points, share, and total cumulate audience. The entries will become understandable as you read through this section, so please refer to the figure from time to time.

Other radio research services provided by Arbitron include RADAR, an acronym for Radio's All Dimension Audience Research, which uses telephone interviews to measure network radio penetration, a complex job now that "networks" can be formed simply by aiming at a satellite. An industrywide organization, the Radio Advertising Bureau, also provides a variety of research on audience, radio usage and other metric information.

In addition, many radio stations hire program consultants to help station personnel understand ratings data and target audiences by creating very specific format parameters.

TOTAL SURVEY AREA, METRO SURVEY AREA These are areas in which audience measurement is undertaken. The total survey area usually includes several counties that are served by two or more stations from within a metropolitan area. The metro survey area is a local area defined by the city and its immediate environs. Remember that most discussions about ratings center on the metro survey area, which is a far more useful measuring area now that most stations serve concentrated population centers rather than broad areas comprising several counties.

RATING A **rating** is a percentage of the total available audience. Sometimes, the number of listeners is expressed as just that—a total number, estimated from statistical interpretation of results. But strictly speaking, a rating will be a percentage of an available audience. The available audience is, in ratings terms, known as a universe.

SHARE The **share** is the percentage of people who are actually listening. This is the most commonly used measurement in radio. The share is frequently broken down among different sexes and age groups, such as "women 18–34." When you see shares listed without any specific reference to age, the figures usually refer to all persons, age 12 and older.

AVERAGE QUARTER-HOUR PERSONS The quarter-hour is the basic unit of measurement in radio audience measurement. **Average quarter-hour (AQH) persons** is the number of listeners who tuned in to a specific quarter-hour for at least 5 minutes.

A problem with AQH is that you cannot simply add up the AQH figures to obtain the total number of people who are listening during the day because the AQH figures will include some of the same people. AQH is important, however, in figuring gross rating points, as you'll soon see.

CUME Cumulative audience measure, **cume,** solves the problem of determining the total number of people listening by using statistical interpretation to determine the number of unduplicated audience listeners.

TURNOVER Turnover is a relatively self-explanatory term even though its derivation is somewhat complicated (which is why we did not include it in Figure 16.1, the hypothetical ratings report). The turnover ratio is simply a measure of how many people out of the entire audience leave the station during a given period.

TIME SPENT LISTENING Time spent listening (TSL) is a measure of the average time an individual listener tunes into the station.

Calculating How Efficiently a Station Reaches Its Audience

Embedded in the total format structure is its efficiency in producing an audience that conforms to the needs of the advertiser. This will become clearer in a moment, but first let's nail down the basic vocabulary relating to how an advertiser buys spots and what the advertiser expects from the buy.

There are several ways of calculating and expressing the effectiveness of a commercial. Remember, even though the total number of audience members is important, it is not the only calculation entered into the formula.

GROSS IMPRESSIONS The most basic unit of measurement for a commercial is **gross impression, which is the total number of exposures to a commercial. Gross impression is calculated by multiplying average quarter-hour persons during the times the commercial was run by the total number of spots. Remember, this figure reflects duplicated audience. The same person may be hearing the commercial a number of times (which is not necessarily a negative factor, as we discuss shortly).

GROSS RATING POINT Gross rating point is simply a way of expressing gross impressions as a rating figure. Multiply AQH ratings by the total number of commercials played in those quarter-hours to determine the gross rating points. Many advertisers buy radio time based on a calculation of how many gross rating points they want to achieve over a given time.

REACH The **reach is a measurement of how many different listeners hear the commercial. It is calculated by using the cume figure. The calculation itself is too complex to merit discussion here because adding cumes requires some statistical weighting; simply remember that reach represents the number of different people exposed to the spot.

FREQUENCY Frequency is the average number of times a theoretical listener hears a commercial. It is determined by dividing the gross impressions by the cume.

Paying for Efficiency

The aforementioned formulas are used to calculate the effectiveness of an advertiser's purchase. The figures are plugged into various formulas that give advertisers a relative cost they can compare to other stations. Those relative costs are typically expressed in one of three ways: *cost per thousand, cost per point,* and *optimum effective scheduling.*

COST PER THOUSAND Cost per thousand (CPM) is simply the cost of reaching a thousand listeners. (M is the Roman number for one thousand.) This figure is derived from numbers that include new listeners to a certain period and listeners who may have heard the commercial before, so it includes, in radio vernacular, *duplicated audience.*

CPM is calculated by dividing the cost of all spots by the gross impressions after you have divided the gross impression by a thousand.

$$CPM = \frac{\text{Cost of All Spots}}{\text{Gross Impressions} \div 1,000}$$

If you spent $500 for 100,000 gross impressions, you would divide the gross impressions by 1,000 (to express the figure in terms of thousands) and divide the cost of all spots ($500) by that number to produce a CPM of 5. This means that it costs $5 to reach 1000 listeners.[3]

If an advertiser knows the CPM, he or she can compare the cost of running ads on all stations in a market or among various markets. The CPM will also be broken down by sex and age of listeners.

COST PER POINT Cost per point (CPP) is a measure of how much it costs to "buy" one rating point in a particular market. CPP is determined by dividing the cost of all spots by gross rating points.

$$CPP = \frac{\text{Cost of All Spots}}{\text{Gross Rating Points}}$$

As you remember, gross rating points are the product of the number of spots run multiplied by the AQH rating. So if you run five spots, one each on days Monday through Friday in a quarter hour with a 1.5 rating, you will purchase $5 \times 1.5 = 7.5$ gross rating points.

If each spot cost you $125, you have spent $625. Divide $625 (cost of all spots) by 7.5 (gross rating points), and you have a CPP of $83.33 per point. Cost per point has become the most commonly accepted way of measuring ad placement efficiency in radio.

OPTIMUM EFFECTIVE SCHEDULING Some advertisers and radio executives argue that cost per point is not a particularly effective way of measuring the effectiveness of radio advertising because CPM and CPP do not account for the amount of audience that hears the commercial more than once.

As we mentioned, a duplicated audience is not always a negative because radio spots often require several listenings for the message to "sink in." A new measure to compare advertising efficiency is gaining some acceptance as

[3] These examples are adapted from another book by the authors, *Radio Station Operations: Management and Employee Perspectives* (Belmont, Calif.: Wadsworth, 1989).

a replacement for CPP and CPM. **Optimum effective scheduling** (OES) is a mathematical formulation that determines the number of people who hear the spot three or more times and shows that figure as at least 50 percent of the total audience.

For the record, OES is determined by multiplying the turnover ratio by 3.29 and the cume by .46. Let's leave it there; the derivation of those figures takes too long to explain. Suffice it to say that though OES has its admirers, it also has critics who say that the formula works best for comparing buys in small markets and that it forces advertisers into excessively large purchases. (The average purchase for a run of spots calculated by OES is about $450.[4])

So what's the point of this dissertation? It's not necessary for someone involved in production to understand the intricacies of audience measurement, but as we mentioned earlier, the vocabulary of audience measurement and composition is intrinsic to understanding the modern format and how production fits within that format.

Armed with the knowledge you've picked up in these few pages, you can now evaluate format design and production within those formats as a program director evaluates them: strategies to capture and keep a large, loyal, and (in the case of commercial radio) affluent audience.

The Specifics of the Radio Format

Why is the format, this tool designed to capture and keep an audience, so complex? After all, can't a reasonably intelligent programmer simply pick some music, announcers, and newscasters and let the show run itself?

Perhaps. But formats live and die on conditions external to the format (competition and changing demographics are among them), as well as the format itself. The programmer, and the production manager, must take all these factors into account when creating the sound of the station.

Defining Current Formats

If you really tried (and some have), you could probably come up with more than a hundred variations of program strategies that qualify as formats. Some who track formats have tried, but most have given up the attempt to classify each and every variation of program strategy; today, we tend to use broad categories descriptive of formats and apply qualifying adjectives to further delineate those formats. (For example, a "lite" adult contemporary features less rock than a "hot" AC.)

[4] See "OES Gets Results Through Effective Reach." *Broadcasting*, January 27, 1992, pp. 32–33.

Billboard magazine and Arbitron (the ratings company) have divided formats into more than a dozen categories for their format share reports. It's worthwhile to define these formats; combining an understanding of typical formats with the audience measurement concepts we explained earlier will allow us, in the final section of this chapter, to take a relatively detailed look at the role of production in reinforcing the format. The following definitions mirror the descriptions introduced in earlier chapters but introduce more types of formats and explain how some terms relate to the construction of the format.

We also briefly mention the primary characteristics and desirability of the demographics. The information on CPM is not essential for a producer, but it does provide some insight into the type of listeners and level of affluence.

ADULT CONTEMPORARY Adult contemporary (AC) is a wide-ranging format that generally includes a few current popular hits, called *currents,* recent hits, known as *recurrents,* and older songs, known as *oldies.* AC ranges from rocking, hot AC to lite, or easy AC. Some AC declares itself a mix, using a mixture of types of songs and eras of songs. AC formats are usually designed for general listeners rather than those listening strictly for only one genre of music. There are Hot AC and Lite AC variations on this theme.

AC has a relatively affluent demographic. CPM is high. This format scores particularly well among women around 30 years old.

ADULT STANDARDS Adult standards is pretty much the same format as *middle-of-the-road* (MOR). MOR is still an extant format, but adult standards is the term used by *Billboard* and Arbitron.

In any event, adult standards usually means music such as Tony Bennett and Brenda Lee. However, this format is no longer synonymous with World War II music. Selections from the Platters and even the Carpenters are often heard on adult standards stations. Remember, fans of the Carpenters who were in their late 20s when the Carpenters were in full flower are now in their 50s. Time marches on.

CPM runs high, but raw numbers are declining.

CLASSICAL The **classical** format usually includes orchestral, opera, and occasional show music. Some classical stations feature modern orchestral pieces, but most tend to stick with Bach, Brahms, and Beethoven. CPM is very high; the audience is typically highly affluent.

CLASSIC ROCK This used to be a splinter format of album rock but now has its own distinct identity. **Classic rock** might best be defined as the top hits from the best 100 rock albums of all time without new releases; selections from Cream and the Moody Blues are examples of classic rock mainstays.

CONTEMPORARY HITS RADIO (CHR) CHR, also known as **Top 40** or **current hit radio**, used to be what the secondary title says: the top 40 songs

repeated over and over. But that strategy is hopelessly vague for a station that wants to distinguish itself in the marketplace. Today's CHR/Top 40 typically features heavy dayparting, that is, specially designed formats for the changing listenership during the day. Some CHR/Top 40 stations also "mellow" their playlist to capture a broader audience whereas others play Rhythmic Top 40 to skew toward the younger audience. These formats often use heavy promotion to build their audiences.

CHR/Top 40 has a fairly low CPM because its audience generally does not have much money, but again, young people have very active spending habits.

COUNTRY As we defined earlier, **country** is a format with rural roots, but it is not limited to rural listeners. Country melodies typically have a "twangy" feel, and the lyrics often deal with the struggles of everyday life.

Country music was rocket-hot in the 1990s and is still among the most popular formats today. But oddly, that's a mixed blessing to country programmers and radio producers, who must tread the delicate line between ignoring the new material and alienating longtime listeners. (The word *producer* is a good substitute for programmer because planning airplay is really a matter of on-air production; thus we use that term with increasing frequency.)

Country is not regarded as having a particularly affluent demographic, although the format has made significant inroads among the affluent and the young, thanks in part to the huge success of several country crossover stars. The young are not particularly affluent, but they do spend a great deal.

DANCE This music is primarily meant for dancing. Some stations play a formula of disco and 1990s techno music. Sometimes dance music stations are also known as contemporary hit radio (CHR) rhythmic. CPM is variable.

MODERN ROCK **Modern rock** or **new rock** features very progressive music, including many selections that would be characterized as alternative new rock. Music tends to current with bands that have gained prominence within the last five years. CPM is highly variable.

NEW AC/SMOOTH JAZZ This music features jazz and compatible vocals. These stations play easy-going music designed to create a "jazzy feel or mood." Music tends to be medium tempo and it is sometimes referred to as New Adult Contemporary. CPM varies widely.

NEWS/TALK According to the *M Street Directory*, the combination of call in, live interview, and news programming, **news/talk** is the most successful format on the AM band. Although durable and popular, this format relies on good talent and is somewhat market driven. When times are not turbulent, talk ratings decline. Luckily for news/talk programmers, we seem to be realizing the ancient oriental curse of "living in interesting times."

News/talk has a fairly affluent demographic. (All-news has a very affluent demographic.) It's particularly strong among businesspeople. Listeners tend to be older (35 and up) rather than, say, in the 18–34 demographic range.

OLDIES Just what constitutes an oldie is debatable, but to most producers, an oldie is a cut released at least two or three years ago, and of course, many oldies date much farther back than that.

Some stations use rotations from all eras of recorded music, but the oldie market is segmented, too. You'll find that most rotations (the scheme of music played) in oldie formats center on an identifiable 15 year period, many playing music from the early 60s through the 70s for baby-boomers.

Oldie CPM often runs a little higher than average, and some oldie formats are quite successful, and highly specific oldies formats, such as "classic rock oldies," have sizable and loyal audiences.

RELIGIOUS The format is self-explanatory, but do note that the format can take on aspects of other formats. Some modern **Contemporary Christian** music, for example, is virtually indistinguishable from that played on adult contemporary.

Many of these stations are noncommercial, so CPM is either not applicable or, in the case of commercial religious stations, varies widely.

ROCK Rock, also known as **album-oriented rock (AOR),** features longer, heavy-rock cuts and is primarily aimed toward a fairly young male audience. Album rock has many variations on its basic theme, but it essentially features older music, longer cuts, and longer sweeps (back-to-back music segments) than Top 40 does.

AOR has a low CPM because its audience is viewed as being less affluent and less likely than other audiences to buy a broad range of products.

SPANISH The Spanish format has become increasingly popular because of the growing number of Latinos in the country. Radio station producers took note of this when they saw the results of the most recent census, hence, a growth in Spanish stations. (In some Mexican border communities and southern Florida, of course, Spanish stations have been broadcasting for years.)

CPM can be good in many areas when there is a mating of easily identifiable products with this audience.

URBAN **Urban** formats feature rap, hip-hop, hard rock, and other format particulars designed to appeal to young, urban audiences, often blacks and Latinos. Not surprisingly, urban is a popular format in large cities.

Like all formats, urban varies in the content and thrust of its programming. Many urban outlets also feature a healthy dose of Top 40 cuts and are nicknamed "churbans" or Rhythmic Top 40. (If you hear, say, a Whitney Houston cut on an urban station, you're probably listening to a churban-

leaning urban.) Rhythmic oldies tends to be a mix of urban oldies interspersed with early rap and upbeat Motown hits. Urban CPM can be quite respectable because the format moves certain products very well.

REMAINING FORMATS There are dozens of other formats, including all-news, various ethnic formats, and even an occasional all-Elvis station. Of particular interest is the emerging all-sports format, which is proving highly successful for WFAN in New York and moderately successful for WEEI in Boston.

There is a great deal of overlap among formats. It's impossible to surgically separate, for example, a hot AC from a light Top 40/CHR. Note that new formats constantly merge and that many of today's large-scale formats were "splinter" or "hybrid" just a few years ago.

Filling the Niche: Today's Trends

After examining the range of formats available, we can see that finding and keeping an audience is not something that can be done in a vacuum. Changing tastes of the audience, rearrangement of competitors' formats, seasonal variations, and other external factors affect the viability of niche programming.

The Industry Update box describes some current trends that apply to the modern format. They are interesting in themselves but are also quite instructive when evaluating the performance of various formats.

On-Air and Off-Air Production in the Modern Format

Here's where audience measurement and format characteristics coalesce: The producer, on- or off-air, must blend the sponsor's desire for a clearly defined audience and the audience's desire for an attractive format.

We deal first with the fundamental issue of avoiding tune-out—a principle that applies to all formats—and then specifically examine production techniques in some major formats, formats you are most likely to encounter at some point in your radio career.

Production and Tune-Out

The producer's job is twofold: Get the listeners, and avoid doing anything to make them tune out. You want to build time spent listening and limit your turnover.

Three major factors are involved here: avoiding dead spots, avoiding jarring transitions, and keeping the listener tuned in through quarter-hours.

AVOIDING DEAD SPOTS Suppose you have a tight Top-40 format, slick and well-timed work by the announcer, and you throw in a low-key commercial

Industry Update

FORMAT TRENDS AND WHAT THE PRODUCER NEEDS TO KNOW ABOUT THEM

Whoever is in charge of production is often in charge of the sound of the station—and therefore at the helm of the station's ride through the turbulent modern marketplace.

We have surveyed an extensive array of literature and summarized the major current trends for this updated edition of *Modern Radio Production*. When possible, we offer some remarks about how, specifically, the person at the production console can meet the changing needs of the market.

Here are the major results:

- In the wake of 9–11, News/Talk continues to be very strong. This format dominates the AM radio dial and has significantly affected FM in the last few years. In fact, news/talk is now the second most popular format on FM and represents more than 7 percent of all FM stations. NPR has created a successful niche with several popular afternoon call-in programs for noncommercial radio stations. News/talk is up and continues to do well in autumn seasons. Autumn seems to be the time when news events coalesce. The issues revolving around the problems faced by President Bush and the continuing "war on terrorism" provide a good deal of fodder for talk show hosts and news junkies.

- Although the over-all listenership of AC stations has declined slightly, the format is an economic powerhouse because it reaches identifiable demographics with large numbers of at-work listeners. Soft AC targets the "at-work" listeners who are desirable because they have regular incomes (remember, they're at work) and stay tuned in for long periods of time.

- CHR is fragmenting among the basic topic 40; CHR mates with urban/rhythm; and often CHR mates with oldies, essentially giving up on teens and aiming toward an older (18+) market. Traditionally, the strongest demos for CHR have been girls 12 to 17 followed by boys 12 to 17, but in the past few months, many stations have been skewing their playlists toward slightly older listeners. The young teen demographic continues to be viewed as rather unprofitable.

- Both urban and modern rock are making inroads with teens, particularly males. Some CHRs are leaning toward modern rock whereas

Continues

Industry Update Continued

others play a good deal of urban, but now modern rock has emerged as a distinct format boasting more than 150 stations in 2002. Modern rock has become a hot commodity in medium-to-large cities, such as Detroit, Chicago, and Denver. Featuring bands such as Creed and Stone Temple Pilots, these modern rockers are gaining significant market share.

- All-sports and all-business stations are enjoying great success; there are about a thousand nationwide. They are usually steady performers, but market share is typically small. The point for the producer: Get all the training you can in news and business because that may be a continuing trend.

- Country continues to fragment (by last count, there are 12 different flavors), but by and large it is very healthy. Although the format has become more popular with young people, it is still fairly weak with teens. Producers really must know the music here; picking cuts can be tricky because you alienate part of the market if you use a cut from distinctly the wrong genre.

- Nostalgia/MOR is declining as the audience in general gets older. The problem for the programmer or producer was the limited number of cuts for airplay but recently soft ballads by Carole King, the Carpenters, and others have been added to the playlist. Also, artists such as Tony Bennett have made astounding comebacks (even on MTV!) in recent years, and certain artists such as Nat King Cole are always guaranteed winners.

- Spanish and Mexican music formats have gained among all radio listeners in the last few years. There are many different subformats in this genre but according to the M Street format count there were more than 300 FM stations classified as having a "Spanish" format in 2002.

- Country continues to be very strong. Younger listeners are being pulled into country listening by the emergence of hot country formats. The continued popularity of hot country stars, such as the Dixie Chicks and Tim McGraw, energizes the genre.

Some programmers worry that the format may be reaching critical mass because almost everyone who can be pulled into country is already there. But the crossover popularity of artists such as Faith Hill has helped country maintain its popularity.

Continues

Industry Update *Continued*

- Top 40 continues to hold steady. Some programmers worry that with so many young country artists emerging, young listeners may be gravitating away from Top 40 to country. Urban and modern rock stations have also grabbed teens. Further, Top 40 depends heavily on contests, but given the current state of the economy, less money is available for contests. Top 40 is tricky to track because there are many seasonal variations. When young listeners are out of school in summer, Top 40 ratings rise, but the rest of the year ratings dip.

- Oldies are down in the important 25–54 age group, probably because overall listenership in this important age group is down generally.

with no music in the background? Chances are you might lose a few listeners, which is why so many Top-40 spots are constructed with good production music.

In fact, almost all formats use high-quality production music. The days when you could grab a disc off the shelf and track any old instrumental underneath your commercial are gone. Today, lively production music that fits the format is an absolute necessity.

A variety of firms lease production music that projects a certain mood within the constraints of various formats. The cuts come on compact disc and are listed by selection. Some libraries of production music are now updated very frequently with new releases so that the music beds reflect current trends.

AVOIDING JARRING TRANSITIONS An on-air producer must take care not to jolt the listener out of his or her seat. A soft cut back-to-back with a bold, loud song may keep your listeners awake, but it may also wake them up enough to change stations.

Some program directors make it a point to listen to ends and beginnings to see if they mesh. If not, some rearranging is in order. For example, a very loud, up-tempo intro is a bad choice to follow a soft song ending, but it is a good choice to back up to the end of a high-energy newscast.

Some program directors match keys of songs. A **key** is the musical scheme in which the notes of a song fall. In simple (and admittedly simplistic) terms, the key of a song is the first note of the scale used to write the song. That note and the note three notes above (the third) and the note five notes above (the fifth) sound natural and complete. The notes not on the base note (called the **tonic**) or on the third or fifth do not sound complete

Figure 16.2 Compatible music keys.

Music in this key will segue with	First choice	Second choice	Third choice
A	A	D	E
A# (B♭)	A# (B♭)	D# (E♭)	F
B →	B	E	F#
C	C	F	G
C# (D♭)	C# (D♭)	F# (G♭)	G# (A♭)
D	D	G	A
D# (E♭)	D# (E♭)	G# (A♭)	A# (B♭)
E	E	A	B
F	F	B♭	C
F# (G♭)	F# (G♭)	B	C# (D♭)
G	G	C	D
G# (A♭)	G# (A♭)	C# (D♭)	D# (E♭)

From Stanley R. Alten, *Audio in Media*, Third Edition. Belmont, Calif.: Wadsworth, 1991. Courtesy of Wadsworth Publishing Co.

and hold us "in suspense," waiting for the piece to be "resolved." Some keys simply do not segue well into one another. A key usually segues well with itself and with a song with a tonic key based on a note found in the first key. Audio specialist Stanley R. Alten has compiled a list of compatible keys—keys that can provide a good-sounding segue from one to another (see Figure 16.2).

For those of you without musical training, the preceding paragraphs are probably pure bafflespeak. And to be frank, even the member of this authorship team who has worked as a professional symphonic musician usually cannot tell the key of a piece of music simply by listening.

However, *anyone* with a decent ear can judge whether a segue between two songs is jarring because of a wide key change. Simply listen; if the beginning of the next selection sounds jarring, dissonant, or "sour" when lapping over the first selection, the keys don't mesh, and it's best to rework the song selection.

KEEPING THE LISTENER TUNED IN THROUGH QUARTER-HOURS Remember that Arbitron, the major rating system, counts listeners by numbers who are tuned in during a portion of the quarter-hour. As a result, part of a producer's or programmer's job is to keep the listener tuned in through those critical quarter-hour mileposts.

Sweeps that cover the quarter-hours are the primary tool for this. Try not to have the stop sets (the grouping of commercials) near quarter-hour mileposts; move them about 5 minutes away from the quarter-hour. You can turn the stop set into an advantage this way by using it to presell a sweep 5 minutes before the quarter-hour. This can build carry-over.

Production for Adult Contemporary

AC needs a particularly cohesive production strategy because there's so much competition. If you're running an easy AC that gets too hot, be assured that there is a hot AC in the market ready to usurp your listeners.

ON-AIR AC PRODUCTION AC stations usually have 6 to 14 currents in the main rotation—that is, 6 to 14 current songs that will be regularly inserted into the playlist. The hotter the AC format, the more currents. In general, AC relies on Top 40 to introduce records in a market, but the hotter ACs today are taking it on themselves to introduce new music.

Song selection is critical because a hard-rocky cut can drive listeners away. AC production directors listen carefully and may even disqualify a cut because of one portion of the song. "It seems like everybody has to throw something in a song to make you nervous," says consultant Bob Lowrey.[5] "'Daniel' by Wilson Phillips is fine, except for the sax, which makes it risky or unacceptable for soft ACs." Don't forget that the situation cuts both ways. Too soft an AC selection ("Feelings" comes to mind) may drive listeners away from radio altogether.

Incidentally, try to have music sweeps briefly **back-announced,** that is, identified after they are played. (The more current term is **backsell,** which means the same as back-announce.) Research shows that lack of song identification is increasingly irritating to the AC audience.

OFF-AIR AC PRODUCTION Your selection of music beds for commercials must reflect the programming strategy of the station. In general, it is hardly ever a good idea to use a current as a music bed. Currents are only a small part of a rotation, so you'll be distracting the listener from the sound of the station and disrupting the format at the same time.

If you are producing a commercial, remember to use a good selection of female voices. Your audience is likely to be heavily female, a factor we sometimes forget. Light ACs are heavy on women aged 18 to 34, and very soft ACs run heavy on women 30 to 50. The commercial voice is often the representative of the listener, so be sure your audience has enough spokespersons.

[5] Quoted by Sean Ross, "Soft AC Reconsiders Its Sources." *Billboard,* February 8, 1992.

Production for Album-Oriented Rock

Album-oriented rock (AOR) programmers want solid TSL in their numbers. AOR needs a loyal core audience.

ON-AIR AOR PRODUCTION Long sweeps are the rule. The basic strategy of AOR is to present long-form music, so frequent stops are audience killers. Although strong personalities are important, a growing body of research shows that AOR listeners are becoming bored by incessant chitchat among the on-air crew, so many stations are keeping intramural banter to a minimum.[6]

OFF-AIR AOR PRODUCTION This does not mean, though, that personalities don't count. Indeed, AOR still heavily depends on the intimate jock who projects a "lifestyle." Remember that AOR spot production must have that intimate feel, usually produced by a high-quality mic and a close-in announcer. Appropriate music beds are OK, and some hard-hitting, compressed audio (for example, "Monster trucks at . . .") is often appropriate. But don't let your spots veer too close to Top 40.

Production for Country

Time spent listening is probably the most important consideration for country. Country's strength is strong TSL; in practical terms, that means that avoiding tune-out is especially important.

ON-AIR COUNTRY PRODUCTION Country stations have a peculiar problem: an embarrassment of riches. Country is making a comeback among young listeners, and dozens of hot young country singers are topping the charts.

So what's the problem? Country fans are very loyal to the old standards, and you risk damaging your TSL and audience base if you alienate them with new music. Many stations are finding that one solution to this problem is to insert a new cut between a gold and a recurrent. This "eases in" the new music without turning off the audience that expects to hear the old standbys.[7]

OFF-AIR COUNTRY PRODUCTION Again, currents are not the best choice for music bed use. You're probably better off using the beds supplied by the

[6] Ibid.

[7] See "Programming: How to Get What Country's Got." *Radio Only,* December 1991, p. 24.

music production houses. Those libraries come with music beds slanted toward the full range of country, from hot to highly traditional.

And don't always feel compelled to use a music bed. Country does not demand wall-to-wall music (as does Top 40). A good, intimate spot read by one of your station personalities can be highly effective.

"Intimate" nicely describes good country because probably nowhere in radio is personality-listener contact more important. Country production directors go to great lengths to make their on-air staff accessible to the public, so take advantage of that known quantity.

Production for Easy Listening

Easy listening has undergone quite a change in recent years, and production techniques often reflect the growing tendency toward a personalized, more modern format.

ON-AIR EASY LISTENING PRODUCTION Many EZs resemble a computer control room more than a typical radio station. Often, the station is automated with preprogrammed CD players or a computer workstation.

But EZ programmers learned many years ago that listeners don't like the canned effect. Some stations have a live announcer during morning drive and sometimes afternoon drive while automating or voice tracking the rest of the day.

Your goal as programmer or producer is to make the program seem as live as possible. If the station is automated, get a familiar voice to do inserts during the day.

If you are taking a satellite feed, try to have an identifiable local voice inserted as often as possible. Further, you may find the supplier willing to record and feed local announcements and weather forecasts. If your supplier is so inclined, you can fax local announcements to studio headquarters and have them fed back to you off-air for local insertion. Incidentally, EZ formats are no longer limited to instrumental music. Soft vocals are fine, but stay away from the clichés.

OFF-AIR EASY LISTENING PRODUCTION Music beds are perfectly acceptable if they fit the format, but beds are not a necessity. What is essential is the careful matching of your on-air voice to the format. Remember your demographic: EZ listeners are heavily female, mainly over 30, mainly *well* over 30. A youthful-sounding voice won't work.

Production for News/Talk

News/talk depends heavily on frequent tune-in to build cume. Time spent listening is important, but news/talk programmers know that the listeners

who tune in and out are the backbone of their numbers. Fresh ideas and fresh presentation are vital for building listenership.

ON-AIR NEWS/TALK PRODUCTION We know the audience will be coming and going, so it's important that they be given the opportunity to do so without losing the flow of the program.

In talk segments, for example, it is wise not to let your conversations lap over the stop sets. A listener tuning in during a stop set will not be able to follow the flow after the set concludes, and as a result, the cume-building tune-in factor may be weakened.

Moreover, if you have a regular feature, make it easy to find. WCBS-AM in New York (which is all-news, not news/talk, but the example we cite holds for both formats) plugs its "News and Weather Together on the Eights." Not only does this help reinforce listener recall of the frequency (88 on the dial), it induces anyone stuck in traffic in New York to tune in at 8 minutes after, 18 after, 28 after, 38 after, and so on. Seduce those listeners into hanging on for 5 minutes, and you've got some very high cume numbers.

OFF-AIR NEWS/TALK PRODUCTION A music bed often detracts from the spots, so be judicious. Ideally, commercials and public-service announcements (PSAs) should sound like the news/talk product itself: punchy and authoritative. The program hosts, and sometimes the newspeople, if station policy permits it, are usually better choices to voice the spots than anonymous announcers.

If you do use music beds, remember that your audience is skewed toward older, more conservative listeners. Hard-rock beds are a no-no.

Production for Top 40/CHR

When you produce and program for Top 40, you're fighting turnover. In general, Top-40 advertisers want the best of both worlds: high gross impressions (reach) and a good many repeat listeners (frequency). Why? Because so many of the staple products advertised on Top 40 need to be distinguished from their competitors.

Soft drinks, for example, need an advertising strategy that has a relatively high frequency. Soft drinks are basically all the same product (you'd be hard-pressed to tell them apart blindfolded) that rely on audience perception for sales. Building an image requires that the message be repeated often enough for the image to sink in.

Top 40/CHR does not have a particularly affluent demographic, so CPM is low.

ON-AIR TOP-40/CHR PRODUCTION So how do you keep those numbers and keep them loyal? You've less flexibility in programming since Top 40/CHR has a limited playlist. In general, your goal is to keep the production

tight, keep on-air chatter to a minimum, and make sure your station has a distinct identity.

The "identity crisis" sometimes involves you in a direct maneuver to get listeners to remember your station. Liners—catch phrases read during the program, often over the intro to the music—are vital. Pounding home the liner helps reinforce your image and give listeners something to remember when they fill out their diaries.

"HOT HITS 100 . . . IT SIZZLES" is particularly useful if your call letters resemble the word *hot* and your frequency is near 100 MHz. Be careful, though, because if diary respondents make up their own call letters (if they think they're listening to WHOT when your station is really WHTS), you may start losing credit for diary entries.

And though Top 40/CHR does not allow great flexibility in playlists, that does not mean that you can't vary your rotation of power cuts—the cuts at the very top of the chart—and oldies. Many Top-40/CHR stations incorporate a good selection of oldies, especially in dayparts where there may be a good share of older listeners, such as afternoons.

OFF-AIR TOP-40/CHR PRODUCTION Hot music beds and heavy compression are a virtual must. In this format, a moment's departure from wall-to-wall music is often seen as a heavy tune-out factor.

The personalized approach does not work as well in Top 40/CHR as in other formats. Jocks are basically second-fiddles to the music, and the audience loyalty is generally to the music, not to the jock. So a no-music, personalized appeal from the jock will generally be less effective on this format than on a country or AC format.

Production for Urban/Churban/Rhythmic Top 40

Rhythm is the key to the urban format, and trendiness is essential.

ON-AIR URBAN/CHURBAN PRODUCTION Rap charts are volatile. What's in favor one week may drop off the charts like a stone the next, so the programmer or producer must keep a finger on the format's pulse.

Although one-song sets used to be the staple of urban programming, many station programmers and producers are finding that sweeps are effective in building audience and keeping audience past quarter-hours.

Incidentally, there's a trick to appearing more current than the competitors. A number of urbans, churbans, and Top 40/CHRs have discovered that frontselling—that is, announcing what's coming—new music helps reinforce their reputation as innovators. This involves moving new cuts to places where they can conveniently be front-sold, such as immediately after a stop set.[8]

[8] See "Programming: How to Bring It Back." *Radio Only,* November 1991, p. 22.

OFF-AIR URBAN/CHURBAN PRODUCTION Rhythmic music beds are important for commercial production though strong personality spots, some without music, are not out of the question. Urban formats lend themselves to strong on-air jocks better than Top 40/CHR does, so don't be afraid to inject a personal touch into commercial or PSA production. But don't go overboard because losing the beat often means losing the audience.

Putting a Format on Air

We will conclude this chapter with a discussion of how one becomes a programmer—putting all the pieces together and implementing a playlist and putting the format over the air.

If you are instructed to "program" your station, one of the first tasks is to construct the program clock and the playlist. The program clock is not always a physical entity hung up on the studio wall. It is often more of a theoretical structure into which program elements are inserted.

Remember the important, over-arching principle: The program clock is simply a structure that creates consistency through each "sound hour" and through each broadcast day.

The Format and the Sound Hour

Your goal is to make the station recognizable and to put the audience in a comfortable listening mode. Each part of the sound hour will have a purpose. For example, here is a typical sequence from an AC sound hour, detailing what happens and why:

- A short news segment and station ID at the top of the hour—give the audience news when they expect it and take care of the legal requirements for identifying the station
- Lively vocal—give the audience a boost back into the programming
- Oldie—provide a mellow "feel-good" memory
- Two commercials—pay the bills
- Bulleted (rising) hit—get the audience's attention again after the commercials; show them that the station is in step with the current music
- Lighter vocal—you can't be intense every minute; the audience needs a break
- Weather, commercial, and station promo—give the audience what they are interested in, pay the bills, and let them know they are happy listening to your station
- A "b-list" song, one fading from the charts—keep consistency in the playlist by letting the audience gradually taper off on the facing hits
- A top-ten hit—keep things lively and current

. . . And so it goes. The mechanics of this clock probably would not be apparent to the listener, but the effect will be.

Different formats will have different goals. In a dance format, the goal will be never to let the rhythm stop. In a nostalgia format, the goal may be · never to leap across decades and, oddly, never to use the word "nostalgia" to avoid reminding listeners how old they are.

Constructing the Playlist

How does a programmer decide what music to play? An important decision-making mechanism is to monitor industry publications to assess the popularity of certain cuts. *Billboard* and *Radio and Records* maintain very detailed charts of sales and airplay. A programmer also monitors local record store sales and, of course, other stations in the market.

The trickiest part of constructing the playlist is introducing new music. Audiences tend to tune out when they hear unfamiliar music, so it's incumbent on the programmer to make sure the new cuts will appeal to the "old" audience.

The following You're On! box contains several hints on rotating new music into the schedule.

Conclusion

Despite predictions of gloom and doom in the mid to late 1990s, radio is back on track and in many ways stronger than ever before. Revenues have been good although some trends show that listenership is fading somewhat.

As we begin this century we also see how traditional strengths of radio continue to boost the medium's appeal. The Internet and the Web and other evolving media have their appeal, but they still lack radio's consummate portability. However, there are new competitors on the horizon. It the next few years it will be interesting to see what effect satellite radio has on the local listenership.

It is radio's ability to be there while we do something else that makes it such a vital part of this age. We can listen at work or in the car or while jogging. And the producer will continue to mastermind this journey through time and space.

Summary

Finding and serving a specific audience is more important to radio now than probably at any time in history.

Radio ratings are generally taken in quarter-hour periods. Both duplicated and unduplicated audience is important to radio stations because stations need to reach large numbers of listeners, but the very nature of the

You're On!

ROTATING NEW MUSIC

As record companies keep sending new music to the radio station, it's hard to stay on top of things and keep the playlist up to date. Then it's hard to make sure that the DJs are actually playing the new stuff that comes in. Here are some guidelines in making your programming as interesting as possible by adding new music into rotation and keeping an even flow for what is played.

What to Do with New Music

Every week a college radio station gets flooded with mail, consisting mostly of CDs . . . ones that usually come from artists and bands that have popped out of nowhere. Assuming your station is diverse, wide-open and "alternative-based," playing as much new stuff as possible should not be much of a problem. Your audience expects to hear just about anything, and will normally want your playlist to stretch out and become as interesting as it can. Anyone who wants "the usual" will just go elsewhere . . . Let them do so.

How to Sample

Listen to the album, single, etc., and read any biographical information about the artist/band that has been sent to you by the record company. (If none was sent, contact the record company and ask for some.) Pick out the most appealing songs and write them down, with reasons why. Recommend how heavily the band should be played. Make note of songs that may be offensive to the listening audience and should not be played. Make sure that every album is labeled for its proper format. (You could attach to each CD an index card that has room for all this information for DJs to write in.)

Forming Your "Add Pool"

Meet with everyone who samples the music. Put all the CDs in the "add pool," which would be the "new music playlist" for the next week . . . from which the DJs will select at least 4 or 5 songs to play in a given one-hour period. Include information on the artists for the DJs to read, especially regarding availability of CDs on independent labels, etc. This way, bands can be introduced, new music gets played, and the listening audience is impressed.

Continues

You're On! Continued

Organizing New Music

CDs in your add pool should be organized in a manner so that DJs can easily find them (by either a numbering system or in alphabetical order, for example) and the information about them, and so on. Separate the music in current rotation from the normal music library so people can access the new music quickly.

Keep the readable information about the artists/music together and categorized, preferably in a filing cabinet, so that it can all be readily accessible.

Promoting New Music Within the Station

Before the audience can hear a new song, the DJ must decide to play it. And the only way a DJ will play something new is if s/he is aware that it exists and is worth playing. Therefore, you should have a way to introduce new music to your staff, and one of the best ways is to have a "listening session." Get everyone together, buy some food and go through each new album that was sampled, allowing for each DJ to get a few ideas of what bands s/he will introduce when that next show comes around.

Promoting New Music over the Air

As mentioned above, each DJ should play new music on each show and include information about the artists. After the music is introduced, DJs should ask for audience response about the music. Seek out what they like best. Try to sort out the most unique and most requested music (gathered from logs kept by DJs), and put those selections in the next set of heavy rotation. The newer, more interesting, different, and appealing the music is, the more it should be played. What is already popular otherwise and what has been played heavily for a long time on your station should be stressed less to make way for the good new stuff. Most of all . . . if it's good, play it!

Other Options

Create a "New Music" Program

Every week, a show to highlight brand new music is a good way to introduce the stuff in your "add pool" to the listening audience and get feedback about the music. Plan each show ahead of time, and be prepared to give a good introduction to each song. Ask listeners for their

Continues

You're On! Continued

thoughts on the music. The song with the best response could be your featured song of the week. If there are some tunes that you are "not sure of," or if your sampling leaves you with a pile of "weird and question-able" stuff, have a "hodge-podge" hour where just about anything can happen. Be creative.

Interviewing Bands

Bringing bands into the studio to play and discuss their music over the air is a fun thing to do, and the audience eats it up. Find out about local bands through clubs, local indie record labels and independent record stores. Live interviews can help the bands, promote their gigs and in-crease your station's audience. This is also a way to get your station in-volved with local clubs to hold "WXXX/KXXX nights" . . . a perfect way to show the community that underground music lives and that your sta-tion is there to support it.

Communicate

Communication within the station is important for the promotion of new music. Stay in contact with DJs to find out what is most liked among the new stuff, and have a system for DJs to tell each other what they like. (A small marking board of some sort is useful.) After tallying up the most played songs for a given week, meet with your DJs if some bands are getting too much or too little airplay.

Tell Record Companies What You're Playing

When you contact the labels let them know what new albums they're promoting are getting the most support on your station. This way, they will send you more music to play, and maybe even supply some promo-tional giveaways if you ask nicely. Report to various college music-oriented trades each week so that all the distributors will take note of what your station is playing. Some labels that do not have your station on their mailing lists may make an addition if they know who you are.

Let the Public Know the Scoop

Make promos for on-air use, print and distribute program guides, adver-tise in campus and local papers and magazines, and invent different ways to promote your station as a "new music" station.

Andy DiGiovanni. Reprinted from the 1993 Radio Station Handbook.

medium makes it important that they reach each listener a number of times with a given advertisement. Arbitron, a company that uses listener diaries to measure audience behavior, undertakes most radio rating.

The major methods of calculating advertising efficiency are cost per thousand, cost per point, and optimum effective scheduling.

There are many types of formats. One particularly useful categorization defines them as adult contemporary, news/talk, country, Top 40/CHR, album-oriented rock (AOR), urban, oldies, Spanish, classic rock, adult standards, easy listening, adult alternative, religious, classical, modern rock, and other formats.

A major factor in radio production is avoiding tune-out. This is done by avoiding dead spots, steering clear of jarring transitions, and essentially giving the listeners the music and talk they want. It is particularly important, because of the way radio ratings are taken, to keep listeners tuned in through the quarter-hours.

Even though radio has had some tough times recently, the medium is recovering, and the natural shaking-out process is, some believe, restoring the medium's basic mission: to give listeners what they want.

Exercises

1. We've purposely avoided showing an array of program clocks because they tend to provide a superficial and not entirely useful conceptualization of what an individual station actually does. But here's one sample program clock. (From Stanley R. Alten, *Audio in Media*, Third Edition. Belmont, Calif.: Wadsworth Publishing Company, 1991. Courtesy of Wadsworth Publishing Company.)

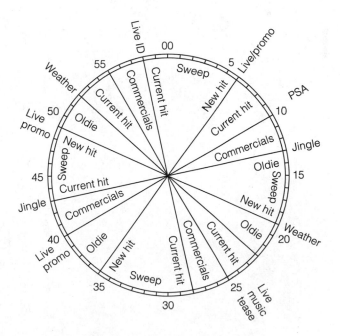

Use it for reference when you construct your own station clock by monitoring a particular station for one hour. Use the vocabulary we've defined in this chapter (current, recurrent, and so forth) along with the obvious descriptors (news, commercial stop set).

This is an ideal class project since you can compare the various formats and, perhaps, individuals' different perceptions of the same station during the same hour. It might also be useful to clock a noncommercial station, such as your local National Public Radio affiliate. Your instructor will assign stations to class members.

2. Write and produce a 30-second commercial for a product of your choice. Produce one commercial three ways: for a soft AC, a Top 40, and a country station.

Don't assume that your choice of background music alone will suffice, and don't burlesque the announcing. (Sounding like a stereotypical character from "The Beverly Hillbillies" won't make for a good country commercial.) You are free, and encouraged, to change the copy itself for the three commercials.

APPENDIX A

A Play by Richard Wilson

*P*roduction of this play can serve as a good exercise in understanding the construction and flow of an outstanding drama. It probably will—as intended—pose a great technical challenge. In fact, we considered less difficult and less sophisticated plays for inclusion in this appendix, but decided that the challenge presented here would provide an excellent learning experience. It also graphically demonstrates what we mentioned in Chapter 11 about the need to maintain a fabric of believability.

The late Richard Wilson was a prize-winning author of fiction and nonfiction. He won the Nebula award of the Science Fiction Writers of America for his novelette, *Mother to the World.* Wilson wrote more than 100 published science fiction stories and three novels. He also wrote a history book and was a reporter and editor in Chicago, Washington, New York, and London.*

And now, Another Time. . . .

Sound: Keys in door, door opens, two men walk into room.

Neighbor	(Don) Come up to my place and have a nightcap, Harry. It's still early.
Harry	No thanks. I've had too much already.
Neighbor	You only have a birthday once a year.
Harry	Is that all? Lately they seem to come along more often.

Neighbor None of that, now. Fifty-three is young. Besides, you don't look a day over 52. This is a nice apartment. You've lived here a long time, haven't you?

Harry About 30 years. Me and my memories.

Neighbor Of Helen? Sorry, but people in the building do talk.

Harry It's all right. Helen died here. We were going to be married. Meanwhile, we were living here. The Ninth Avenue El was still up then. The trains rattled right outside these windows. What a racket they made! But we didn't mind. We kept the shades down and felt all the more secluded.

Neighbor I didn't mean to stir up painful memories.

Harry It's never painful to think of Helen. I miss the El, though. They started tearing it down the day of her funeral.

Sound: Neighbor shuffles nervously.

Neighbor Look, I better go.

Harry It's all right. I live in the past a lot, except when somebody snaps me out of it, like you. Thanks for the pub crawl, Don. It's been years since somebody dragged me out.

Neighbor Don't mention it. I've got to go.

Harry Want some coffee or anything? Want to sit with me and watch TV?

Neighbor No thanks. Good night, Harry. Happy birthday.

Harry Good night.

Sound: Door opens, neighbor exits.

Sound: Harry pulls up chair, snaps on television, twists TV channel dial. Through sound of television speaker, commercials come on. They are chanted and build to an offensive crescendo.

Voices Better! More! Bigger! Newer!

Best! Most! Biggest! Newest!

Pain! Pain! Pain!

Relief! Get relief! Get instant relief!

Cramps? Irregularity? Aching back? Hurt? Hurt?

Eat! Smoke! Drink! Diet! Lose weight! Exercise!

Go! Come! RUN! ASK YOUR DOCTOR! ASK YOUR GROCER!!

ASK YOUR. . . .

Sound: TV clicked off. Footsteps as Harry walks across room. Click of radio being turned on. . . . Characteristic sound of stations sliding past as dial is twisted.

Voice (*calm and friendly as Harry moves the dial*): We have brought you the Atwater Kent concert. . . .

New Voice (*as dial is turned*): This is station WEAF signing off. . . .

New Voice (*as dial is turned*): And so it's good night again from those sweethearts of the air, May Singhi Breen and Peter de Rose. . . .

New Voice (*as dial is turned*): This has been Raymond Knight, the Voice of the Diaphragm, enunciating.

New Voice (*as dial is turned*): Tune in again tomorrow to WJZ for Billy Jones and Ernie Hare, the Happiness Boys.

Sound: Harry clicks off radio.

Harry (*not believing it*): WEAF. WJZ. I'm back in the past . . . when I was happy . . . young. When life was uncomplicated.

(*Laughs*). I am *happy*. I am *young*. (*He begins to believe it.*) It's true. Why not? As long as I want it to be it's true, here in this room, right now. As long as I don't look in the mirror—as long as I don't switch on the TV.

And I'm 25! Helen's alive! But where is she? She's gone down to the corner, I guess. She'll be back in a minute with our midnight milk and oatmeal cookies. . . . Maybe a couple of charlotte russes.

Sound: In distance, the rumble of the el. It grows louder, louder, and closer.

Harry The El . . . but if I look, it won't be there.

Radio Voice *Yes it will.*

Harry Who said that? The radio? You . . . but . . . I want it to be, but it isn't.

Radio Voice *Yes it is.*

Harry I have to meet it halfway. Have faith. I have to go out. Then it will be there. *I know. I know.*

Sound: The vague rumbling of an el platform.

Harry This is the El platform. . . . And the gum machine . . . and the mirror—I'm *young*. (*His voice is reflecting change in age.*)

April	Of course you are. Handsome, too.
Harry	Who are you? Are you Helen?
April	Helen? No. Have you got a buffalo nickel? To get me through the turnstile?
Harry	Buffalo nickel?
April	Jefferson won't do. He hasn't been minted yet. *You* know that.
Harry	I'm not sure I know what you mean.
April	Yes you do. Have you got two buffalo nickels for a Roosevelt dime?

Sound: Clink of coins as they exchange.

Harry	How could you know about Roosevelt dimes? He wasn't—isn't even president yet. FDR, I mean. Wouldn't he still be governor of New York?
April	I'm not good at current events, but I think it's later than that. Just a minute, let me get through the turnstile.

Sound: Coin drops at turnstile and turnstile turns. April's footsteps.

Harry	You're not from here either—are you? Your clothes look right, though. How did you get here? (*Laughs.*) I don't even know what year it is. It was too dark to see the license plates and I couldn't find a newsstand—to buy a paper.
April	You don't need a paper.
Harry	I seem to be about your age. How old are you?
April	Twenty-four.
Harry	And I'm twenty-five. Let's see—I was born (*he figures to himself*)—and if I'm 25 this is 1936. Is that right?
April	It doesn't matter. Everything is relative in the duoverse.
Harry	In the what?
April	Never mind. You don't have to understand.
Harry	I really don't want to—to push it too far. It's too fragile.
April	It's not really. But I can understand your feeling.
Harry	Can you? I was listening to the radio—it's an old Atwater Kent—because I was mad at the television. . . . You know what television is?
April	Yes, of course.

Harry That's right. You know about Roosevelt dimes and Jefferson nickels. Maybe you know about Helen. She died, but if this is. . . .

April I'm sorry. You won't find Helen. You can reverse time but you can't cancel death.

Harry I didn't *really* think you could.

April You said you were listening to the radio—steeping yourself in the past.

Harry I didn't say that.

April That's the way it happens.

Harry It happened to you, too?

April Not exactly *happened*. I planned it.

Harry Well, I certainly didn't—what's your name?

April April.

Harry (*formally*): Hello, April. I'm Harry. Where are you going, April?

April I'll be going with you . . . while you do your sightseeing in 1936. Then I'll go home with you.

Harry (*surprised and embarrassed*): Oh? Home with me?

April It'll be all right.

Harry (*not so sure*): Of course. But—home where the TV set is? You'd be—wouldn't you be—old—?

April Don't worry about anything, Harry. Enjoy yourself. That's what you came back to do, isn't it? Aren't you happier?

Harry (*after a pause*): Yes, I am.

April Where do you want to go?

Harry First? First to the Staten Island Ferry. Because—because it was there—

April You don't have to explain. Not in the duoverse.

Sound: Train rattles into station. . . . Sound dissolves to wind, lapping waves, harbor sounds such as foghorns in distance.

April I'm glad you had two buffalo nickels for the ferry.

Harry I'm really here? Literally?

April What do you think?

Harry I don't know. Here—now. It's too—could I meet myself? If I looked, could I find another Harry? The one who's living through 1936 the first time?

April No. You're the only Harry in this 1936.

Harry This 1936? I—is that what you mean by—what do you call it—the duoverse? There are more than one?

April Yes, but you mustn't think I understand everything I have a name for. I do know you couldn't be here—and neither could I—unless there was something controlling the paradoxes. That's the duoverse, they tell me—a twin universe to keep time travelers from running into themselves.

Harry (*troubled*): Who tells you that? No . . . don't tell me. I don't need to know. I'm just so glad I found you.

April I'm glad I found you. I'd been looking for so long.

Sound: Foghorn.

Harry (*almost as a prayer*): Let's not lose what we've found. Let's keep it forever.

April And thou beside me—under the branches of the time-tree . . . ? Something like that? Oh, Harry!

Sound: They embrace and kiss.

April (*with infinite regret*): It's impossible, Harry . . . I'm going the other way.

Sound: Harry and April walking to door of Harry's apartment. Sound of el in background.

Door opens. Sound of Harry and April walking in.

April We haven't done much sightseeing in your beloved past. We haven't seen the Hippodrome—the streetcars on Broadway—

Harry No, don't turn on the lights yet. You're all the past I want.

 (*Concerned.*) Is it all right for you to be here?

April It's the way it has to be. There's no other.

Harry But here I'm old—and you—?

April Not till we turn on the TV, Harry. Not till then. I'll turn on the lights now.

Sound: Light switch.

Harry I'm still young. I'm—sit down, please. What can I get you?

April Coffee?

Harry I just have to heat it up. It's already been percolated once.

Sound: Walks across room.

April (*calls to him*): I might have known you'd have real coffee. No millions of tiny flavor buds for you, eh, Old Timer?

Harry (*calls to her*): I don't have the room.

Sound: Harry walks back into room, sound of cups clinking and Harry and April drinking.

Harry starts to say something, but el train drowns him out. Finally:

April (puts down cup; sound of her chair scraping back as she stands): Thank you for the coffee—and everything.

Harry (*sound of him jumping up*): Don't go! Please!

April I must. It's a long way. Turn on the TV, please.

Harry No—I won't! I won't make you old!

April You don't understand.

Harry Please! It's too early. There's nothing on. Wait. . . .

April I *have* waited, Harry. You don't know how long.

Sound of el. Sound of April moving past and turning on TV. Sound of TV voice. As TV voice comes on, sound of el dies out.

TV Voice . . . And now, kiddies, it's time for your Uncle Jack to tell you about a wonderful surprise waiting for you and your mommies in the supermarket. . . .

Sound: TV clicks off.

Harry (*the age once again in his voice*): You're the same! I'm old—but you're twenty-four! Even though we're back in the present!

April (*sadly*): I told you we were going different ways. Your way was back. Mine was—is—forward. Oh, my dear, I'm sorry. I had to use you. I had no choice.

Harry You came from the past—but in 1936—you weren't even born!

April I wish—I'm so afraid this will hurt you—but I'm not from your past, or even your present . . . I'm from the future.

Harry The future—then I'm just—a stop on your journey . . . where you're going . . . I'm dead!

April No, Harry. It's all—relative. It's what you are *now* that matters. Not what will be, or what was.

Harry I know I hoped for too much. I wanted my youth and I wanted you—and I can't have both. I can't have either.

April (*distressed at his unhappiness*): It was to have been so simple, so scientific. I was to go back—they have machines—and make notes. Saturate myself in the atmosphere of the past. Oh, it doesn't matter! You're what counts. I've hurt you and all I wanted was to give you what happiness I could, in passing—

Harry It doesn't matter. I'm just a phantom in your life—in your real present. Where you belong, I'm only a corpse in the graveyard.

Sound: April starts to cry.

Harry Let me finish. Be realistic. I'm just a complicating factor who got in your way. You mustn't compare yourself with—with someone who doesn't exist in your own time, but think of me occasionally . . . up there in twenty-hundred and—whatever it is.

April Harry, stop it! Don't kill yourself in your own lifetime . . . I'll stay with you, my dear. I will! I can't do this to you.

Harry No, I won't let you. Look, I'm a sentimental man who's been privileged to know his youth again. Knowing that youth, I know yours. I won't let you sacrifice yourself—for a phantom who died before you were born.

Sound: April sobs.

Harry Come on, child. Wash your face. Off with that lipstick. Cupid's bows are passé. (*Indulgently, fatherly*) Scoot! You've got to fix yourself up and find somebody who can make change for a coin that hasn't been minted yet. . . . Forgive my vanity, but I hope this time it's a woman.

Sound: April walks to bathroom, distant sound of water running. Sound of walking back into room.

Harry When you go, don't say goodbye.

April All right.

Harry I hate long goodbyes. Leave as if—as if you were going down to the corner—to get some—some milk and oatmeal cookies.

April (*tries to pretend*): All right. I guess I'm ready. Is there—anything else you want while I'm out?

Harry Maybe a charlotte russe?

April (*the pretense fails*): Oh Harry, I don't even know what that is!

Harry Never mind.

Sound: Door opening, April walks out. There is silence. Suddenly, the door bursts open. April's footsteps as she runs in.

Harry You didn't go!

April (panting, barely able to speak): Y-yes.

Harry You couldn't have, and been back so soon.

April (*panting*): I could have come back to yesterday, if I'd wanted, traveling in time. At least there *is* a yesterday.

Harry Of course there's a yesterday. That's where we—you mean where you went back to—ahead to—whatever you say—it's not—it's been—?

April There's no tomorrow.

Harry What do you mean?

April Where I was going I'd have been a corpse—without even a graveyard. I mean when I got close to where I wanted to go I realized it wasn't even there any more. Something wiped it out—or it finally blew itself up—I don't know what. I just know it's gone.

Harry . . . and so you came back to me.

April That's not very flattering, is it? I'm sorry.

Harry You're here. The details don't matter.

April You're the one I turned to.

Harry That matters. Very much. You're welcome. But the one you've turned to is an old man.

April Hush. You're not old. You've lived in a suspended life. I'm the one who's aged, dashing back and forth between the centuries.

Harry You lie—adorably. But stay with me. At least until you find your bearings in this crazy time.

April I *want* to stay with you. You're the same person I met on the El platform. Do you think you've changed—inside?

Harry (*lightly*): Inside, I always think of myself as 19—much too young for a mature woman like you.

April Oh, Harry, I *can* love you. I will. Just give me a little time.

Harry You have all the time I have left.

April . . . I want to stay with you forever, Harry. And if we only listen to the radio all our remaining years, that'll be all right, as long as we're together. And one night, Harry, who knows— we'll turn on the old Atwater Kent—and hear the Street Singer or the Happiness Boys—and then the program will be drowned out by the Ninth Avenue El—I can almost hear it—rattling its way through that magic time when you're twenty-five and I'm twenty-four.

Sound: The el is heard. Its sound swells and then fades to silence.

A Capsule History of Radio: Past Meets Future for the Modern Producer and Programmer

*T*hroughout this text, we have tried, where appropriate, to demonstrate how much of radio's modern practice is tied to the past. But because this is a radio production text, the amount of space in the main chapters that can be devoted to history was limited.

Here in the appendix we can take a more expanded view of radio's development. The point is to show how radio as it exists today developed because of cultural changes, advances in technology, and changing demographics.

And although we cannot really predict the future, certain elements of history do repeat themselves, and perhaps we can discover some keys to the future of radio production and programming by examining its past.

To radio's early listeners, invisible signals flashing through thin air seemed to be nothing short of magic—a type of wizardry that not only moved messages with lightning speed but also eliminated geographic barriers. Distance no longer imposed geographic limits on one's awareness of human events. Information could pass through space, penetrating walls and mountains. Any form of human expression that could be communicated through voice or music could reach the most distant farmhouse as well as a Manhattan penthouse. A simple box could turn one's home into a theater, a concert hall, or a classroom. The romance of the idea is powerful and undeniable.

And it's a short story, beginning little more than a hundred years ago.

The Beginnings of the Magic Medium

Radio traces its origins to the theoretical physics of James Clerk Maxwell. Maxwell's *A Treatise on Electricity and Magnetism*, published in 1873,

postulated the existence of electromagnetic waves. Using mathematical formulae, Maxwell determined that an invisible energy existed in the universe, an energy that behaves like visible light.

About a decade later a German physicist named Heinrich Hertz conducted a laboratory demonstration that confirmed Maxwell's theory. Hertz's demonstration of the existence of electromagnetic phenomena, however, provided no clue to any practical application of this form of energy. In fact, it was doubted at the time that these waves would be of any practical benefit.

About a hundred years ago, a young Italian tinkerer named Guglielmo Marconi was the catalyst for translating these academic discoveries into a means of transmitting information. "Hertzian" waves fascinated the young Marconi, who outraced other scientists attempting to manipulate these waves to send telegraphic messages.

Marconi used an on-and-off method to transmit the code developed by Samuel Morse, and within a couple of years developed a method to transmit signals powerful enough to cross great distances, including vast expanses of water. The development of ship-to-shore "wireless," as it was called, promised to be a considerable advantage in an age of growing inter-oceanic travel and commerce.

Marconi brought his discoveries to the Italian government, which expressed no interest. Marconi's mother, who earned a reputation as a wily and persistent businesswoman, brought Marconi to England instead. The British government, in contrast, was entranced by a technology that offered a rapid communication system to its far-flung empire.

Marconi's product showed every promise of becoming a practical success, and a company was formed with Marconi as one of six directors and a major stockholder. After patents and licenses were obtained, radio became a financial success as well.

Marconi repeated this success in the United States, where the Navy had a strong interest in a technology that promised tremendous strategic advantage. Marconi formed an American company, and radiotelegraphy, as the industry was called, became an American commercial venture that would soon form the basis of an entire industry.

Radio Finds a Voice

Other inventors and experimenters were intrigued by radio but disenchanted with dots and dashes. The challenge was to discover a way to manipulate radio waves so that sound could travel through space the same way it travels through wires. An inventor named Reginald Fessenden believed that the physical nature of the on-and-off interrupted wave—which worked fine for Morse code— would prevent the interrupted wave from ever transmitting sound. Fessenden teamed up at General Electric with F. W. Alexanderson, and together they developed a device called an alternator, which could transmit a continuous wave.

Fessenden put the alternator through a test-drive on Christmas Eve at Brant Rock, Massachusetts. He played his violin, read from the Bible, wished the audience a Merry Christmas, and told them that he would broadcast again on New Year's Eve. No doubt this came as quite a shock to the small audience of shipboard wireless operators—who previously had heard only the staccato of dots and dashes.

In the early years of the twentieth century, many experimenters moved radio forward. One of them, Charles D. Herrold, who operated a college of engineering in San Jose, California, transmitted regular programs and provided listeners with a written schedule. Herrold's operation ended when World War I began, but after the war others took it over. Today, KCBS Radio in San Francisco traces its lineage to Herrold's small, low-power transmitting facility.

That low power, incidentally, remained a serious problem for early radio stations wanting to transmit voice and music. An interrupted wave carrying Morse code could travel many miles, but waves carrying sound produced a weak signal. An experimenter named Lee de Forest (see Figure B.1) worked to improve the capability of the new medium by amplifying the signals. His invention was called an "audion tube," and in theory it was really quite simple: The signal was transmitted across an electronic grid, and a more powerful signal was sent through that grid, picking up the imprint of the first signal but greatly amplifying it. The device operated most efficiently in a vacuum; hence it was later called the vacuum tube.

De Forest also provided early radio programming to a scattered group of experimenters and amateurs. Early listeners heard a wide variety of live musical performances, lectures, recordings, and reports of events. The hum and babble over the airwaves was fascinating, in part, because it was so novel—much the same as early Internet transmissions. It was an exciting time, with wireless companies sending out dots and dashes and legions of amateurs "playing radio," operating out of their bedrooms or barns or chicken coops. The government began to issue licenses for radio stations in a vain attempt to sort out some of the confusion developing, because those who "played radio" often arbitrarily chose a frequency and did not give much thought to the problem of interference.

The days of playing radio would come to an abrupt end. With the advent of World War I, the Navy and Army shut down the amateur stations and took over the commercial wireless operations. Because of the expertise they had developed, amateurs were in demand by the armed services.

Radio After World War I

During the First World War, technology advanced rapidly, and after the war's end several American firms resumed exploring the commercial possibilities of radio. Several major companies were involved in one aspect or another of

Figure B.1 Radio pioneer Lee de Forest invented the audion tube.

© Bettmann-UPS/CORBIS

wireless technology—among them were General Electric, AT&T, Westinghouse and, of course, American Marconi.

During the war, numerous contentious patent disputes were put aside as the firms concentrated on filling military orders. Following the armistice, American Marconi found itself to be an unwanted player in the communications sweepstakes. America was turning isolationist, and the British owned American Marconi. Communications technology was considered too important to be in foreign hands. So a deal was made, and a new American corporation was created.

Shareholders of Marconi were given a piece of the action. The articles of incorporation stipulated that no more than twenty percent of the stock could be held by foreigners and that only U.S. citizens could be officers or directors. GE, AT&T, Western Electric and Westinghouse picked up large blocks of the stock. The name of this new corporate behemoth, established in October of 1919, was the Radio Corporation of America (RCA). Many of the former American Marconi employees moved over to RCA; David Sarnoff among them. At RCA, Sarnoff picked up the theme he had begun at Marconi, trying to generate interest in his "radio music box" idea. As before, there were no takers. But it wouldn't be long before RCA realized it was missing the boat.

Radio Carries a Tune

Why did it take so long for the radio industry to catch on to the seemingly obvious potential of radio? At the heart of the problem was a classic chicken-and-egg scenario: listeners had no easy way to pick up the signal short of building their own sets. This meant very few radio receivers were in existence. Companies were reluctant to invest in manufacturing receivers, though, because there wasn't much actual radio for listeners to pick up. Schedules were still catch-as-catch can, and programming was decidedly uneven.

And from the standpoint of the companies that could provide radio programming, there really was no point in developing a regular, high-quality schedule until there was a large number of listeners and a way to make money off them.

The Westinghouse Company cracked this particular egg. Westinghouse, located in Pittsburgh, Pennsylvania, had carved out a strong role in communications and electric power. During World War I, the firm had acquired many government contracts for radio and related communications. But when the war ended, Westinghouse was at a competitive disadvantage because RCA and the American Telegraph and Telephone Company (ATT) dominated the market. RCA and ATT controlled the lion's share of the radio-related patents.

The man who helped Westinghouse crack that barrier was Frank Conrad (Figure B.2). Conrad had only a seventh grade education, but he learned on the job and became one of Westinghouse's most valued employees. His bosses told him, however, that amateur radio work was on his own time. Using his call letters, 8XK, he talked from his garage to other hobbyists, who often commended him on the technical quality of his transmissions. As interest grew, Conrad began to present programming for a short time every Saturday night, using records from a local music store, which received free mentions. He also carried some live saxophone and piano recitals. Keep in mind that radio was still a novelty, mainly for experimenters and hobbyists. But with a big boost from Frank Conrad, radio was about to take the country by storm.

A local Pittsburgh department store ran a newspaper ad mentioning Conrad's programs, noting that the transmissions were picked up by a "wireless set" operating at the store. The ad pointed out that similar sets were for sale at the store for ten dollars. Conrad's boss, Westinghouse vice-president Harry Davis, saw the ad and had an idea: If enough interesting programs could be provided, radio could move beyond the stage of being a hobby for technically oriented people, and become a medium for everyone to enjoy. In short, radio could become a mass consumer product and Westinghouse could make the radios . . . and the profits.

Davis called Conrad into his office and outlined a plan. Conrad would build a new transmitter to be located at the Westinghouse plant. A regular (though limited) schedule of programming would be instituted and publicized in advance. Davis figured that, with some regularity of programming,

Figure B.2 Westinghouse engineer Frank Conrad built an empire from his garage and licensed the first radio station.

© Bettmann-UPS/CORBIS

people would want to buy radios. (Hindsight tells us he was absolutely right.) Davis took his idea a step further with an eye toward maximum publicity. He wanted Conrad and his coworkers to have the new transmitter up and running in time for the approaching presidential election.

Time was short, but Conrad said it could be done. In the last week of October, the U.S. Commerce Department assigned the call letters KDKA to the Westinghouse station. The *Pittsburgh Post* agreed to telephone wire service results to the station and, on November 2, 1920, KDKA broadcast the election returns that put Warren Harding in office as the twenty-ninth President of the United States.

Radio After KDKA: The Coming Chaos

Across the country, people were talking about this phenomenon called radio. Companies and entrepreneurs were opening up radio stations. Manufacturers

were turning out radios as fast as they could. Secretary of Commerce, Herbert Hoover, described it as "wireless fever" and called it "one of the most astounding things that [has] come under my observation of American life."

In those exciting and chaotic early years, radio programming was a hodgepodge proposition. Station operators relied in large measure on free "talent." Musical groups, soloists, and lecturers were happy to go on the air for the exposure radio provided. Other commercial stations sprang up quickly, but the term *commercial station* meant only that they were licensed by the U.S. Department of Commerce. Advertising as yet played no role in radio. But for the time being, many newspapers, colleges and universities, and religious organizations developed new stations, even though those stations did not produce revenue. (Again, it is impossible to keep from making a comparison to the companies that now sponsor Web sites for publicity and good will, with no immediate financial benefit.)

In fact, the situation became something of a stalemate. Station owners were not about to pay for programming when they didn't have to. Besides, there was no firm notion on how, exactly, stations should support themselves. The idea that advertisers could pay for commercial announcements was not widely accepted. Many thought such advertising would not only be crass, but would also discourage listeners from tuning in to stations. Political leaders and many radio broadcasters were adamantly opposed to "selling out" to sponsors. Hucksterism was to be avoided.

But the idea that stations existed to sell radios was on the wane. As listenership increased, so did the demand for improved technical quality. Station owners felt the need to purchase better-quality professional equipment instead of relying on jerry-built studios and transmitters. This was going to cost money. What's more, the better performers were becoming less enthusiastic about appearing on the radio for nothing. And the listening public was becoming more sophisticated and demanding about the kind of programming it expected.

Something had to happen. There was talk of following the British system of financing broadcasting, charging set owners annual user fees. That concept didn't fly in the United States. Another failed idea involved radio stations making direct pitches, asking listeners to send in money to support the station. That tactic didn't generate much interest, though public radio and TV stations use it even today.

Commercialization of the airwaves was about to begin. It would start fairly unobtrusively, then gain momentum and boldness. It would turn radio into a "cash cow" for many owners. It would also allow radio programmers to hire the best talent available . . . from symphony orchestras to first-rate Hollywood and Broadway stars.

AT&T Develops Toll Broadcasting

The first inkling of radio's new commercial potential came in 1922, and the company behind it was AT&T. The concept was radical: AT&T—the telephone

company—would provide no programs, only facilities. In the same way that the company provided customers with telephones—and a telephone *network* to plug it into—so broadcast facilities would be made available to paying customers for whatever they wished to put over the air. AT&T's profits would come from the charges made for this service, called *toll broadcasting.* Under AT&T's concept, programming was to be supplied by paying customers. If you wanted to perform or lecture on the air you could do so for about $50 for 15 minutes of airtime. The company originated this concept at a station in New York City with the call letters WEAF.

But AT&T discovered a flaw in the concept—the same flaw marring the entire radio industry. If there was no attractive programming, there was no audience.

AT&T decided that it needed to supply a certain amount of programming to prime the pump, so to speak. And soon, WEAF began to attract paying customers. An area real estate company decided to give toll broadcasting a try. Its message stressed the appeal of country living and the firm, with apartments for rent in the "country," was happy with the response it received. As the months progressed, other companies paid for the privilege of getting their messages out to the public by radio. Commercial broadcasting was on its way to becoming the means of support for the great majority of radio stations in the United States.

Exit AT&T

Ironically, just as radio's commercial and very profitable future was taking shape, AT&T got out of the radio business, selling pioneer station WEAF to RCA for one million dollars.

The phone company's decision came after a good deal of wrangling among the principal players in the fledgling industry, specifically those companies that had bought stock in RCA and reached agreements on cross-licensing of patents. AT&T had been contending that it held the exclusive right to sell commercial airtime. In addition, it controlled the higher quality phone hook-ups that would allow two or more stations to carry the same program simultaneously, a concept known at the time as "chain broadcasting." Other broadcasters had to use inferior telegraph lines.

Clearly, a resolution of the tensions was overdue. So the feuding parties agreed to binding arbitration.

AT&T did not fare well. The decisions favored RCA, GE, and Westinghouse. After further discussions, the phone company agreed to a plan under which it would essentially leave the radio business but would have the sole right to set up wired interconnections (networks) among stations.

Development of the Networks

Broadcasting pioneer David Sarnoff, who would later become the president of RCA, demonstrated the potential of network broadcasting as early as 1921

when radio was still in its "hobby" stage. The occasion was a championship prizefight with international appeal: Heavyweight champion Jack Dempsey versus French champ Georges Carpentier. The event would take place in Jersey City, New Jersey. Using a borrowed transmitter and an improvised antenna, Sarnoff arranged to broadcast the fight through radio sets and loud speakers in theaters, halls and barns connected together in a "network" throughout the eastern part of the country. It is estimated that some 300,000 people listened to the big fight. It was an important day for radio, but not nearly as good for Carpentier, who lost by a knockout in the fourth round.

The next year AT&T hooked up its flagship station, WEAF in New York, with Boston station WNAC for a musical program. By 1923 there was a mini-network of six stations and by 1924, a chain of radio stations reaching from the east coast to the west. RCA, Westinghouse, and General Electric ventured into "chain broadcasting," but because they had access only to lesser quality telegraph lines they were not as successful as AT&T—although their time would come.

NBC and CBS

By the mid 1920s, the significance and potential of radio broadcasting was apparent to all but the most diehard skeptics. RCA, which had ignored Sarnoff's prescient "music box" memo just a few years earlier, now was ready to take the big plunge. With Sarnoff's continual prodding, RCA established a permanent network, calling it the National Broadcasting Company (NBC). And just a few months later, NBC set up a second network. The original one was dubbed the Red Network and the newcomer, the Blue Network.

The federal government eventually forced NBC to give up its Blue Network because the government feared too much concentration in the hands of one company. The Blue network would eventually become the American Broadcasting Company, ABC.

The idea of radio networking made sense on several fronts. If many stations, instead of just one, were carrying the same programming simultaneously, the cost of the program could be shared. The quality of programming could be upgraded, thus attracting more listeners, and the larger the audience the more appealing the program would be to sponsors. It seemed to be a win-win situation for all concerned (except, perhaps, for those who felt community-oriented programming was being squeezed into smaller and less desirable time periods. Many believe those people had a valid point).

New Competitors Set Their Sights on NBC

NBC could look over its corporate shoulder and see competition moving in. A struggling company called United Independent Broadcasters (UIB) was offering some programs. But it wasn't much to worry about. NBC was clearly the king of the hill, and UIB most likely wouldn't last—and it didn't. UIB

acquired some stations, but eventually folded. The Columbia Phonograph Record Company bought what was left of UIB and renamed it the Columbia Phonograph Broadcasting System (CPBS).

The new name didn't help. Sponsors were hard to come by as most radio advertisers preferred to be associated with the quality network, NBC. New investors, including WCAU owners Isaac and Leon Levy, jumped into the breach as the CPBS, piling up debt, was about to call it quits. At about this time, the name of the network was changed to the Columbia Broadcasting System (CBS).

Paley Takes Over CBS

William S. Paley was twenty-six years old and an executive in his family's Congress Cigar Company, a firm that had advertised on WCAU and on the CBS network. He was impressed by the power of radio advertising. With the encouragement of the Levys and the blessing (and investment) of his family, Paley decided to see if his instincts about radio were right. He moved to New York as President of the Columbia Broadcasting System. David Sarnoff didn't know it yet, but he now had good reason to look over his shoulder. Part of that story is revealed in the sidebar (page 392), which profiles two of the most fascinating—and contrasting—personalities who shaped broadcasting.

Advertising Comes of Age

In the late 1920s, radio was still uncomfortable with its growing commercialization. That radio came into the living room dictated, according to the thinking of the day, a certain decorum. Hard-sell messages were looked down upon. Network executives fretted over the content of commercials: was toothpaste a distasteful product to advertise on the air? Should one mention the actual price of the product?

One interesting practice in the effort to advertise without really advertising involved a rather circular approach: To gain the advantage of frequent on-air mention without the unseemliness of actually presenting a commercial message, entertainment groups were frequently named after their sponsors. The Cliquot Club Eskimos, for example, were named after a beverage company.

But the raw power of the medium meant that subtlety would not last. Slowly, the commercial sales pitch became a common feature of radio. Many stations that had been started as good-will and publicity vehicles by newspapers, department stores, or other business ventures made the move into commercial sponsorship.

As a result, advertising agencies (companies that design a firm's advertising, advise where to place that advertising, and negotiate the sale of

advertising time or space on various media) began to play a major role in radio. In fact, ad agencies began to create and produce programs as well as sponsor them. Radio departments were created at leading ad agencies, and agency personnel coordinated scripts and hired talent. The networks, which received revenue for the airtime, were enthusiastic about this arrangement.

By the mid 1930s, radio was being taken seriously as a major economic power. In fact, some newspapers saw radio as a threat to the very existence of printed media and engaged in such futile protests as refusing to print radio station broadcast schedules. Despite this tactic, radio only became stronger and crested in popularity during what was known as its "Golden Age."

The Golden Age and Mass Entertainment

What intrigued advertisers about radio was the massive audience—both national and local—that the medium could attract week after week.

But what troubled radio executives was how to reach and hold this broad and diverse audience. The regular schedule of radio programs could chew up enormous amounts of material, and all this newfound popularity was straining an industry that actually wasn't quite sure what it was supposed to be providing. What was the ideal radio program? There was no existing "tradition" of radio programming, so radio programmers had to look to other models. For example:

- Newspapers knew that columnists appearing in the same part of the paper each day attracted a regular readership, as did comic strips, which provided readers with running stories that needed only small development week after week.

- The motion picture industry had exploited the serial with great success. Multipart adventures and dramas drew regular crowds who faithfully followed the adventures of Tarzan or "The Perils of Pauline."

- A type of stage show known as vaudeville attracted audiences who craved the variety of different acts rapidly performed, one after the other.

These types of programs, adapted for the airwaves, became mainstays of radio in the 1930s and into the 1940s. And radio developed these forms into program styles that were uniquely radio—combining the appeal of the serial with radio's relentless (if still sometimes indirect) advertising message. For example, "Jack Armstrong, All American Boy" was sponsored by Wheaties, a cereal that touted itself as the "Breakfast of Champions." Serials gave listeners the opportunity to become familiar with a cast of characters who would develop over time. The characters actually carried most of the shows; the plots were generally devices to provide the characters with situations and predicaments to negotiate. Imaginative dialog and sound effects were used,

Sidebar

DAVID SARNOFF AND WILLIAM S. PALEY

Among other things, David Sarnoff (see Figure B.3) liked to be remembered for his role in an international tragedy when he was in his early twenties, long before he became known for his contributions to radio and television broadcasting. Sarnoff had come to this country from Russia with his family at the turn of the century. He took a job with the Marconi Wireless Telegraph Company of America and became a highly competent operator, sending and receiving the dots and dashes of Morse code. According to an official biographer's story, Sarnoff can take the credit for notifying the world on April 14th, 1912, that the luxury ship *Titanic* had struck an iceberg in the North Atlantic and had sunk, with the loss of more than 1500 lives. Sarnoff allegedly stayed at his post for 72 hours with almost no food or rest, acting as the information link between the scene of the disaster and the mainland.

We say "allegedly" because there is serious question if the account of Sarnoff's heroism is accurate. Later information shows that Sarnoff may have been carried away when he spoke with his biographer and portrayed himself as the only link to the *Titanic* when, in fact, other operators may have played significant roles as well. Like many great men, Sarnoff had an impressive ego, and his knack for self-promotion likely led him to play with the facts. Nonetheless, his place in history is assured. From very humble beginnings he moved successfully through the Marconi Company to the Radio Corporation of America, where he served as Chief Executive Officer from 1947 until his death in 1971. He was an early proponent of radio broadcasting when others failed to see its potential and was a major force in the development of television.

William Paley (see Figure B.4) grew up in comfort, unlike David Sarnoff, the man who would become his great business competitor. But Paley wasn't really satisfied as an executive in his family's cigar company. He found the challenge of his life in the young and not-at-all prosperous radio network, the Columbia Broadcasting System. Paley was urbane and could be a charmer, but he was also a shrewd businessman who nursed CBS to health and then built it into a colossus. In the late 1940s, during the golden age of radio, Paley made a swift and dramatic move on NBC, staging a "talent raid" on the other network, luring many of its top stars to CBS. In both radio and television, Paley was noted for his programming genius and his appreciation of talent.

As World War Two approached, Paley supported establishment of a serious radio news operation for CBS. CBS News, initially in radio, then in television, became known as the premier broadcast news division.

Continues

Sidebar Continued

Figure B.3 *Radio and TV pioneer David Sarnoff (1891–1971), shown doing a reenactment of the night the* Titanic *sank. Sarnoff received the S.O.S. signal in the wireless room of the* U.S.S. Carpathia. *He later became chief executive of RCA.*

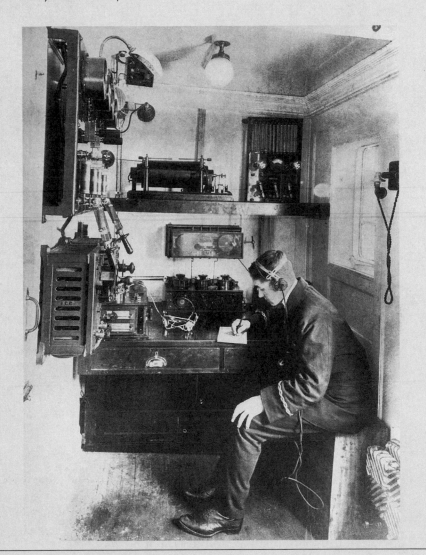

Continues

Sidebar Continued

Figure B.4 *November 5, 1934, New York. William S. Paley, founder of CBS, interviews the sponsor of NY Committee of Better Homes who has guaranteed sufficient funds to finance the house and its operation for at least one year.*

© Bettmann-UPS/CORBIS

With the help of correspondent Edward R. Murrow and colleagues Eric Sevareid, Charles Collingwood, William Shirer, and others, CBS set journalistic standards for the broadcast industry. Paley was proud of his news division, which was not expected to be a profit center. It was "the crown jewel" in the CBS empire. And under Paley, the respected CBS Labs developed the long-playing record.

But there were also some missteps along the way. In the 1940s, the CBS-developed color television system lost out to the RCA version. In the 1960s, during a period when many corporations went on a diversification spree, CBS bought up several companies, including the New York Yankees (which then dropped from first to last place in a scant two years), a guitar company, and a toy company. In later years, CBS divested itself of most of these not-very-successful acquisitions, deciding to concentrate on its core businesses. Despite these setbacks, Paley, like Sarnoff, is a truly historic figure in the saga of broadcasting.

"Sarnoff and Paley" was written by Michael C. Ludlum exclusively for *Modern Radio Production*. Used with permission.

but the real magic took place inside the listeners' heads, who added their own imaginations to the mix and created unseen characters in the theater of the mind.

Vaudeville's radio version evolved into the variety format. Instead of the lighted stage in the darkened theater, the magic sound of laughter emanated from a stage the listener could only imagine. A cross between variety and serial—the situation comedy—soon became a mainstay of radio's Golden Age. Audiences became devoted fans of stars they had never seen, and some series, such as Amos 'n Andy, were so popular that many motion picture theaters would interrupt their schedules when the program came on so as not to suffer a drop in movie attendance.

Programs like situation comedies and escapist adventure, as well as game shows, provided good times in an era when good times were scarce. Radio's Golden Years were terrible times for the nation as a whole. The 1930s and 1940s were a time of deep economic depression followed by a huge overseas war. That war would soon provide a new stage for radio.

Radio Comes of Age

Though some early broadcasts featured news items, such as election returns in 1920 on KDKA, regular reporting of news did not develop quickly. Radio, which had few reporters, was in no position to compete with newspapers, an industry that had two centuries of collective experience and tradition to draw upon, a solid economic base, and a vast network of news providers. In fact, news on radio was often used as filler if announcers were obliged to fill airtime when a performer failed to arrive at the studio. (And often as not, the announcer would read the news right out of the local paper.)

But certain events pointed to radio's potential. One of the most dramatic demonstrations of the power of radio news to cover breaking events—and score a huge "scoop" over newspapers—took place in 1933 when a reporter was describing the expected routine docking of the dirigible Hindenburg as it arrived in Lakehurst, New Jersey. The airship exploded while the announcer was on air live—and the announcer's wrenching description of the scene, as burning passengers fell to earth, became a vivid and memorable example of what radio could do.

Before World War II, there was major development of the role of commentators. One of the best known was H. V. Kaltenborne, who had a background as a newspaper editor. Kaltenborne began to give "talks" on the air—which sometimes contained withering criticism of the government. There was some movement to stifle him; after all, the government, in the public interest, licensed radio. Was it proper for Kaltenborne to use public airwaves to roast public officials? Kaltenborne won out and established himself as the dean of radio news commentators; but the fundamental issue of how a private individual could use public airwaves remains more or less an open question today.

Figure B.5 Edward R. Murrow, the dean of broadcast journalism.

© Bettmann-UPS/CORBIS

As the war in Europe heated up, Americans began to experience the full force of radio. When a CBS radio administrator named Edward R. Murrow (see Figure B.5) began his famous broadcasts from London in the 1930s, radio had been broadcasting from Europe for almost a decade. CBS, led by the young William Paley, had emerged as a competitive force against the powerhouse NBC. A CBS news reporter named Caesar Searchinger pioneered those

European broadcasts that allowed Americans to hear the live voice of the British monarch, and later that of playwright George Bernard Shaw, who used the opportunity to castigate the American social system.

But it was Hitler who made Europe seem relevant for Americans. The voices of Hitler, and other European leaders such as Churchill, Mussolini, and Chamberlain, were literally brought to the American dinner table and living room.

Thanks largely to radio, European events began to seem more like American events, and just as important. The isolationism that had characterized American foreign policy since the end of World War I melted away as the world became, figuratively, a much smaller place. Americans increasingly realized that what affected Europe affected America.

When Germany began its Blitzkrieg (German for "Lightning War"), Murrow was on hand to describe—in a live broadcast, as it happened—the nightly bombing raid. He conveyed to Americans, sitting in the comfort and security of their homes, the stark, ravaging fear that accompanied the sound of the air-raid sirens. Radio listeners heard the sirens, the explosions, and the screams, while Murrow's rich, clipped baritone described the scene in economical phrases that captured the sights, the sounds, and even the smells of his surroundings:

> This . . . is London. (Bombs explode in background.) There are no words to describe the thing that is happening. The courage of the people, the flash and roar of the guns rolling down the streets, the stench of the air raid shelters.

Gradually, Americans became aware that Hitler must be stopped. Europe had been at war for years, while America sat on the sidelines; Americans, sickened by the devastation of World War I, justifiably wanted no part of another European conflict. But President Franklin Delano Roosevelt believed that America must enter the war, and he used radio as a medium to present this view.

Roosevelt recognized the value of radio as a *mass medium* with an *intimate quality*. Roosevelt broadcast what became known as "fireside chats," friendly, encouraging conversations, which originally dealt with his plans to work the country out of its depression troubles. Later, talk turned to war.

Americans in cities, in towns, and on farms all over the country tuned in to hear their president, often speaking like a father, offering bits of hope. Then, in early December of 1941, President Roosevelt spoke before a joint session of Congress, his speech carried live by radio.

> Yesterday, December 7th, 1941, a date that will live in infamy, the United States of America was suddenly and deliberately attacked by naval and air forces of the Empire of Japan . . . I ask Congress declare that since the unprovoked and dastardly attack by Japan . . . a state of war has existed between the United States and the Japanese Empire.

Congress acted on the President's request and the United States went to war. Sons, brothers, husbands, and fathers volunteered or were drafted. The

families who stayed behind relied more and more on radio to keep them in touch with developments. Reports from overseas were sent by short wave radio to network control rooms in this country, which then fed them out to their affiliated stations.

By the end of the war, radio journalists had become proficient at gathering news that was startling in its immediacy. Murrow and a seasoned team of correspondents formed the nucleus of a news organization that would come to represent a major force of excellence in American journalism. CBS became the model for other networks as they developed worldwide news organizations of their own.

Radio news, and radio, entered the 1950s at a crest of power, prestige and popularity. And then the roof fell in.

Television Lowers the Boom

Television had been demonstrated at the 1936 World Fair (covered by *The New York Times,* which offered the observation that television's commercial possibilities were doubtful); it was perfected in the 1940s and became a household fixture in the 1950s. At first, many in radio were openly skeptical of the possibility of television's becoming a respected and respectable medium. Many of the star newspeople at CBS avoided the medium because they viewed it as a short-lived gimmick.

But that gimmick crushed radio like a steamroller. Stars who could be seen had much more appeal than those who could only be heard. Stars like Jack Benny made the crossover to television and saw their audiences increase dramatically. Television began to exploit its own technical advantages, becoming more than just radio with pictures. Milton Berle, for example, used elaborate sight gags to produce his own variety of slapstick. Ernie Kovaks used special effects, often tying up breathtakingly expensive studios for hours to produce a visual that would last only a couple of seconds.

Radio's magic appeared to be gone; it simply could not compete with a medium like television. But it could leave the mass audience to television and reinvent itself as a medium that appealed to a more targeted listenership.

Radio targeted its audience through airplay of recorded music, song after song. This was not exactly a new practice, having been "invented," according to radio legend, in the 1930s when an announcer named Martin Block popularized the format in a program called "Make Believe Ballroom." Block reportedly came up with the idea when a studio orchestra failed to show and he needed to fill time. Block is credited with developing the modern "disc jockey" format, which was later adapted into programs like "Your Hit Parade." These programs played the most popular tunes of the week and were in part responsible for the evolution of the "Top 40" format.

Music on radio was generally an eclectic mix well into the 1950s. Disc jockeys might play some classical, followed by jazz, followed by big band,

and then followed by, essentially, whatever the disc jockey wanted to play. Disc jockeys had developed considerable skill in weaving all this together. They became consummate professionals, able to entertain, persuade, and motivate. What's more, they had fun doing it. And when television threatened to dismantle the radio industry, the talent of the emerging corps of disc jockeys was melded with a powerful new force: Rock and Roll music and the lifestyle that went with it.

Rock Saves Radio

As rock evolved from rhythm and blues, the youth of the nation became captivated with this new form of musical expression. Rock in the 1950s was rebellious, a refreshing change from the heavy cloak of conformity that settled over the postwar United States. Young people wanted more of a role in society, and coincidentally they also were developing quite a bit of disposable income during these prosperous years.

Radio stations sensed this new awakening, and as millions tuned into the sounds of early rockers like Bill Haley and the Comets, Carl Perkins, and Ferlin Husky, radio programmers discovered something of enormous importance:

This was more than music. Rock was a lifestyle.

The old hit-parade format—playing the most popular songs of the week according to record sales—was now used to program stations' broadcast schedules. It was a relatively easy format to implement, even in the tiniest radio station: All you had to do was read one of a number of record industry publications and play the top 40 most popular cuts.

As it turned out, making money off Top 40 was fairly easy, too. Soft drink manufacturers, traditionally heavy advertisers, found that they had a direct pipeline into the youthful lifestyle . . . in one case, they called it joining the "Pepsi Generation." Grooming products and the rapidly growing fast-food market all fueled radio's comeback.

Radio had found a new and eloquent voice. Disc jockeys such as Allen Freed, who developed the concept of "personality" as an essential component of Top-40 radio, became stars. Radio itself became a powerful force in the music world, so much so that some radio programmers engaged in an unethical and illegal practice called "payola," where—in return for a bribe from the record company—they would give a certain cut heavy airplay.

The youth culture was the biggest, but not the only, segment of the population to be intrigued by the newly rediscovered music box. Adults found radio to be a fine companion; development of new, small components called transistors (replacements for the bulky vacuum tubes invented by de Forest) meant that radio could travel to the beach, to the backyard, and most notably, in the car.

Radio Tunes into Its Audience

Programmers became aware that enormous numbers of commuters were driving to and from work in the morning and evening, and once radios became commonplace in cars the programmers exploited this lucrative "drive time." Soon a station could be identified by its format, a term that came to mean the type of music played on the station. A station was usually known as Top 40, or Country and Western. Those that chose a middle path were called middle-of-the-road (MOR).

Through the 1960s, methods of sampling the audience became more sophisticated, and the distinctions among audiences were fine-tuned. By the late 1960s, where previously perhaps four or five stations had dominated a major metropolitan area, now there was room for many more because of the niche markets that had been discovered and cultivated.

Almost all this growth came on the AM band. (AM stands for *amplitude modulation*.) There were several reasons for AM growth. The FM (*frequency modulation*) band had been available for years, but confusion over assigning frequencies had caused that technology to languish. Getting an FM radio for your car was an expensive proposition, and home sets equipped to receive FM often did not work very well.

But in the late 1960s, significant advances were made in the quality of receivers as well as the capability of stations to transmit a high-quality FM signal.

Once FM was perfected, it outshone AM in sound fidelity, primarily because the signal is less prone to interference and because FM stations are assigned a broader range of frequencies, meaning that the signal can carry more sound information. Once-unused FM frequencies became dominant powerhouses, and AM suffered. But after incurring severe losses in the 1980s, AM radio stations returned to relative health, many of them by programming talk and news, two formats that have continued to increase in popularity.

GLOSSARY

AC See *adult contemporary.*

acoustics The study of sound. Also, the properties of a studio, room, or concert hall that contribute to the quality of the sound heard in it.

actuality The sound of an event, recorded or broadcast at the time the event took place. Also called a *sound bite.*

ad-lib To speak over the air without a prepared script.

adult alternative A radio format featuring jazz and compatible vocals.

adult contemporary (AC) A wide-ranging radio format that generally includes a few current popular hits, recent hits, and older songs.

adult standards A middle-of-the-road radio format, generally featuring older music, including show tunes and durable vocalists.

air monitor A source on the console that monitors the output of the station as it is received over the air (in other words, the actual output of the transmitter rather than an output from the console or any other piece of equipment along the audio chain).

airshift Period during which any particular radio operator puts programming on the air at a radio station.

album-oriented rock (AOR) See *album rock.*

album rock A radio format that features long, heavy-rock cuts and is primarily aimed toward a fairly young male audience. Also called *album-oriented rock.*

ambient noise Noise randomly occurring in an environment.

amplification The raising of the volume or strength of a signal.

amplifier A device used to raise the volume or strength of a signal.

amplitude The property of a sound wave or electrical signal that determines its magnitude.

analog In radio, a type of recorded sound source that produces a sound wave similar to the original wave. Traditional methods of reproducing sounds, such as phonograph records and standard audiotape, use analog methods, rather than *digital* recording.

AOR See *album rock.*

ASCAP American Society of Composers and Publishers, a music-licensing agency.

attack time The length of time an audio processing unit takes to activate the compressor after a particular sound affects it.

audio Electronically transmitted or received sound.

audiotape Thin tape used to record sound that has been transduced into a magnetic signal.

audition A mode of console operation in which sound can be channeled into a speaker without being fed to the on-air transmitter. Also, a session for assessing material or talent in advance of production.

automation Machinery for putting program elements on the air, taking the place of human workers.

average quarter-hour (AQH) persons The number of listeners who tuned in to a specific quarter-hour for at least 5 minutes.

back-announce Identifying musical selections after they are played.

backsell See *back-announce*.

backtracking Counterclockwise rotation of a disc on a broadcast turntable; part of the sequence of functions used to cue a record.

bed See *music bed*.

bidirectional A microphone pickup pattern in which sound sources are accepted from two opposite directions—in front of and in back of the mic but not from the sides.

billboard A rundown of information to be fed by an audio service; usually printed but sometimes spoken.

binary The digital computer's method of using two pulses—on or off—to encode computer language.

bit A binary digit. The smallest portion of computer language.

BMI Broadcast Music International, a music-licensing agency.

board An audio control console.

bus A junction of circuits where the outputs of a number of sound sources are mixed together.

capacitor A device for storage of electrical signals, used (among other functions) as an element in a condenser microphone. *Condenser* is an old-fashioned term for capacitor.

capstan A revolving metal post on a tape deck that determines the speed of the tape's movement; it turns the pinch roller.

cardioid A microphone pickup pattern that is unidirectional and heart-shaped.

carousel A circular, rotating device for automatically playing cartridges.

cartridge The element of a turntable assembly that converts vibrations of the stylus into electrical energy. See also *cartridge tape*.

cartridge machine A unit that plays and records cartridge tapes.

cartridge tape A continuous loop of recording tape housed in a plastic case. Usually called a *cart*.

cassette Two small reels of tape enclosed in a plastic case.

central processing unit (CPU) The brain of a computer; the circuitry that performs calculations.

channel The route followed by a signal as it travels through the components of a system. Also, an input or output designation on an audio control console.

channel bouncing A production technique that moves sound from one speaker to another. Sometimes called *pan potting*.

classical Music format that plays standard form orchestral and choral pieces, frequently referred to as concert music.

classic rock A radio format featuring album rock without the new releases.

coincident mics Two cardioid mics set up to cross at approximately a 90-degree angle; used as a standard method of recording.

coloration The nuances of sound that give it a particular character.

combo Combination of operating the audio console and announcing over the air. Doing this is usually called *working combo*.

compact disc A small disc that is recorded digitally and is played back by laser-beam read-out.

compact disc (CD) player A device to play back a digitally encoded disc using a laser that reads the code on the disc.

complex waveform A visual representation, usually on a computer or an oscilloscope, of the various sound waves that make up a particular sound.

compression Process used to minimize distortion by reducing the differences in level between low- and high-volume segments of a recorded or broadcast sound.

condenser mic A microphone that contains a capacitor as an element and typically requires an external power supply; changes in the position of the vibrating diaphragm of the mic alter the strength of the charge held by the electrical element.

console A device for amplifying, routing, and mixing audio signals.

contemporary Christian A religious format featuring Christian rock and uptempo songs.

contemporary (current) hit radio (CHR) See *top 40*.

cost per point (CPP) A measure of how much it costs to "buy" one rating point in a particular market.

cost per thousand (CPM) The cost of reaching a thousand listeners.

country A radio format with rural roots but not limited to rural listeners.

CPM See *cost per thousand.*

CPP See *cost per point.*

CPU See *central processing unit.*

cross-fade Gradual replacement of one sound source with another. One sound is faded out, and the other is simultaneously faded up; at one point, their sound levels are the same.

crossover A song that bridges two categories of music, such as country and pop.

cue To ready a record or tape playback device so that it will play at the first point of sound or at some other desired starting point. Also, to indicate by hand signal or other means the desired time to begin a performing activity. Also, a channel on a console that allows you to hear a sound source without putting it on the air.

cue tone A sound meant to convey a signal to an operator or to an automated device.

cume Cumulative audience measure. A measure that uses statistical interpretation to determine the number of unduplicated radio audience listeners.

current hit radio See *top 40.*

cut A segment of recorded sound on a disc or tape. Also, to record a segment of audio production such as a commercial or public-service announcement.

cycle One complete movement of a sound or electrical wave through its naturally occurring pattern to its starting point.

daypart Segment of the broadcast day. Dayparts include morning drive (6–10 A.M.), midday (10 A.M.–3 P.M.), afternoon drive (3–6 P.M.), and evening (6 P.M.–12 A.M.).

dead air Silence over the air.

dead-potting Starting an audio source with the pot closed; usually done at a carefully calculated moment, with the goal of finishing the audio source (such as a song) at an exact time.

decibel As applied to sound, a relative measure of volume.

delegation switch A device that allows the operator of a console to choose which of two or more sources is to be controlled by a particular pot.

demographics Statistical representation of a population; usually used in radio to refer to the characteristics of the listening audience.

diaphragm The portion of a microphone that vibrates in response to sound.

digital Based on the translation of an original sound source into binary computer language.

digital audiotape Audiotape combined with an audiotape recording system that allows sound to be recorded in binary computer language.

directional mic A microphone that picks up sound from only one direction. Also called a *unidirectional mic.*

disc A phonograph record or compact disc.

disc jockey A staff announcer who acts as host of a music program.

distortion A change or alteration in the quality of sound that impairs the listener's ability to identify it with its source.

Dolby A trade name of a noise-reduction system.

donut In radio production, a recorded audio segment that provides an introduction, an ending, and a music bed; an announcer uses the segment as a production aid by reading copy over the music bed, thereby filling the hole in the donut.

doubletracking Recording a voice and then recording another version of the voice that has been slightly altered electronically; when both voices are mixed and played back, an eerie effect results.

downlink The method by which a receiver on earth can pick up a transmission from a satellite.

dubbing Recording sound from one recorded source to another.

dynamic mic A mic in which a coil moves through a magnetic field in response to sound vibration sensed by the diaphragm of the mic.

dynamic range The difference in volume between the loudest and quietest sounds of a source.

echo Repetition of a sound, usually caused by the reflection of the source bouncing off a hard surface. Also, an electronic special effect created by using a delay unit or by feeding back the output of a tape machine's playback head while recording.

editing In audio production, the alteration of a recorded sound—most commonly through the physical cutting and splicing of the tape or through the electronic transfer of the tape from one source to another.

editing and production structures Patterns of editing commonly used in radio production: establish music; voice under, voice up; cross-fade; voice out, music up; music wrap; voice wrap; and various combinations of these patterns.

edit point A location on a tape or other playback source where the producer wants the edit to begin or end.

electromagnetic field A magnetic field—an area where there are patterned magnetic waves—produced by electricity.

electronic splicing (editing) The removal of portions of a recording and the subsequent reassembly of the remaining material by means of electronic equipment rather than by physically cutting or splicing the tape.

element The part of the microphone that transduces sound into electrical energy.

Emergency Alert System (EAS) A federal network for broadcasting information to the public, activated in times of war, natural disaster, or other dire circumstance.

equalization Alteration of a sound source as a result of varying its frequency balance.

equalizer A device for boosting, limiting, or eliminating certain frequencies of audio.

erase head The part of the head system of a tape unit that removes the recorded signals from tape.

establish To play a recognizable and noticeable portion of a sound source. For example, a producer may establish a music theme before potting it down.

fact sheet A listing of facts given to an announcer as a guide for delivering an ad-lib commercial.

fade To bring a sound source up or down on an audio console at a given rate of speed (usually slowly).

fader See *vertical/slide fader.*

false ending In some recorded material, an apparent end of the recorded segment that is in fact not the end.

feedback Reamplification of a sound, resulting in a loud squeal from a loudspeaker; often caused by mic pickup of the output of a speaker that is carrying the sound being picked up by the mic; also occurs when the record head of a tape machine receives the output signal of the same recorder.

filter An electronic system that reduces or eliminates sound of designated frequencies.

flanger Device for throwing a sound and its mirror image out of phase to produce unusual sound effects.

flanging Slightly delaying reproduction of a source and then mixing the reproduced sound with the original source of the sound to produce a special effect.

flat response A faithful response by a microphone.

format A radio station's programming strategy to attract a particular audience; the mix of all elements of a station's sound, including type of music played and style of announcing.

formatics The study of developing and applying generic programming concepts for radio.

forward echo An echo in reverse, used as a special effect; the echo comes first, and the sound follows.

frequency The number of times a sound wave repeats itself in 1 second—expressed in cycles per second (cps) or hertz (Hz). Also, the average number of times a theoretical listener hears a commercial.

frequency response The range of frequencies that can be produced by an audio system.

front-selling Announcing upcoming musical selections before they are played.

full-track A method of recording in which the signal is placed over the entire width of a tape.

geostationary (Of a satellite) staying in an orbit over the same part of the earth, as a result of moving in tandem with the earth's rotation.

graphic equalizer A device for tailoring sound; the controls produce a visual representation of the frequency response, hence the term *graphic.*

grooves The continuous narrow channel in a phonograph record that the stylus tracks.

gross impression The total number of exposures to a commercial.

gross rating point A way of expressing gross impressions as a rating figure. AQH ratings multiplied by the total number of commercials played in those quarter-hours determines gross rating points.

half-track A method of recording in which signals are simultaneously placed on two tracks (one-half of the tape width each) of a tape, thus making stereo recording possible. Also called *two-track.*

hardware The physical equipment of a computer.

hard-wired (Of equipment) physically wired together.

harmonics Frequencies related to a fundamental frequency that are multiples of the original; the mixture of harmonics with the fundamental gives a sound its particular timbre or tonal color.

heads The devices on a tape machine that impart a signal to the tape; they generally consist of an erase head, a record head, and a playback head. The erase head scrambles the iron oxide particles on the tape, the record head arranges the particles in order, and the playback head reads the pattern formed by the record head.

headset mic A mic that fits directly on the head, using earpieces; useful for sports announcers.

headstack A post on which multiple recording heads are placed one on top of the other.

hertz (Hz) A unit of frequency (identical to cycles per second) named after Heinrich Hertz, whose discoveries made radio transmission possible.

high fidelity Giving high-quality, faithful reproduction.

high-pass filter A filter that allows only high frequencies to pass, chopping off lower frequencies; used, for example, to eliminate a low-pitch rumble.

hot-potting Starting a sound source with the pot open.

hypercardioid A microphone pickup pattern that is very narrow, heart-shaped, and one-directional.

inverse pyramid A method of newswriting whereby the most important details of a story are given at the beginning or top. The story can then be cut from the bottom.

iron oxide Rust; the substance on a magnetic tape that holds the signal.

isolated-component recording Recording various components of an orchestra, or other multiple-component sound source, using a separate mic to record each component. The output of each mic is recorded on a separate channel, and these are mixed after the recording session.

jazz Music format characterized by syncopation and melodic variations, frequently improvised by the performer.

key On an audio console, the device for turning a pot (and through it, a sound source) on and off.

Also, the musical scheme in which the notes of a song fall.

lavalier mic A small mic that hangs from a string around the announcer's neck or clips to the announcer's clothing; not widely used in radio production.

lead The beginning sentence or sentences of a news story—ostensibly the most important part of the story.

levels The volumes of signals, usually as read by a VU meter.

limiter A device used to suppress dynamic levels of a reproduced sound above a preset limit in order to provide a more constant output level.

live-assist A method whereby automation is used to help the operator perform tasks more simply and efficiently.

log The station's official record of what will be and what was aired during a broadcast day.

loudspeaker A device for reproducing sound by transducing it from audio into sound.

low-pass filter A filter that allows only low frequencies to pass, chopping off the highs; used, for example, to eliminate a hiss.

magnetic tape In radio production, audiotape composed of a backing strip coated with iron oxide particles. When the particles are aligned in response to a signal in an analog or digital recording device, the signal can be stored and later played back as sound.

master pot The potentiometer (volume control) that governs the entire output of a console.

microchip A small circuit produced by a photographic process, used in computer technology.

microphone A transducer that converts sound energy into an electrical signal, which may then be amplified, recorded, or broadcast.

middle-side miking Technique for total-sound recording, involving a bidirectional mic picking up sound from the sides of the performing area and a cardioid mic in the middle; used to produce a very spacious sound.

MIDI (Pronounced "middy") A device for interfacing a number of sound-producing instruments with a computer and with each other.

minidisc A magneto-optical recording system developed by SONY. Each disc can hold about 80 minutes of stereo recording on 255 tracks. Minidisc machines can be used for recording, playback of spot announcements and for editing.

mix To combine a number of sound sources.

modern rock A radio format featuring very progressive music.

modulation The electrical imprint of a sound signal on an audio or radio wave.

monitor Loudspeaker in a sound studio or control room.

motional energy Energy produced by movement, such as sound. Sound qualifies as motional energy because it is produced by a physical vibration in molecules in the air or in some other medium.

mouse A device for controlling the movement of information on a computer screen.

moving-coil mic A microphone whose characteristic element is a coil that moves through a magnetic field (thereby producing an electric signal) in response to the movement of a diaphragm, which vibrates in response to sound waves.

multichannel A type of console capable of isolating a number of channels from one another; used in sound recording.

multiple A setup that allows many mics to be plugged into a sound source; useful for public events where many press people will be using tape recorders.

multitrack A device that records several audio sources, usually laid down on one tape.

music bed A segment of recorded music used as background sound in a broadcast production (usually a commercial). See also *donut*.

muting system A device that automatically cuts the control room speaker when a mic is opened to prevent feedback.

mylar A substance used as a backing for audiotape; it stretches more easily than acetate.

needle drop The means of measuring usage of material from a licensed set of sound effects or music beds. Feeds are charged "per needle drop."

network A linkage of broadcast stations in which a central programming source supplies material to the individual stations making up the system.

new rock See *modern rock*.

news/talk A radio format that is a combination of call in, live interview, and news.

newswire News feed from a "wire" service such as the Associated Press. Today, the term is a misnomer because the source is usually a satellite downlink, not a teletype wire.

normal connection The way in which an engineering staff routes a signal under normal circumstances. If you want to change the pattern, you can use a patchcord to break the normal.

omnidirectional (Of a microphone pickup pattern) capable of picking up sound sources equally well from all directions.

optimum effective scheduling A mathematical formula that determines the number of people who hear a radio spot three or more times and, at the same time, comprise at least 50 percent of the total audience.

output Anything that is fed out of an audio system.

overdub To add another audio element to an existing one. For example, a singer can listen to his or her previously recorded work while recording (overdubbing) a harmony part.

pan pot A control that allows a producer to move a sound source from the left stereo channel to the right one, or vice versa.

parabolic mic A microphone positioned in a reflecting dish that has a three-dimensional parabolic shape; used to pick up distant sounds.

parametric equalizer A type of equalizer that allows an operator to select one particular frequency and boost or lower that frequency.

patchbay A device in which patchcords are plugged for the purpose of routing signals.

patchcord A wire with an easily inserted connection, used to reroute signals for the convenience of the operator.

patching A method of changing the routing of a signal through an audio system. Also, a connection that is temporarily placed between audio inputs and outputs.

phase Synchronicity. When two or more sounds reach a mic at the same time, the sounds are said to be *in phase,* and their amplitudes combine. When the sounds reach the mic at different times, they are called *out of phase,* and they cancel each other. A similar principle applies to electrical waves.

pickup pattern A representation of the area within which a mic effectively picks up sound, based on a 360-degree polar pattern.

pinch roller A rubber wheel, driven by the capstan on a tape deck, that keeps the tape moving at the correct speed.

pitch The ear's and mind's imprecise interpretation of the frequency of a sound.

plate The part of a turntable that holds the disc and revolves.

playback head The part of the head system in a tape recorder or deck that reads the patterns created on tape by the record head and produces an electrical signal conveying this information to the rest of the playback system.

playback only Designation for a cartridge machine or other audio unit that does not have a recording capability.

polar pattern A graph consisting of concentric circles that are assigned decreasing values toward the center of the graph; a pattern superimposed on the graph represents the area within which the microphone effectively picks up sound.

pop filter A wind-blocking screen in or on a microphone, designed to prevent the blasting or popping noise caused by announcers who pop their *p*'s and *b*'s.

popping An undesirable explosive sound caused by too vigorous pronunciation of sounds such as *p* and *b.*

pot Short for *potentiometer.* A device on an audio console that controls volume.

potentiometer See *pot.*

preamp Short for *preamplifier.* A small amplifier that boosts a signal, usually up to line level. It generally accomplishes the first step in the amplification process.

preamplifier See *preamp.*

pressure-gradient mic Another name for a ribbon mic, which operates by measuring the difference in pressure between one side of the ribbon and the other.

producer A person who manipulates radio equipment to construct a program and achieve an effect.

production The process of manipulating sound elements with radio equipment to transmit a message and achieve an effect.

production library A collection of music or sound effects used in production. Production libraries are generally leased but sometimes bought outright; increasingly, they are appearing on compact discs.

program A mode of operation in which sound can be channeled through the console to the on-air transmitter.

programming The selection and arrangement of music, speech, and other program elements in a way that appeals to the station's listeners.

proximity effect A property certain mics have of accentuating lower frequencies as sound sources move closer.

public-affairs programming Program elements in the general public interest.

public-service announcements (PSAs) Program elements designed to provide the public with needed information.

quantization The process of converting a sound waveform into a computer word that expresses both frequency and amplitude.

quarter-track A method of recording in which individual channels are laid down on each of four tracks of a tape.

RAM See *random access memory.*

random access memory (RAM) In a computer, the area in which software can be loaded and information can be loaded and retrieved.

range The portion of the frequency spectrum that a microphone or other audio element can reproduce.

rarefaction An area in which air molecules become less dense; the opposite of a compression. Sound waves are carried through the air by a series of rarefactions and compressions.

rating A percentage of the total available audience.

rating services The companies that collect data about radio station listenership.

reach A measure of how many different listeners hear the commercial.

read only memory (ROM) The area of a computer where information (which has been factory installed) can be read but not accessed.

record head The part of the head system in a tape recorder that imprints the sound pattern on the magnetic tape.

release time The length of time it takes for an audio processing unit to let a signal return to its previous level.

remote Production done on location, as opposed to in a studio.

reverb Short for *reverberation.* An effect produced with an electronic device that adds a time delay to a sound source and then adds it back to the signal.

reverberation See *reverb.*

ribbon mic A microphone with a paper-thin element that vibrates in response to the velocity of sound waves. The element is suspended in a magnetic field that converts the sound into an electrical signal.

riding levels Keeping close watch on the strength of signals to ensure that the program is not overmodulated. Also known as *riding gain.*

rock Music format featuring electric guitars and drums. Subgenres include modern rock, classic rock, and alternative rock.

ROM See *read only memory.*

routing Channeling an audio signal.

sample and hold circuit Electronic circuit used to convert analog audio into digitized audio.

sampling The process of converting analog audio into digital bits for use in a computer or synthesizer.

sampling frequency The number of times per second (expressed in Hz) a digital recording unit takes a sample of a sound source.

satellite An orbiting device that, among other things, retransmits signals to a broad portion of the earth's surface.

segue The transition between two recordings played consecutively without interruption.

SFX Sound effects.

shape As a component of frequency response, the level of response at various frequencies within a mic's range; basically, the form of the graph that indicates the mic's sensitivity at various frequencies.

share The percentage of people who are actually listening to a station.

shotgun mic A long, narrow mic that has a very narrow, highly directional pickup pattern.

sibilance The noticeable prominence of hissy *s* sounds.

signal-to-noise ratio The ratio (expressed in decibels) between the intended sounds of a

recording or broadcast and the undesirable noise of a system.

sine wave A visual representation of a sound wave as it moves through its various values of compression and rarefaction.

slipcueing Finding the starting point of a disc by slipping it back and forth on the turntable plate (without allowing the plate to move). Also, often used synonymously (though somewhat inaccurately) with *slipstarting*.

slug A heading used by a wire service for quick identification of a story. (Example: WEATHER FOR SEVEN WESTERN COUNTIES.)

software The programs run by a computer.

solid-state (Of electronic equipment) operating without using vacuum tubes.

solo A control on a multitrack console that mutes other inputs so that the remaining channel can be heard alone.

sound The perception by the ear or by some other instrument of waves resulting from the vibration of air molecules.

sound bite A piece of sound recorded at the scene of a story and integrated into a newscast. Often used synonymously with *actuality*, but the term *sound bite* is more commonly used in radio if the piece of sound is a sound effect, such as a siren screaming.

sound effect Any sound other than music or speech that is used to help create an image, evoke an emotion, compress time, clarify a situation, or reinforce a message. Abbreviated as *SFX* in scripts.

sound envelope The waveform that represents a sound. In modern usage, the term usually refers to the waveform representation on a computer screen produced by means of a MIDI or other digital editing device.

sound shapers Devices on a recording console that can be used to change the physical characteristics of the audio signal.

spaced-pair mics Two microphones set up parallel to each other, 1 or 2 feet apart; used in stereo recording to produce a very broad sound.

spatial enhancers Devices used to alter the stereo signal to give the impression of a larger physical environment—that is, to create the impression of a very large hall.

splicing The process of joining together two pieces of recording tape, usually with the aid of an editing block and adhesive tape made specifically for this purpose, in order to edit recorded material or to repair broken tape.

spot A prerecorded announcement (usually a commercial).

stereo Using two channels for sound reproduction in order to create the illusion of depth and spaciousness.

stinger A brief musical opening designed to attract attention. Increasingly, stingers are produced by digital technology.

stylus The portion of a phonograph that makes contact with the grooves in a record and vibrates in response to the shape of the grooves. The vibrations create an electrical signal in the cartridge, and this signal is subsequently fed into an amplifier and distributed within an audio system.

submixer A miniature console through which several sources can be output to one of several submasters on a full-size multichannel console.

supercardioid A microphone pickup pattern that is narrow, heart-shaped, and unidirectional and falls somewhere between a cardioid pattern and a hypercardioid pattern.

supply reel The reel on a tape recorder from which tape spools off during play.

supply spool The part of the DAT cassette that contains the audiotape. Tape unwinds from the supply spool across the head and onto the takeup spool.

syndicators Firms that distribute programs or program material to individual radio stations for a fee.

synthesizer An electronic musical instrument that resembles an organ but can produce a wide range of sounds.

takeup reel The reel on a tape recorder that pulls and collects tape during play.

takeup spool The part of the DAT cassette where tape is collected once it has been pulled across the recording head.

tape guide Equipment on a tape deck that keeps the moving tape in a precise position.

task-oriented sequence The arrangement of radio production tasks in the most convenient and efficient order for accomplishing them within the confines of the production studio. Thus, doing the ending of a commercial first may actually be preferable under some circumstances.

telco drop The point at which the telephone company terminates a transmission line for carrying a remote signal back to the studio from the site of a remote broadcast. The station's remote equipment is connected to the drop.

time spent listening (TSL) A measure of the average time an individual listener tunes in to the station.

tonearm The movable arm on a turntable unit that holds the stylus and cartridge.

tonic The fundamental note that determines the rest of the musical notes that will form a proper chord.

top 40 A radio format that may include many of the most popular songs or heavy dayparting (specially designed formats for the changing listenership during the day). Also called *contemporary* or *current hit radio*.

total-sound recording Recording the entire sound output of, for example, a musical group, as a single sound source rather than recording separate sections or instruments with separate mics. Also see *isolated-component recording*.

track The portion of a strip of magnetic tape that is used for recording sound information. Also, of a phonograph cartridge, to trace with accuracy the grooves of a record.

transducer Any device that performs the function of converting energy from one form into another.

transmitter The device responsible for producing the radio waves that carry a station's signal.

trim control An adjustment control that makes very fine changes on the volume level on a console.

turnover A measure of how many people out of the entire audience leave the station during a given period.

turntable A system consisting of a plate, a drive mechanism, a tonearm, a speed control, and an on-off switch; used to play conventional disc recordings.

two-track A two-channel stereo recording where each track uses one half of the recording tape.

unidirectional (Of a microphone pickup pattern) capable of picking up sound sources clearly from one direction only. Also called *one-directional*.

uplink The piece of equipment that sends a signal up to the satellite.

urban A radio format featuring rap, hard rock, or other format particulars designed to appeal to young, urban audiences.

vertical/slide fader A pot that slides up and down a linear slot rather than turning on a projecting axis (as does the traditional circular pot).

voice actuality A report from a journalist with an actuality segment inserted in its midst.

voice report (voicer) An oral report of a news item, spoken by a journalist who signs off with his or her name, sometimes the location from which the report emanates, and sometimes the name of the news organization. (Example: "This is Bob Roberts reporting from Capitol Hill for WAAA News.")

voice-tracking Using a computer program to insert voice-over segments into radio programs, thereby eliminating the need for a disc jockey.

voice wrap An editing and production structure that begins with one voice, which gives way to a second voice, which gives way finally to the first voice until the conclusion of the spot.

volume The level of sound, perceived as varying degrees of loudness.

volume-unit meter (VU meter) A device that provides a visual readout of loudness. The most important use of a VU meter is for taking zero on the scale as a reference level for the proper audio-level output.

wave A complete cycle of electrical or sound energy.

waveforms Visual representations of physical waves.

wild sound Ambient sound used to enhance the atmosphere of an actuality or a sound bite.

wind filter A filter that fits inside or outside a mic and blocks the blasting noise caused by wind.

wire service A news-gathering organization that supplies news copy and audio reports to subscribers, who use the wire-service material to supplement their own news-gathering resources. The name is something of an anachronism since most of the material is delivered by satellite today rather than by wire.

wow The sound a record or tape makes when the audio portion is heard before the playback device has reached full speed.

XLR A type of three-pin connector commonly used in radio.

SUGGESTED READINGS

Listed in this supplemental section are books and periodicals that will be of particular help in understanding radio in general and production in particular. Some may be out of print, but many of the older books are readily available in libraries.

Production and Technical Works

Stanley R. Alten. *Audio in Media,* 6th ed. Belmont, Calif.: Wadsworth, 2001. The most comprehensive guide available on audio; much of the content is applicable to radio production.

David E. Reese and Lynne S. Gross. *Radio Production Workbook,* 4th ed. Focal Press, 2001. A workbook approach to radio production.

National Association of Broadcasters. *A Broadcast Engineering Tutorial for Non-Engineers,* Washington, D.C.: NAB, 1999. Clear and concise. Good handbook for de-mystifying radio technicalities.

Alec Nisbett. *Use of Microphones,* 4th ed. Stoneham, Mass.: Focal Press, 1994. A very thorough study of the sound studio. Useful for radio though probably more useful to recording-studio engineers.

General Radio, Radio Operations, and Surveys Dealing Substantially with Radio

Erik Barnouw. *A History of Broadcasting in the United States.* New York: Oxford University Press, 1966, 1968, 1970. Three-volume history; comprehensive and readable.

Joseph Dominck, Fritz Messere, and Barry Sherman. *Broadcasting, Cable, the Internet and Beyond,* 5th ed. New York: McGraw-Hill, 2003. The well-known, all-in-one guide to understanding the broadcasting, cable business world.

George H. Douglas. *The Early Days of Radio Broadcasting.* Jefferson, N.C.: McFarland Publishing, 1987. Narrative of radio's troubled birth and childhood.

Michael C. Keith. *The Radio Station,* 5th ed. Stoneham, Mass.: Focal Press, 2000. A heavily illustrated guide to radio.

Lewis B. O'Donnell, Carl Hausman, and Philip Benoit. *Radio Station Operations: Management and Employee Perspectives.* Belmont, Calif.: Wadsworth, 1989. A comprehensive guide to many aspects of radio, including physical facilities, station programming, operations, production, sales and advertising, and management.

Christopher H. Sterling and John M. Kittross. *Stay Tuned: A History of American Broadcasting,* 3rd ed. Lawrence Earlbaum. 2001. More than just a history—an easy-to-use, quick-reference guide to many aspects of broadcasting.

Gilbert A. Williiams. *Legendary Pioneers of Black Radio.* New York: Praeger, 1998. An interesting and readable work about black disc jockeys, often unheralded shapers of the industry.

Radio Programming

Susan Tyler Eastman and Douglas Ferguson. *Broadcast/Cable Programming: Strategies and Practices,* 5th ed. Belmont, Calif.: Wadsworth, 1996. A broad but concisely analytical study of programming with specific references to radio.

Herbert H. Howard and Michael S. Kievman. *Radio and TV Programming.* 2nd ed. New York: Macmillan, 1994. Coverage of programming, primarily from a historical point of view.

Michael C. Keith. *Radio Programming: Consultancy and Formatics.* Stoneham, Mass.: Focal Press, 1987. An in-depth analysis of strategies for commercial radio formats.

Murray B. Levin. *Talk Radio and the American Dream.* Lexington, Mass.: Lexington Books, 1986. An exhaustive study of radio talk shows. Includes transcripts of broadcasts.

Edd Routt, James B. McGrath, and Frederic A. Weiss. *Radio Format Conundrum.* New York: Hastings House, 1978. A dated but nonetheless thoughtful view of how and why formats work.

Gini Graham Scott. *Can We Talk?: The Power and Influence of Talk Shows.* New York: Insight Books, 1996. Interesting inside view of one of radio's hottest commodities.

Radio News

Carl Hausman. *The Decision-Making Process in Journalism.* Chicago: Nelson-Hall, 1990. A guide to principles of news judgment.

Brad Kalbfeld. *The Associated Press Broadcast News Handbook: Incorporating the AP Libel Manual,* 3rd ed. New York: Associated Press, 2000. Thorough guide to writing and staying out of trouble.

Ted White, Adrian J. Meppen, and Steven Young. *Broadcast News Writing, Reporting and Production.* 2nd ed. New York: Macmillan, 1996. An incisive guide that goes beyond writing and shows the entire range of radio (and, of course, television) news operations. Excellent examples of how news is gathered and scripted for broadcast.

Announcing and Performing

Stuart W. Hyde. *Television and Radio Announcing.* 7th ed. Boston: Houghton Mifflin, 1995. A durable book, now updated.

Carl Hausman, Philip Benoit, Fritz Messere, and Lewis B. O'Donnell. *Announcing: Broadcast Communicating Today,* 5th ed. Belmont, Calif.: Wadsworth, 2004. Many of the techniques discussed are applicable to radio; some chapters deal specifically with radio announcing.

Commercials and Advertising

Terri Apple and Gary Owens. *Making Money in Voice-Overs: Winning Strategies to a Successful Career in TV, Radio and Animation.* Los Angeles: Lone Eagle, 1999. Practical and interesting career advice.

David Ogilvy. *Confessions of an Advertising Man.* New York: Atheneum, 1989. A revealing insight into the world of professional advertising by the founder of one of the world's most successful advertising agencies. Useful for anyone who wants to design advertising of any type.

Charles H. Warner and Joseph Buchman. *Broadcast and Cable Selling,* 2nd ed. Belmont, Calif.: Wadsworth, 1991. A very useful guide primarily aimed at selling time, but much insight is provided into producing effective advertising.

Sherilyn K. Zeigler and Herbert H. Howard. *Broadcast Advertising: A Comprehensive Working Textbook,* 3rd ed. Ames: Iowa State University Press, 1991. Step-by-step guide; a good reference for a producer.

Periodicals

In addition to the preceding books, the following periodicals are recommended as ongoing references for anyone interested in any aspect of radio.

Billboard. 1515 Broadway, New York, N.Y. 10036. A source of in-depth information on the music industry, both broadcast and music stores.

Broadcasting and Cable. Reed Business Information, 245 W. 17th Street, New York, N.Y. 10011. A trade journal of the industry; heavy emphasis on business and regulatory aspects.

Broadcast Management/Engineering. 820 Second Ave., New York, N.Y. 10017. A resource designed for engineers but comprehensible to managers. Excellent source for keeping up with latest technologies; special attention is paid to production equipment.

Radio. BE Radio Magazine., Primedia., 745 Fifth Ave., New York, N.Y. 10151. A good resource on technology and engineering issues related to radio broadcasting.

WEB LINKS

Listed in this supplemental section are Web sites that will provide more information about radio in general and production in particular.

Chapter 1

Web Radio locator: www.web-radio.fm

Microsoft Media Player: www.microsoft.com/windows/windowsmedia
/default.asp

XM Satellite Radio: www.xmradio.com

Chapter 2

Articles from Broadcast Engineering: broadcastengineering.com/ar
/broadcasting_broadcast_production_audio_2/broadcastengineering
.com/ar/broadcasting_audio_consoles

Wheatstone Production Consoles: www.wheatstone.com

Chapter 3

Turntable history: www.djsociety.org/Turn%20History.htm

How CDs work: www.howstuffworks.com/cd.htm

Chapter 4

Sound recording history: www.inventors.about.com/library/inventors
/blsoundrecording.htm

How hard disk drives work: www.howstuffworks.com/hard-disk.htm

Ploeg's Recording History Page: www.geocities.com/Vienna/Strasse/6397 /rechist.htm

Chapter 5

How microphones work: www.howstuffworks.com/question309.htm

Multimedia Bluffer's Guide to microphones: home.pacific.net.sg/ ~ firehzrd /audio/mics.html

How the ear works: www.bcm.tmc.edu/oto/research/cochlea/Volta

Chapter 6

The tapeless studio: www.webdevelopersjournal.com/studio

Guide to digital editing: www.thislife.org/pages/trax/comic/nuzum.html

Chapter 7

The ASCAP homepage: www.ascap.com

The audio production den: www.audioproductionden.com

Chapter 8

The FCC's Emergency Alert System page: www.fcc.gov/cgb/consumerfacts /eas.html

Listen to classic radio jingles: www.pams.com/pams/sampler.html

Jinglesfreak.com: www.jinglefreaks.com

Chapter 9

How computers work: www.howstuffworks.com/category.htm?cat = Comp

How MIDI works: www.dj-media.com/doc/how_do_midi_work.asp

Information about in-band digital radio: www.broadcastsignallab.com /digital.php3

Shareware for radio production: www.hitsquad.com/smm/cat /RADIO_PRODUCTION/

Chapter 10

Sound effects in radio broadcasting: www.old-time.com/sfx.html

BBC's Creating sound effects for 'Walking with the Beast': www.bbc.co.uk /beasts/makingof/sound

Chapter 11

Mercury Radio Theater Web site: www.unknown.nu/mercury

Collection of old time radio dramas and shows: users2.ev1.net/ ~ ey /audio.html

Radio Days–A Web Quest: www.thematzats.com/radio

Chapter 12

Old Time Radio Commercials: www.old-time.com/commercials

Library of American Broadcasting–Sound Bites: www.lib.umd.edu /LAB/AUDIO/soundbites.html

Chapter 13

C-SPAN Radio: www.c-span.org

National Public Radio: www.npr.org

UPI news: www.upi.com

Chapter 14

Yahoo's Sports Radio Program List: dir.yahoo.com/Recreation/Sports /News_and_Media/Radio/Programs

ESPN Radio: http://espnradio.espn.go.com/espnradio/index

A second look at sports: www.secondlookatsports.org/RadioPrograms.htm

Chapter 15

Midwest Radio Theater Workshop: www.kopn.org/mrtw.htm

Soundprint: www.soundprint.org

Chapter 16

TVRadioWorld radio formats: www.tvradioworld.com/directory /Radio_Formats/

Old Time Radio: www.old-time.com

Radio locator: www.radio-locator.com

Yahoo's guide to Internet: http://dir.yahoo.com/Entertainment/Music /Internet_Broadcasts

CREDITS

Chapter 1. Figure 1.2 Courtesy of Z100 Radio, New York. Figure 1.3 Photo courtesy of XM Radio. Figures 1.4, 1.5 KEYT News Radio 1250, Santa Barbara, CA/ Photo by Austin MacRae Photography. Figure 1.6 Photo by Philip Benoit. Figure 1.7 © Bettmann/CORBIS

Chapter 2. Figures 2.2, 2.6 Photos by Philip Benoit. Figure 2.12.a, b Photo courtesy of Harris Corporation, Quincy, IL. Figure 2.12.c Photo by Philip Benoit. Figure 2.12.d Photo courtesy of Pacific Research & Engineering, Carlsbad, CA. Figure 2.13 Photo by Fritz Messere. Figure 2.14 Screen shot courtesy of Bias Software. Figure 2.16 Photo courtesy of Electro-Voice, Inc., Buchanan, MI. Figure 2.17 Photo by Fritz Messere. Figure 2.19 KEYT News Radio 1250, Santa Barbara, CA/Photo by Austin MacRae Photography

Chapter 3. Figure 3.1.a, b Photos by Philip Benoit. Figure 3.3 Photo courtesy of Yamaha Electronics Corporation, Buena Park, CA. Figure 3.5.a Photo courtesy of TDK Electronics Corporation. Figure 3.5.b Photo by Fritz Messere. Figure 3.6.a, b Photos by Fritz Messere. Figures 3.7–3.9 Photos by Philip Benoit

Chapter 4. Figure 4.5 Photo by Fritz Messere. Figures 4.6, 4.8 Photo courtesy of TEAC Corp. of America. Figures 4.10, 4.11 Photo by Fritz Messere. Figure 4.12 © 1999 Cartworks/dbm Systems, Inc. Figure 4.14 Photo by Fritz Messere. Figure 4.15 Photo courtesy of TASCAM, TEAC Professional Division, Montebello, CA. Figures 4.17, 4.18.a–c Photos by Philip Benoit

Chapter 5. Figure 5.6 Photo by Philip Benoit. Figure 5.14.a, c, e Photo by Philip Benoit. Figure 5.14.b Photo courtesy of Gotham Audio Corporation, New York, NY. Figure 5.14.d Photo courtesy of Sennheiser Electronic Corporation, New York, NY. Table 5.2 Gotham Audio Corp., Sony Corp. of America, Sennheiser Electronic Corp., Electro-Voice, Inc., Shure Brothers, Inc. Figure 5.15 Photo by Philip Benoit. Figure 5.16 Photo by Austin MacRae Photography

Chapter 6. Figures 6.1–6.5 Fritz Messere. Figure 6.10 Photo courtesy TEAC Corp. of America. Figure 6.11 Photo by Fritz Messere

Chapter 7. Figure 7.1 Photo by Fritz Messere. Figure 7.3 Photo by Philip Benoit. Figure 7.4 Photo by Fritz Messere. Figures 7.5–7.8 Photo by Philip Benoit

Chapter 8. Figures 8.1, 8.2 Photo by Philip Benoit. Figures 8.3, 8.4 Courtesy Intelligent Broadcasting System

Chapter 9. Figure 9.1 Photo courtesy of AKAI Professional, Fort Worth, Texas. Figures 9.2, 9.3 Photo by Fritz Messere. Figure 9.4 Courtesy of SmartSound. Figures 9.5–9.7 Philip Benoit. Figure 9.8 Photo by Fritz Messere. Figure 9.9 Photo courtesy of Broadcast Electronics, Quincy, IL

Chapter 10. Figures 10.1, 10.2 Photo by Carl Hausman

Chapter 11. Figures 11.3, 11.4 Photo by Philip Benoit

Chapter 12. No photo credits

Chapter 13. Figure 13.1 Screen shot of E-Z News, courtesy of Automated Data Systems. Figure 13.2 Photo by Fritz Messere. Figure 13.4 Courtesy Purdue University News with NASA photo. Figures 13.5, 13.6 Photos by Philip Benoit. Figure 13.7 Screen shot of E-Z News, courtesy of Automated Data Systems

Chapter 14. Figure 14.1 Photo courtesy of JK Audio. Figure 14.2 Photo courtesy of Marti Electronics. Figure 14.3 Photos courtesy of Musicam, USA Holmdel, NY. Figure 14.4 Photo by Philip Benoit. Figure 14.5 Photo courtesy of Telex. Figure 14.6 Photo by Philip Benoit

Chapter 15. Figure 15.1.a, b Photos by Philip Benoit. Figure 15.1.c Screen shot of Deck 3.5, courtesy of Bias, Inc. Figure 15.2.a Photo by Fritz Messere. Figures 15.2.b, 15.3, 15.6, 15.7 Photo by Philip Benoit. Figures 15.8, 15.9 Photo by Fritz Messere

Chapter 16. No photo credits

Appendix A. No photo credits

Appendix B. Figure B.1 © Bettmann-UPI/CORBIS. Figures B.2–B.5 © Bettmann/CORBIS

420

INDEX

NOTE: Page numbers in bold-face indicate locations of definitions of terms.

A

ABC (American Broadcasting Company), 389
Abrams, Lee, 14
acoustic couplers, 289
acoustics, **105**
action, 228
actualities, 257, 258, 266, 267–268, 288–289
actuality interviews, 298
actuality sound, 162
Adaptive Transform Acoustic Coding (ATRAC) compression, 85–86
add pools, forming, 366, 367–368
ad-libbing, 146, 171, 183–185, 278–279
adult contemporary (AC) format, 184, 351, 355, 359
advertising/commercials
 absence of commercials, 12
 carts and, 93
 early, 390–391
 elements of effective, 238–240, 253

execution of, 244–248
frequency of hearing a commercial, **348**
music in, 244–246, 253
music selection for, 152
practical approaches to, 240–248
production of commercials, 237–238, 248–251
proportion of copy in commercials, 256
responsibilities of producers of, 237–238
revenues, 2
simplicity of messages, 250, 253
thrust/focus of a commercial, 249, 253
voice in, 246, 248, 255–256
air monitors (or monitors), **26**, 175
airshifts, 15, **16**, 165–168, 174
airtime, 147
album-oriented rock (AOR), 359
Alexanderson, F. W., 382
Alten, Stanley, 130, 358
alternators, 382–383
AM (amplitude modulation) band, 400
ambient noise, **319**
ambush interviews, 299–300

American Society of Composers, Authors and Publishers (ASCAP), 151
American Telegraph and Telephone Company (ATT), 385, 387–388
amplification, **23**
amplifiers, **26**
amplitude, **100**, 101–102, 103, 105
analog recording, **52**, 55, 86–91, 162, **191**
announcers. *See also* performance; speakers (announcers/guests)
 ad-libbing, 146, 171, 183–185, 278–279
 combo announcing, 49–50
 on-air performance, 19–21
 reading to time, 255–256
 responsibilities of, 204
 roles of, 165
 sports, 318–319
 style of, 21, 171
 using a mic, 119–122, 124–125
 voice quality of, 218
appeals, advertising, 241–244, 253. *See also* audience/listeners
AQH (average quarter-hour) persons, **347**

421